AMBIGRAMMIA

BETWEEN CREATION & DISCOVERY

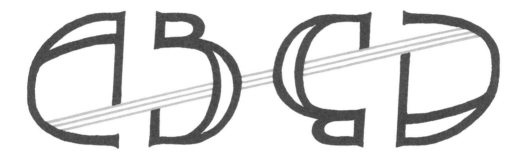

Yale University Press New Haven and London

Yale University Press books may be purchased in quantity for educational, business,
or promotional use. For information, please e-mail sales.press@yale.edu (U.S. office)
or sales@yaleup.co.uk (U.K. office).

Designed by Douglas Hofstadter with Julie Allred, BW&A Books, Inc.
Set in Baskerville, Americana, and Fritz Quadrata types.
Printed in the Czech Republic.

Library of Congress Control Number: 2024943173
ISBN 978-0-300-27543-8 (hardcover : alk. paper)

A catalogue record for this book is available from the British Library.

This paper meets the requirements of ANSI/NISO Z39.48-1992 (Permanence of Paper).

10 9 8 7 6 5 4 3 2 1

To the memory of my friend Peter Jones
and to my friend Scott Kim,
who together gave me
Ambigrammia

• • •

•

CONTENTS

Foreword by Scott Kim ix

Introduction 1

1 • Olivieromaggio 5

2 • Ambigrammia's Shaky Start 12

3 • Pioneers of Ambigrammia 17

4 • Creative Perception 32

5 • Two Early Exhibits 44

6 • Cheating and Reading 54

7 • Chunks and Low-hanging Fruit 65

8 • Playing in Peoria 78

9 • Snippets from *Ambigrammi* 86

10 • Cousins of Ambigrams 107

11 • Ambigrams in New Venues 115

12 • Ambigram Renaissance 122

13 • A Surprise for Dr. J 136

14 • From the Early 2000s 157

15 • Zologrammes à Paris 177

16 • Couplings 184

17 • Michaeliana 193

18 • Cognitive Science and Music 197

19 • Unigrams and Multigrams 204

20 • Six (or so) Impossible Things 214

21 • A Phalanx of Fine Physicists 225

22 • E Pluribus Unum 258

23 • The August Lulu 274

24 • Why This Book? Why Now? 284

Words of Thanks 287

Bibliography 290

Illustration Credits 291

Index 293

FOREWORD

by Scott Kim

Welcome to *Ambigrammia: Between Creation and Discovery*, or *ABCD* for short — a land of wonder and enchantment, where Douglas Hofstadter takes us on a tour of a lifetime of his lettering art, born out of his love of letterforms and creativity.

Doug wrote the foreword for my book *Inversions: A Catalog of Calligraphic Cartwheels* in 1981, so now I get to return the favor for my dear friend. Symmetry!

A lot has changed since then. What long was a curiosity in one corner of the lettering universe has now blossomed into a global phenomenon, with dedicated practitioners working in every language. As Doug says, ambigrams are an endless source of "pocket-sized creativity puzzles" — which is why he and I keep getting drawn back to create more of them.

Three Books in One

The book you are holding is three books in one. If you find yourself more interested in following one thread than another, I encourage you to skip around to chapters that interest you.

First, *ABCD* is a gallery of Doug's lettering art. There are many gems to behold here, both artistic and conceptual. Some of my favorites include his bilaterally symmetrical rainbow of color names (page 162), his spectacularly appropriate "oscillation" ambigram on the dual nature of light (page 220), and his ambitious states of the union (pages 260–269). Doug always strives for a graceful sense of line, and his whimsical shapes (see the four regions of Italy, on page 104) remind me of the art of Paul Klee.

Second, *ABCD* is a chronicle of Doug's life, as seen through the lens of ambigrams. We visit Italy, France, and Russia, dive deep into his many artistic and scientific interests, and get to know something of the people in his life through

the ambigrams he created for them. Like songs or poems, ambigrams are deeply personal creations, and Doug cares deeply about his friends and family.

Finally, *ABCD* investigates the nature of creativity and cognition. A theme that runs through all of Doug's work is the slippery nature of conceptual categories. While many AI researchers attempt to reduce recognition to a mechanical task, Doug heads in the opposite direction, pointing out that even the most mundane recognition tasks are full of slippery edge cases.

Doug probes the nature of thinking by studying microworlds that are highly simplified but that nonetheless contain a bottomless well of subtlety. Here are some puzzles I invented within three of Doug's favorite problem spaces.

Bongard problems. These are visual analogy problems named after the late Soviet computer scientist Mikhail Moiseevich Bongard. In each of the three figures below, what simple characteristic do each of the six figures on the left share that makes them different from each of the six figures on the right?

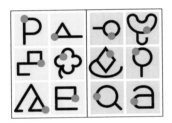 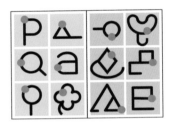 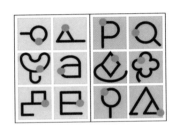

SeekWhence. What are the next six numbers in the sequence 1 2 3 2 3 4…? Usually such math puzzles are presented as if there were only one answer, but in this version of the puzzle, I'm going to ask a subtler question. Explain why the sequence 1 2 3 2 3 4… could be logically continued in any of the following ways:

 a. 5 3 4 5 6 7…

 b. 5 4 5 6 7 6…

 c. 3 4 5 4 5 6…

LetterSpirit. In each "gridfont" below, draw the lowercase letter "e" in the same style as the letters "a", "b", "c", and "d", using only horizontal, vertical, and 45° diagonal strokes chosen from the grid. These four examples are simple challenges; other gridfonts (there are hundreds of them!) present far more difficult challenges.

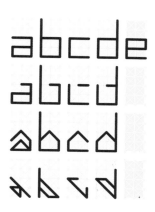

Three Pioneers

In this book, three names come up rather often: Doug's, of course, and John Langdon's, and my own. The three of us have been in touch for many years, and we represent three different approaches to ambigrams.

Doug, as a cognitive scientist, is especially interested in ambigrams as a laboratory for studying the nature of creativity and perception.

John, as a typographer, is especially interested in creating works of art that adhere to the timeless rules of designing beautiful letterforms while at the same time stretching them.

And I, as a puzzle designer, am especially interested in inventing new formal challenges that stretch the definition of *ambigram*, and I often concoct a new trick to suit the meaning of the word or name I am drawing.

For instance, Arnold Schönberg was an influential twentieth-century composer who pioneered twelve-tone serialism (atonal music that uses all twelve pitches of the scale equally). So I set myself the challenge of writing his name with the numerals running from 1 to 12.

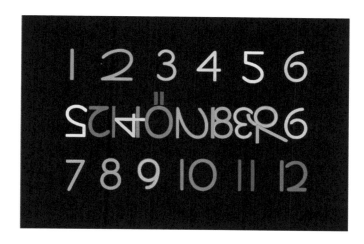

I later used a similar trick to pay homage to the mathematician Richard Guy, co-author (with John Conway) of the *Book of Numbers*.

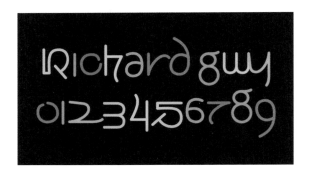

This, of course, is not a trick with wide application, but it seemed appropriate for these two people. As John Langdon has observed, creating such a design is like solving an algebra problem — one must find a solution that satisfies multiple constraints simultaneously. In this case, I wanted to make the name out of the ten digits, with all the letters and digits being as legible and consistent as possible.

Three Challenges

What I love most about ambigrams is that they invite participation. As you read this book, try these challenges.

1. When you look at an ambigram, study why the letters are shaped the way they are. Which quirks resulted from the demands of making a letter read in two different ways, maintaining a consistent style throughout the design, or achieving legibility?

2. Close the book and reproduce one of Doug's ambigrams from memory. This will help you appreciate the subtle decisions he made when drawing the ambigram… or maybe you'll improve on his design!

3. Create an ambigram on your own name or the name of a friend. Let Doug's creations inspire you to explore your very own corner of Ambigrammia.

I look forward to seeing what you create (or do I mean "discover"?).

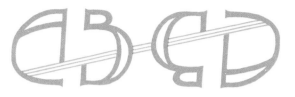

Introduction

The Funniest Thing in the World

In August of 1950, when I was just a little tyke and my sister Laura was but a babe in arms, our family set out in our 1947 Kaiser from Princeton, New Jersey, for parts west. We easterners were moving all the way out to California so that my Dad could take up a new position as associate professor of physics at the almost unknown institution named Leland Stanford, Jr. University. En route we passed through many states and innumerable gas stations. I loved the smell of gasoline when we filled up, and I was fascinated by the logos of the many different brands of gas. One day, as we were passing through Ohio, my Dad pointed at the sign of the Standard Oil of Ohio station where we had stopped:

SOHIO

He offhandedly commented that if you twisted your head around, you could read it upside-down. He even said it out loud: "*Oy*-hose". What a silly-sounding, meaningless word! I practically split my sides. "OIHOS" was the funniest thing my five-year-old self had ever heard. It was also the first ambigram I had ever seen.

ABCD

Well, actually, it wasn't a true ambigram, but it was a close cousin to one. Let me explain. By "ambigram", I will henceforth mean *a piece of writing expressly designed to squeeze in more than one reading*. (Once in a blue moon it's more than two readings, but almost always it's just two.) The etymology combines Latin's *ambi-*,

meaning "two-sided", with Greek's *gram*, meaning "piece of writing" — and thus, if you look at an ambigram one way, it says one thing, and if you look at it another way, it says another thing (or possibly the same thing) — and *deliberately* so. A true ambigram is intentionally designed so as to have that Janus-like property. Since I seriously doubt that the creator of the "SOHIO" logo had the non-word "OIHOS" in mind as a rotated reading, I hesitate to call it an ambigram, although, as my Dad keenly observed, it had two pronounceable readings.

Now that I've defined the "A" part of my book's title, let me explain its "BCD" part — namely, the phrase "Between Creation and Discovery". When you engage in *ambigrammia* (the act/art of producing an ambigram), you are not so much creating something *new* as discovering something *old* — or rather, something timeless, something that already (sort of) existed, something that *could* have been found by someone else, at least in principle. Ambigrammia is thus neither fish nor fowl, in the sense that it floats somewhere between creation and discovery.

Let me spell this out a little more explicitly. Some ambigrams, when you see them, make you think, "Oh, that was such an obvious find. A triviality! *Anybody* would have seen that possibility a mile away." Those are *discovery*-type ambigrams. Other ambigrams, though, make you wonder, "How on earth did anyone ever dream *this* up? What kind of a mind could have created this?" Those are *creation*-type ambigrams. And then there are ones that are in between those two extremes.

In this book, you'll see ambigrams that lie at just about every point along the creation/discovery spectrum. I hope that when you reach the book's end, you will have acquired, thanks to the quantity and diversity of the examples, many fresh insights into creativity and what I call "discoverativity" (a proneness to making discoveries) and how they are linked. Aside from those two "ivities", ambigrammia involves *explorativity* (a passion for probing unfamiliar terrain), *manipulativity* (a bent for tweaking things), and *projectivity* (the ability to imagine how others see things).

Once in a while I will write "Ambigrammia" with a capital "A", using it as a proper noun, almost as if it were a place, a realm, a territory, a world — for indeed, Ambigrammia is a microcosm inhabited by, well, *ambigrammists*, of course.

It's time for me to exhibit some ambigrams to make all of this more concrete.

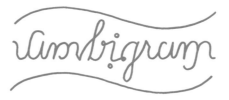

Like "SOHIO", this design has a second reading if you rotate it by 180 degrees. Do so, and you'll see that it still says the same thing. It's not that the word "ambigram" is a palindrome, of course, nor that it is intrinsically symmetrical. Rather, it was *forced* to be symmetrical by the act of distorting its letters.

Here is another example:

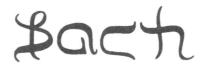

This one doesn't have rotational symmetry; it has *mirror* symmetry. Reflect it, and it will look identical. Once again, the word doesn't *naturally* have this property; it was *forced* to be symmetrical by that sadistic letter-abuser, Douglas R. Hofstadter.

In each of these ambigrams, the two "different" readings are not different, but identical. Each of the ambigrams is *symmetrical* (but they have different symmetries). However, an ambigram's two readings need not be identical. Take the facing page's "*Creation vs Discovery*", for example. If you turn the whole thing upside-down, it still says "*Creation vs Discovery*", but on the other hand, if you turn just "*Creation*" upside-down, it becomes "*Discovery*", and vice versa — so that's a case where the two different readings are, in fact, *different*.

Rotating an ambigram through 180° and mirror-reflecting it are not the only ways of obtaining a second reading; on rare occasions, an ambigram's two readings will be *perpendicular* to each other, as in the following example:

Rotate it counterclockwise by 90°, and you will find a pleasing surprise in Latin (and also, for that matter, in Italian, Spanish, Portuguese, Polish, Swedish, Dutch, etc.). There are yet further types of ambigram — but for now, this sampler will do.

What's indispensable to a would-be ambigram is that its two readings should be *easily legible*. An ambigram being a personal piece of art, its maker is totally free, but on the other hand, if the artwork can't be read, it will have little appeal. A would-be ambigram that is illegible is no better than a would-be gourmet meal that is inedible. Taste matters in ambigrammia no less than in gastronomia.

Preview of *ABCD*

In what follows, I will tell how ambigrams (but without that name) initially entered my teen-age life as a silly game and how, twelve years later, they reentered it as an art form; I will tell how I was slowly sucked into the vortex of ambigrammia, and what goes on behind the scenes of my ambigrams. I will tell how the word "ambigram" was coined and how the creation/discovery of ambigrams, although always done just for fun, eventually turned into a passion that changed my life.

You will come to understand why I think of each ambigram challenge that comes my way as a "pocket-sized creativity puzzle". Another such puzzle is the famous nine-dots puzzle (which gave rise to the cliché slogan "Think outside the box!") — but the nine-dots puzzle is *isolated*; there is no big family of similar puzzles. Ambigrammia, by contrast, is an endless source of puzzles that force you to "think outside the box" in ever-new ways. The smallness of a single ambigram challenge means you can tackle vast numbers of them, and each will teach you something about the creative/discoverative act. After doing a few dozen, you will have a fresh perspective on creativity and its mechanisms. Certain universal themes and principles will have cropped up over and over again, thus exposing the true nature of creativity — and revealing that what we instinctively tend to call *creation* is more accurately called *discovery*. And often, what is discovered is not so much a *physical object* or a *new shape* as a *hidden vein of receptivity* in the collective mind of humanity.

As in an art gallery, I will exhibit a few hundred of my best ambigrams (and a few of my worst), roughly in chronological order. And I confess that although I have boundless admiration for the ingenious and often dazzling works of many other ambigrammists, my primary purpose here is to share my own art with the world, so I will show only a couple of dozen ambigrams by other people.

Probably the most unexpected stretch of this book (unanticipated even by its author!) is found in Chapters 20 and 21, which exploit ambigrams as a vehicle to talk about the discipline of physics and to tell some anecdotes about its practitioners and some key episodes in its history.

Chapters 22 and 23 showcase my two most intense efforts ever in the world of Ambigrammia; I think of them as the pinnacle of my ambigrammatical adventure (at least so far). From here on out, ambigrams will be sprouting all around, like wildflowers in a spring meadow. I wish you a merry romp through Ambigrammia.

Olivieromaggio

Birthday Request from an Old Friend

Not long before the fifth day of the fifth month of the fifth year of the new millennium, I received an email from Trieste, Italy. It came from my dear friend Oliviero Stock, who'd sent out a request to 5×5 of his friends scattered around the globe, asking them all if, for his 55th birthday, coming up on May 5th, they would indulge him by sending him replies "with something interesting concerning the number 5" — a fun idea for math-loving folks like me — but what actually popped into my head, instead of curious facts involving the number 5, was the thought that I ought to try to design a celebratory ambigram for Oliviero, which would star, in some as yet unclear fashion, the multiple 5's linked to his special day.

It was obvious to me that one of the two readings of my ambigram should be Oliviero's *name* (but did that mean his first name only? or his first and last name together? — I wasn't sure), while the other reading should probably involve the month and day of his *birth*. That, at least, was the ill-defined goal I set for myself. But I wanted to include the year, as well. Would I use the current year (which was 2005), or the year in which my friend was born (1950)? Either one seemed like a reasonable possibility to explore.

If I arbitrarily opted for 1950, then the challenge would be to map, by hook or by crook, Oliviero's name (or his two names) onto the date "May 5th, 1950", or maybe onto "5 May 1950", or, in Italian, "5 maggio 1950", or some other variant. There were many possible avenues I could try. One of them, however, started to seem unlikely, which was using both Oliviero's first name and last name, because taken together they seemed to contain too many symbols — so for the time being, I assumed I would map only his first name onto his birthdate.

But using what kind of letters? Should I try block capitals ("**OLIVIERO**")? Or lower case ("Oliviero")? Or cursive ("*Oliviero*")? Actually, my standard ambigram-making practice is to start out by writing the desired name, in pencil, in all three of those styles, at the top of a sheet of blank paper, as follows:

OLIVIERO Oliviero *Oliviero*

Then I rotate the sheet of paper by 180°, getting (in this case) this image:

Oliviero Oliviero OLIVIERO

Next, in my mind's eye, I try to imagine if the upside-down letters (in any of the three versions) seem easily distortable into the *other* reading that I'm aiming for.

As it happens, I'm partial to trying out block capitals first, so let's see what that gives, when compared with three different ways of writing the birthday target:

OLIVIERO OLIVIERO OLIVIERO
5 MAY 1950 MAY 5TH 1950 5 MAGGIO 1950

One obvious matchup jumps out in all three cases: the "O" at the right end of the rotated "OLIVIERO" matches the "0" at the right end of "1950" perfectly. That's nice, but not much else looks promising. For example, the "O" at the left end of the rotated "OLIVIERO" doesn't match either the "5" or the "M" at the left ends of the three dates. The number of serious mismatches is in fact discouraging enough to make one think that maybe some route other than 180° rotation might be more promising.

And indeed, back in 2005, when tackling this challenge, I thought to myself, "Okay, you started out presuming you were going to do a rotation ambigram, as that's usually the easiest kind to do — but since it now turns out not to be so promising, how about checking out the possibilities of a *reflection* ambigram instead?" Accordingly, I flipped my sheet of paper around and looked through its back side, and again, in my mind's eye, I examined the new possibilities:

OLIVIERO OLIVIERO OLIVIERO
5 MAY 1950 MAY 5TH 1950 5 MAGGIO 1950

Sadly, these were no more promising than the rotations I had just looked at. It occurred to me that I might shorten "1950" to just "50", but that didn't seem to open up any great new avenues of insight.

But then, all at once, it hit me that the day of the month, if it's a single digit, is often preceded by a "0" (as when a website forces you to write a date in the form "DD/MM/YYYY"). This meant that I could explore "05 MAY 1950" or "05 MAY 50". With 180° rotation and mirror reflection, "05 MAY 50" gave these matchups:

OЯƎI∧I˥O OЯƎI∧I˥O
05 MAY 50 05 MAY 50

Now, whichever route I took, I had "O"s matching "0"s at both ends! But that still left a lot of unpromising matchups in the interior. To my dismay, I saw my hope of using rotation or reflection starting to fade.

Should I just throw in the towel and admit defeat? At this point, I wasn't nearly ready to do so. I had other tricks up my sleeve, one of which was a different type of reflection — namely, what I call *lake reflection*, which means that instead of exchanging the left and right sides of a word, you give it a vertical flip. You reflect it in a lake rather than in a mirror on a wall. In the case of "OLIVIERO", lake reflection gives this potential matchup of name and date:

OᒋI∧IEᚱO
05 MAY 50

And now, all at once, sparks started flying in my mind. To my delight, the lake-reflected "L" (the "Γ") could easily be tweaked to make a perfectly legible "5" (and thus the "OL" at the *name's* beginning would easily become "05" at the *date's* beginning). Take a look at this distorted "OL" and its lake reflection:

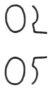

Then, even more pleasingly, I saw that the right side of the lake-reflected "R" (near the right end) could be quite easily tweaked into another "5". This meant

that, under lake reflection, the "RO" at the right end of "OLIVIERO" would flip
into "| 50" (the vertical post coming from the *stem* of the "R"):

$$\text{ORO}$$
$$\text{|50}$$

The unexpected arrival of such a post might sound like bad news, but in fact
it was excellent news, because a post could easily serve as a *slash* coming before the
year "50" (and of course, slashes are often used inside dates). These, then, were all
promising omens for the lake-reflection avenue.

But if I was going to have *one* slash inside the date, I would need a *second*
one as well, because in dates, slashes come in pairs. As it happened, Providence
was smiling down on me that day, because next I noticed that the first "I" in
"OLIVIERO", when reflected in a lake (an operation that left it invariant), could
serve as the *other* post (or vertical slash) needed inside the date, meaning that "OLI"
would invert into "05 |". Things were looking up!

Here, then, is where I was (in my mind's eye) at this stage of the game:

$$\text{OLI|VIE|RO}$$
$$\text{O5|ΛIE|5O}$$

At this point, the trio of letters on the left and the pair of letters on the right were
exactly what I wanted. On the top line, I had both "OLI" and "RO" — and on
the bottom line, I had both "05 |" and "| 50". Lots of good stuff was happening.

But what about the *middle* — what about the month of May? The flip of
"VIE" — namely, "ΛIE" — didn't look at all like "May" or "MAY" (let alone
"maggio"). Could I somehow cleverly distort the trio of shapes "ΛIE" so as to get
some version of "May" without destroying the "VIE" in "OLIVIERO"? If I were
unable to do this, my dream of using lake reflection would be dead in the water.

I continued to gaze at the "ΛIE" that was sitting between the two posts inside
the lake-reflected "OLIVIERO", and after a while — what do you know! — by
mentally splitting the "Λ" up into two hypothetical pieces, I spotted (or more
accurately, *imagined*) the word "FIVE" drifting up out of the blurry fog and into
clear visibility. Not "May" or "maggio" or "MAY" or "MAGGIO" — and not "5"

or "05" or "V" (let alone "cinque"!) — but the English word "FIVE". Can you see, in your mind's eye, what I saw, dear reader? Here it is, more or less:

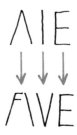

Surprisingly enough, the three (lake-reflected) letters "ΛIE" quite easily lent themselves to being read as "FIVE" (with its four letters). And the English word "FIVE" — a first-class monicker for the merry month of May — was just perfect. What a joyous moment of insight that was — a breakthrough that gave me exactly what I'd been shooting for. It felt like a small miracle.

To sum things up, I had discovered that "OLIVIERO" can be made to turn gracefully into "05 | FIVE | 50" through the device of lake reflection. This gratifying discovery had taken place through a sequence of small strokes of insight, each one leading naturally, almost inevitably, to the next — a bit like dominos falling.

That, in a nutshell, is how I came up with the *conceptual skeleton* for my ambigram (meaning the abstract idea lying behind the scenes, as opposed to the final fleshed-out work of art). After that crucial stage came the working-out of all the details of how I wanted to draw each letter and numeral.

In this phase, the idea of *minimality* (meaning "avoid all fancy ornamentation", or better yet, "less is more") was crucial to me, but so was the *anti*-minimal idea of making the two vertical posts very salient, so I tried to find a good balancing point between these opposing forces, and the two-colored hand-drawn ambigram displayed below is what finally resulted, meeting Oliviero's birthday request to a tee, since what could be more focused on the number *cinque* than "05 | FIVE | 50"?

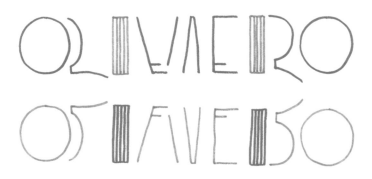

A Bird's-eye View of the Saga

Below I have listed what I see as the key discrete steps that I took in coming up with this ambigram (or rather, with its conceptual skeleton):

1. Use "Oliviero" for one reading and his birth date for the other.
2. Use capital block letters, not lowercase or cursive, for his name.
3. Try out 180° rotation to turn one reading into the other.
4. Use Oliviero's birthyear (1950) instead of the current year (2005).
5. Simplify "1950" to "50".
6. Insert a zero in front ("5 May" becomes "05 May").
7. Abandon all hope of 180° rotation, and explore wall reflection.
8. Abandon all hope of wall reflection, and explore lake reflection.
9. See the upside-down "L" (that is, the "Γ") as a potential "5".
10. See the right side of the upside-down "R" as another "5".
11. Welcome two posts (or slashes) into the date.
12. Try replacing "May" (or "maggio", etc.) with the English word "FIVE".
13. Split the upside-down "V" (that is, "Λ") into two pieces ("F" and "I").
14. Widen the upside-down "I" so that it becomes a "V".

That's quite a long series of small insights! But of course to Oliviero or any other viewer of the final product, none of them is visible (especially the routes that were abandoned). How, for instance, could anyone know that I didn't *begin* by thinking I would use "05 |" at the left end of the date, and " | 50" at the right end? Or who knows — maybe I had even begun my explorations with "05 | FIVE | 50" as my original target! That's preposterously unlikely, but it's at least conceivable.

And somebody might imagine that I never thought for a split second about 180° rotation or wall reflection, but simply jumped straight to lake reflection. Again, that's outrageously unlikely, since 180° rotation is by far the most standard route for an ambigrammist to try at first — but as a mere viewer, you don't think about all the alternative routes that the designer might have explored and dropped.

And keep in mind that after the abstract conceptual skeleton had been found, countless key decisions, involving such aspects as the exact shapes of curves, the relative proportions of strokes, inter-character spacings, colors, and so on, were still needed in order to elaborate the skeleton into the final visible product. As in any work of art, almost the entire creative process lies hidden beneath the surface.

Once the final design was cast in stone (or rather, inked on paper), I wanted to give a title to my gift, so I spliced "Oliviero" together with the Italian word *omaggio* ("homage"), thus coining the term *Olivieromaggio*, and in so doing I also managed to sneak in a reference to his birth month, *maggio* — a delightful little free bonus!

Although this design certainly has aspects that one could critique and perhaps improve on (indeed, weaknesses can be spotted and cast into doubt in virtually any ambigram), I'm very proud, overall, of my *Olivieromaggio*, and I feel that, out of the five thousand or so ambigrams that I've devised, it's one of the most pleasing and surprising. That's why I chose the tale of this piece's genesis, with its mixture of good and bad luck and with its many back-and-forth steps, as my quintessential example of ambigrammia.

Ambigrammia's Shaky Start

Where Did Ambigrams Come From?

To the best of my knowledge, the idea of systematically distorting letters in order to make doubly-readable words was born in the scintillating mind of my recently deceased lifelong friend Peter Jones in the spring of 1964, when we were both undergraduates at Stanford.

One day, Peter, who had inherited his amazing artistic gift from his mother, started doodling on large sheets of lined paper, and somehow or other — this is the part I can't explain — he hit on the idea of writing a word in such a way that when it was mirror-reflected, it would still be readable (or at least *sort of* readable). When I first eyed Peter's zany concoctions, I found them delightful and hilarious. Never before had I imagined that letterforms had so many degrees of freedom, or that words could look so silly.

Being, both then and now, an assiduous collector and preserver of creative efforts not just of my own but also of my kith and kin, I saved all, or at least a fair fraction, of Peter's reversible words (just over two dozen) in my then-nascent filing system, and below I share some favorites with you. I don't know for sure what order he did them in, but I suspect this was the first:

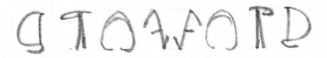

If you can't read it, don't worry; it verges on the illegible. However, just above it on the original sheet, the word "STANFORD" is clearly printed, so that resolves

things. We can critique this scribble all we want, but to do so would miss the point. The point was neither grace nor easy legibility; it was simply to try out a new game.

Ever since Peter was a kid (we met in 1954, at age 9), he had been aflame with creativity, and on this day in 1964 he had just dreamt up something that he wanted to share with me, and I was a most enthusiastic recipient of his idea. Here are three other reversible words that he drew on the sheets I preserved:

You may well have deciphered all three, but in case there's some doubt, here are the intended readings: "BANANA", "SPHYNX", and "WURLITZER". Why Peter chose those words, I have no clue. And why he misspelled "sphinx" I also don't know, since he generally was a very good speller.

As you can see, these were just humorous experiments exploring the flexibility of roman letters; they were not in any sense attempts at art. To show this even more vividly, here is a famous long word that Peter couldn't resist trying:

The extreme clumsiness of some of these letters still cracks me up today — such as the opening "A", onto which Peter brazenly grafted an arch, so that an "M"-like shape (sporting a semi-crossbar) would appear at the far end. Or, near the middle, the feeble "B" that flips into a feeble "M", or the supposed "L" whose mirror image is doing its best to be an "H". What a riot!

Note that Peter's explorations were all *wall reflections* (left–right mirror images), and were all based on *printed capital letters* (although he occasionally deviated from that "rule", as in the scripty lowercase "n" that is the second letter above), and he always mapped a single letter onto a single letter.

A mildly pathbreaking experiment was this one:

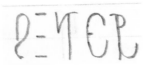

You probably deciphered his first name, but did you notice what it mirror-reverses into? Here is the mirror image:

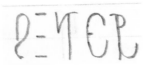

Voilà — it's his last name! (At least to a generous eye.) If I were fond of jargon-slinging, I would call this the world's first *heterogram* (meaning an ambigram that has two *different* readings), in contrast with Peter's previous ones, all of which were *homograms*. But I see no point in indulging in technical-sounding jargon.

The final example I want to show you of Peter's creations is this one:

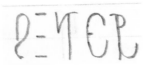

To be sure, it's as gawky as could be, but I include it here because it shows that Peter had the insight that wall reflection was only one avenue via which to get a double reading; 180° rotation was another avenue, and an equally valid one.

Imitation Is the Sincerest Form of Flattery

When I saw Peter's droll reversible words, I immediately caught on fire and started trying my own hand at the "art". I have an old looseleaf notebook for the classes I was taking at Stanford that spring quarter of 1964 (psychology, physics, differential equations, and number theory), and in it I doodled like crazy, drawing funny faces and curious abstract patterns, and I also penned whimsical parodies of mathematical proofs as well as dozens of short phrases in Hindi and Sinhalese, both of which I was intoxicatedly studying on my own — and, of all things, I even took occasional class notes!

Here and there in that falling-apart notebook are scattered my own attempts at doing reversible words, and they, like Peter's, are all single-letter-to-single-letter

mappings using printed capital letters. Also, they were all executed using the symmetry of wall reflection rather than rotation. Here are three examples:

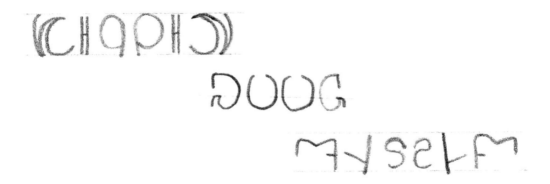

Albert Hastorf was Peter's and my adored psychology professor that quarter, and my attempt at writing his name reversibly is (I think) fairly legible. On the other hand, my try at "PSYCHOLOGY", venturing into lowercase letters a couple of times ("y" and "h"), is less successful. As for my stab at making "KHRUSHCHEV" look symmetrical, well, it's a bold attempt but pretty pitiful, demonstrating very clearly that I had nowhere to go but up. At the time, however, it didn't occur to me that there was any space to move "upwards" into.

Here are three last examples of my "prowess" at the time:

If you couldn't make out "CHOPIN", you are forgiven. My first name (with two identically-shaped yet hopefully different vowels) and "MYSELF" (sneaking in a lowercase "e") were probably recognizable, though. At least I hope so.

Back then, Peter and I chuckled a lot at our gawky creations (or discoveries), but after a few weeks we had chuckled enough, and our output started slowing down; soon it fizzled out completely. We had run out of laughing gas. For us, this sport was not an art form to explore deeply; it was just an amusement, a bagatelle, a cute divertimento, easy entertainment — a flighty, frivolous, graceless lark.

Two years later, while idly flipping through a newspaper, I chanced to see the company name "Chemway". It struck me that I could easily write it (using lowercase letters, which was a novelty for me) in such a way that it would survive a 180° rotation (another novelty for me). I made a few attempts, and in them I actually strove for *grace* rather than for guffaws. Here's one of the nicer ones:

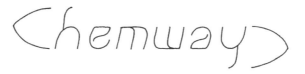

The upside-down "C" at the end was a blatant cheat, as it was pretending to be just an innocent piece of ornamentation (I thought of it as an arrow symbolically pointing towards the company's dazzling future), whereas in fact it was utterly extraneous, its sole purpose being to make the design symmetrical. Cheating of this sort, and of a myriad other sorts, lies at the heart of the art of ambigrammia.

Here are two more of my explorations of the same company name:

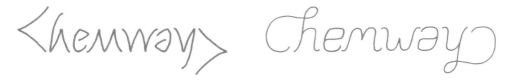

In the one on the left, there is more "arrowness" to the arrow, whereas in the one on the right, there's no longer any arrowhead at all; instead, the upside-down "C" is subsumed in the closing swirls of the final "y".

These 1966 designs constituted my lone foray into genuine *art* in the genre that my friend Peter Jones had invented. I even vaguely thought of sending them to the Chemway company's headquarters to see if they would richly reward me for this miraculous new corporate logo! But I never did, so they never did. For better or for worse, the idea of pioneering a new calligraphic art form was way off Peter's and my radar screens, and so, as time passed, our droll game just petered out.

CHAPTER 3

Pioneers of Ambigrammia

Come Kim

In the fall of 1975, having finished my doctorate in physics at the University of Oregon, I returned to Stanford to work on an ambitious book that I had started to write, bearing the tentative title of "The Human Brain and Gödel's Theorem". I was lucky enough to be given a nonpaying appointment as Visiting Scholar at the Institute for Mathematical Studies in the Social Sciences in old Ventura Hall, a charming one-time nurses' residence nestled in a grove of tall redwood trees. My parents supported me with what these days I fondly call a "Hofstadter Scholarship". I even had an office (albeit shared). I felt I was in the lap of luxury.

I decided it would be helpful for me to teach a seminar with the same title as my book, so I went to several departments to see if they would serve as sponsors. Math, Philosophy, and Computer Science all turned me down, but I was extremely grateful when Al Hastorf in Psychology and Don Kennedy in Human Biology gave me the official approval I was seeking, as well as financial support. I designed a flyer with a paradoxical picture by M. C. Escher on it, plus a capsule description of the ideas I would cover, and then I dashed madly all about the campus, sticking my flyers up on bulletin boards, kiosks, walls, and doors.

A day or two later, a student showed up at my IMSSS office, introduced himself as Scott Kim, told me he was fascinated with all the topics I had mentioned in my flyer, and said he would love to take my course. When we got to talking, we soon found out that we had an amazing overlap of interests, one of which was — to my enormous surprise — drawing words in such a way that they had two readings. That afternoon Scott didn't have any examples with him, but we agreed to meet in the evening at Tresidder student union, where he would show me some samples of his two-way letterplay.

Before I exhibit any of Scott's designs, I want to point out that this shows that the idea of ambigrammia *itself* was a discovery, not a creation. First Peter Jones discovered it in 1964, and then, roughly a decade later, Scott Kim rediscovered the very same idea. Or rather, not exactly the same idea, since Scott, unlike Peter and me, polished and polished the idea, and in so doing he turned a giggly game into a gleaming art form. But before I saw Scott's creations, I had no inkling that he had done any such thing. I naturally assumed that he, like Peter and me, had merely drawn a bunch of barely-readable words made of silly-shaped letterforms.

That evening, however, the moment that Scott opened up a notebook filled with his designs, the scales fell from my eyes. I was stunned. Each of them was a truly graceful work of art — nothing at all like the glumpfish chicken-scratches that Peter and I had come up with in the mid-sixties (aside from my attempts at a "Chemway" logo). Here are a few of Scott's designs from that early period.

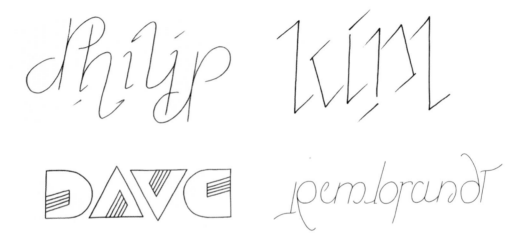

I'm sure you can see why I was so impressed. First of all, the lines are just so graceful. Secondly, most of the designs exploit curvilinear cursive writing, relying frequently on the use of lowercase letters, as opposed to Peter's and my block capitals. Thirdly, letters are freely broken apart and recombined to make other letters. For instance, the "h" in "Philip" becomes the "li" upside down; in "kim", the "ki" inverts into the "m"; and in "Rembrandt", the "R" becomes "dT", the "em" turns into "an", and the "br" cleverly regroups upside-down and rebecomes a "br". I found such regroupings devilishly ingenious. Fourthly, each design has its own distinctive and charming calligraphic style. Together, all of these features just took my breath away.

Let me make a few further observations about "Rembrandt". First of all, the "T" at the end, when flipped, becomes the stem of the "R", and its crossbar

is either ignored or seen as a long serif; likewise, the little loop that's crucial to make the "e" not be taken for a "c" goes unnoticed inside the "n". Secondly, the relatively unimportant baseline stroke that joins the "a" to the "n" becomes, when flipped, a key ingredient in creating "m"-ness. Similarly, the baseline stroke that joins the "e" to the "m" becomes, when flipped, the top of the "n". These were archetypical maneuvers of Scott's — namely, having noncrucial joining-strokes down at the level of the baseline play crucial roles in letters up at the x-height.

Why didn't Peter and I think of this x-heighting idea? Well, in part because we had somehow gotten fixated on using only block capital letters — but more importantly, because we did only wall reflections, so the baseline didn't become the x-height in the act of reversal. It simply stayed at the baseline.

Notice that in "Philip", Scott uses a trick like the one I used in "Chemway": the bold calligraphic swirl at the bottom of the final "P" is seen simply as a gracious decoration, but when the word is rotated, that same swirl, now higher up, is seen as much *more* than a decoration — it is an indispensable ingredient that pulls the first letter irrevocably into the "basin of attraction" of the alphabetic category *capital "P"*. Meanwhile, the curve that made the *final* letter be a lowercase "p" becomes merely a calligraphic swirl — an elegant fillip, if you will — at the baseline, when the design is rotated.

Or look at how the "k" in "kim" consists of two pieces that don't touch each other at all. Why didn't Scott make them touch, to strengthen the "k"-ness? Well, because doing so would have fatally damaged the "m"-ness at the other end. So he took the risk of breaking the "k" up into two disjoint pieces. But then, why doesn't one's eye — mine, yours, anyone's — read the opening as "lc" instead of as "k"? One reason is the shape's angularity, which reduces its "c"-ness. Also, Scott intuitively estimated how wide a gap between the two pieces of the "k" he could get away with, and then he went for it. (Another key factor is that no English word or name begins with "lc".)

The stylistic unity of each design above is striking. "DAVE", for instance, has a riveting beauty and is so easily readable that it is almost as clear as if it had been written in Baskerville (the typeface you're now reading) or in Helvetica. And yet… where is the "E"-ness in that final "E"? Where is its middle stroke? For that matter, where are its upper and lower strokes? Or then again, what is that bold interloper of a shaded parallelogram doing on the left side of the "D"? How can it possibly be adding to the shape's "D"-ness? Well, of course, it isn't — in fact, it *subtracts* from the "D"-ness — but only a tiny bit. And in the meantime, it's strongly adding to the artistic unity of the word as a whole. What an eminently worthwhile tradeoff! And last but by no means least, how in the world can a similar shaded trapezoid, tilted more toward the vertical, play (very roughly) the role of the *empty space* that is criterial for "V"-ness and *also* play (once again very

roughly) the equally criterial role of *crossbar* in the "A"? How can something that's supposed to be seen as *vacuum* in one letter turn around and be seen as a *solid object* in the next-door letter?

Though these tricks may seem simple, each of them is actually a small flash of brilliance. If what Scott did in these designs isn't creative, then I don't know what *would* be creative!

Letters and Words as Perceptual Categories

Admittedly, "DAVE" is a pretty easy ambigram to do, and even a novice would try to make the "D" turn into the "E" and the "A" into the "V"; after all, there are obvious, alluring forces that would suck anyone straight into that choice. But just how to carry off this trick in precise detail is far from obvious, and there are lots of avenues to try. For instance, just now I made a couple of attempts:

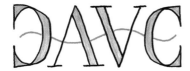 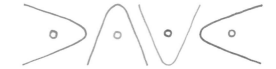

The "DAVE" on the left uses thickened strokes that I colored in (in pencil), and it has an orange "snake" slithering all the way through it (or perhaps an orange garden hose). You ignore the snake/hose where it isn't needed (in the "D" and the "V"), yet you automatically perceive it as part of the letters that *do* need it (the "A" and the "E"). That's the kind of psychological trick that any ambigrammist worth their salt exploits all the time.

The "DAVE" on the right is an attempt at minimality, and to that end it uses the selfsame arrowhead-*cum*-dot for all four letters (albeit using different colors). I deliberately placed all four dots at the same height, thus forming a horizontal straight line, after having first tried putting them at different heights. I liked both solutions, but I opted to display this one.

One can of course legitimately wonder whether the four given arrowhead shapes with dots inside them are valid members of their intended alphabetic categories. Is that first shape *really* a "D"? Is the final shape *really* an "E"? Such questions make it sound as if precise scientific determination is called for, but category membership is blurry and is influenced by context, and the nearby letters (or nearby *shapes*, to use a more neutral term) form a context in which each of these four shapes is perceived. Even if each shape taken in isolation is a somewhat shaky member of its intended alphabetic category, it's a different ballgame when all four are placed side by side, since now, the shaky alphabetic suggestion made

by each one, supplemented by the prior existence of the familiar name "DAVE", results in each questionable part reinforcing all the other questionable parts, and the overall upshot is, *mirabile dictu*, a strong member of the higher-level "DAVE" category. After all, written words, no less than letters, are visual categories, and they too can have members and non-members, and dubious in-between cases.

By the way, all these ideas about shades of alphabetic-category membership, about mutual propping-up of shaky category members, and about words as visual categories on a higher level than letters apply equally well to my green "DAVE", to Scott's earlier-exhibited "DAVE", to my *Olivieromaggio* — in fact, to all ambigrams. Indeed, they apply to any visual piece of writing at all.

Inversions

As you might imagine, when I was exposed to Scott's album of ambigrams in 1976, I was not just impressed but intimidated. I felt I wasn't even close to being in his league, so I just left him alone to do his thing. I didn't dare draw a single new ambigram for over five years!

In 1979, the popular writer Scot Morris published an eye-catching column in *Omni* magazine in which he showcased some of Scott's creations, and since they had no standard name yet, Scot M anointed them with the word "designatures" — about as unpronounceable a name as I could imagine. (Do you pronounce the "g" or is it silent? Is the "i" a short or a long "i"? Is the "s" voiced or unvoiced?) Needless to say, that clunky appellation went nowhere fast, but Scot M's fine column brought Scott K's ingenious art to the attention of a vast public.

Right around that same time, Scott decided he wanted to do a book of his letterplay creations, and he set to work on it. He decided to call them *inversions* and to use that word, with a capital "I", as his book's title — and he decided that the title, at the top of the book's cover, would rotate into his name, at the bottom. What he came up with was one of the most elegant ambigrams of all time:

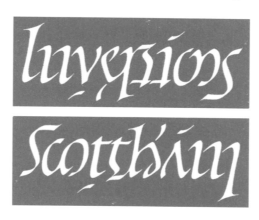

A year later, as his book was coming in for a landing, Scott asked me if I would write a foreword for it. I was excited and honored to do so, and in my foreword, in addition to giving Scott a roaring 21-gun salute, I tipped my hat to Peter Jones for dreaming up the idea, albeit in a far cruder form, back in the 1960s.

I Finally Throw My Hat into the Ring

When *Inversions* appeared in 1981, its publisher offered to compensate me for my foreword by giving me 100 copies. I was happy with that offer, but when my 100 copies arrived, I had to figure out what to do with them! Of course I wanted to give copies of the book to many friends, but I was caught off guard when some friends asked me to sign their copies. Faced with that prospect, I thought, a little nervously, "Hmm… Maybe, in signing these books, I ought to see if I can calligraph my friends' names as ambigrams." (Or rather, "as inversions", since the word "ambigram" didn't exist yet.) And so I bit the bullet and started doing just that in each copy that I gave away. Since I couldn't improvise them in ink (Scott could have done that, but not me!), I first made pencil sketches in the book, and then used ink on top of them. That worked fine.

Although at the outset I worried a lot about gawkiness, I found my sea legs before long, gradually gaining confidence. After a few months I started feeling very pleased with some of my dedications. Here is one of the better ones:

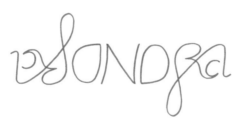

By the way, it says "Sondra", not "Sandra". Or rather, it says "SONDRa", with a lowercase "a" amongst all those capitals (darn it all!). The "OND" in the middle rotated so easily into itself that I felt pretty much forced to use that avenue of approach. After a spell of head-scratching, I was proud of figuring out a way to sneak that upside-down "a" into the initial decorative swirls of the "S". By the way, that "a" illustrates one of my maxims: Instead of trying to hide something by making it small and scrawny, make it big and bold! Don't be bashful; be brazen! Today I would most likely do "Sondra" differently, but this remains one of my happy ambigrammatical memories from the early 1980s.

By the time I had given away most of the 100 books, in the fall of 1983, I was a fairly seasoned "inversionist". I had started to develop my own tricks of the trade

— what Scott called "riffs" or "standard technology" — meaning ideas that one dreams up in solving a particular challenge but later finds reusable in other contexts. Some of my riffs were specific shapes that I memorized and repeatedly drew almost identically, while others were abstract patterns that manifested themselves in highly different forms in different designs.

The Coining of "Ambigram"

During the academic year 1983–84, I was on sabbatical in Boston, and there I infected several of my friends with the bug. We had great fun designing invertible or reversible words, and we would often show one another our creations and compare notes. One fall evening, over a Chinese dinner in Brookline, some of us expressed dissatisfaction with the word "inversion" as a generic name for our creations. We felt it didn't apply to all the ideas we were exploring, so we began batting about alternate names.

Greg Huber, for example, tossed out the droll term "iffyglyph", suggesting the dubious readability of some of our more far-fetched designs, and from that word we jumped to "rotaglyph", which sounded nice but implied that *rotation* was always involved, which was far from the case. We kept on trotting out new prefixes and suffixes and combining them, inventing strange and humorous words with varying degrees of catchiness, such as "flip-and-see", "redundan-see", "dilex", "extra-see", "see-saw", "amphinym", "palingraph", "polyparse", "bi-word", "double doodle", "flip-flop", "lexifusion", "lexiblend", "lexiflex", "word marriage", and even "holy wordlock". It was quite a zoo, and in my old files I have several sheets of paper covered with such suggestions, including lots of names in French as well.

At some point that evening I said, "How about *ambigram*?", and everyone in our little coterie seemed to resonate with the term, so we decided to try it on for size, although for a while Greg continued referring to his own creations as "iffyglyphs". But "ambigram" soon caught on among us as the generic term, and later it turned out that even Scott found it more apt than "inversion". From then on, the new word took on a life of its own.

Lifting My Glass in Honor of John Langdon

In this book devoted to displaying and discussing my own art, it would throw me way off course if I were to try to relate the full history of ambigrams and to celebrate the countless practitioners of the art today — in fact, it would take several volumes and a huge amount of research — but there are three early pioneers whom I could not leave out. I have already written glowingly of Peter Jones and Scott Kim, but there is a third name I feel it is essential to mention.

I don't recall exactly when, but sometime in the late 1980s, I learned that John Langdon, a professional typographer and graphic designer in Philadelphia, had invented/discovered the idea of ambigrams at virtually the same time as Scott Kim had (the early or mid-1970s), but the two had done so via entirely independent routes, and on opposite sides of the country. At some point, Scott, John, and I all got into contact by email, and John was very pleased to encounter kindred souls and to adopt the label "ambigram" as the name for his ingenious creations.

In 1992, John came out with a collection of his best ambigrams to date, which he called *Wordplay*, and of course the cover featured the title and the author's name, both rendered in impeccable ambigrammatic fashion:

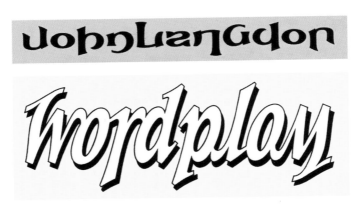

I was very flattered that John's author-name ambigram was based on a pencil sketch I'd sent to him, although I felt that my wall reflection on his name:

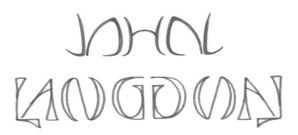

was spicier than the rotation I'd sent him. But given that "Wordplay" was already done and was a rotation, it made sense to use a rotation rather than a reflection for his name. It would have been strange to mix rotation and reflection on the cover.

Incidentally, my choice to do an all-capitals wall reflection to pay homage to John foreshadowed a growing tendency of mine, which was to use all-caps wall reflections very frequently. I didn't make this decision consciously; it just happened by itself, even though Scott Kim had clearly shown the world the immense richness of using 180° rotations in lowercase cursive. I just had a different style.

Chapter 3

One of my favorites in John's book is this one, which uses 180° rotation:

SYZYGY

The rare but charming word "syzygy" is a venerable astronomical term denoting an alignment of three heavenly bodies (usually but not necessarily the earth, moon, and sun) — and John's construction embodies a metaphorical syzygy of three rhythmically aligned (but very different) copies of the letter "y".

I am a big fan of minimalism, and here John self-referentially demonstrates it:

minimum

Among the most successful 'grams in *Wordplay* is this 180° rotation:

Philosophy

Not only is it instantly and effortlessly readable, but its fluid lines are marvelously graceful. That "P"⟺"y" transformation is truly inspired! These are the kinds of thing to shoot for if you are going to plunge into ambigrammia.

My final tribute to John is not really an ambigram (at least not in *my* sense of the term), but it is undeniably an amazing lexifusion:

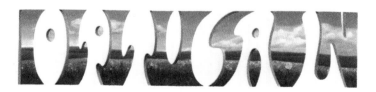

Against a charming pastoral background, the word "OPTICAL" pops right out to the eye. So where is the second reading? Well, just let your eyes focus on the blue and green, ignoring the beige letters. All of a sudden, the sky and field will turn into eight letterforms spelling out the word "ILLUSION". It's quite a magical figure/ground effect.

Why do I resist labeling this superb design an "ambigram"? Simply because to me it doesn't feel as if it belongs to the same category as rotations and reflections. It strikes me as a subtly different art form. However, many ambigrammists play very skillfully with figure and ground, and who am I to declare, from my high horse, that their productions are not ambigrams? Even if I concocted the word (sort of by accident, in a group session), I have no copyright on how it is used by others.

Thanks to the book *Wordplay*, the novelist Dan Brown fell in love with John Langdon's ambigrams, and for his 2000 novel *Angels and Demons* he commissioned Langdon to design several ambigrams, which in fact played key roles in the plot. An ambigram he designed on the book's title was used on the cover, and in John's honor the main protagonist was named "Robert Langdon"!

In sum, three creative/discoverative individuals — Peter Jones, Scott Kim, and John Langdon — all deserve much credit for having brought into being the now-flourishing art form of ambigrammia. At different times and in different ways, I have been inspired by each of them, and have followed in their footsteps.

Why Did Ambigrammia Come Along Only Recently?

For centuries, calligraphy was mostly about making florid embellishments of conventional letters, rather than about manipulating their essential forms. But from the late nineteenth century on, pushed largely by advertising, much creative energy was devoted to the design of playful, risk-taking typefaces where the core concept of each letter category was daringly manipulated. Below, three curvy Art Nouveau alphabets from roughly 1900 — a nameless one designed by Peter Schnorr, an anonymous font called "Odessa", and a font called "Mig", designed by one M. J. Gradl in the year of "i902" — illustrate how this tendency was evolving.

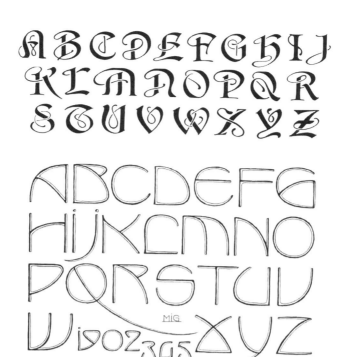

A couple of decades later, in the 1920s, even wilder letterplay experimentation was flourishing, as is visible in these three highly imaginative Art Deco typefaces:

Fat Cat (designer and date unknown)

Bobo (designer and date unknown)

Zany (designer and date unknown)

Over the next fifty years, experimentation with far-out letterforms continued apace, passionately exploring heretofore unimagined regions of alphabetic space. Below I've selected a few of my favorite typefaces from that epoch, which show some of the enormous creativity that was unleashed.

Calypso, by Roger Excoffon (1958)

Stop, by Aldo Novarese (1970)

Sinaloa, by Rosmarie Tissi (1972)

Piccadilly, by Christopher Mathews (1973)

Magnificat, by Friedrich Peter (1975)

In roughly the same period, European artists were exploring ambiguity and visual illusion. Salvador Dalí created paintings that from up close seemed to be of people, but from further away looked like skulls. Oscar Reutersvärd in Sweden was

Chapter 3

a remarkable pioneer in exploring impossible figures, and he was followed (though not imitated) by M. C. Escher in the Netherlands, who also created prints in which figure and ground were equally important but depicted different subjects. In short, paradox, ambiguity, and double meanings were major forces in visual art by the middle of the twentieth century.

When Peter Jones began idly tinkering with letterforms in the 1960s, he had been swimming for many years in a sea of pictorial double meanings and of zany alphabets that pushed at the edges of categories; such games were just a built-in element of the cultural Zeitgeist in which he'd grown up. To Peter, who had a great gift of visual imagination, it was natural and easy to fuse these ideas together, even if he wasn't conscious of being influenced by themes that were blowing in the wind. And thus was ambigrammia born.

The fact that only a decade or so later two other bright minds independently hit upon pretty much the same idea and pushed it much further is perhaps not all that surprising. It is reminiscent of the fact that in the early nineteenth century, several mathematicians dreamt up non-Euclidean geometry independently and nearly simultaneously. In any historical era, certain ideas are just ripe for the picking, and ambigrammia was one such idea in the 1960s and 1970s.

A Friendly Salute to the Guild of Ambigrammists

As I said above, there are dozens if not hundreds of skilled ambigrammists on the planet today, but I'm unaware of most of them. I don't go scouring the Web in search of ambigrams — after all, *ars longa, vita brevis*. If you surf the Web for ambigrams, you'll soon be awash in a tidal wave of them!

In person or via email, I have been in touch, over the years, with many excellent ambigrammists, especially my longtime friends Roy Leban, Greg Huber, and David Moser. I have also corresponded for a long time with two top-notch French ambigrammists: Joël Guenoun and Basile Morin. And I would be remiss if I didn't mention Robert Petrick, a painter and graphic designer who, inspired by his friend John Langdon, has designed high-quality ambigrams for decades (somewhat the way I was inspired by Peter Jones). Last but not least, I hoist my nonexistent glass and offer a hearty toast to Gilles Esposito-Farèse, Patrice Hamel, Lefty Fontenrose, Punya Mishra, Burkard Polster, and Nikita Prokhorov, who have all created lovely ambigrams, and the latter two have published books on ambigrammia.

On the following page are ambigrams by Roy, Greg, Robert, Joël, and Basile. Roy celebrates his marriage, Greg tips his hat to a duo of magicians, Robert salutes the camera, Joël reflects on day and night, and Basile offers an elderly friend a birthday wish meaning "This rose, planted here, has a tender secret: being green."

EMILE + ROY

Penn & Teller

photography

jour nuit

cette
rose
ici
semee
a
un
tendre 🌹 secret
etre verte

Chapter 3

I close this chapter with a salute to Tom Tanaka, who I came to know in the 1980s, through his contributions to the Japanese translation of *Gödel, Escher, Bach*. Around that same time, he also caught the bug of ambigrammia. Of late, he has produced many figure/ground oscillations. As I said earlier, designs of that sort fall outside my *personal* conception of ambigrammia, but to be honest, I must admit that they incontrovertibly meet the definition I gave in the Introduction: "a piece of writing expressly designed to squeeze in more than one reading".

TT's favorite example of his art is this oscillation:

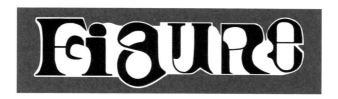

I suspect you will easily read the six *black* letters (the figure); the question is, can you read the six *white* letters (the ground)? From the context you can probably guess what they say, even if at first you can't truly *read* the word itself. To help the second reading pop out, I've inserted a reduced version of the same design below:

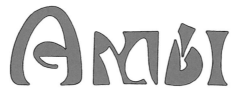

Now can you read the white word?

If you're still having trouble reading it, TT offers this hint: "It's not called a *squintygram* for nothing!" So try squinting! I have good grounds to believe that the word in white will then jump right out at you. If not, just back up a bit further.

And as a closing gesture to Tanakian artistry, I present another figure/ground study, this one yielding a single word when you combine its red and white readings.

Regarding both this example and the preceding one, I hope you will agree that not only the figures but also the grounds are excellent.

CHAPTER 4

Creative Perception

"That Property"

"Oh — I didn't know my name had that property." Those are the offhand words that the famous MIT cosmologist Alan Guth blurted out to my friend Greg Huber back in 1984, just after Greg handed to Guth (his senior-year research advisor) the following little present, which he had just come up with:

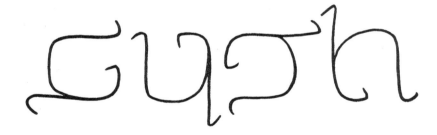

At first, this design may strike you as no more than a graceful rendering of Guth's last name, but a moment's scrutiny will reveal that *all four letters have exactly the same shape*, each being obtained from its left-neighbor by a counterclockwise 90° spin. Kudos to Greg! "Spinonym" is what he dubbed his ingenious invention (if I may call it an "invention"), and, much like me with my *Olivieromaggio*, Greg was very proud of his find (if I may call it a "find").

However… when his advisor's reaction to this elegant gift was only to mumble those dismissive words, Greg was both puzzled and disappointed. How could the brilliant Prof. Guth make such a silly remark? It was preposterous! Greg knew very well that his spinonym was a result of *artistic creativity*, not just the recognition

of some objective quality that had always been sitting right there under everyone's nose, like a pretty shell on the beach, all ready to be picked up by any random stroller who happened by. How could Guth give Greg so little credit?

When Greg told me that story, I laughed out loud at Guth's unintended insult. But after a while it dawned on me that, in a subtle way, Guth was right. Greg had indeed discovered a hidden property of that last name — a property it had *always* possessed! Just think: if spinonym-realizability *hadn't* been a property of those four roman letters in that order, then how could Greg have *realized* his design? It would have amounted to doing the impossible!

Counterfactual Guths

As I said, these matters are subtle. Let's thus explore the flavor of Guth's odd remark by making up a few counterfactual variations on the story and deciding which ones seem more reasonable — and which seem less so.

Our first variation leaves the gift untouched and merely varies Guth's reaction to Greg's explanation. Guth remarks, "Oh — I didn't notice that your design had that property," thus attributing the spinonymic property entirely to the *design*, without any implication that his *name* possesses this property inherently. At first, this may sound quite reasonable. But why is it not a property of the name itself?

This segues nicely into our second variation, wherein Greg (who in real life greatly enjoys anagrams) has been devising anagrams on the names of all the MIT physics professors. He comes to Alan Guth's office and says, "You know, the letters in your name can be rearranged to spell 'Halt — a gun!'" The hypothetical Guth reacts just as the real one did: "Oh — I didn't know my name had that property." In this scenario, the once-offensive remark seems correct and innocuous; although Greg has made an interesting observation for which he deserves credit, Alan Guth's name *does* manifestly possess this property independently of Greg, and it always did. Anybody could have found that anagram.

In our third variation, Greg again gives Guth the spinonym, but this time Guth replies, "Oh — I didn't know that my name could be written in such a way as to have that property." (Perhaps this is what the real Guth meant.) This remark makes Greg's trick seem to be a property of a peculiar way of writing the name rather than a property of the name itself. Yet on the other hand, to say that the name "could be written in such a way" suggests that *all possible ways of writing "Guth" are somehow inherent in it*, even if they are deeply hidden. In that case, the possibility of making a spinonym on "Guth" *could have been seen by anybody* — at least anybody sufficiently insightful. This variation hovers halfway between implying that the spinonymic property was always there to be found (whether or not anyone ever noticed it), and implying that it took genuine insight to *insert* it into the name.

But doesn't it also take insight to notice "Halt — a gun!" lurking in "Alan Guth"? If Greg Huber the spinonym-maker is a creator, then isn't Greg the anagrammist just as much a creator? And what about someone who notices that "racecar" is a palindromic word, or someone who notices that "above and beyond the call of duty" can be abbreviated as "ABCD" — are such people not creators, too? Where does observation spill over into invention, discovery into creation?

In a fourth counterfactual variation, Guth says, "Oh — I didn't know that any shape had that property" (meaning the property of spelling out some word — not necessarily "Guth" — when used four times in a row, rotated by 90° each time). This Guth thinks it's a property of the curious twisty shape, not of his name.

In a fifth variation, Guth says, "Oh — I didn't know that any word had that property" (meaning realizability as a spinonym). Now he thinks that Greg is the discoverer of an exotic new property that only certain very rare words possess (which is, in a sense, right on the mark). He didn't know Greg had such acuity!

In my last counterfactual variation, J. S. Bach visits Greg and improvises a six-part *contrapunctus* on Greg's piano. Greg listens with amazement and then remarks, "Oh — I didn't know my piano had that property." He then presents Bach with a new 90° rotation ambigram that turns "Bach" into "FUGE". Bach responds in kind, saying, "Oh — I didn't know your quill had that property."

So much for counterfactual excursions; let's return to the real story. The four curvilinear shapes Greg drew are all congruent, and each is easily readable as a member of its intended alphabetic category. This is an objective fact about those shapes (or rather, about that one shape), and always was so. What role did Greg play here, then? One could say he was merely a passing beachcomber who *noticed* this fact. Admittedly, few people would have noticed it, and so, in that sense, Greg performed an act of "creative perception", but still, his creation (if I may use that word) was a *find*, not an *invention*. A perceptive stroller had espied a pretty shell on the strand. So, Prof. Guth, Greg and I heartily thank you for the edifying lesson conveyed by your casual blurt!

If, dear reader, you're not convinced, let me explain it a bit differently. Nearly four decades after Guth's remark, I was teaching an ambigrams seminar at Indiana University, and after defining the concept of "spinonym", I asked my students to see if they could devise a spinonym on Guth's last name — and to my complete non-surprise, several students rediscovered Greg's shape, each of them rendering it slightly differently. Is that not a crystal-clear demonstration of the prior, objective existence of a property of the name "Guth" that *anyone* could have found at *any* time? My students were like beachcombers who, having been told where to look, all spotted the same pretty shell, even if it was slightly covered by sand.

So… what about my *Olivieromaggio*? What if my friend Oliviero Stock, on receiving my emailed gift, had merely shrugged his shoulders and written back:

"Oh — I didn't know my name had that property"? Had he done that, I would have felt hurt and baffled. And yet, even though such a remark sounds, on first hearing, absurd and perhaps even rude, I can argue that Oliviero would have been spot-on if that's how he had reacted. The fact is, the ambigram's mere *existence* demonstrates incontrovertibly that Oliviero's first name does have, and always did have, the property that its letters can be drawn in such a way that its lake-reflection reads as the date of his birth. Nonetheless, it took a highly trained eye to notice that property.

What these two cases illustrate is a general truth about ambigrams: a successful ambigram is an artwork delicately balanced on the knife-edge between creation and discovery. It is, on the one hand, a highly personal artistic *invention*, and yet it is, at the same time, a *find* that anyone could have made.

Well, no — I take it back — not *anyone*! That's the most important point here. In order to be a high-quality ambigram-discoverer, you must be able to see, in your mind's eye, a myriad ways to distort letters while maintaining their identities, and all sorts of novel ways of breaking letters into pieces (or combining letters or letter-pieces into new wholes). You must be able to juggle variants of the challenge (such as "May 5th 2005", "05/V/1950", and "05 maggio 50", etc.), and you must be prepared to explore different symmetries. But not only imagination counts; also a reliable intuitive sense for designs that will probably "play in Peoria" (an old phrase that I hope my readers know), versus those designs that veer so far off into wild territory that their readability is lost. And lastly, a strong sense of esthetics is crucial — the ability to imbue a calligraphic design with a unified, appealing style.

Only someone who possesses all these skills will be able to see the beautiful metaphorical shell lying on the metaphorical beach, partially covered by drifts of metaphorical sand. Yes, the exotic shell is objectively there, lying in plain sight for "anyone" to see — but ironically, very few people have the vision needed to recognize it. That's why Prof. Guth's bizarre remark to Greg, although arguably true in a *theoretical* sense, is *in practice* as false as you can get. Even though a good ambigram is validly describable as being merely a shape that was always present in the abstract universe of all possible calligraphed letters and words (the analogue to the down-to-earth world of a sandy beach), it can nonetheless be a highly fanciful creation filled to the brim with imaginative magic.

Selection as Creation

One way of looking at what Greg did is to say that it is poised midway between creation and discovery. By seeing something that was there to be seen but was far from obvious, Greg performed a creative act. I believe this is the best way to look at it, and I will now delve more deeply into this notion of creativity as *seeing*.

When cameras were first being developed, most people would probably have laughed at anyone who predicted photography would one day be considered an art form. When you think about it, it does seem pretty odd that the mere act of aiming a rectangular frame at some portion of external reality and occasionally clicking would be considered a high art. Everybody has access to the same sights, after all.

For some perspective, consider the hypothetical activity of "audiography", which consists of carrying one's cell phone around and occasionally turning on an app to record a two-second snippet of ambient sound. (The constraint on duration is meant to mirror the fact that cameras record scenes in frames of predetermined shapes — rectangles are all you get, and of fixed proportions, to boot.) Does audiography, so defined, not seem a dubious candidate for a form of art? And yet, since it is so parallel to photography, I surmise that it *could* become an art form of equal depth, although it probably won't catch on. I bring this idea up simply to emphasize the fact that photography *is* thought of as an art form.

So what makes photography an art? It can't be the degrees of freedom afforded by a darkroom or a program like Photoshop, helpful though they may be; one does not need to process one's own pictures for them to be artistic. My answer is simple: *selection* is an incredibly subtle skill. I would argue that artistic creativity in general is nothing but selection — and for me photography reveals this truth more clearly than any other activity does.

Matt Kahn, Selector par Excellence

Some sixty years ago, I attended a presentation of color slides given in a Stanford residential hall by Matt Kahn, a professor of art. The show was not a travelogue, but most of the slides Kahn had taken were of scenes in France and Italy, and they included many famous places of artistic interest. The student audience was thus primed for a certain type of subject matter. In the middle of the show, when Kahn clicked a button, the following image appeared on the screen:

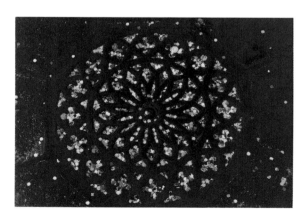

Prof. Kahn asked, "Anyone know what this is?", and several of us, trying to show off our erudition, yelled out, "A stained-glass window in the Chartres cathedral!" Then he told us that it was not in France but in Italy — in Milan, in fact — and that it was a sewer cover littered with confetti after a parade. When we looked more carefully, we could see it was true, and we felt ashamed of our naïveté. But when you didn't look carefully, it was hard to believe it wasn't a cathedral window.

Was this a cheap trick, a kind of optical illusion? Not at all. It was just one of the many miraculous strokes of visual insight that Matt Kahn's keenly perceptive eye had discovered during various sojourns in Europe.

That slide show opened my eyes to the magic that a camera can perform — or rather, that it can help a human perform. Convinced, I eagerly went out and bought a 35-millimeter camera and became an avid seeker of visual interest around me. Seemingly overnight, what had once been mundane scenes became sources of potential magic. Just as when I had read *Sherlock Holmes* as a 12-year-old and had thought that anybody could make brilliant deductions if only they paid attention to the proper details, so I thought that, with my eyes now opened by Matt Kahn, I too could look at sewer covers and see stained-glass windows!

Sensitizing One's Vision

What a comedown I had when my first few rolls of color slides came back: there were telephone lines and power lines overhead everywhere; irrelevant cars and people (often cut off by the edges of the frame) intruded and distracted; the intended focus of attention was often tiny; there was too little contrast or too much light; and so on. A Matt Kahn I was not! Gradually, though, over many months, my vision was honed and I learned to look at scenes through a type of filter — what I might call a "camera-tuned eye". I gained a type of sensitivity to ordinary scenes that I hadn't imagined before, and that often drove my parents and sister crazy, since I was constantly asking to stop the car when we were out together, to take one photo and then another. They would object: "Why can't you just *enjoy* the view? Why do you have to *capture* it?"

I probably never answered that question to their satisfaction, but the gist of the matter must be that without the passionate hope of taking magical photos, there would be no force driving my vision to sharpen itself. In other words, if the camera were taken away from me, my vision, having nothing to push it, would revert to its earlier dulled quality.

I don't want to give the impression that for me, a good photograph necessarily involves some *trompe-l'œil* effect. Very few of Kahn's slides had that punlike quality, but he had a constant sensitivity to odd juxtapositions, unusual visual rhythms, curious relations of foreground to background, and even interesting interactions

between the frame itself and the subject matter. To illustrate this kind of thing, I've chosen a photo snapped by the great French photographer Henri Cartier-Bresson in 1953 in Athens, Greece.

The ubiquitous abstract echoes — both architectural and human — pretty much speak for themselves, but what I marvel at is the acute sense of timing that Cartier-Bresson must have had to capture this stunning image. Of course it might have been a lucky accident, but the rest of Cartier-Bresson's work shows clearly that it was not. He probably waited there for a long time until he recognized a bit of magic. His portfolio is filled with examples of superb timing — being at the right place at the right time (*le moment décisif*, as he himself called it), and *knowing* it.

Much the same could be said about other excellent photographers. They have an amazing awareness of what is before them: what is (or might be) about to happen, which parts of the scene are "where the action is", how to frame the scene, and on

and on. And yet — to come back to an earlier theme — the same world is out there in front of us all. Great photographers don't inhabit a visually richer world than the rest of us do! The three-dimensional space of objects, people, motion, and so forth is given to us all, and we can all pilot ourselves around in it, looking wherever we want, zooming in on details, zooming out to get the big picture, blurring things by squinting, or shining lights on things that are too dim.

Scott Spots Seashells, Down by the Seashore

Thirty years ago, I idly picked up an ordinary brownish rock on the ground near my research center and accidentally dropped it. As it was a quite soft rock, it unexpectedly split into two pieces. I was stunned to find a sparkling crystal hidden inside both parts, peering out at me. Who would have thought that something so unprepossessing on the outside would be so gleaming inside?

For me, certain pieces of music have a similar feeling of inevitable crystallinity to them, such as the melody of the last movement of Camille Saint-Saëns' fourth piano concerto, which the composer boldly announces as a series of single notes played by one right-hand finger after another, with no left hand at all. I will never forget the first time my teen-aged self heard that melody. It felt as if I was hearing something that had always existed in the abstract timeless space of melodies — something noble, something transcending humanity, transcending earthly existence.

And there are certain very rare ambigrams that, to me, have that same feeling of inevitability and crystallinity to them; one was a throwaway drawing that Scott Kim (who, like me, had been a student and admirer of Matt Kahn's) made 45 years ago. (*Eheu fugaces labuntur anni…*) One evening when we were hanging out with our friend Fanya Montalvo, Scott casually tossed off an ambigram on her first name. I think he drew it on a paper napkin. A day or so later I recalled it and made a crude sketch of it on a scrap of paper, which I saved but forgot about for decades; that's the only record I had of it until recently. But I just refound it and brought it back to life by redrawing it very carefully myself.

When looking at this ambigram, I'm inclined to think, "Gee, *I* could have found that, too!" It's as if this pristine shell had been lying on the beach for a long time, a bit covered in sand, just waiting patiently to be discovered. It happened to be Scott Kim who spotted it, but *anyone* could have spotted it, right? Well, no — *not* anyone, that's the thing. It took very special eyes and a very unusual mind. But once it had been spotted, it was self-evident that it had always been there, wasn't it? Or was that impression all wrong?

With that as prelude, dear reader, I urge *you* to try to spot the pristine shell on the beach that Scott spotted. Don't turn the page!

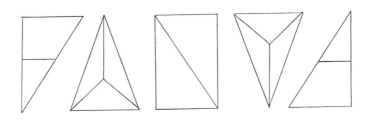

Well, did you find it yourself, reader? If so, my hearty congratulations! If not, then I suggest that you regard it with humble awe. In reconstructing it after all these years, I chose to render it in thin gray pencil lines, in order to highlight its amazing simplicity, just as Saint-Saëns chose to introduce his stunning melody in single notes. Right triangle, isosceles triangle, rectangle, isosceles triangle, right triangle. It's hard to think of a more ideal tribute to a friend.

Did Scott discover this structure, or did he invent it?

Bull's-eye

In 1942, Pablo Picasso was looking at a junkheap filled with random discarded objects, and among them he noticed two parts of an old bicycle: the worn seat and the rusty handlebars. A year later, he told the photographer Brassaï, "In a flash, they joined together in my head. The idea of the bull's head came to me before I had a chance to think."

Pablo Picasso grew up in Spain where bulls are a very central part of life, and he had drawn countless images of bulls before he had this flash. As Louis Pasteur astutely observed, "Chance favors the prepared mind."

Did Picasso discover this structure, or did he invent it?

¡Ay ay ay!

Did you notice a resemblance between the bull's head by Picasso and the fourth letter (and the second letter as well) in Scott's "FANYA"? Is that resemblance artificial and contrived, or is it real and merely discovered? And what about the connection of those items to the title of this briefest of sections in the whole book? My goodness, the connections are flying so thick and fast! ¡Eye eye eye!

A Sign of Things Ahead

One rainy afternoon a few years ago I was nonchalantly driving from Menlo Park to Palo Alto. I'd just turned off El Camino to go under the railroad tracks and enter University Avenue when I passed a traffic sign with an unusual message. Here's the scene in question, with the sign in question:

The sign economically conveyed the following information to drivers like me:

If you want to go straight onto University Avenue, get into the left lane;
If you want to turn right at either of the next two streets, get into the right lane.

Moments later, as I was driving under the tracks, it hit me, *a posteriori*, that the sign could be perceived as the English word "If". This humdrum traffic sign in Silicon Valley expressed a typical "if" statement, as in computer programming (Silicon Valley's meat and potatoes):

If condition A holds, perform action X;
If condition B holds, perform action Y.

At first I merely chuckled, but after a few seconds I felt a delighted wonder at this unintended double entendre. It had to be captured for posterity! As soon as I got to University Avenue I found a parking place, then hastily walked back through the underpass and snapped the photo before the sign could run away. I wonder if anyone else in Silicon Valley ever noticed that double entendre. Was my act a creation or a discovery?

Greg Huber, Ambispeaker

To conclude this exploration of creative perception, I'll return to Greg Huber. Quite a few years ago, Greg was scheduled to have an interview for a faculty position at an excellent engineering school in Southern California. Part of the visit involved giving a teaching trial in a calculus class. A few days before flying out, Greg was told what topic he should teach the students, and then, trying to plan his lecture most carefully, he called me up to ask how to explain why the power series for the exponential function e^x converges for all values of x. After talking about it for a while, we realized that we needed to check a few facts first, as we were both a bit rusty. I said, "I haven't thought about this in a long time." Greg said he hadn't either, and then added, "I have to speak with some authority before the class." Suddenly sensing an unintended ambiguity lurking in the word "authority", I jokingly quipped, "And am *I* that authority?"

But only moments after I made my little joke, we realized that *just about every word* in Greg's sentence was ambiguous. At first I had thought he meant: "In a few days, when my future self is holding forth in front of the young crowd out there, he will want to radiate self-confidence." But later, we realized that his words equally well might mean: "I'm so jittery right now that I feel compelled to seek out a sage who, prior to my teaching trial, can hand me the key to this tricky theorem."

Thus we were able to draw up the following chart of double meanings:

This math-rusty guy today urgently needs to get advice from this or that reliable expert, well in advance of the official meeting time.	*I have to speak with some authority before the class.*	That job candidate next week will feel honor-bound to deliver a lecture, demonstrating considerable self-assurance, in the presence of the set of students sitting there.

It's a breathtakingly Janus-like sentence, when you come down to it, far more riddled with double meanings than the wondrous (and 100 percent real) newspaper

headlines "Squad Helps Dog Bite Victim", "Red Tape Holds Up New Bridge", "British Left Waffles on Falklands", and "Milk Drinkers Turn to Powder" (see the Bibliography for their sources), except that the ambiguities in Greg's utterance are subtler to notice and explicate than the ambiguities in those classic headlines.

The seldom-noticed ambiguities lurking under nearly every stone in everyday language are similar to the potential ambiguities lurking in the letters making up each word and name we encounter — ambiguities that allow an ambigrammist to turn a word or phrase into an ambigram — but it takes a lot of practice to develop a sensitivity that allows one to "see" what is there (and always was there) but that goes unseen by nearly everyone.

A Last Word on Guth

A long time ago, I came across the Chinese phrase 文章本天成，妙手偶得之 ("Wénzhāng běn tiān chéng, miàoshǒu ǒu dé zhī"), which means something like: "A great artwork is made in heaven; a great artist may, with luck, come across it." In other words, a refined artistic creation is a chance discovery that only a truly skilled seeker could have made. Could this be the compliment that Alan Guth was trying to pay to Greg Huber, spinonymist at large?

Two Early Exhibits

A Bolt from the Blue

In May of 1983, I received an invitation from Adelina von Fürstenberg, founder and director of the Centre d'art contemporain in Geneva, Switzerland, to participate in a symposium she was organizing on creativity at her small museum the following summer. As it happened, I had spent a deeply formative year of my adolescence in Geneva and adored that city, and ever since that time I had been in love with the French language (the language of the symposium) — and on top of that, in my cognitive-science research I was trying to unravel or pinpoint the key mechanisms that underlie human creativity. For all those reasons, the invitation struck me as providential.

In my reply to Adelina, I suggested that I could talk about the creative leaps behind the scenes of my *"dessins calligraphiques à double lecture"* (at the time, no official name for such things existed in either English or French). Along with my note, I included a few of my best designs. Luckily, Adelina found them charming, and in her reply she really surprised me by asking if, during the symposium and for a few weeks on either side of it, I would like to have a little exhibition of my ambigrams in her museum. I couldn't have been more flattered, and I accepted her offer with great enthusiasm.

Over the following year, the word "ambigram" was invented (or discovered), I did scads of new ones, selected several dozen favorites, made high-quality versions on light-brown paper, and sent them across the ocean. When I arrived in Geneva in June of 1984, I had a jolly time with Adelina, who turned out to be a funny and bubbly soul of Armenian origin who had grown up in Turkey but had lived in many European countries, and who was constantly nonchalantly hopping about

from one language to another — Italian, French, English, Spanish, Turkish, Greek, Portuguese, and Armenian, as I recall — and although I often couldn't keep up with her, I loved playing the polyglot game with her.

Adelina took me to visit her *Centre*, where I was delighted to find a whole room dedicated to my ambigrams, with some hanging on walls and others displayed in little cases in the middle of the room. In the symposium, I gave a talk entitled "*Les Ambigrammes : Ambiguïté, perception, et balance esthétique*". The basic theme was similar to the saga of my *Olivieromaggio*: I described how I had come up with a few of these pieces, although I knew full well that my stories fell far short of explaining the deep mysteries behind the scenes. This talk was later published as a chapter in a book called *Création et Créativité*.

Adelina hoped to publish a book in English and French with all the exhibited ambigrams as well as my talk, but unfortunately that plan fell through. But I still fondly remember the amusing English subtitle that the volume was going to have: "A Panoply of Palindromic Pinwheels", humorously echoing the alliterative subtitle of Scott Kim's book *Inversions*, which was "A Catalog of Calligraphic Cartwheels".

Examples from Geneva

Altogether, there were fifty ambigrams on display, of which I'll here show a handful, exactly as they were in the exhibit. Many were done on names of friends — for example, my old Swiss friend Cyril Erb, who I'd met in 1958 when we were in Third Form together in Geneva's venerable International School. All these years later, Cyril still lived in Geneva — even in the very same apartment — and to salute my old trilingual pal, I designed several ambigrams on his name, in the end choosing the one below, as it struck me as being the most off the beaten track.

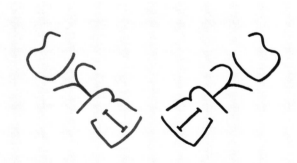

In a sense, this is a wall-reflection ambigram, in that its left and right sides are mirror images of each other (if you ignore the color difference), but its two readings are mutually perpendicular. That is to say, if you tilt your head 45° leftwards

(counterclockwise), you'll see that the left side reads "CYRIL" vertically downwards, while the right side reads "ERB" in the normal horizontal manner. It's thus not a 90°-rotation ambigram, but what I dubbed a *rotoflip*. Today's I is very pleased with the way in which yesterday's I managed to turn five letters into three.

As for my next trick, see below... Before I reveal what the two ambigrams say, I'll let you try to decipher them, each one in two orientations. (I feel sad saying "decipher", since for me the top goal for any ambigram is that both of its readings should jump out at the eye as rapidly and effortlessly as if they'd been printed in Baskerville or Helvetica — but how very seldom that goal is reached!)

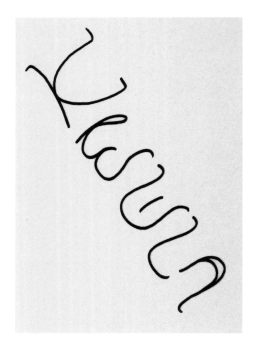 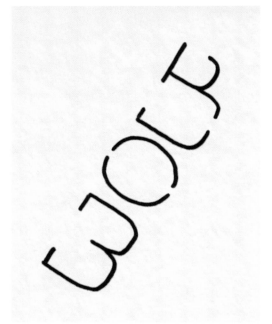

Both are, as you probably could tell, 90°-rotation ambigrams, but they involve quarter-turns in opposite directions. If you start with the horizontal reading, then to obtain the vertical reading, you have to rotate the 'gram either 90° *clockwise* (a "q-turn") or 90° *counterclockwise* (a "counter-q-turn"). A counter-q-turn exchanges the word's head and tail, while a q-turn leaves its head and tail in the same places.

The left-hand ambigram's two readings are "URSULA" and "KEES", the latter being a Dutch nickname for "Cornelis". Thus the ambigram reduces six letters into four (almost as radical as five into three). Ursula and Kees Gugelot (Swiss and Dutch respectively) were among our family's closest friends. In this q-turn in their honor, "URSULA"'s "R" and "S" merge to make "KEES"'s first "E", and her "L" and "A" merge (but leaving a crucial little gap) to make her husband's final "S".

The two readings of the right-hand ambigram are "BOB" and "WOLF", thus upgrading three letters into four, and the ambigram's destinatee is an old math friend of mine. In this counter-q-turn, "WOLF"'s "L" and "F" merge to make the opening "B" in "BOB", but that "B" has an odd little gap on the right side of its lower loop. This gap, which might be criticized as a blight, is instead treated with all the respect that a good stylistic motif deserves, and accordingly it is *echoed* two times inside the same "B", then twice more inside the "O", and once again inside the lower "B", as if to proclaim to the world, "I'm a gappy-go-lucky lettering style, and proud of it!"

I made sure to tip my hat to Peter Jones both in my Geneva show and in my talk, describing his pioneering role in ambigrammia. Peter, back in 1964, drew his first name in such a way that it reflected into his last name; twenty years later, I connected the two names with a 90° rotation instead:

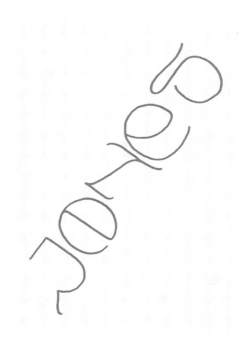

To be specific, the above design is a counter-q-turn, as "Jones" has to be rotated counterclockwise in order to become "Peter". On the other hand, if you rotate your gaze instead of the 'gram, then the swiveling takes place clockwise.

Another close friend I saluted in Geneva was David Moser, who at the time had not made any ambigrams himself, but who in a few years would be a prolific producer of some of the most unusual ambigrams ever. (That story will be told in the next chapter.) Here is what I came up with on David's name:

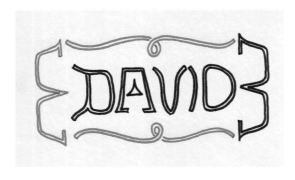

This q-turn uses a curious trick: it turns the rightmost edge of the curly rectangular frame around "DAVID" into the initial "M" of "MOSER". Today, I look upon that ploy as brazen, over-the-top cheating. For shame! These days, I wouldn't allow myself to draw a frame and then bald-facedly exploit it as if it (or a part of it) were a component of the word. But back then I frequently did so with nonchalance, and I am still fond of this 'gram.

As you may have noticed, I have something of a predilection for q-turns — or at least I used to, back in the 1980s. Today I seldom use that technique; in fact, it seldom even crosses my mind to try it out on a new challenge. I don't know quite why, since some of my most interesting ambigrams are q-turns.

Examples from the Canadian Rockies

Shortly after the Geneva exhibit, an artist named Hu Hohn invited me to give a talk at the Banff Centre for Arts and Creativity in the Canadian Rockies. My reaction to Hu's invitation was like my reaction to Adelina's: I liked the idea of mingling with people in the arts, as I felt that only half of my personality was scientific, the other half being artistic, and I wanted the artistic half to be more visible. I thus accepted with enthusiasm, offering to talk about ambigrams as a unique window onto the creative human spirit, a topic that resonated with Hu.

I decided to make a couple of new ambigrams specially for the occasion, one of which would be based on the unusual town-name of "Banff", with its distinctive final "nff" consonant-cluster. Today I see "Banff" as an easy wall reflection, but at the time I was stumped until I hit on the idea of using a *rotoflip*, as described earlier. This is a variation on the quarter-turn theme, the difference being that after

you've made the 90° rotation from horizontal to vertical, you throw in an extra wall reflection. (You can also think of a rotoflip as a reflection across a 45° line.)

Once I had this idea in mind, it all went swimmingly, as long as I allowed myself to make another out-of-the-box leap by letting two letters — the two "F"'s (or perhaps "f"'s) — stand side-by-side at the bottom of the vertical reading:

On seeing this, residents of Banff might exclaim, "Oh — we didn't know our city's name had that property!"

Coming up with this "Banff" rotoflip was a mildly creative act, but coming up with an ambigram on the name of my inviter Hu Hohn was far trickier. I tried all sorts of approaches, but nothing seemed to work. My growing frustration served to raise the metaphorical temperature in my search, making me increasingly willing to wander out on ricketier limbs and to entertain riskier approaches than I would have dared to explore at the beginning. Failure is the thermo of creativity!

The fact that there were three evenly-spaced "H"'s in "HU HOHN" was highly salient (they were reminiscent of the three evenly-spaced "y"'s in "syzygy"), and I felt constantly tempted to try to take advantage of this inviting pattern, but for a long time I couldn't figure out any way to exploit it. Finally, though, when my mental thermometer hit boiling or thereabouts, it occurred to me that I might align all three "H"'s in a vertical tower (so that a lake reflection would leave the tower invariant). It was an irresistible idea!

Stacking the three "H"'s in that way implied making a three-story tower each of whose floors would consist of just two letters: "HU", "HO", and "HN". But doing so would break the monosyllabic last name "HOHN" into two pieces. Did I dare make such a wildly norm-violating move? Well, I was at least willing to explore it, and having come this far, I took one last norm-violating step, which was to throw in a hyphen between "HO" and "HN", as if to suggest that I was merely making an ordinary vanilla line-break — no big deal.

To my great fortune, the top floor's capital "U" could easily be drawn so as to flip into the bottom floor's capital "N", while the middle floor's "O" and hyphen were both intrinsically symmetrical. What luck! The upshot is shown below:

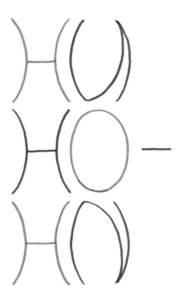

Like the *Olivieromaggio*, this is one of my favorite ambigrams, and one reason is that it is so simple, so minimal, both conceptually and visually — but at the same time so non-obvious. I am particularly fond of that jaunty hyphen, which casually pretends that it is standard practice to break a single syllable into two pieces. Such chutzpah! And the tower built out of three "H"'s is just so eye-pleasing — if, reader, I may be permitted to pat my (1985) self on the back. One last amusing feature is that the three blue letters form a picture of a water molecule.

A third ambigram featured in my Banff talk was based on an inspiration of Greg Huber's, which was to make a quarter-turn in which a horizontal "Bach" would rotate into a vertical "fugue", J. S. Bach being the canonical master of the art of fugue. Greg played with this tempting idea for a while, but when it didn't pan out for him, he creatively let the challenge slip into a nearby alternative — namely, to make "Bach" rotate into "Fuge" (the German word for "fugue"). He was well on his way to making a very nice ambigram when I glanced at his work-in-progress and saw a natural way to make a counter-q-turn in which "Bach" would rotate into the *Latin* word for "fugue" — namely, "fuga". I quickly worked this idea out, slipping into capitals ("FUGA") to make it happen. Greg should thus be credited as the muse behind this ambigram. You've already seen the result in the Introduction, but there I displayed it only horizontally. To complement that, here it is once again, this time vertically:

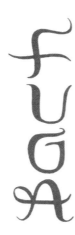

It's easily legible, the swirls are pretty, and *case* is respected, in the sense that the horizontal reading is all lowercase (except for the initial "B"), while the vertical reading is all uppercase. If I were to ask you where this ambigram deviates the furthest from norms, what would you point to? Is that spot the *weakest* part of the ambigram, or is it perhaps its *strongest* point? Or both?

Different Strokes by Different Folks

By now, you've been sufficiently exposed to my ambigrams to see that my style is quite distinct from those of Scott Kim and John Langdon. To put it simply, their products are more polished and professional-looking than mine. Decades ago, both John and Scott chose to use professional drawing software (such as Adobe Illustrator) to render their final products on paper. What comes out always looks very sophisticated, whereas my ambigrams look, well, hand-drawn. You can easily see unevenness in my lines, and imperfect symmetry — and most of the ones I've shown so far are made of thin, fixed-width lines, whereas theirs often use lines with gracefully tapering widths.

I might add that the ambigrams by Scott that I exhibited in Chapter 3 were among his very earliest creations (they date back nearly fifty years), and in the intervening decades since then, he has polished his ambigrams so finely that they virtually gleam with smoothness. To show you what I mean, here is an elegant ambigram by Scott, typifying his more recent style:

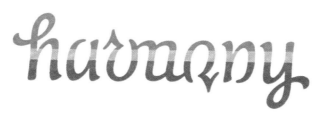

What could be more graceful — or more harmonious — than this ambigram? And what could be more of a masterpiece than John Langdon's "Philosophy"? And so I sometimes ask myself: How can I be so presumptuous, or so naïve, as to display my own hand-drawn ambigrams alongside such ideal models? As an old Chinese homily says, 班门弄斧 ("Bān mén nòng fǔ"), which roughly means "to brandish an axe in front of Master Ban's door" (Ban was a carpenter admired far and wide in ancient times), or in other words, "to foolishly show off one's mediocre skills at the home of a true master". Am I waving my axe at Master Ban's door?

If so, my only defense is to say that I love hand-painted ceramics from Italy and hand-woven rugs from Iran, in large part because of their imperfections. I adore art where one can see traces of the human hand and mind behind the scenes. Photography is great, but so is impressionistic painting!

To borrow another Chinese saying, then, 百花齐放 ("Bǎi huā qí fàng"), which means "Let a hundred flowers bloom!" In short, there is room for a wide variety of diverse styles in art — in this case, in ambigrammia — and down through all these decades, I have deliberately opted for a simpler, rougher, more "artisanal" style than the styles of Scott Kim, John Langdon, and most of the ambigrammists who post their wares on the Web.

From here on out, therefore, I won't apologize for often using thin fixed-width lines, or for being a little shaky and uneven here and there. I don't *try* to be shaky and uneven, mind you, but even when I do my best to be smooth and symmetrical, the touch of a human hand often still shows through. The fact is, although I strive for perfection, I don't want my ambigrams to look as if a machine had printed them. For better or for worse, I want them to look 100 percent human-drawn.

The Seductive Siren Song of Retinal Razzle-Dazzle

There is a regrettable tendency among many ambigrammists to spend far more time on the surface veneer of their creations — the "retinal razzle-dazzle", as I often call it — than on their creations' legibility. This tendency reminds me of people who insecurely cake on tons of makeup before a date, ingenuously thinking that doing so will make them irresistibly attractive, when in fact the overuse of makeup tends to have the opposite effect.

Another term that I often use to refer to the overuse of bells and whistles in ambigrammia is "shallow style". In my experience (by which I mainly mean the ambigram courses I've taught, and the 1988 *Omni* magazine competition in which I served as a judge), beginning ambigrammists often tend to fall into the trap of slaving away for hours on the shallow style of their creations, often using fancy software, while being oblivious to the all-too-frequent *illegibility* of what they are working on. To me, this misplaced priority puts the cart before the horse.

My Personal "Religion" in Ambigram Design

My philosophy of ambigrammia places all its chips at the other end of the table. In my guidebook, what comes first and foremost is *legibility* (or equivalently, *clarity*). To me, that's the *sine qua non* of a good ambigram. If a design has zero readings rather than two, it should be called a *nullogram* rather than an ambigram.

Hot on the heels of legibility and clarity comes the beauty of individual strokes and letters — a feeling of effortless and unforced *grace of line*. That's a quality whose value I realized the moment I first set eyes on Scott Kim's inversions.

After grace of line — a local or small-scale property — comes *uniformity of style* across an entire ambigram — a global or large-scale property. This includes the desideratum (but certainly not a rigid rule) of *not mixing cases* (in other words, you should eschew lowercase letters in an uppercase ambigram, and vice versa).

Last but not least comes the virtue of *simplicity* (or its cousin *minimality*), a principle that is related to that of not caking on the makeup. Less is so often more.

Although I just said "last but not least", there is actually another aspect of certain ambigrams (though not of all good ones) that I rank very highly, which is *playfulness* or *humor*. Greg Huber's "Guth" spinonym is a good example of these qualities; another would be my "HU HOHN" lake reflection. By contrast, I see nothing droll in my "Bach/FUGA", or in Scott Kim's "harmony", or in John Langdon's "Philosophy". They are just pleasing to the eye.

Although I try hard to instill the above guidelines as a "religion" among my students, I am aware that a superb ambigram can violate any of my guidelines. For this reason, I am not dogmatic about my "religion", but in my classes I always try to stress and transmit the above priorities (in the order in which I listed them), because I strongly believe that internalizing and practicing this philosophy will help students learn to produce high-quality output. Once they can do that reliably, then of course they are free to violate any of the tenets of the creed, and in so doing they may push the envelope of ambigrammia in novel and positive ways.

CHAPTER 6

Cheating and Reading

Cheating in Ambigrammia

When I give someone an ambigram as a gift, one of the most common reactions, other than expressions of surprise and pleasure, is the question "How did you do that?" The answer, in a nutshell, is: "I used my imagination." But it's a specific type of imagination — one that involves *stretching category boundaries* left and right. That is to say, *violating norms* left and right. And another term for norm-violation is: *cheating.* That's the name of the game in ambigrammia — cheating left and right, cheating up and down, cheating across the board, cheating every which way.

In Chapter 5, I asked where my "Bach/FUGA" q-turn deviates the furthest from norms. Most people, I suspect, would point to the buckle on the left side of the "A" in "FUGA" and the two curvy swashes on the left side of the "B" in "Bach". Why point there? Because those swashbuckling ornaments make the letters weaker members of their intended categories than if they weren't there. In neither case, though, is category membership seriously challenged — just slightly weakened.

If you go back and look at any of the other ambigrams exhibited in previous chapters, you'll find norm-violations everywhere. Look, for instance, at the "m" in Scott Kim's "harmony". When you first read it, did you notice that the central vertical stroke, at its bottom, curves over and touches the right-hand vertical stroke? If you didn't, then Scott pulled a fast one over on you. Not only did he break the conventions that define "m"-ness, but he got away with it — Scott free! Likewise, the hook at the bottom of the "o" is very weird — almost grotesque, if you look at it in isolation — but when you see it in context, it's completely harmless — and of course that hook is needed in order to make a lowercase "r" appear when the design is rotated by 180 degrees.

I cheated blatantly in splitting a monosyllable in two in "HU HOHN", and also in placing two "f"'s on a single line in "Banff" — but I got away (I hope) with those misdeeds, because the human perceptual system is very forgiving — up to a point. It is forgiving because there are often many redundant clues as to category membership. If one clue is missing or is even severely contradicted, that may not matter, because other clues can make up for its naughtiness.

Scott Kim once remarked, in giving advice to beginners, "Almost *any* shape can be seen as an 'i' as long as it has a dot on top." What he meant, of course, is that if there is sufficient context, a dot is sufficient to suggest an "i" in a place where we expect one. Scott's remark is not just funny but true. Here is an example, with a very unusual sort of dot — but it works perfectly!

It's not as if we see "Ch", then some chicken scratches, and then "na"; rather, we read "China" effortlessly, even if the "i" consists of two brush-stroked Chinese characters, 中 and 國, stacked vertically. Those characters (中, pronounced *zhōng*, meaning "middle", and 國, pronounced *guó*, meaning "realm") together mean "China". It's common for them to be set side by side or stacked vertically.

Incidentally, this humorous "i" is the old-style way of writing China's name, before Mao Zedong and comrades introduced a language reform in the 1950s in which many complex characters were somewhat simplified (a bit like the English words "nite", "lite", and "thru"). In that reform, 中 was left untouched, but 國 became 国. Today, simplified characters are standard on the mainland, while the older, more complex characters continue to be used in Taiwan and in most Chinese-speaking communities outside of China.

Mo Dawei's Pathbreaking Sinosigns

With China and Chinese characters front and center here, I can't resist a slight digression. During my 1983–84 sabbatical in Boston, I gave my language-fascinated friend David Moser his first few lessons in Chinese. At that point I had studied Mandarin for a few years, and though I was far from fluent, I had a good accent. A totally unanticipated side effect of those initial humble lessons was that

David soon grew obsessed with China and its language, first heading off to Taiwan for several months, where he acquired the Chinese name 莫大伟 ("Mò Dàwěi"), then coming back to the States for a while, and then going back across the ocean to Beijing to join the Chinese translation team for my book *Gödel, Escher, Bach*, which had come out in English in 1979.

Wearing his translator's hat, David was constantly swimming in Mandarin and, thanks to much struggle and fierce dedication, he became remarkably fluent in that most challenging of tongues. After a few years, so good was Mo Dawei's Chinese that he frequently appeared on national television performing *xiàngsheng* with experts at that art (the term literally means "crosstalk", and it is a uniquely Chinese form of stand-up comedy). That was and still is a great tribute to David's linguistic achievement. (As a result of his long struggles with Chinese, David wrote a now-classic article called "Why Chinese Is So Damn Hard", which completely agrees with my own experience, and which I highly recommend.)

Before going to China, David had been enchanted with the idea of ambigrams, and in Beijing, he started making calligraphic designs that could be read one way in Chinese and another way in English. He dubbed his concoctions "sinosigns". Many years later, I thought up an appealing way to say "ambigram" in Chinese: 双观语 ("shuāngguān yǔ"), which means "double-view phrase", and which sounds identical to the Chinese term for "pun" (双关语), so it's a pun itself.

Ambigrams of any sort were unprecedented in China, and a few newspaper articles appeared about David's sinosigns, but in general he was surprised by the lack of interest in them. Years later, though, the tide turned, and 双观语 became popular in China, with many of them cleverly hiding subversive political messages.

Below, in red, I've shown a counterclockwise q-turn by David; its horizontal reading will jump out to any native speaker of English, while its vertical reading will jump out to any native speaker of Chinese (it uses the simplified character 国).

Both readings are the name for China, of course, in their respective languages — five letters in English versus two characters in Chinese. To help you see how close the vertical reading is to a standard version, I've included, on the right, an ordinary version of the same two Chinese characters, as calligraphed by David.

Most residents of the mainland (especially elderly people) are familiar with (and maybe even prefer) the old-style characters, and David chose to use the older version of 国 — namely, 國 — in a second sinosign on "China", exhibited below in red. To its right I've added a typical calligraphed version in green (again by David) to help non-Chinese speakers see what's going on.

This remarkable 双观语 works by *oscillation*, meaning that it involves neither rotation nor reflection, but just a perceptual shift. I hope that you, as a speaker of English, effortlessly recognized the word "china"; however, what jumps out to a native Chinese speaker are the two characters "中國". So strong and clear is this perception that most Chinese speakers, no matter how well they know English, don't see any roman letters, and if you tell them that it says "China" in English, they think you must just be pulling their leg. Only if you explicitly point out each individual letter do they begin to see how it could be seen in an alternate way.

Cheating in Chinese

In designing this oscillation ambigram, Mo Dawei took many liberties, both in the roman letters and in the Chinese characters. For example, there's a big bold "i"-including circle swirling around the "na". It's so eye-grabbing — and yet we English speakers pay it no heed, taking it merely for some kind of decoration. We also benevolently ignore the lines under the "n" and over the "na" — just more decorations! And then there's a backslash through the "a", which in some ways enhances its "a"-ness and in other ways detracts from it.

In the Chinese reading, just as many liberties are taken. The character 中 is broken — with impunity — into two pieces. A Chinese reader wouldn't bat an eyelash at this. And what *should* be a little square (口) inside the big square looks like an "n", not like a 口 — but once again, that's seen as a trivial sin. And what *should* be a little slash crossing the larger backslash has somehow drifted into being a quasi-circular curve — and yet to a native Chinese reader, that merely looks like a run-of-the-mill calligraphic stroke made with a swiftly-moving brush. Invisible! Lastly, the dot near the roof of the big "room" is missing — but Chinese people wouldn't even notice. Like the AWOL crossbar of the "A" in the car name "KIA",

the absence is barely noticed. In sum, in this sinosign, Mo Dawei gets away with calligraphic murder and is found totally innocent. Hats off, gentlefolks!

A few years after this illusion appeared in a Chinese newspaper article, a friend visiting Memphis, Tennessee walked by a Chinese restaurant, recognized the oscillation sinosign (a "sinosign sign"), photographed it, and sent it to David.

Someone, perhaps the restaurant owner, must have come across that obscure newspaper article and shamelessly ripped off the idea. However, if taken to court, the owner might argue, "*Rip-off*?! What on earth are you talking about? Didn't you know that the word 'China' *intrinsically* has that property? We here — I mean my honorable family members and I — discovered it completely independently of that Mo Dawei fellow, whoever he might be! And we'd next like to call to the witness stand Prof. Alan Guth of the Massachusetts Institute of Technology…"

Bottom-up and Top-down Perception in Reading

When reading, a human brain is doing two things at once — namely, reading *letters* and reading *words*. (I'm simplifying things for the sake of clarity. The reading brain is doing many things at once, but that's not crucial for our purposes here.) When reading in a bottom-up fashion, you put letters together to hypothesize a word that contains them in the given order. Conversely, when reading in a top-down fashion, you perceive a word as a whole and hypothesize the existence of several constituent letters inside it.

But how could someone read a whole word without first having recognized the letters inside it? That sounds like nonsense. Indeed, it seems self-evident that when you read, you mentally put together *strokes* to see *letters*, then *letters* to see *words*, and then *words* to see *phrases* — in other words, you carry out perception from the bottom up, always moving from smaller visual elements to larger ones. But what would you say about the following eleven images that I photographed while wandering about at random in our amusing world?

BOOBY CLUB

YoseMite

ARDS UNLIMITED, INC

MONROE COUNTY PUBLIC LIBRARY

ATHLETE

WELCOME

LUXEMBOURG

The Maids®

I hope they made you smile. Did the two non-letters in the middle of the spare-tire cover give you pause in trying to figure out the vehicle's make? Did you get confused by the heart made of knickknacks for neonates? I doubt it. I also doubt that you hesitated for even a microsecond, vainly trying to parse a girl's head as a letter (or as two letters). Nor do I suspect you were thrown off track by the picture of Half Dome serving as an "M" (or rather, as an "m"); I even bet that you read "LOVE" instantly despite the dog-shaped "O".

How about that leaf next to "ARDS" (and with its stem poking between "UNL" and "MITED")? Were you lost? How about that pair of moose horns against red mountains serving as a prefix to "THLETE"? In the next two images, a tree is first seen as an "I" and then another tree is seen as an "X" — and we wind up with a butterfly and a vacuum cleaner serving, respectively, as an "O" and a "d".

We've all seen a million such typographical games over the years, and few if any of them have thrown us for a loop. Even more extreme in their reliance on top-down visual processing are many of the "Google doodles" that have popped up on our screens for over two decades, of which two are shown below:

They symbolize a moon landing and the artist Jackson Pollock. Did you "read" the word "Google" in each of them?

Years ago, I clipped the phrase below from a newsletter. What does it say?

Did you read those two words as "*e*urrent *e*vents"? I doubt it. Or as "*c*urrent *c*vents"? Again, I doubt it. And as for "*e*urrent *c*vents", no chance in the world. Rather, I suspect that you effortlessly parsed the phrase as "*c*urrent *e*vents" without ever noticing that exactly the same shape was used for both the "c" and the "e". Your brain saw that shape as a "c" in the first word and as an "e" in the second word. Now how could it do that if it was reading in a purely bottom-up fashion, one letter at a time?

The answer, of course, is that was *not* reading in a purely bottom-up fashion. It was effortlessly mixing bottom-up and top-down processing. Long familiar with the words "current" and "events", and never once having encountered either "eurrent" or "cvents", it combined the bottom-up clues provided by eleven unambiguous letters with the top-down information stored in its deeply ingrained mental lexicon, and zeroed in on the stock phrase "current events", while rejecting (or not even considering) the extremely far-fetched possibilities of "eurrent" and "cvents". All of this took place silently, beneath the surface, unconsciously, in a flash, so it felt to you as if no processing whatsoever was going on at all.

Scott Kim's Amazing Boxed Proverbs

All this shows that your brain has a repertoire of visual concepts of *words as wholes*, and thanks to those higher-level expectations embedded in it, it often sees words faster than it can make out the letters that make them up. Moreover, your brain even has visual expectations for written language-chunks at levels *higher* (meaning *larger*) than that of words. This may be starting to sound implausible, so let me provide some fascinating and vivid evidence for my claim.

In 1987, Scott Kim was writing a monthly column called "Puzzler" for a magazine called *Publish!*, and he devised a remarkable challenge. He exhibited a set of unusually-printed proverbs, all of which are familiar to any native speaker of English. The challenge: Read them all! Below are six of Scott's boxed proverbs:

How many of them did you "read", dear reader, and how long did it take you? More to the point, how could you possibly have read *any* of these proverbs, given that not a single one of their letters was present? Oh, all right — each letter was there, but it had only a ghostly presence, in that it was represented by the smallest upright rectangle that would enclose it tightly (not counting the dots on "i" and "j"). This meant that you, being letter-deprived, were forced to rely on a higher-level set of visual categories stored in your brain — not just the categories of full words, but even categories for whole proverbs as visual chunks!

Some of the words in Scott's quiz have very recognizable gestalts (at least to my eye), such as the third word in the first proverb, which practically leaps off the page, and the third word in the fourth proverb. Of course the apostrophes in the first and fifth proverbs give huge clues, even though they aren't letters at all.

If you're still stumped by one or more of Scott's boxed proverbs, here they are, decoded, although I've shuffled their order:

> Beauty is only skin deep.
> A penny saved is a penny earned.
> Look before you leap.
> A rolling stone gathers no moss.
> You can't judge a book by its cover.
> All's well that ends well.

What more convincing evidence could there be of the importance of top-down processing in the act of reading?

Expectations and Hallucinations

Top-down processing is a reality, and this fact is exploited constantly — to the hilt — by skilled ambigrammists, who, over the course of time, develop a powerful (though not infallible) intuition for how ordinary viewers will perceive the shapes that they draw. It all comes from expectations carried in the brain.

When I speak of "expectations", I don't mean that a few moments before you are handed an ambigram, you somehow get primed to see certain words, and are thus all set to encounter those words in the ambigram that you're receiving. That almost never happens. What I mean, rather, is that your lifetime as a speaker of your native language has provided you with countless thousands of words, names, and phrases, and *those* are the concepts that embody your passive expectations.

Consider, for example, this logo of a famous brand of orange juice:

It looks perfectly good, doesn't it? But is the "u" really there? What about the "n"? Whichever of them is fully there, the other one is only half there. Yet few people notice anything wrong. (By the way, in Chapter 3, did you spot the similar "o"/"n" elision in Scott Kim's book title "Inversions"?) The aberrancy slides right under most people's radar. That's why it's so hard for most people to proofread a manuscript — they just *don't see the typos*, since the brain hallucinates correct words where there are misspelled ones.

In the world of ambigrammia, consider this:

Did you have any trouble recognizing that famous name? I suspect that even though some of the letters are a bit hard to find if you look for them, that didn't slow you down at all. Probably the correct reading jumped out at you without any straining. At least I hope so! That's top-down perception for you.

I might add that I'm not terribly thrilled with this wall-reflection ambigram — it relies on several tricks that today I would cringe at using, but that's okay — it's from a long-gone period of my life. One lives and learns.

If anyone is curious, I would point with particular disapproval at the three horizontal strokes in the second "E" in "SHAKESPEARE". By being very short, they are pretending not to exist in the "K" four letters earlier. They make for an ugly and ill-suited "E", especially inside a word that contains two other "E"'s that look nothing like it. Uniformity of style is very important in ambigrammia, but at the time I was just learning that principle. There are several other aspects of this ambigram that, if a student were to give it to me today, I would criticize gently but firmly, but I'll leave the critiquing as an exercise for the reader.

CHAPTER 7

Chunks and Low-hanging Fruit

The "Prime Numbers" of Ambigrammia

Here's an ambigram I drew in the 1980s that I suspect you'll read instantly, partly because of, but also in spite of, the letters that make it up:

Speakers of English — especially ones from Britain — are all strongly primed for this name, and are likely to forgive it its numerous sins (such as the grotesque "A" on the top line) without even noticing them. Instead, they may say to themselves, "What a fittingly regal lettering style!" They may even forgive the blatant act of cheating whereby I shoved the final "H" of "ELIZABETH" underneath the "T", so that when the ambigram is rotated, the "R" of "REGINA" looks grand and rather queenly, perhaps suggesting the familiar letters "HRH" (standing for "Her Royal Highness").

This ambigram affords me an excellent opportunity to explain the notion of "minimal chunks" (or "indivisible chunks") in ambigrammia. Suppose we were to draw a (more or less) vertical line in order to separate the letters "E" and "L" in "ELIZABETH". That line would unfortunately cleave the upside-down letter "A" in "REGINA" into two pieces. But suppose we don't want to split any letters; we want to leave them all intact. In that case, to protect the "A"'s integrity, we have to respect the "EL" chunk by not splitting it. For similar reasons, the "IZ" chunk is indivisible, because chopping it into its two constituent letters would slice the letter "N" in "REGINA" into two pieces. I think the idea is clear.

Below, I have dissected the QE II ambigram into its minimal chunks — you can't further split any of them without breaking up a letter in either the top line or the bottom line.

The chunks shown here, being indivisible, are therefore the "prime factors" of the ambigram; you cannot break any of them into smaller pieces.

Most ambigrams consist of a handful of such chunks, but once in a blue moon, an ambigram will consist of just *one* indivisible chunk. Here are two examples:

You can't cleave either one anywhere between neighboring letters without cutting an upside-down letter in two. You can check this out yourself. These ambigrams are therefore analogous to large prime numbers having no divisors.

I am always delighted when I come across a many-letter minimal chunk inside an ambigram I've designed, because it means that my ambigram is very far away from being based on a naïve single-letter-to-single-letter mapping, as were all the ones that Peter Jones and I started out with, way back when.

Intrinsic Ambigrams

Certain words lend themselves effortlessly to being ambigrammized; they have intrinsic, built-in symmetries. For example, "MOM", in block capitals, is wall-symmetric, and "NOON", also in block capitals, has an intrinsic 180°-rotation symmetry. The uppercase word "TIDBIT" enjoys no such symmetry, but if you put it into lower case in Baskerville ("tidbit"), it comes *close* to being a wall-reflection ambigram, and if you switch to a minimalistic sans-serif font such as Avant Garde, you get a perfect one: "tidbit". All I can say is: WOW.

A word that has a more unexpected yet still intrinsic symmetry is "chump", but only when it is written in lowercase cursive:

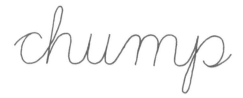

(You just have to make sure, when writing it, that the bowl of the "p" doesn't hit the descending tail, since that would ruin the "c"-ness of the opening shape.)

Note how this charming ambigram uses an aspect of Scott Kim's "standard technology", whereby a joining-line (at the baseline) becomes a criterial stroke in a letter (at the x-height) when the 'gram is rotated. In particular, the little curve joining the "m" to the "p" is indispensable in bringing upside-down "h"-ness into existence. Clever, eh?

Well, to tell the truth, no one was doing anything clever here; the intrinsic symmetry of this cursive word was merely *noticed* by a certain Mitchell T. Lavin of Cincinnati, Ohio, around the turn of the last century. Mr. Lavin sent his find to *The Strand* magazine in 1908, commenting, "I think it is the only word in the English language which has this peculiarity." That was a most naïve thought on Mr. Lavin's part, but naïve or not, it convinced the editors of the magazine to print his submission and give him his fifteen minutes of fame.

To call this specimen of handwriting an "ambigram" (which I did a few lines up) is a misnomer, as it doesn't meet my definition — namely: *a piece of writing expressly designed to squeeze in more than one reading.* The word "chump" as submitted by Mr. Lavin was not expressly designed to have two readings; it was just a natural way of penning the word. When Mr. Lavin noticed the word's symmetry, he saw it as just a fortuitous accident of script writing — a curious linguistic fluke. It didn't involve clever distortions of letters dreamt up by an ingenious artist, so although this specimen undeniably has two readings, it doesn't count as a genuine ambigram (at least not in my book).

Chunks and Low-hanging Fruit

Likewise, "MOM", "NOON", "tidbit", and "WOW" don't count, for me, as ambigrams; they are simply words that, as anyone can see, *intrinsically* possess some sort of symmetry. Along these lines, I remember learning, as a kid, that the word "CHOICE", when printed in block capitals, as here, was intrinsically lake-symmetric (although that term wasn't used). I later realized that there are many words that lake-reflect into themselves when printed, and so, when I started doing ambigrams, exploiting lake reflection to write a friend's name symmetrically didn't strike me as much of a feat. For instance, if I were to give to my friend Bob an ambigram that says "BOB", it would hardly be something for him to write home about. Of course, when a lake reflection's two readings are unrelated, as in my *Olivieromaggio*, that's quite another ballgame.

Many block-capital letters possess intrinsic left–right symmetry, and it follows that quite a few words, when printed *vertically* in block capitals, possess a natural wall-reflection symmetry. For instance:

You already knew that youth is wasted on the young; now you know that it is boringly symmetrical when printed in vertical sans-serif capitals. It's cute, but once again, not a full-fledged ambigram (so say I), as it doesn't feel in the least *creative*.

Low-hanging Fruit and Creativity

Suppose your hypothetical friend Debbie Hickox said to you, "You think you're so good at ambigrams! Well, I bet you a million dollars you can't make an ambigram on *my* name! I've tried and tried, and it doesn't work at all! Some names simply aren't ambigrammizable, and mine's one of them. The ball's in your court, smartie!" (At this point, the reader may wish to take up Debbie's challenge before reading further.)

If you were me (which admittedly is a rather dubious proposition, but if I were you, I would ignore its dubiousness and just keep on reading), you'd begin by jotting down Debbie's name on a piece of paper in three ways, as I described in Chapter 1: first in printed capitals, then in printed lowercase letters, and lastly in script, more or less like this:

DEBBIE HICKOX Debbie Hickox Debbie Hickox

Then, as a matter of long-ingrained habit, you/I would rotate the paper and would see whether there seemed to be any promise for a 180°-rotation ambigram. You/I might even make a very rapid and crude exploratory pencil sketch like this:

and then say to ourself, "Hmm… Ugly, forced… No hope here!" So then you/I would move on to check whether the lowercase or the script version seemed more amenable, but soon enough you/I would reach similarly pessimistic conclusions.

Having thrown the 180°-rotation hope out the window, you (being me) would then move on to consider the feasibility of a *wall* reflection. And after a while, that, too, would start to seem unpromising, at which point you/I might start to think about trying quarter-turns or rotoflips…

But what if it eventually occurred to us two, dear reader, to consider a *lake* reflection? (As I said above, I almost always avoid that pathway, but since you're not me, perhaps you, in my shoes, *would* try it out.) All of a sudden, when we looked at the all-caps pencil version of Debbie's name, a bright flash would go off in our joint brain, and we would joyfully write this down:

Now look at that — it reflects *perfectly* in a lake! (If there's a nearby lake, you can actually go and try it out. But don't fall in!) This discovery certainly gives the lie to Debbie's claim, and so, hand in hand, we two would triumphantly carry it over to our friend, demanding that she instantly fork over our cool $1,000,000.

After breezily laughing off that silly claim, she would say, "Wow, I sure didn't know my name had that property!" Should we feel insulted by Debbie's Guth-like remark? Definitely not. After the fact, it's clear as day that her name has (and has always had) that property. It's not as if you and I jointly carried out some ultra-sneaky calligraphic shenanigans to *make* it have that property. Not at all; this is just a case where an ambigram was handed to us on a silver platter, all done, no tweaks needed! But given that, do we deserve any *credit* for creating/discovering it? Is this sequence of block capitals any more of a true ambigram than "MOM" or "NOON" or "BOB" or "CHOICE"?

I'd say "yes", simply because very few people would ever notice the name's symmetry; it is hardly in-your-face. Even Debbie herself, who'd written it countless times, had no clue that her name had that property! It took *perceptivity* on our part

to reveal the property, even if, *ex post facto*, it seems totally obvious. It's a discovery, but a subtle enough one that it becomes a *creation*, ergo it's a genuine ambigram.

When the Obvious Conceals Something Profound

Sometimes it is extremely difficult to notice "obvious" things (such as the lake-symmetry of someone's name), and sometimes being the first to notice something obvious can have profound repercussions. The physicist Albert Einstein was a specialist at this great art throughout his life. I'll cite just one example.

When he was in his late twenties, Einstein was deeply struck by the then well-known fact that an object's *inertial mass* (a measure of how strongly the object resists being moved by a force) and its *gravitational mass* (a measure of how strongly gravity tugs on the object) are independent properties of the object that nonetheless are precisely equal to each other — but unlike anyone before him, Einstein thought this coincidence was a mysterious miracle that craved explanation and that must have extraordinary consequences.

Einstein's sense of awe at this identity led him to muse about how objects would fall in a little room sitting motionless on earth's surface, and it then led him, by contrast, to muse about how objects in an identical room far out in gravity-free empty space would move, as the room was being pulled ever faster by an angel (or a rocket, if you prefer) tugging on a cable attached to a hook on an outer wall.

It fascinated Einstein that the equality between gravitational mass and inertial mass implied that these two very different scenarios would be indistinguishable to people inside the rooms. In the first case, all released objects would fall toward the stationary room's floor at one and the same speed (as Galileo showed), and in the second case, the angel's tugging on one wall would make the opposite wall act like an effective *floor* inside the accelerated room, towards which all objects released inside the room would seem to fall, and once again, all at the same speed. (The fact that all objects released inside the angel-tugged room will "fall" at the same speed is "obvious" after the fact, since you can redescribe the scene by saying that the room's floor is rushing up ever faster towards them.)

With this simple but ingenious thought experiment, Einstein demonstrated that *gravitation* and *acceleration* were indistinguishable. Thus did he cast an amazing new light on the elusive nature of gravitation. Einstein called this sudden flash of

insight "the happiest thought of my life" and gave it the name *equivalence principle*. That principle became the cornerstone of his theory of general relativity, which many physicists would call the greatest discovery ever made in physics.

GRAVITATION = ACCELERATION

The exact equality between inertial mass and gravitational mass had been common knowledge among physicists for centuries, but to no one had it occurred that this fact was a profound clue into the mysterious nature of gravity. Intuiting that fact was typical of Einstein's way of thinking.

Of course I don't mean to suggest that discovering general relativity and noticing the lake-symmetry of "DEBBIE HICKOX" are acts of similar depth or import; I just want to point out that the timely exploitation of a publicly available, "obvious" fact may eventually lead to something innovative that catches the world (or part of it) by surprise, whether it be an earth-shaking revolution in physics or a cute little birthday ambigram for a friend.

Blurting Out the Opposite of What I Believe

In the late 1980s, I had lunch with Sergei Tabachnikov, the editor of a lively Russian magazine called *Kvant*, which was devoted to recreational mathematics and related topics. I brought along a few of my ambigrams, thinking Mr. Tabachnikov might enjoy them. Indeed, he was mesmerized, and then and there he decided to sponsor an ambigram contest in his magazine. He asked me if he could use some of my ambigrams to inspire his readers (of course I said yes), but he also wanted to give his readers some examples in Cyrillic writing. He said to me, "I'm sure that if we look around enough, we'll find some Russian words that are symmetrical, although it might take a while." I reflexively blurted out, "No, no, no! You don't just go out and *find* ambigrams — you *make* them!" I felt I had to disabuse him of the simplistic notion he had of ambigrammia.

Of course what I meant was that intrinsically symmetric words like "NOON", "CHOICE", "tidbit", and so on give a wildly false impression of what ambigrammia is all about. Genuine ambigrams involve a wholly different idea: the deliberate and subtle distortion of letterforms in order to achieve a double-reading effect. When I pointed this out to Mr. Tabachnikov, he quickly caught on. (The next year, *Kvant* held its Cyrillic-ambigrams contest, but sadly, the winning entries were terrible.)

Clearly, when I was under pressure and had no time to go into a long song and dance, I reverted to the simple and intuitive way of talking (like saying the

sun circles the earth) — that ambigrams are creations, not discoveries. But there is a wide spectrum of *degrees* of discovery, including deeply creative acts, and ambigrams are located at all possible points along that spectrum.

Automorphism

Many years ago I was driving on a curvy country road in Italy, and just above the license plate of the car ahead of me I saw the logo of the dealership where the vehicle had been purchased. It looked like this:

"Auto tua" means "your car". I broke out in a great big smile. What a perfect name for a car dealer — not only palindromic but even ambigrammatical! And by a lovely coincidence, the phrase's left–right symmetry constitutes an *automorphism* (a math term meaning a one-to-one mapping of a structure onto itself).

Later on, I dreamt up a palindromic wall-reflection "rejoinder" to the logo:

This says "oro loro" in Italian, meaning, in English, "their gold" — the idea being that when you get your car, they get your cash. It's another automorphism.

To me, the "**AUTOTUA**" logo seems to fully merit the label "ambigram", since it took a tidbit of inventivity to think up the phrase in the first place, then a dab of observativity to notice that it's spelled the same backwards and forwards, and lastly an extra little dollop of discoverativity to notice that it also reads the same when reflected in a mirror. So I take my hat off to that car dealer in Udine, Italy.

Plucking Ambigrams from Tree Limbs

Some ambigrams, such as "**AUTOTUA**", appear (after the fact) so simple and natural that they give the impression — even if wrongly — that anyone at all could have stumbled across them. The symmetry seems so inherent in the word (or name or phrase) that one says to oneself, "Such a low-hanging fruit, just begging to be picked — no wonder someone eventually noticed it!"

Of course, plenty of ambigrams are found on fairly low limbs, but seldom so low as to be *begging* to be picked. I'm thinking of three ambigrams that I drew in the early 1980s. At that time, I was exploring a lot of country names, and some came pretty quickly while others took more time.

"SWEDEN", for example, in capitals, seemed at first to be nearly a giveaway as a counterclockwise rotoflip. "S" rotoflipped trivially into "N", and so did "E" into "W" — which left only "E" and "D" in the middle. Those, however, didn't seem to work naturally. I tried force-fitting them for a while, but it never felt right.

At this point, some people might be inclined to throw in the towel, sighing, "What a pity that the 'E' and 'D' in the middle loused it up — close but no cigar." But that would be the wrong attitude. Indeed, this is precisely the moment where a dash of explorativity is called for (the cliché term is "thinking outside the box"). So I mentally explored a little bit and gave myself permission to try out a lowercase "e" instead of a capital "E", and that quickly gave me:

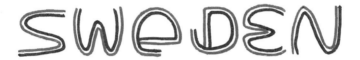

Success! It's far from being one of my finest efforts, but it was a very pleasing find for a relative beginner. Except for those middle two letters, it was as easy as pie (preferably lingonberry pie) served to me on a silver platter!

Another country name that I tried at the time was "Egypt". The three middle letters temptingly winked at me, beckoning me to try wall reflection. (I could see "g" and "p" as nearly mirror images of each other.) But there was a glitch. What about the "E" and the "t"? Hmm…

Once again, a bit of reflection, so to speak, gave me the needed insight. I decided to let both the top and bottom of the "t" curve *leftwards* (thus violating norms twice) — so as to give me the *right*-pointing upper and lower arms of the "E". It was a nonstandard move, for sure, but with care, I was able to make my insight work, and it yielded a spare and simple wall reflection:

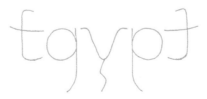

Of course the wiggly tail of the "y" makes it slightly asymmetrical, but that's okay, since it's equally readable in both directions.

My "Egypt" ambigram was not handed to me on a silver platter, fully formed; it was not screaming out at me; it was not a piece of fruit begging to be picked. Some of it, to be sure, was pretty obvious, but in order to make it actually work, I had to come up with a few not-so-obvious tweaks.

Another country name I tackled at the time was "Great Britain". When I tried a 180° rotation, everything at first went swimmingly, using quite familiar single-letter-to-single-letter riffs (*e.g.*, flipping an "a" into a "t"), cheating all the time but in a quite standard manner — until I hit the very middle, where I found myself in what seemed to be a blind alley. I had to make "Br" rotate *into itself*, which seemed a ludicrous challenge. How could *that* be done? No way!

But then it occurred to me that I might use a sneaky snaky curve to give me the two bowls on the right side of the "B" (whichever way you turned it), and an upside-down "r" as the vertical post of the "B". With this insight, things rapidly fell into place in a most gratifying manner, and even with a bit of fortuitous icing on the cake — namely, a bit of blank space between "Great" and "Britain":

This was easily one of my favorite ambigrams up till then. Most of it, but not all of it, was pretty low-hanging fruit for me, since at the time I had developed quite a number of standard riffs, but in the center it required some genuinely new ideas on my part. This meant that this ambigram was actually perched on a quite high limb, where it wasn't in the least begging to be picked; in fact, it wasn't even visible to most people. On the other hand, if I were to give the challenge to a few talented ambigrammists today, I wouldn't be surprised if more than one came up with the same conceptual skeleton, though of course not the same exact shapes.

There are ambigrams that are much higher than this one on the metaphorical tree — ambigrams that require huge vats of industrial-strength cheating to work. Most of my favorite ambigrams are ones of that type, secretly nestled way up in the tree, and since they involve so much novel cheating, they seem much more elusive, and therefore more creative and more artistic.

Paradox?

There is something verging on the paradoxical in what I just stated, so let me spell it out as clearly as I can, after which I will dispel it as clearly as I can.

According to my "religion", found at the end of Chapter 5, the *most perfect* of all ambigrams are those that are the *most legible*. But that, by definition, means

they involve the *least cheating*. And that in turn means that they are the *most obvious* of ambigrams. But that means they are the *least creative* of ambigrams. It would thus seem to follow that the most perfect ambigrams are the most obvious and least creative ones! But in the previous paragraph, I stated that my favorite ambigrams require vats of industrial-strength cheating. How to reconcile this flat-out contradiction?

The answer is that "perfect" ambigrams involving no cheating are, in the end, just blah, bland ambigrams. They may read effortlessly and instantly, but when inspected more closely, they are seen to involve no magic, no insight, no creativity — they were just *always there* from the get-go, like Mr. Lavin's cursive "chump", or "tidbit", or good old "BOB". Shells on a beach that anyone could have picked up.

To make an ambigram that has long-lasting power to give viewers delight, you have to discover some creative insights, which means you have to *cheat* in numerous places. And the more cheating, the better, perhaps! It's just that the cheating should not draw overt attention to itself. It should sail right past the eye. A top-notch ambigram is one whose out-and-out cheating *arouses no suspicion* on the part of most viewers; it reads easily (hopefully instantly) in both directions, and merely seems to have some innocent little embellishments that add charm to it.

If an ambigram challenge gives a seasoned ambigrammist no tough problems to resolve, it will have little character; it will just be a routine production composed exclusively of standard riffs. Scott Kim once said to me, after tossing off a very easy ambigram that didn't excite either of us, "Oh, that one was too easy — there weren't any misfortunes. Misfortunes are good, because they give an ambigram some *character* — they determine its overall appearance."

An Unexpectedly High-hanging Fruit

Not long ago, my friend Margie Khosrovi told me in an email that the town where she and I grew up (Palo Alto, California) and the town where I've lived for the last few decades (Bloomington, Indiana) had just been named "sibling cities". She added, "Why don't you use your talents at forwards and backwards lettering to make a logo for the new partnership?" I welcomed Margie's suggestion and felt confident that I could do it in a snap — but what a wrong snap judgment that was!

It wasn't just the difference in lengths (eight letters versus eleven); something in these two town names just didn't want to mesh. I was plagued by misfortunes galore. Wasn't I lucky? Scott Kim would certainly say so. I made several attempts, each time starting from a new avenue of approach, but I always ran into some recalcitrant region inside the names, some region that just wouldn't yield.

Below, for example, is one of my attempts; though legible, it's riddled with defects. In "Bloomington", both "o"'s are weak, the "ng" is pathetic, the "t"'s

crossbar is outrageous, the final three letters are run together... And in "Palo Alto", there's that extravagant swirl in front of the "P", the overly decorated "a", the final "o"... Altogether, not a very good show.

But I was stubborn, and for days on end I kept on coming back, moth to the flame, seeking, seeking, seeking the secret. Finally, after countless hours and many starts and restarts, I devised what I thought was an acceptable logo for the sibling cities, although it included, I admit, a bit of unneeded but crowd-pleasing retinal razzle-dazzle (the three suns).

There remain dubious aspects to this design (that final "N", most of all!), but perhaps they are what makes it fun, in the end. Along the creation/discovery spectrum, it is certainly located at a point very distant from "chump".

Easy or Hard?

Here's a curious little exchange I had with someone to whom I had just given two ambigrams as a present, and who had never seen an ambigram before. After I'd explained what they were all about, our conversation went as follows:

> Wow, these are amazing! I love them!
>
> Thanks a lot! Your daughter's name turned out to be pretty easy, but I had a rougher time with *your* name.
>
> Oh, yeah — mine is a *hard* one.

Chapter 7

Oh, really? There is definite naïveté here. If you know nothing at all about ambigrammia, how can you presume to say which names are easy and which are hard? That's like someone who's never done one whit of rock-climbing looking at two sheer rock faces nearby and nonchalantly declaring, "Oh, *that* one looks pretty easy, but *this* one sure looks hard." How can somebody with zero experience make such a self-confident claim?

A word that gives seasoned ambigrammist A a very rough time might turn out to be child's play for seasoned ambigrammist B, and yet with some other word, the exact reverse could be the case. Hardness in ambigrammia isn't a quality that can be spoken of objectively, let alone snap-judged by a total outsider.

It's different with someone at the stratospheric level of Scott Kim, who can do ambigrams in his head. Scott can look at an ambigrammatical challenge and in a single glance assess how hard it will be not just for himself but for any skilled ambigrammist. In fact, he doesn't even need to *look* at the word to size it up; he just needs to *hear* it and he can already see its possibilities in his mind's eye. That's an experience that I will never have.

So I should backtrack a bit and acknowledge that the level of difficulty of a challenge does have some objective reality. But assessing a word's difficulty from just a quick glance is a rare ability that comes only from long experience. An outsider shouldn't have the chutzpah to claim, "Word *X* would be very hard to do an ambigram on." That's just an invitation to a seasoned ambigrammist to show the claim is dead wrong!

CHAPTER 8

Playing in Peoria

Spicy Salsa

In 2010, I was living in Paris and, among other things, taking salsa lessons at a little dance studio called "Paris Mambo". So inspired was I by my teachers Hubert and Karine, who'd founded the studio, that I decided to make ambigrammatical T-shirts for them. Seeing that the word "salsa" lent itself to wall reflection, I drew it out, then worked hard to make "Paris Mambo" also wall-symmetric, and finally toiled at making "Hubert" turn into "Karine" when wall-reflected. These were nontrivial challenges, and you can judge my results for yourself:

For now I'll concentrate on my curvilinear blue "salsa". I wanted to celebrate the swirling, whirling, twirling fluidity of salsa-dancing, especially as practiced by Karine and Hubert, so I sacrificed quite a bit of legibility by running the "s" and the "a" into each other, both before and after the central "l". This was an artistic decision that I can't fully explain or justify, but I was pleased with my handiwork, and made the T-shirts and gave them to Hubert and Karine.

Some people might say that it's actually a *plus* that you have to work a bit to read the words on the T-shirts. They'd say it makes it more fun, in some sense. I can understand that attitude, but in my opinion it opens up a dangerous slippery slope, in that it provides an excuse for creating weak ambigrams that people find hard or impossible to read. A bad ambigrammist can argue, "My ambigram is *better* than one that's instantly legible, because trying to decipher it is a key part of the fun!" Well, that's certainly not my viewpoint.

Years later, it occurred to me to make a new wall reflection on "salsa" that would be more legible than the one I'd drawn for the T-shirts, so I borrowed the three relevant letters from Helvetica and tweaked two of them. I chose Helvetica since I've always admired its lowercase "a", whose graceful upper half comes close to mirroring the curviness of the "s". Take a look:

sa

So, wearing my ambigrammist's hat, I simply decreed that my "s" and "a" would be based on these Helvetica letters, but would mirror each other *exactly*. Here's what resulted (the color echoing the spicy sauce):

salsa

For me, this small artwork raises a provocative question: Does its existence prove that the lowercase word "**salsa**" (like the lowercase word "tidbit") enjoys the *intrinsic* property that you can read it in a mirror? Would Alan Guth, on seeing this ambigram, exclaim, "Oh — I didn't know 'salsa' had that property"?

What Counts as a Member of a Category?

This is where what one means by terms like "to read" or "readable" gets very blurry. Is the red display above a genuine instance of the word "salsa"? Or is it merely very *close* to being one? Are the second and fifth shapes in the display actually "a"'s? Or are they not true "a"'s, but just shapes that can *pass for* "a"'s?

Where lies the boundary between what is a true "a" and what can merely pass for one? Where lies the elusive boundary line between a *genuine* instance of a word (such as "salsa"), and an impostor that merely *looks like* an instance of the word?

The answers to such questions lie in the collective mind of the millions of people who, on a daily basis, effortlessly use the given writing system and fluently speak the language involved — and therefore, questions like "Is this shape an 'a' or not?" do not have black-and-white yes/no answers, but only *statistical* ones.

Check out this greeting card:

Is it perchance wishing its recipient *flappy* holidays? Although most people would probably just laugh that droll suggestion off, the identically calligraphed word in a different context — a video showing a flock of geese taking off from a pond, say — might well be read as "Flappy".

Or look at this opening of an advertisement for a book aimed at teen-age girls (and their sisters, mothers, and grandmas):

A Book of Braiding and Styles
by Anne Akers Johnson

When I first read the title, "Flair" jumped out at me. Of course, a lowercase "l" shouldn't have a crossbar running through its midriff, because that brings it dangerously close to "t" territory, but I nonetheless read it as "Flair". I didn't even see "Hair" at all, believe it or not. But in reading the ad, I found out that the book's title is actually "Hair". I wonder if the ambiguity wasn't deliberate.

The "correct" readings of these two examples, inside a specific context (or outside of any context), would have to be decided by a poll of "The People" (a term that I'll define shortly), and it would result in some percentage voting for "Flappy" (or "Flair"), another percentage voting for "Happy" (or "Hair"), and perhaps small minorities voting for other readings as well.

One of my favorite typefaces, dreamt up in 1966 by the designer of Magnificat (see page 28), is called "Vivaldi". Here are its uppercase letters, in order:

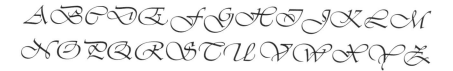

I hope you agree with me that it is wonderfully graceful and eminently readable. Now please read the following sentence that I have typed for you in Vivaldi:

I Very Much Prefer Classical Jazz Over Cool Jazz.

I suspect that you read it with no difficulty — as easily as if it had been printed in Baskerville. Speaking of which, let me copy-and-paste the Vivaldi sentence and then flick its font over into that other favorite typeface of mine. Here goes nothin'!

I Yery Much Yrefer Tlassical Iazz Qver Tool Iazz.

Hmm, now… What do you make of that? The first letter of the Vivaldi sentence is also the first letter of "Jazz". So is it an "I" or a "J"? And how can the first letter of "Very" *also* be the first letter of "Prefer"? And how come what looks like a "C" in Vivaldi translates into a Baskerville "T"? And on and on…

Now I'll type the sentence again, this time with the *correct* letters in Vivaldi:

I Very Much Prefer Classical Jazz Over Cool Jazz.

Oh, my goodness — what is "*Cool Jazz*"? Is it a type of music played by musicians decked out in bathing suits and drifting about on inner tubes? For that matter, what is "*Classical Jazz*"? And say, wasn't that Vivaldi fellow (speak of the devil) a renowned composer of many a *Concerto*? And in what *City* was Vivaldi born? *In Venice*, so says Wikipedia (but that, alas, is a typo). *Oh, What a Great City!*

In numerous upscale restaurants, I've seen menus printed in Vivaldi, and I'm always tempted to order such vegetarian delicacies as *Corn*, *Carrots*, *Capers*, and *Cauliflower* (a favorite dish of the late great Austrian physicist Wolfgang Pauli) — and of course, to round out the delicious meal, a *Cup of Colombian Coffee*. Indeed, a pup of Polombian poffee would be *Car for the Course*, wouldn't you agree?

So now, dear reader, what do you say about the capital letters of this "tlassic" (or "plassic") typeface? Are they really as legible as we'd agreed a page ago, when I displayed them in alphabetical order? Is the Vivaldi "*C*" actually and objectively a capital "C"? Would it be factually and scientifically wrong to read it as "P"?

How do we decide what something written in Vivaldi really says? Is there an objective fact of the matter? Or is it up to a vote? And if it's a voting matter, then what about words written in Baskerville or Helvetica? Are they also up to a vote?

Humbly Bowing to the Judgment of The People

This is where the sadly fading phrase "to play in Peoria" hits the nail on the head. A hundred years ago, vaudeville shows that made hits in that stereotypical midwestern burg in the heart of Illinois were supposedly sure to make hits on Broadway as well; and if they failed there, then they would also flop on Broadway. Peoria was the canary in the coal mine, so to speak. Metaphorically, then, "to play in Peoria" means *to succeed with average viewers*. And that's the goal in ambigram creation — in fact, the goal is to make a big hit in Peoria — and to do so in only an eyeblink or two. You want instantaneous Baskerville-like readability!

The reading *intended* by an ambigrammist (no matter how talented) is one thing, but the judgment of the **Peo**rian **ple**bs (henceforth, "The People") may be quite another. As an ambigrammist, you must always be willing to humbly bow to what The People tell you they see, whether you like it or not — and over time, with luck, you will learn many valuable lessons from The People, and thereby will build up a reliable internal model of how they tend to perceive items you calligraph; the existence of this model in your head will allow you to craft ever-better ambigrams.

How many times have I shown an ambigram to a friend who "misreads" it, and I frustratedly mutter things like "That's *not* an 'N'… it's an 'H'!" — as if what I *intended* it to be is necessarily what it *is*. As if there were some objective truth to the matter. No, I have to accept the fact that to *that* person, it's an "N", not an "H". That's how they see it. The fact that I'm the one who drew it doesn't mean that I'm right about what it *is*! Humility is the operative term here.

Audiences and Visuences, and Local and Inner Peorias

This brings up the question of who you are aiming your ambigram at — your expected audience — although since it's visual, not auditory, the word "audience" seems like a misnomer. But "visience" and "visuence" both sound terrible, and since I can't think of anything else, I'll stick with "audience".

If you're giving two sweethearts a wedding present that marries their names to each other, then they are your principal audience, and they're likely to eat up their

wedding-day ambigram without detecting any sour tastes in it. When they later frame it and hang it on a wall in their home, it's still likely to fly just fine in that limited context, since all their kith and kin know their names very well.

On the other hand, if you're making an ambigram on a word that targets no specific recipient (for instance, an abstraction like "philosophy" or "harmony"), or the title of a book or movie, then you have to be far more self-critical — especially if, say, you're designing a logo that might eventually be read by thousands or even millions of people. Then you have to be super-careful and super-precise.

And if you're designing an ambigram that you expect will be shown to people whose native language doesn't use the roman alphabet, then the demands that you place on yourself will have to be even more stringent. Imagine the challenge of designing an ambigram on, say, "The Hound of the Baskervilles", for a "visuence" of 9-year-old Chinese children who have just learned the roman alphabet. Now that would be a really tough ambigrammatical challenge.

In short, there's a wide spectrum of audience types, and you have to keep the likely audience in mind when designing your ambigram. But even in the most relaxed of cases — the wedding present, say — you obviously still have to try hard to make all the letters belong to their intended categories, so that each name, as a high-level structure in its own right, will jump right out as belonging to its intended category. The upshot is that to be able to make ambigrams well, you have to develop a strong and reliable *internalized Peoria*, and you can develop such a model if and only if you regularly ask the opinions of viewers who you feel have reactions that are typical of your larger and unseen intended audience.

In my personal case, my "local Peoria" (not the same thing as my *inner* Peoria, which lives wholly inside my own head) consists mainly of my two children, Danny and Monica, plus a few trusted ambigrammist friends — especially Greg Huber, David Moser, Roy Leban, and Scott Kim. All six are strict and honest critics, zeroing in on weaknesses like an owl swooping in on its prey. And though it's always disappointing to be told that a lovely creation I was so proud of and imagined was perfect is in fact flawed and needs salvaging, it's all right, for in the end, not only the specific ambigram itself gets improved (a short-term benefit), but also my private inner Peoria grows more refined (a long-term benefit).

My wife Baofen is also sometimes a guinea pig for my ambigrams, but her native language is Chinese, and although she speaks and reads English very well, her perceptions of letters and words are often different from those of native readers. Even so, I'll often run a fresh ambigram by her eyes as a useful test of how grabbing it is, even to someone whose training on letters and words is not like that of a more typical member of the intended audience.

At the other end of the spectrum, I have a couple of native English-speaking friends who, for one reason or another, are hopeless at reading my ambigrams.

Over and over, they've stumbled on even the easiest-to-read ones, so I've learned to discount their opinions. You don't ask a tone-deaf friend for their opinion on your latest musical composition.

After the Shower, I and Eye Dance Together

I almost always design my ambigrams on paper, but once in a while, I'll be in the shower and suddenly feel inspired to try to see if I can do an ambigram on, say, "San Diego". So in my head I say to myself, "Hmm… Maybe the capital 'S', which goes *above the x-height*, could map onto the upside-down 'g', which goes *below the baseline* [in reality I'm thinking of the *other* style of 'g', as in Helvetica], and then the 'a'-to-'e' riff is easy as pie, and then maybe the *left* side of the 'n', with a dot underneath it, could flip into an 'i', and maybe the *right* side of the 'n', with some fancy footwork, could somehow be made into an upside-down capital 'D'… Well, this sounds somewhat promising, but then again, I've totally left out the 'o'! Hmm… Maybe I could make the 'o' look like a swirly flourish coming off of the bottom left of the capital 'S'… Have to try it out on paper."

At this point, what I have is just a plan — a conceptual skeleton with no flesh whatsoever on it yet. And I honestly don't know if it'll work or not.

After I'm out of the shower, I go find a pad and a pencil and start fleshing out my hopeful conceptual skeleton. Once I've got a first sketch, then my *eye* — take that as a nickname for my inner Peoria — scrutinizes it and tells me it's weak here and it's weak there, so I tweak it here and tweak it there, and my eye keeps on finding little flaws, so I keep on tweaking it in pencil. It's an "I–eye" dance that goes on for as long as it has to — either until *eye* tells *I* that this is getting pretty good, or until *eye* tells *I* that it doesn't seem to be working out. It's my inner Peoria that is the judge, and I just have to accept its verdict. I have to know how to listen to what my eye is whispering to me. If the sketch eventually passes my eye's muster, then I go and make a first tracing of it in ink, and then round and round goes the dance once again, but at a more polished level. It can take hours of dancing, but it all came from a few little mental gleams during the shower.

I'll now let *your* inner Peoria tell *you* what it thinks of my sparingly fleshed-out conceptual skeleton:

Chapter 8

"Having That Property" is Not a Black-and-White Matter

When Alan Guth said to Greg Huber, "I didn't know my name had that property", it sounded as if he was referring to an objective, black-and-white fact about Greg's spinonym. But a quality like legibility is not black-and-white. Some of my ambigrams are read instantly (to my joy) by nearly everyone I show them to; others often give readers pause, but after a while (to my relief) most people make out the desired readings; and there are yet others that (to my dismay) only a small portion of viewers ever manage to read "correctly".

If, say, 60 percent of my friends can read "Paris Mambo" in the wall-reflection ambigram at this chapter's start, will I be justified in saying, "The name 'Paris Mambo' has the property that you can write it mirror-symmetrically"? I don't think so. I think it's a shades-of-gray matter. That name (at least in that version) has that property at a 60-percent level. It's not a matter of yes versus no.

Playing *for* Peoria versus Playing *in* Peoria

Art is a spread-out social phenomenon. The lasting quality of a piece of art, or of an artist, is judged not by one person but by humanity as a whole, or at least by large chunks of humanity. A great work of art jibes with, and thereby reveals, a *vein of receptivity* in the collective human mind. Put more succinctly, great art is crowd-pleasing art.

But that doesn't mean that an artist should set out to be a crowd-pleaser. For example, Frédéric Chopin didn't compose his music with some Polish Peoria in mind; he didn't constantly fret, "Will this new mazurka of mine knock 'em dead in Poznań?" He composed *to please himself,* not to make big bucks. But his musical mind just chanced to be in synch, in ways he couldn't control, with those of people not only in Poland but all over the Europe of his day, and moreover, as it turned out 150 years later, with the musical minds of people all over the globe. Am I ever glad that he didn't *calculate* his pieces, trying to make them be crowd-pleasers!

Chopin wasn't playing *for* Peoria; it simply turned out that his music played *in* Peoria. To create deep art, you have to obey your own innermost artistic instincts, but those instincts have to be informed by the reactions of people you respect. In the end, it's a subtle balance between your own most private and personal taste and the external world's taste. That's why even Frédéric Chopin, child genius that he was, had to receive a high-quality musical education in order to *become* Chopin. And luckily, that's exactly what he got, and that's exactly what *we* got.

CHAPTER 9

Snippets from *Ambigrammi*

My First Book on Ambigrams

Breathlessly back from Paris, Peoria, and Poznań, I resume the thread of my journey in the enchanted realm of Ambigrammia, located in the further reaches of the remote Artic continent.

I married Carol Brush in October of 1985, and the next May she and I set out on a belated two-month honeymoon in Italy, zigzagging all over the northern two thirds of that beautiful country in a rental car, and I gave lectures in many historic and scenic sites, including Torino, Siena, Padova, Trieste, Firenze, Perugia, Napoli, Amalfi, and others. Quite a few of my talks were about ambigrams, and it was in giving them that I cut my teeth in the art of lecturing in Italian. I had to learn how to say crucial things like "working under tight constraints", "cheating", "curlicue", "swirl", and dozens of others, and had to invent Italian terms for such novelties as "counterclockwise q-turn" and "rotoflip". It was a trial by fire for me, but it was also exhilarating to be acquiring, bit by steady bit, fluency in talking about artistry, beauty, creation, and discovery in a language of such sublime sounds and patterns.

Whatever town Carol and I went to, I set myself the challenge of designing the best possible ambigram I could do on the town's name, and having done that, I would then branch out to the names of nearby localities. By the time our wild zigzag tour was over, I had designed ambigrams on the names of about fifty Italian cities, including all the largest ones, from Milano and Venezia in the north to Palermo and Catania in the south, and dozens of smaller towns as well (Agrigento, Bolzano, Civitavecchia, Domodossola, Erice, Fiesole, Genova…). This was the first time I had systematically tackled a significant number of individually small ambigrammatic challenges, while thinking of the entire set as constituting one large *collective* challenge.

My polyglot Genevan friend Adelina von Fürstenberg had put us in contact with some friends of hers in Florence who had just started up a small publishing house with the odd name of "Hopeful Monster", and Carol and I met with them there. The hoped-for book on *ambigrammes* in French had never come to fruition, alas, but it emerged that the Hopeful Monster folks were champing at the bit to have me do a book on *ambigrammi* in Italian. This was an irresistible proposition, although I knew it would inevitably lead, on my part, to many long and hard sessions at the drawing-board grindstone.

When Carol and I returned home, I plunged straight into the writing of a wide-ranging essay about ambigrams and related topics for the book. It wound up taking the form of an extended dialogue between me and a fictitious alter ego named "Egbert B. Gebstadter". I wrote it first in English, and when it was done, I helped to translate it into Italian, collaborating closely with a native speaker who was a friend of the *mostri speranzosi* in Florence. While I was working on the text in both languages, I came up with lots of new ambigrams — about thirty more Italian cities, as well as the names of all of the twenty *regioni* into which Italy is divided. It demanded intense concentration, but it also afforded great pleasure.

In 1987 the book came out, with the title *Ambigrammi: Un microcosmo ideale per lo studio della creatività* ("Ambigrams: An Ideal Microcosm for the Study of Creativity"). It was nearly 300 pages long and included about 245 of my ambigrams. It was well produced and it sold in small quantities for a few years, but after a while Hopeful Monster went out of business and the book went out of print.

I never thought it would be appropriate to try to publish it in English, because from the very start, the whole book had been conceived with an Italian audience in mind — it featured about 100 Italian place names, the names of numerous Italian friends, and so on. To publish it in English would have entailed redoing the entire book from top to bottom, and that was out of the question.

The Gramma Sutra

Since I sank so much of myself into *Ambigrammi*, it would seem only reasonable to include here a sampler of some of the most lively and diverse creations in it. To begin with, I used a wall reflection in dedicating it to Carol ("*a Carol*" in Italian):

I also "grew a wild hair" (one of Carol's pet phrases) and started doing a ton of ambigrams that combined our first names in all sorts of ways — first horizontally, then vertically. I made both a horizontal and a vertical 180° rotation turning "Doug" into "Carol" (and vice versa), and then two lake reflections, two wall reflections, and all sorts of quarter-turns (both clockwise and counterclockwise), not to mention rotoflips. Untold scads of "Doug/Carol" ambigrams! Below I've selected two samples — on the left, a vertical wall-reflection (shown both forwards and reflected), and on the right, a counterclockwise q-turn (also shown both ways).

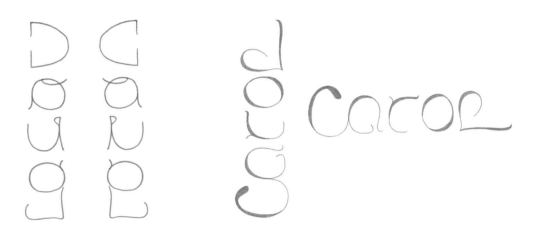

One thing that's clear from these examples is that I had no qualms about cheating; throwing consistency to the winds, I mixed upper case and lower case whenever and wherever I needed to, always chasing the two holy grails of easy legibility and visual grace.

To round out the set of all possible ways of combining our first names, I set myself an especially tough challenge, which was to design two "Doug/Carol" *oscillation* ambigrams, similar in spirit to David Moser's bilingual "china/中國" ambigram, which could be read in either Chinese or English without any physical motion of the 'gram itself. In other words, my goal was to make ambigrammatical analogues to the famous duck/rabbit bistable image (or the bistable Necker cube), where, instead of the image being rotated or reflected to reveal a different reading, all that happens is that a mental switch flips inside your head, and somehow you interpret the image in a different way.

I had to make *two* oscillations, one horizontal and one vertical, just as I'd done for the more common types of ambigram. Each was supposed to jump back and forth easily between the duck of "Doug" and the rabbit of "Carol". After a while I came up with solutions that were by no means the crown jewels of the collection of my ambigrams on our first names, but I thought I'd show them to you anyway.

Chapter 9

Both of these flutter at the fringes of readability, but that's often the case with oscillation ambigrams. I'll just let you observe how all the letters shift whenever that mental switch flicks over from one setting to the other. Although these 'grams were quite feeble, the fact that I'd somehow managed to make them *at all* gave me great satisfaction, as only the very rarest of name-pairs have even the slightest chance of being realizable as (somewhat) successful oscillation ambigrams.

When I tallied up all the theoretically possible ways of ambigrammatically fusing our first names (or any two distinct names), I found a grand total of sixteen (that's what I called "untold scads" above), and I made a valiant attempt at doing each type — with varying degrees of success.

From the get-go it had been apparent that there was only one conceivable title for this collection of sixteen ambigrams — namely, "Gramma Sutra"; after all, it was graphically displaying all the possible positions for husband and wife: vertical and horizontal, rotating and flipping and oscillating back and forth in every which way. I was relieved when Carol was amused by this slightly risqué appellation.

Harmonic Oscillations

The "Carol/Doug" oscillations in *Ambigrammi* were not the first oscillations I'd ever attempted; in fact, I'd made several attempts at oscillations in the previous few years, some of which turned out semi-decent, while others were pretty dubious if not complete flops. One of the more curious of these efforts was an out-of-the-box oscillation on the first and last name of one of my closest friends, which I will let you try to figure out by reading (or inspecting) the 'gram itself. Here it is:

Snippets from Ambigrammi

It's obviously composed of letters of two different sizes, with each larger letter being composed of two smaller ones (except for the final "O", which is the same size as itself). If you step back and look from a distance, the last name should come into focus fairly easily.

The whole thing says "Francisco Claro" — the name of one of my dearest chums from our days back in physics graduate school in Eugene. Francisco, who lives in his birth city of Santiago, Chile, is still among my closest friends. Aside from being a highly accomplished physicist, he is an excellent artist, musician, and author. He also has a terrific sense of humor, a trait that matches this ambigram pretty well, since it's one of those ambigrams that I find funny; it's just so gutsy, or perhaps I should say "just so silly". It appeals not so much to my sense of esthetics as to my sense of whimsy.

To me, the oscillation for Francisco skirts the fringes of ambigrammia because of the salient discrepancy of letter-sizes in the two readings. In a normal ambigram, both readings should consist of letters that are very nearly the same size. And yet I admit that I was proud when I made "CYRIL" turn into "ERB", cramming five letters into the same space as three, and I was similarly proud of turning "ELIZABETH" into "REGINA" (nine into six). What's so different between those cases and that of "Francisco Claro", which carries nine letters into five? Numerically speaking, the latter is only slightly more extreme than those — but it feels *very* different, since all but one of its large letters are made out of two blatantly smaller letters. That seems like out-and-out cheating. (For shame!) The other two just-cited ambigrams don't strike me that way.

The game of different letter-sizes can be carried to much greater extremes, of course, as in the following design, which I threw together about that time, using the humorous and idiosyncratic typeface called "Hobo" (see page 113):

```
NUMEROUS        NUMEROUS        NU                US
NU              NU              ME                RO
ME              ME              RO                ME
RO              RO              US                NU
USNUMERO        USNUMERO        NU      USNU      US
US              US              ME    RO ME       RO
NU              NU              RO    ME  RO       ME
ME              ME              US   NU   US  NU
RO              RO              NU  US    NU  US
US              USNUMEROUS      MERO      MERO
```

I would be reluctant to call this typographical stunt an ambigram, even though it has two distinct readings. For me, it goes way beyond the admittedly ill-defined boundaries of Ambigrammia.

Below is another early attempt at oscillation, and once again I won't reveal what it says (or rather, what I hope it says, since what it *actually* says isn't under my control, but is, as always, a collective judgment of our old friends The People).

Until writing this paragraph, I'd never noticed how similar this ambigram is to my "Francisco Claro", in that it consists of letters of two sizes, with two smaller letters making up each larger letter (except for the letter in the middle). But it plays the doubling game very differently from the way "Francisco Claro" plays it, since all eight letters in this 'gram have exactly the same height.

Have you deciphered it, dear reader? I hope so, but if not, let me reveal what it says (or was intended to say) — namely, "SCOTT" one way, and "KIM" the other way. What more natural name for me to play with ambigrammatically? The "K" is made of an "S" snuggling up to a "C", and the "M" is made of two affectionate "T"'s. But the trickiest trick is that "I"/"O" rabbit–duck in the center. On the one hand, it's a skinny rabbit of an "O" (after all, an "O" is supposed to be a circle as wide as it is tall), but on the other hand, it's a chubby duck of an "I" (after all, an "I" is supposed to be merely a one-dimensional vertical stick).

I can try to bring out each of the two readings more clearly by playing with the relative dimensions (thanks, computer, for your help!):

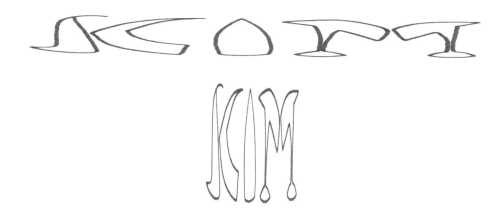

If the wind is in my favor, the upper line will now look more like "SCOTT" and the lower one more like "KIM" — but as you know by now, dear reader, it's you and your fellow Peorians who are the ultimate judges of the success or failure of any 'gram, so I'll leave it to You The People to decide what you think.

Snippets from Ambigrammi

My next attempt at an oscillation ambigram explored totally new territory for me. Here, without further ado, it is:

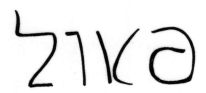

Can you figure out what it says?

Before I decipher it for you, a few words of explanation. In 1984, two friends of mine were getting married — he from Saskatchewan and she from Tel Aviv — and I thought it would be a cute coup if I could design an oscillation for them with her name written in Hebrew letters (thus moving from right to left), and his name written in roman letters (thus moving in the opposite direction). I tried and tried and tried, but to my great dismay came up with absolutely nothing.

Part of the problem was that I was but a dabbler in Hebrew, so I had next to no idea what kind of stretching (that is, what kind of *cheating*) was possible with Hebrew letters and names. This meant I had no choice but to stick very close to the classical archetype of each Hebrew letter, which is to say, I felt tethered by a tight cord to the core of each letter-category in *her* name. Of course I felt much freer to play all sorts of games with the letters in *his* name, as I was then in my own sandbox and knew far more clearly what I was doing. But that one-sided freedom wasn't enough to allow me to realize my plan.

After slowly grinding down to a dead halt, I had a sudden epiphany: why not reverse the languages? Why not write the bride's name in roman letters, and the groom's name in Hebrew? In a way, such a language-flip might seem all wrong, but on the other hand, the ambigram was to be in honor of a marriage, and what could be more beautifully symbolic of two loving newlyweds than for each spouse to bend graciously toward the other? So I decided to give it a try.

This second time around, though still severely limited by my lack of familiarity with Hebrew, I was somehow able to tinker around with the roman letters well enough that, according to a couple of native Hebrew speakers whom I consulted, "Paul" jumped out very clearly in his Hebrew togs, and I myself judged that "Ziva" jumped out very clearly in her Roman toga. I therefore hope, reader, that you saw "Ziva" (and not "Zika"!), even if you'd never encountered the name before, and I also hope that — if you are a fluent speaker/reader of Hebrew — you promptly parsed the 'gram as "Paul" (spelled phonetically — "Pa-ool").

Chapter 9

The next quarter-turn is a clockwise one, carrying head to head and tail to tail, and is very minimal. I'll exhibit it both ways, and I hope they are easy to read:

If you guessed that I made this one for my friends John and Liz (not "Loiz"!), you'd be close, but slightly off the mark. John and Liz are the central protagonists in Vikram Seth's brilliant novel-in-verse *The Golden Gate*, which I read voraciously when it came out in 1986, and have since reread countless times. Reading that Pushkin-inspired novel had massive repercussions on the rest of my life, among which a very minor instance was the above ambigram.

Not surprisingly, what I was most proud of in it was the discovery that I could exploit the "O" in "JOHN" to serve as the dot on the "I" in "LIZ". I thought that was pretty darned clever — and also hilarious. Now you might protest, "*What* dot on the 'I'? A capital 'I' *has* no dot!" In a sense you'd be right — if you peruse typeface catalogues, you'll find nary a capital "I" with a dot on top of it. But if you go to Italy or France (and probably many other European countries as well), you'll see store signs galore that feature dots on top of capital "I"'s. I well remember that when I first noticed this phenomenon, back in the mid-sixties, I was outraged and offended, thinking it was primitive and stupid. (Ah, those were the days — if only what outraged me today were as innocent as a dot on a capital "I"!) But after a while, dotted capital "I"'s grew on me, and I started to think of them as whimsical and playful; indeed, over time I began to exploit that device in my ambigrams whenever I wanted to reinforce the "I"-ness of an "I" whose "I"-ness might otherwise be in doubt.

I couldn't resist doing an ambigram on the name of my favorite composer, and the symmetry that came most naturally to me was a counterclockwise q-turn.

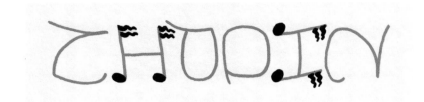

Adding sixteenth-notes with their flags waving in the Mazovian wind was an afterthought, but I think they enhance the ambigram's charm. Someone might accuse me of resorting to retinal razzle-dazzle, that *bête noire* of mine, in order to make my ambigram more likely to play in Peoria. I would retort that the allusions to musical notation were not tossed in to cover up weaknesses of the letters; they are just playful ornaments. If they spice it up with a bit of visual pizzazz, so much the better! What's wrong with a little spice in life?

The next quarter-turn, another exercise in minimality, is long out of date (it was drawn during the Cold War), and for that reason it may not ring any bells in younger readers. It's another bilingual ambigram, this time using roman letters for the first reading and Cyrillic letters for the second one.

The horizontal reading hopefully needs no decipherment for Peorians. As for the vertical reading, it consists of the four Cyrillic letters "CCCP", which are the initials of the former Soviet Union (or more fully, the Union of Soviet Socialist Republics — that is to say, Союз Советских Социалистических Республик). I'm not sure what political point I was trying to make here, if any — probably just a gesture of international friendship.

Here is yet one more q-turn in honor of my primary ambigrammatical mentor:

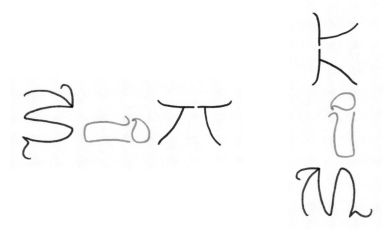

Once again, I used an "O" to dot an "I", and this time, the two "T"'s of "SCOTT", rather than making up the "M" of "KIM" (as they did in the earlier oscillation), form the "K". Ornamenting the "S" is a headdress, which slightly risks turning it into a "B", but since "Bcott" doesn't match any expectations, I think that that danger is successfully skirted.

I wonder if Scott knew that his name has this property…

More Odds and Ends from *Ambigrammi*

I earlier showed my oscillogram on the name of my Chilean friend Francisco Claro; *Ambigrammi* also included a wall reflection on the names of Francisco's two daughters, who were young children at the time.

Once I had hit on using wall reflection, I found that a letter-by-letter matchup would turn the trick. The main obstacle was "A" reflecting to "M", and vice versa. Only recently did I notice that my "A"/"M" reversal is very similar to Peter Jones' "A"/"M" reversal in "ANTIDISESTABLISHMENTARIANISM" (page 13). How droll!

We come next to one of those unusual ambigrams where I simply was the beneficiary of good luck, but I had to supplement that luck with trickery. My old friend Michael had just embarked on a romance with a woman named Barbara, so I decided to celebrate their union. Little did I suspect, though, how well-mated they were — until I discovered their deep affinity while playing around with their names. The printed name "michael" (with a lowercase "m"), when seen in a mirror, reads very easily as "barbara" (with a lowercase "b"). Check it out:

Well, now that I'm looking at it with fresh eyes, I have to laugh, since I realize it's not nearly as obvious as I implied above. It takes some imagination to see it, but at that time, being a fairly experienced ambigrammist, I saw it as clearly as could be in my mind's eye. Here, more or less, is what I saw, or imagined:

It jumped right out at me, as if handed to me on a silver platter!

To see "barbara" clearly in the mirror-reversed "michael", I had to do a bit of fancy footwork in terms of regrouping. The reversed "el" became the initial "b", the reversed "ch" became "rb", and so forth. The only thing that really bothered me was that the reversed "i" had to be seen as an "a", and it wasn't obvious how to make that work. Adding a dot would increase the "i"-ness, of course, but it would simultaneously diminish the "a"-ness. This was a tricky tradeoff. In the end, I came up with the following design, thick with innocuous retinal razzle-dazzle:

In Bloomington in the early 1980s, I was introduced to the young but already famous violinist Joshua Bell (he was 15 years old at the time), and despite the big age difference, we quickly became friends — in fact, one of the things that first bonded us was that Josh fell in love with ambigrams! I celebrated our friendship by doing a 180° rotation for him.

Chapter 9

A number of unusual features mark this ambigram. First and foremost is the first letter. Why did I use lower case at the outset? Well, because the "ll" at the end of "Bell" wouldn't turn easily into a capital "J", but it slipped nicely into a pair of "j"'s. Actually, dear reader, I ask you: is that *two* "j"'s, or is it just *one*? In some odd unconscious manner, our desire to see a capital letter at the outset allows the doubledness of the "j" to serve in lieu of capitalization. Just as importantly, there's only one dot on the "j", so *of course* it is just one "j"! That dot cements the deal! But what a dot it is — an inverted tintinnabulum! Now why would I have used *that* unusual shape in this ambigram?

Lastly, the "s" in "Josh" is flirting dangerously with "e"-ness. However, the English-speaking mind easily overrides the potential "e" with an "s", thanks to the familiarity of "Josh" (and the nonexistence of "Joeh") as a first name. Name or word familiarity is a crucial top-down force constantly exploited in ambigrammia.

The next piece borrowed from *Ambigrammi* is a favorite of mine, again thanks to its underdone quality. Minimality has great appeal for me. Here 'tis:

It was made as a gift to two good friends of Carol's and mine when we lived in Ann Arbor — Mary and Rudi Arnheim. Rudi was a renowned psychologist and

philosopher of art — among the most eminent in the world. Having been trained in the gestalt school of psychology in Germany, he came to believe that cognition is fundamentally just sophisticated perception, and his writings were all about what happens in a human mind when it perceives a work of art. For that reason, no one could have been a more ideal reader of *Ambigrammi* than Rudi, and he was clearly intrigued by the ambigrams I showed him, especially the one for him and his wife.

I still recall his appreciation of the way the stylized "M" of "MARY", when rotated, became the stylized "DI" ending his own name, and how, in symmetrical fashion, the stylized "R" opening *his* name became the stylized "RY" ending *her* name. I unfortunately don't recall how he reacted to the way the little dot acts as a crossbar in the "A" while merely decorating the "U", nor if he noticed how the "A" and "U" are located right above/below each other, making a kind of elongated ellipse. Oh, well… Like most of life, it's lost in the sands of time.

Can you read the two names above? They belong to another couple who were friends of ours, this time in Bloomington — Alice and Roy Leake. They had always been so hospitable to us that I wanted to reciprocate in my way. This 'gram uses quite a bit of shallow style, but I think it is pretty successful, both despite and because of that. On top of the "I" in "ALICE", I added a dot, of course, and I used a second dot as the "A"'s crossbar — and a third one as the "E"'s crossbar. And yet not a single one of the three dots in "ROY" plays any letter-defining role at all; they are all just ornaments.

Here's a challenge for you to decipher. Hint: it's the name of an Italian friend.

Chapter 9

Pino's last name is "Longo" (though here I lowercased the "L", just as I lowercased the "P" of his first name), and he is a computer scientist and a novelist from the polyglot city of Trieste, at the north end of the Adriatic Sea. I've included this ambigram here not because it is one of my most elegant, but because of a trick (*i.e.*, cheat) that I exploited in it: making a lowercase "g" rotate into a lowercase "i" whose dot looks like a child's balloon sailing up into the sky, with a string dangling below. I would never have thought of such an unlikely shape for an "i" if it hadn't been for the pressures of trying to write Pino Longo's name symmetrically. In doing ambigrams, I've made countless discoveries of weird ways of writing letters that I would never have made "unaided", so to speak. Ambigrammia forces you to concentrate on two different ways of looking at one thing. But since working on two levels at once is something that comes naturally to me, I feel justified in saying that these discoveries were made "on my own", not with artificial help.

In the early 1970s, I ran across the powerful writings of the San Francisco psychiatrist Allen Wheelis — most notably his slender set of musings entitled *On Not Knowing How to Live* and his touching novel *The Scheme of Things*. Several years later I came to know him well. In his honor I designed counterclockwise rotoflips on both his first name and his last name and then I superposed them, having them perpendicularly cross each other, so that together they constituted just one rotoflip.

I exploited the same "A/N" trick here as in my "BANFF" rotoflip. I believe, however, that this was the moment of its conception, and that by the time I tackled "BANFF", the trick had become part of my "standard technology". Standard technology inevitably develops when you do large numbers of ambigrams, although of course it is seldom sufficient on its own to make a good new ambigram. No matter how many riffs you have concocted before, you find yourself continually confronted with novel challenges whose solutions inspire new discoveries, which you then add to your ever-growing repertoire of riffs. And what at one time was not you at all gradually becomes an intrinsic and permanent part of you.

I think the most sparkling section of *Ambigrammi* is the collection of 74 Italian city names followed by all twenty of Italy's *regioni*. I will give a small sampler of each of those collections. First I'll present twenty city names, and below them I'll make some observations; then I'll give four region names, also followed by a couple of comments.

Chapter 9

FIESOLE FIRENZE

orgosolo ARNA

ASTENZA Ravenna

roma Todi

torino OTRENTO

VENEZIA Verona

Snippets from Ambigrammi

In case you had trouble reading one or more of the city names, here are all their decodings:

Amalfi, Aquileia, Assisi, Bari, Bologna, Brindisi, Cagliari, Como, Fiesole, Firenze, Orgosolo, Parma, Potenza, Ravenna, Roma, Todi, Torino, Trento, Venezia, Verona.

Among them, seven are wall reflections: Amalfi, Aquileia, Como, Parma, Potenza, Roma, and Torino; the rest are 180° rotations. Nary a q-turn!

"ASSISI" cries out for commentary, not so much because of its two flaming dotted capital "I"'s (by now, that's old hat), but because of the way the "ISI" at the end is made to flip into the capital "A" at the start. That's a bold move, yet I feel it works, probably mostly because of those two sloping lines surrounding the "S". They almost force the "A" down your throat.

In "bari" (it starts with small "b"), turning the dot on the "i" into the loop of the lowercase "b" was pretty off-the-wall. And my choice to fill in all four of those teardrops gave it visual charm, offsetting the flaw of mixing upper and lower cases.

At the end of "COMO", I reflected the initial "C" in the hopes that it would be seen as merely part of a frame. That's a ploy that, as I said before, I no longer indulge in, but back then I did it often. I chose to exhibit it here precisely because of this feature, from which today I would reflexively recoil.

I think of "FIRENZE" (the Italian way of writing "Florence") as one of my most elegant creations, even if one of the main reasons behind its appeal is just that bright red retinal razzle-dazzle. But I would never praise it if I didn't think it was also eminently legible. To an Italian-speaking eye (did you know that eyes could speak?), it jumps right off the page.

You've probably never heard of the Sardinian hamlet of Orgosolo, located in the wild, craggy mountains in the remote center of that rugged island. A sad movie called *Banditi a Orgosolo* was filmed there in 1961. The town's name is stressed on its second "o", and the "s" (whose anomalous tallness I ask you to forgive) is voiced.

Who would have thought an "O" could turn into a "Z"? Yet it happens in "POTENZA"! In fact, the five central letters of that name form an indivisible chunk.

"Ravenna" is rife with retinal razzle-dazzle, but I forgive it that sin and hope you will, too, since it reads so easily (at least to that mythical Italian-speaking eye).

I was most proud of how I made "roma" read both backwards and forwards by exploiting the "r" and the little "o" that are handed to you on a silver platter if you are lucky enough to think of splitting the mirror-reversed "a" into two pieces.

I didn't need any of the four dots in "TODI" (a beautiful medieval hilltown in picturesque central Umbria), but I threw them in anyway because I felt they made an attractive diagonal motif.

"Torino" commits the same sin as does "COMO", this time with the stem of the reflected "T" being the frame-element that is intended to be ignored. I have to forgive my younger self for such sins, and just appreciate his creations.

In "TRENTO", the loop opening the crossbar of the "T" (borrowed, of course, from the cursive form of the letter) becomes the "O" at the other end of the name. As part of the initial "T", however, it's just supposed to be a swirl that is ignored, or that is considered a pretty embellishment. Such boldness makes me smile.

In "VENEZIA" (the Italian name of Venice), the roundish form of the "V" and the "A" is borrowed from Venetian architecture, and the cloverleaf is another Venetian architectural motif, so together those forms imbue this ambigram with vivid echoes of the visual flavor of *La Serenissima* (the "most serene" of cities).

I feel the need to add a bit of personal background about these Italian city ambigrams. Italy meant so enormously much to Carol and me that in 1993–1994 we returned there with our children Danny (then 5) and Monica (then 2), to spend my sabbatical year. Our "little four family" moved into a lovely house in a tiny village in the hills by the mountain-ringed university town of Trento, and one balmy November day Carol and I took a train down to the mythic town of Verona to explore it and to see a Kandinsky exhibit. We had a wonderful time that day. Three weeks later, Carol had a series of worsening headaches, so I rushed her to the Trento hospital, where the gentle Dr. Tranquillini, after doing an MRI scan, said to me, *Purtroppo, c'è una formazione* ("Unfortunately, there is a growth") — the grimmest sentence I had ever heard — and in a flash Carol and I were in an ambulance en route to Verona once again, but this time to the big hospital called "Borgo Trento". There, thirty hours later, she fell into a coma, and ten days after that, she was gone. Just like that, my beloved wife and our children's adoring mother had been swallowed up by eternity. It happened virtually overnight, overwhelming our family in a tidal wave of incomprehensible grief. It was a tragedy I will never get over. You can thus imagine the mixed feelings I harbor for these names — an incommunicable blend of tender love and indelible sorrow. But back in 1986 and 1987, when I was devising these ambigrams, all that lay hidden in the foggy crystal ball of the future. I was blissfully unaware of the bittersweet connotations that my little artistic creations would take on for me some years later.

Quattro Regioni Italiane

Unlike the cities and towns of Italy, the list of which is as vague and ill-defined as the list of facts that you know or things that you've ever done, the list of *regioni* in which they are located is sharp, and has a precise count. There are exactly twenty of them, and for *Ambigrammi* I set myself the challenge of doing each one of them. Of those twenty, I selected just four to show here.

As I did with the cities above, I will now give you the decodings: Lazio, Liguria, Sicilia, and Toscana. I realize that English-speaking readers who have no strong tie to Italy are unlikely to know the names of its regions, but to Italians they are as familiar as the names of the states are to Americans, so I hoped that to the readers of *Ambigrammi* they would all jump out easily.

"LAZIO" (where Rome is located, and the root of the word "Latin") stands out for its precise, hard-edged geometry — a seldom-seen facet of my style. I admit that I resorted to using an old-fashioned school ruler to help me draw those straight lines. Every letter in "LAZIO" strains at the edges of its intended category, and yet when all five are put together, the top-down pressure of the Italian geographical lexicon makes it a piece of cake to read (for Italians, anyway).

"LIGURIA" (home of the classic port city of Genova) has a few bells and whistles, which, I hope, are seen as charming rather than as caked-on makeup.

In "SICILIA", the sole wall reflection in this quartet, I chose to bring out the easy-to-overlook periodic rhythm of the three internal "I"'s, not just by making them all identical in shape, but also by using a different color for them. You might see the droll hats on their heads as cherries on three identical sundaes. The "A" (or "a") at the end is very odd. I actually don't know whether I intended it to be a capital "A" or a lowercase "a". Most likely there's no answer to that question. Its identity as a letterform is up to The People, not me.

I'm very fond of my "Toscana" (the Italian name for Tuscany, that mecca for tourists where Florence, Siena, San Gimignano, Arezzo, Lucca, Pisa, Pistoia, Prato — and Poggibonsi, of course! — are all located), because of that swashbuckling *svolazzo* ("swirl, flourish, squiggle") constituting the crossbar atop the opening "T", and echoed upside-down at the other end by the *svolazzo* that underlines "cana". That crazy sinuous swirl is one of the most daring things I have ever done in all my meanderings through Ambigrammia. It came out of sheer desperation on my part, and I took the risk, and today I still feel that it paid off.

Imbuing an Ambigram with Its Own Style

The preceding set of twenty-four ambigrams on the names of Italian cities and regions reveals a tendency that I was just starting to adopt at that time — a manner of bringing about a strong feeling of visual uniformity inside a given ambigram, otherwise known as *style*.

Take "SICILIA", for instance. Once I'd chosen to give the initial "S" and final "A" a triangular shape, I echoed that flavor in the three "I"'s, which also brought out their periodicity. Moreover, I surrounded the middle "I" by a circle defined by its flanking letters. Thanks to careful gestures like that, the piece acquired a tight artistic unity of a sort that my ambigrams from a year or two earlier hadn't had.

This kind of deliberate internal echoing of a visual theme is perhaps clearest in "bari", where the whole ambigram feels very tightly unified by the fingerprint-like motif. But similar games, if not quite as blatant, are played by the six small circles in "Brindisi", by the four bricks in "Cagliari", by the four tildes in "FIESOLE", by the uniform thickenings at the top of "PARMA", by the parallel diagonal lines in "POTENZA", by all the swirls in "RAVENNA", and so on.

Over time, this tactic of intra-ambigram motif-echoing became ever more important in my approach to ambigrammia — a fact that will be increasingly apparent in the meadows that we will romp through from here on out.

Ambigrammia Goes into Hibernation

Therewith finishes my condensation of my 1987 book *Ambigrammi*. I've left out all of its text, of course, but I've replaced it with the text you're reading.

For the next few years after the book was out, I did precious few ambigrams — I had plenty of projects I was working on with my graduate students in cognitive science, and I was also being a devoted dad to our two lovable kids, which was deeply gratifying to me. But then, out of the blue, came the traumatic upheaval of Carol's sudden death in December of 1993, and in the wake of that tectonic shift in our lives, the act of parenting fell on me even more intensely. In a sense, I took on the dual role of Carol-and-Doug, becoming a kind of ambiparent.

After our severely wounded family returned from Trento in the summer of 1994, Italian became the language that the three of us spoke at home — the kids' mother tongue, so to speak. I use that poignant expression deliberately. Carol, who was of half-Italian heritage, had an imperishable love for Italy, its art, its cuisine, and especially its language. It had been her dream that our children would grow up speaking it along with English, so I made sure that her dream was realized. But as they were growing up and becoming fluent in Italian, Ambigrammia was receding into the fog, and it faded almost totally away for seven or eight years.

I have only a handful of ambigrams that I made during that fallow period, among which is this whimsical rotoflip that I drew for an old friend from my days at Écolint (Geneva's International School), who I hadn't seen in about 35 years:

I hope you can make it out, but if you can't, I'll just say that I found "Lucie" to be a surprisingly elusive challenge. I tried it again recently and found a couple of somewhat more legible solutions, but they weren't so spunky and high-spirited as this light-hearted one.

Chapter 9

CHAPTER 10

Cousins of Ambigrams

Palindromes and Rotoportraits

Often, when I show someone a symmetrical ambigram, their first reaction is, "Oh, is this a sort of palindrome?" (meaning a phrase like "Madam, I'm Adam" or "A man, a plan, a canal: Panama" — phrases that read the same forwards and backwards, if you disregard spaces and punctuation marks). My answer is, "Well, there's a similarity, in that my calligraphic design reads the same in two ways, but a palindrome does so because of how it's *spelled*, whereas this does so because of how it's *drawn*. Palindromes and ambigrams are horses of quite different colors."

There are many other types of visual item that in some way are reminiscent of ambigrammia. I'll never forget the first time I gave a lecture on ambigrams in Italy — in Torino, in May of 1986. After my talk, a young student named Maurizio Codogno came up to me and said he had an image from just after World War II that he suspected would interest me. The next day he brought it to me:

LA MASCHERA ...

You may not recognize this face, but Italians do: it is that of Giuseppe Garibaldi, considered by Italians as the heroic unifier of their nation, in the 1850s and 1860s. In Italy, no one is more esteemed than Garibaldi. Now to the point of this example.

In 1948, when Italy was still very poor, the national election pitted the Fronte Democratico Popolare, a left-wing coalition allied with the Soviet Union, against the Christian Democrats, allied with the United States and NATO. The FDP claimed to embody the spirit of Garibaldi, but their opponents came out with a card sporting this image of Garibaldi. The caption below Garibaldi's face — "LA MASCHERA…" — means "THE MASK…". The reason for that word was that if you rotated the card 180 degrees, a very different face would unexpectedly appear:

...E IL VOLTO

Here we see Joseph Stalin, dictator of the Soviet Union for three decades and a notorious symbol of violence, repression, murder, and famine. The caption underneath this scary image was "…E IL VOLTO", meaning "…AND THE FACE". The card was thus claiming that the FDP, although wrapping itself in a heroic Garibaldian mask, was in reality the devil incarnate. (By the way, "IL VOLTO" is also a pun, since "volto" means "rotated" as well as "face".)

I have seen many rotoportraits (*volti volti* in Italian), but this is by far the best of them, as both faces are famous historical figures, and neither gives any hint that its rotation is another recognizable face. It's a shame that the artist is unknown. In any case, a rotoportrait is an interesting cousin of an ambigram.

Drawings and Pieces of Text Made out of Text

In the previous chapter, I exhibited the word "FEW" typeset using seventeen small copies of the word "NUMEROUS", and stated that I don't consider it to be an ambigram. One reason is that the higher-level reading, consisting of just three letters, is made out of 136 letters, which seems like a trivial game to play. If you

have a bunch of pebbles, you can always arrange them in the form of letters that spell out a word. It's almost as if the pebbles were acting as pixels.

One could imagine a portrait of a famous person made out of celebrated words that they wrote or uttered. It is of course critical that the quotation should be long enough that the letters are small compared to the facial features, so that they can function somewhat as pixels, but also that the quotation not be too long, for otherwise no one could read it. In the limiting case — say, using the entire text of *Anna Karenina* to form a picture of its author, Leo Tolstoy — no one would even see that there are any letters there at all; they would be infinitesimal. The lower level would be invisible, making the whole exercise absurd.

The ideal middle ground would use a relatively short quotation, so that the perceptual jump between levels should be easy. An example might be a portrait of Abraham Lincoln made out of the words of his Gettysburg Address. As soon as I had that idea, I guessed it had probably been done, and indeed a quick Web search revealed a few, including this one, elegantly drawn in 1926 by O. O. Bowers:

Although it is less common to play this kind of two-level game with words at *both* levels, it is certainly within the realm of possibility. For instance, someone might take the first page of a classic old Russian novel and typeset it in such a way as to spell out the novel's title. That would take some work, but it could be done. Or perhaps just the novel's first *sentence* could spell out its title. Is that possible?

Cousins of Ambigrams

Well, I guess this recent design of mine shows that it is possible. (Incidentally, it reminds me of a droll self-referential sentence that I made up eons ago: "I am going two-level with you.") The design is indeed readable on two levels, but does that make it an ambigram? I would say no. Although "ANNA KARENINA" jumps right out, you have to make a concerted effort to read the famous first sentence, and such efforts are not what ambigrammia is about. The same holds for the blue part, where "LEO" jumps out but "TOLSTOY" takes work to see.

This red-and-blue design is humorous and thought-provoking, but I feel it falls outside Ambigrammia. On the other hand, its bottom line comes quite close to the "national border", being similar in spirit to my oscillation ambigram on "Francisco Claro" in the preceding chapter.

Strange Fusions

The ornithologist John James Audubon employed an amusing trick to write long letters without increasing the cost of their postage. After filling up a sheet with his handwriting, he would simply turn it 90 degrees and proceed as if it were blank, filling it up for a second time perpendicular to the first. Apparently his recipients could read these epistles perfectly well because the interference between the two perpendicular messages wasn't too strong. After I learned of Audubon's trick, many years ago, I occasionally borrowed it myself in order to squeeze an extra-long message onto a postcard, although to enhance readability I always used another color to write the rotated section.

Both in Audubon's dense missives and in my dense postcards, two distinct messages occupy the same physical territory in a coarse-grained sense, but their overlap, when inspected on a more fine-grained scale, is actually very sparse. Although such amusing examples of writing undeniably possess double readings, the gulf between them and ambigrams is vast.

Advertisers and logo designers, too, occasionally use superposition of words, as for instance in this old airline-magazine title:

In a very loose sense, this image could be seen as an oscillation ambigram with two readings: "SKY" and "magazine". But to call it an ambigram would be absurd.

Here is a way in which the city of Buffalo, New York once advertised itself as being good for two different purposes at the same time:

PWLOARYK

If you can't make sense of this, try separating it into two typefaces: a sans-serif face (whose letters are all solemnly vertical) and a serifed bookface (whose letters are all jocosely tilted). Is this an ambigram? Certainly not by my lights, but someone else might see it as one. But even for such a person, it would have to be an outlier in the category.

An even more extreme example of a pseudo-ambigram is this familiar sight (or its mirror image, as seen in one's rear-view mirror):

AMBULANCE
AMBULANCE

Here, one can't help but read the easier of the two readings while basically ignoring the more difficult one. Someone (or more precisely, myself, in this case) could even claim that the ignored reading is just a "decoration" of the main one. Obviously this would be a hard claim to defend in court, but it gets across a point of view.

All of these "strange fusion" examples exploit the idea that there is no sharp distinction between *two separate shapes* and *a single shape*. More generally, whenever one is dealing with a complex structure composed of parts, it is always a judgment call as to whether this is *one* thing, *several* things, or *many* things. It's not natural to us to perceive a fellow human being as an organized collection of dozens of organs,

Cousins of Ambigrams

let alone as a collection of trillions of cells, not to mention as a collection of trillions of trillions of elementary particles, but any of those viewpoints is just as valid as the "natural" one. In the "AMBULANCE" case, is that *one* shape, *two*, *eighteen*, or more?

How Many Different Readings Lurk in a Given Shape?

Consider the phrase "quince pies". It hardly looks like an ambigram, but it so happens that "quince pies", when read in Spanish, means "fifteen feet". Thus there are, in a weird and unanticipated sense, two different "readings" lurking in this structure made of ten pieces (or, if you prefer, in this single shape).

This naturally raises the question as to whether the Spanish and English meanings, semantically different though they are, really constitute different *readings*. After all, no matter what the language of the reader is, "quince pies" consists of the same set of letters in the same order. At that level there is no ambiguity at all, which is why one instinctively feels that "quince pies" is not a genuine ambigram. In this case, the disqualification comes from the fact that the ambiguity is not *perceptual* but *conceptual*; it requires some kind of abstract thinking. But where lies the boundary between percepts and concepts? What would Rudi Arnheim say?

Here is a quite amusing turn-of-the-twentieth-century Russian cigarette ad:

You might wonder to which of the mustachioed gents the humorous label "HOBO!" applies, as they both look quite dapper and dashing, hardly hobo-like. But in fact, the label is not the English word "HOBO" but the *Russian* word "НОВО", written in Cyrillic. It is transliterated as "novo" and sounds roughly like "nuova" in Italian, whose meaning it shares — namely, "new". And "НОВО!" applies to neither of the two gentlemen, but to the then-new brand of cigarettes called "Duchess".

According to typeface expert Peter Zelchenko, this droll ad was the origin of the jaunty typeface called "Hobo", created in 1910 and displayed below:

ABCDEFGHIJKLMNOPQRSTUVWXYZ
abcdefghijklmnopqrstuvwxyz

Check out the "O" in the Russian word "Чудно" (meaning "Marvelous!") in the poster's upper righthand corner. It is virtually identical to the "O" of this typeface, and I find that to be convincing evidence for Mr. Zelchenko's claim that it was this very poster that inspired American designer Morris Fuller Benton to invent the whole typeface, which he then whimsically called "Hobo".

So the visual pattern "HOBO" can jump back and forth between being seen as a word in roman letters and a word in Cyrillic letters. Does that not make it a perfectly valid biscriptual oscillation ambigram? I'm inclined to say yes. On the other hand, there's a Ukrainian town whose name in Cyrillic letters and in roman letters is identical — namely, "TOKMAK". Despite this curious fact, I would not wish to call that name a biscriptual oscillation ambigram, since it seems so banal. One feels no magic in jumping back and forth between the two scripts. Similarly, there is no magic in jumping between "Paris" as the French name of the French capital and as the English name for the same city, even if they are pronounced quite differently. The game seems as bland as a soft drink that's lost all its fizz. And so I am not inclined to grant either "TOKMAK" or "Paris" membership in the category *ambigram*.

Odd as it may seem, biscriptual oscillograms can crop up even in a totally monoscriptual context. Take the word "COWS". You might wonder, "How in the world could that be an oscillogram?" But consider: is it written in capital letters or in smalls? Unlike the vast majority of words, it can be perceived either way. One can flip back and forth between the two "scripts" — uppercase and lowercase roman — just as in a "real" biscriptual oscillogram. So does this little 'gram have two readings, or just one? Note that this ambiguity, unlike that of "quince pies", lies at the *visual* level, not at the level of concepts or meanings. (Speaking of quince pies, the English word "pies" not only means "feet" in Spanish, but also "magpies" in French, and "dog" in Polish — a super-quasi-ambigram!)

To conclude this somewhat digressive chapter on a humorous note, here is a clockwise q-turn that, believe it or not, reads as easily in either orientation as if it were printed in Baskerville! (I won't decipher it for you — a thousand pardons! — but my old friend Robert Boeninger, who finally deciphered it after a long struggle, might be willing to help you out, should you find yourself spinning your wheels and getting nowhere fast. He's a gentle soul and loves to help people in distress.)

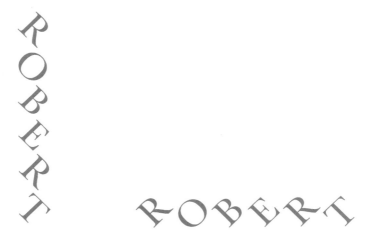

Chapter 10

CHAPTER 11

Ambigrams in New Venues

Teaching Ambigrammia Is Tough!

In 1984, I accepted an exceptional job offer from the University of Michigan and, with very mixed feelings, left my beloved town of Bloomington for Ann Arbor. In gratitude, I dedicated my 1985 book *Metamagical Themas* to Bloomington, "for all the times we shared", having no idea that I would wind up returning to Indiana University four years later. Among the many pieces of art in the book were fifteen ambigrams I'd designed in the previous few years. Two years later, *Ambigrammi* came out, so then I had two books that showcased my ambigrams, one published on each side of the Atlantic. Ambigrammia was becoming an ever more visible side of my public identity.

In my fancy new position at Michigan ("Walgreen Professor for the Study of Human Understanding"), I was encouraged to give seminars on any subject that fell within the purview of the School of Literature, Science, and the Arts, so I dreamed up an interdisciplinary course that I called "Analogy, Essence, and Elegance", which explored creativity through a variety of challenges. For instance, after having introduced the students to some of my own ambigrams and Scott Kim's, I challenged them to design their own, and, if possible, on the names of the solar system's nine planets. (In that bygone era, the International Astronomical Union hadn't yet demoted Pluto from its splendid status of *planet* to the humbler status of *dwarf planet*.)

I had several talented students who eagerly tackled the assignment, but ambigrammia was not always their forte. Some of the solutions they submitted were, shall we say, highly creative — or perhaps I mean "highly *cheative*". Take this one by Michael McCormick, for example:

On the left side, you can probably make out the name of the planet closest to the sun, with some lines rendered rather boldly and others rather delicately. After undergoing a 180° rotation, Mercury becomes… well, sort of… *hot*. What, though, are all those dainty squiggles connecting "h" to "o", and "o" to "t"? Well, they're just squiggles, that's all — or maybe they say something in Mercurese. I wouldn't know, having never studied the language.

Another highly cheative solar-system submission by Michael McCormick, far out in more senses than one, was this:

"Pluto" (but with a lowercase "p") is quite legible, but the ornamental squiggle to the left of the "p" reminds me of the extravagant swirl to the left of the "P" in my first attempt at "Palo Alto" (see the top of page 76); however, this squiggle is considerably more outrageous than mine. As you know, a ubiquitous tactic in ambigrammia is to use, here and there, extra lines and curves, odd superfluous dots, and so on — elements that are crucial to one reading but that the artist hopes will be seen as mere decorations in the other reading. That's fine — but this squiggle, like the squiggles inside "hot" (above), constitutes a *reductio ad absurdum* of that idea. To be more explicit, dear reader, I ask you: Is the following an ambigram?

It clearly says "Pluto" in two orientations, doesn't it? All I did was to toss in a smidgen of "innocent embellishment" on the left side. But seriously, I hope you agree that this object is an ambigram only in a very stretched sense of the word, and I would say more or less the same about McCormick's rendition of "Pluto".

Whenever I teach, I always tell my students, "If you don't understand idea X, it's not *your* fault; it's *my* fault." And I fully believe in this mantra about teaching. (Of course if you haven't made at least a decent *attempt* to understand idea X, that's another matter. You have to meet me halfway!) From the two quasi-ambigrams above, I can only conclude that I fell short in my role of ambigrammia teacher. I somehow didn't manage to get across the key idea that you can't just throw an arbitrary amount of superfluous stuff into an ambigram. *Some* superfluity is almost always needed, to be sure, but *this* much? No way!

I also must have failed in conveying the importance of legibility, and of using retinal razzle-dazzle only in the service of beauty and clarity, rather than as an end in itself. Those shortcomings of mine are evident in the following ambigram from my student Tiff Crutchfield (and his 'gram has nothing to do with the solar system):

Both sides of this 180° rotation snag the eye with heaps of retinal pizzazz, but for me, re-encountering them after so many years, they were nearly impossible to read. It took me several minutes of trial-and-error *reasoning* (as opposed to quick and effortless perception) to figure out what they were intended to say. I don't know if you can decipher them, dear reader, but a hint is that both are names of old-time computer languages.

Omni Competitions

Scot Morris's September 1979 "Games" column in *Omni* magazine revealed ambigrams — first known as "designatures", later as "inversions" — to the world. In that same column, Scot announced a "designatures competition", and within short order the magazine's offices were flooded with entries from fascinated readers. The winning entry was submitted by Charles Krausie (it netted him 100 dollars):

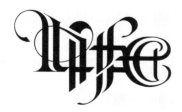
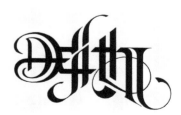

I found it visually stunning — it looked professionally designed — but it was far from clearly readable. Once I knew what it was supposed to say, I could easily get both readings, but they were smothered in what I considered to be elegant but irrelevant eye-catching frippery. The more I looked at it, the more alien it felt to my personal conception of ambigrammia. Rather than focusing on the two simple words' clarity, it was indulging in ornamentations galore, like a bravura baroque harpsichordist. To me, an ambigram should ideally be direct and understated, not a flashy display of virtuosity.

A few years later, in 1988, *Omni* held a second ambigrams contest (by then the word "ambigram" was very much in the air, so *ambigrams* are what Scot asked his readers to send in). I was delighted that he invited Scott Kim, David Moser, and me to be co-judges of the competition.

A few of the submissions were very attractive, original, and readable, but most held little charm for me. Perhaps I was being curmudgeonly, but I felt that many of them were stuffed to the gills with shallow style. To me their potential beauty was ruined by all the makeup slathered on to disguise their essence. About one entry I frustratedly wrote: "It looks for all the world like a *great* ambigram, yet it's *illegible*! It's like an argument by intimidation — the retina is so wowed that the intellect can't judge it."

To make my viewpoint more concrete, let me offer as stark a contrast as I can imagine. In 1987, there was a math-and-art event at which Scott Kim was signing copies of his book *Inversions*. For anyone who asked, he improvised an ambigram on their name on the first page of the book, in ink. *In ink!* I found that mind-boggling, and with high admiration I reproduce below a couple of the ambigrams that Scott spontaneously drew that day:

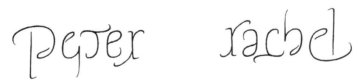

Here, "Peter" turns into "Rachel" as gracefully as anyone could desire. There are no fancy visual fireworks; it's just clean, simple lines drawn by hand. (The curmudgeon in me nonetheless wishes that the "r" in "rachel" were an "R".)

And here is another example from Scott's pen on that same day. Once again, it's graceful and minimal, and it was drawn in real time!

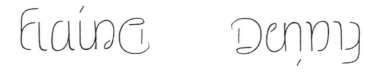

Scott turns "Elaine" into "Denny" smoothly, effortlessly, and charmingly (and both names start with uppercase letters, so no snide snapping from me this time!). It's instantly readable. What more could one ask of an ambigram?

I realize that *de gustibus non est disputandum*, and that some people may find Charles Krausie's "Life/Death" ambigram just as enticing as these two by Scott Kim. I won't devote any further keystrokes to trying to persuade them of my view.

One Last Word on Shallow Style

There are thousands of ambigrams on the Web, and I'm sure a good number of them are terrific, but as I said in Chapter 3, I don't seek them out. However, I do own several published compilations of ambigrams, and one of them — Nikita Prokhorov's *Ambigrams Revealed* — is like a sampler from the Web. Many of its ambigrams are just oozing shallow style. Here's an example:

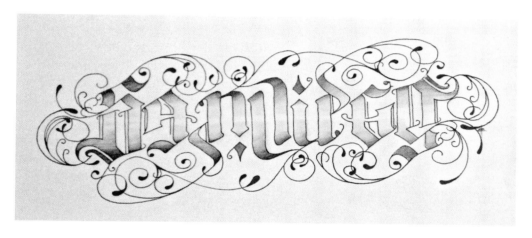

This 180° rotation was done by an artist named Elwin Gill, whose talents are evident. Look at all those graceful swashes and flourishes! Look at all those fancy letters! Yes… but can you read it? On page 84, I showed an ambigram of my own on the same town-name; however, it had little if any shallow style. The two approaches are night and day. But as Mao said, "Let a hundred flowers bloom!"

Art Exhibits Alter My Sense of Who I Am

The lightweight (fifty 'grams) exhibit that Adelina organized in Geneva in 1984 was the first time there was an exhibit of any of my art, so it was a very special occasion to me. Tiny though it was, it had a significant psychological effect on me. It opened up a fresh new facet of my public identity, and thereby also altered my own self-image.

Seven years later, Timothy Buell, a composer and professor of media studies at the University of Calgary, offered me the chance to give a lecture on my "Whirly Art" and also to have an exhibit of it in the university's modern-art museum, the Nickle Galleries — and I gladly took him up on it. This was another watershed moment, reinforcing my sense of being a card-carrying artist. Sometimes one needs external validation in order to form a clear image of who or what one is.

Then in 1998, my research center's dedicated administrative assistant, the late Helga Keller, did something stunning for me, for which I am eternally grateful. She suggested to her friend Betsy Stirratt, director of Indiana University's SoFA Gallery (short for "School of Fine Arts"), that it might be interesting to have an exhibit showcasing several different kinds of art done over the decades by Douglas Hofstadter. Betsy had no idea that I had ever done any art, let alone thousands of small pieces, but once she saw some samples, she was eager to have such a show on the walls of her gallery.

For me, this was a once-in-a-lifetime chance, so I took it up with alacrity. *Carpe diem!* I selected 21 pieces of Whirly Art, around 80 ambigrams, 50 gridfonts or so, 30-some "jazz scribbles", a couple of dozen pieces of "alphabetics", and a few other miscellaneous pieces, including some from my teen-age years. I paid a hefty sum to have all of these works framed, which took months of intense and fun collaboration with my framer-friends Ron and Judy Mansell, who did superlative work for me at their shop, The Framing Guild. Betsy and I chose the name "For the Love of Line and Pattern" for my exhibit, and I wrote and typeset a glossy 35-page catalogue. I had never imagined anything of the sort. It made my head spin.

When the exhibit went up in October of 1998, it consisted of about 220 pieces filling up a huge room, and it stayed up for seven weeks. For me, it was incredible to see all those fruits of my lifelong visual imagination adorning the walls of a major art gallery on the Indiana University campus, only a few blocks from my house. Seldom if ever have I had such a giddy feeling of pride.

The next year, there were follow-up but somewhat smaller exhibits of my art at Ohio State University's Hopkins Hall Gallery and at Cooper Union University's Great Hall Gallery in New York City. These, too, marked high points in my life.

Two Mini-exhibits

In September of 2001, to deepen the already-deep connection to Italy of Carol's and my children, I took them back for another sabbatical year, this time in Bologna. We moved into our apartment the nightmarish day of 9/11, and for a long while I was unable to feel anything but tragedy and fear. But after a couple of months, the long-dormant flame of ambigrammia reawakened in me, and soon I was coming up with ambigrams like there was no tomorrow. By the time my

sabbatical year was over, I had created hundreds of new ones, given many lectures on *ambigrammi*, and added new elements to my personal ambigrammatical style.

During that year, I met a talented artist named Aldo Spinelli, who was just as fascinated by letterforms and words as I was. When I showed him my recent crop of ambigrams, he kindly offered to organize two ambigram shows for me in the summer of 2002. The first one took place in a minuscule gallery in Milano called "Spazio Avirex", and the other in an even smaller one by the seaside in Genova — smaller than my house's dining room! But I didn't mind its minuteness at all — I considered it an honor to have a one-person art show of any size.

Ambigrams Bring Cash, Dude!

I will never forget an amusing thing that happened when Aldo and I visited the Genova exhibit together. After we'd been there for an hour or so, the gallery's owner sidled up to me and very discreetly pointed out an elderly couple who were browsing about. She quietly said that they had inquired about purchasing one of my ambigrams, and asked me how much I would want to charge for it.

Aldo had never mentioned to me that my pieces might be for sale, so I was caught off guard. After hemming and hawing a bit, I suggested, "How about 50 euros?" The owner, visibly shocked, replied curtly, "That's *far* too low a price. Who would want to pay so little for a work of art they admired?"

I in turn was shocked, but after mulling it over, I said, "Okay, then — how about 500 euros?" (which struck me as preposterous). She said, "Well, that might be acceptable" (*i.e.*, sufficiently expensive), and after consulting with the couple, she came back and said that my price was just fine with them. It was a deal! After they'd left with their precious new acquisition, I received 250 euros in cash and the gallery owner kept 250 euros for herself. Aha! Now I saw why she'd wanted the price to be high — but why would the *buyers* have wanted that as well?

Soon I figured it out. I had been very silly. Never had it occurred to me that art collectors want to think of a piece of art that they're purchasing as being *worth* something — hopefully quite a lot — and so, unlike what one might naïvely expect, the last thing they want is for a piece of art they admire to be offered to them dirt-cheap. Heavens no! They want to pay through the nose for the opportunity of paying through the nose. It's circular, but it makes a strange sort of sense.

That day in Genova marked the beginning, and the end, of my career as a professional artist. Never again did I sell a piece of my art, nor did I ever wish to.

CHAPTER 12

Ambigram Renaissance

Turn-of-the-Millennium Ambigrams

During my Bologna sabbatical (2001–2002), I gave far more lectures than I've ever given in any other year — around sixty. Seven of them, bearing the too-fancy title of *"lezioni magistrali"* ("master classes") were arranged by the famous writer Umberto Eco in the fall. These talks were all highly publicized and were given in a huge auditorium that, to my amazement, was filled to the brim every time. Each evening, Eco would introduce me, sit on the stage near me as I spoke, ask some questions at the end, and then open things up to the public. For my so-called *lezione magistrale* on ambigrams, I designed a rotation in his honor.

Just take a gander at all that shallow style, at all those curliworks! Why did I put them in? Well, for just one reason — to hide the fact that the orange upside-down "U" at the very end — the rotated counterpart of the initial green "U" — was utterly superfluous in terms of lettering. It was just a decoration. All that fancy swirliwork, green and orange, was there solely to distract your eye from my sin. I plead guilty of committing the sin of retinal razzle-dazzle!

For my *lezione magistrale* on translation of poetry (content-wise, my seven talks were all over the map), I used this 180° rotation:

It says *Traduttore, traditore* — or in English, "Translator, traitor." The purpose of my lecture that evening in Bologna was to show that this undeservedly famous Italian slogan was, well… sheer bologna.

Although the slogan is absurd, it is so damn catchy that many thoughtful people would swear that it expresses an eternal verity about translation. Plenty of intellectual folks, including the most elite of Ivy League literary critics, fall for the slickness of this cute sound bite. The fact is, however, that we all, and they all, rely all the time on such "betrayal" in our communication.

For instance, highbrow speakers of English happily cite Archimedes ("Give me a place to stand and I will move the earth"), Julius Caesar ("I came, I saw, I conquered"), Dante Alighieri ("Abandon all hope ye who enter here"), René Descartes ("I think, therefore I am"), Leo Tolstoy ("Happy families are all alike"), Robert Schumann ("Hats off, gentlemen — a genius!"), Louis Pasteur ("Fortune favors the prepared mind"), Mao Zedong ("A revolution is not a dinner party"), and so on, all *in English*, without batting an eyelash. They have no qualms about betraying these historical figures by sticking English words in their mouths. And the truth is, if the translations are of high quality, they *aren't* betraying anyone.

In the end, the sound-bitey slogan in its English garb constitutes its own best disproof, since "Translator, traitor" is every bit as pithy and catchy as is *Traduttore, traditore* (plus, needless to say, the two have exactly the same literal meaning). In short, there need not occur a shred of betrayal when a passage, including the slick translator-damning slogan itself, is carried into another tongue. QED.

Dot Dot Dot…

My ambigrammatical *rinascimento* took place over that Italian year, and when I look back at the 'grams I devised in that period, I sense in them a clear feeling of exuberant exploration. A frequent characteristic of that set of ambigrams is a liberal sprinkling of randomly colored dots, like colored sprinkles on an ice cream sundae. Here is one of my earliest and liveliest uses of that device:

Ambigram Renaissance

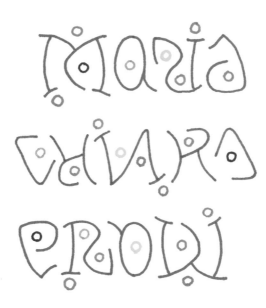

This is the name of a young woman I encountered at a couple of lively parties held in the refined home of Giulio Cesare Barozzi, a mathematics professor at the University of Bologna. Like our host, Maria Chiara was a keen lover of classical music, and she was also a niece of the then-president of the European Union, Romano Prodi. I was happy to find myself in the company of such bright people who were so culturally rich and who were exerting an enlightening influence on the European scene.

This joyful ambigram set the tone for many others that soon followed. Note the wild inconsistency of the four "A"'s in it — but that seeming flaw probably enhanced the ambigram's charm.

Shortly thereafter, I made an ambigram on the name of one of Danny and Monica's former teachers at the *scuola materna* (nursery school) in the hillside village of Cognola, just outside of Trento, during our sad sabbatical seven years earlier.

All three of their teachers that fateful year — *maestra* Lucia, *maestra* Silvia, and *maestra* Mariangela — were deeply devoted to the kids, and we loved them all in return and remained friends for many years thereafter. For me, they became everlasting paragons of human goodness. In this ambigram, once again, the three "A"'s differ strikingly, but that just makes it more bubbly and fun.

At one point during our year in Bologna, I was invited by Ivano Dionigi, then chair of the Faculty of Latin Literature at the University of Bologna, to participate in a large public event he was organizing, devoted to the Roman poet Lucretius and his great work *De Rerum Natura*. I felt honored to be asked, so I accepted and gave a talk. Through this cultural event, I got to know several other young professors of Latin and Greek, including the friendly fellow to whom this next ambigram is dedicated:

To decode this jaunty design, you may need a hint. So here's my hint: I suspect the difficulty is probably due mostly to the two overlapping "L"'s in the first name. Does that resolve things for you? If not, here's the recipient's name: "CAMILLO NERI". As you can see, I was enthusiastically playing the game of using informal and silly letterforms. I also had no qualms about being less than perfectly symmetric: the dot inside the "O" is not centered, nor are the "a" and the "R" each other's accurate rotations. Moreover, I wasn't troubled by using inconsistent cases. That was my mood that day.

As I did more in this vein, I became more confident in my unchecked style, as is shown by the following 'gram, which I admit may pose some problems in reading:

Since this name appeared earlier on this page, I'll hold off on retyping it here. Instead, I'll just point out that all three "I"'s in the last name (but not the "I" in the first name) are adorned with red dots. Particularly audacious is the dot on the first of them, tethered as it is to the letter below it. It reminds me of the game of *bilboquet*, where you toss a ball on a string into the air and try to snag it in a wooden cup at the string's other end. In this case, the "string", "ball", and "cup" are all clearly visible, and it even looks as if the ball is about to land in the cup. And look at that crazy "G" near the end of the last name…

Have you managed to read it yet? I hope so. It says "IVANO DIONIGI", and a few years later its recipient was elected Rector of the University of Bologna.

For about fifteen years before our sabbatical in Bologna, I had been immersed in the translation of poetry — my "religion" in that activity being to respect all the formal constraints of the original poem. In fact, in the mid-1990s I wrote a long tome, *Le Ton beau de Marot: In Praise of the Music of Language*, on translation in a very broad sense, in which, among other things, I tried to bring readers around to my stance of placing form on an equal level with content, in poetry translation.

One of the book's chapters dealt with the most revered of all Italian writers —

— and during our Bologna year, I felt it made sense to devote several ambigrams to him and to his celebrated *magnum opus*, the tripartite and intricately structured *Divina Commedia*. (By the way, in the above ambigram, I wonder whether you hallucinated an "N" when in fact only its left half was actually there. I hope so! As I have oft repeated, ambigrammia is all about gracefully and invisibly cheating.)

Dante Alighieri's *Commedia* consists of three *cantiche*, or "canticles", each of which is devoted to describing the author's visit to one of three "geographical" areas that, by the tenets of Catholicism, are reserved for human souls that have shed their mortal coils. In Italian, those areas are:

Here the three regions are displayed in their proper "spatial" order, with the most pious souls' exalted celestial zone on the top line, and the most sinful souls'

wretched subterranean zone on the bottom line. In the *Commedia*, however, these "places" are dealt with in the reverse order — ascending from the horrors of hell to the heights of heaven, passing through purgatory. If you wish to see the regions displayed in their Dantean order, it will do no good to turn this ambigram upside-down, as heaven will still be on top even after the reversal. Sorry about that!

By the way, you might find it amusing to pinpoint which of the many dots in the 'gram actually serve as parts of letters, and to identify the roles they play therein. (By my count, there are seven such dots.)

In the *Commedia*'s final canticle, the poet describes his dazzling heavenward flight in the company of his beloved — an idealized woman he fantasized about for his whole life, solely on the basis of having become smitten with her when she was an eight-year-old girl and he was all of nine. If you look at this ambigram —

— you might think of it as a representation of the blessed pair flying exultantly together through space en route to meet their heavenly maker.

As a nonreligious person, I was never profoundly moved by the *Commedia*'s vivid and devout depictions of people and events; in fact, I found them a bit quaint, surprisingly provincial, and even rather corny. But I was extremely impressed by Dante's reverence for pattern. The strict eleven-syllable-per-line *terza rima* verse form (ABA, BCB, CDC, etc.) in which he composed the opus (roughly 15,000 lines of verse, consisting, not by accident, of exactly 100 cantos) is a marvelous artistic constraint, and that's why, for me, the *Commedia* is a remarkable work of literature.

Once I had come to know the *Inferno* reasonably well and was familiar with many English translations that shamelessly threw both meter and rhyme out the window, I gave a few lectures amusingly called "To Hell with Terza Rima".

Reflections a Bit Off the Wall

Sometimes one feels one is handed an opportunity on a silver platter, as I had felt was the case with "Michael/Barbara" some years earlier. In 2002 I was invited

to a conference in Toulouse, France on analogy-making, and I went. While there, I made an ambigram on the name of the psychology professor who had invited me. I soon realized that it would be a piece of cake if I were to opt for wall reflection, so I did that; then, as was my habit at that time, I jazzed it up with colored dots:

Bruno Gaume was delighted with his traffic-light-decorated present.

A few months later I was invited to a forum on science and art in Genoa, and I went. (As I said, I gave sixty talks that crazy year!) One of the speakers was a Chinese author of whom I'd never heard, but who had recently (A.D. MM) won the Nobel Prize in Literature. In his talk, he told us he always listened to Mozart for inspiration while writing, and in my talk, I wondered aloud as to whether his Nobel Prize shouldn't be revoked because of his dependence on an artificial stimulant. He took my joke with good humor.

I also carefully designed a wall-reflection ambigram — actually two — on his name. Here they both are — first in *pinyin* roman transliteration and below it in Chinese characters:

Chapter 12

The upper one is a case where you, as the viewer, presumably aren't *a priori* familiar with the person's name, and most likely are also not sure how Chinese names are transliterated into *pinyin* (especially with tone marks). In that case, you're pretty much deprived of top-down influences, and thus have to rely solely on bottom-up processing, meaning you have to get each letter independently of the others. This makes reading a bit iffy, but I hope you can make it out nonetheless.

As for the lower one, I took a risk in trying to do an ambigram in a writing system in which I was not naïve but far from native. It's foolhardy to venture into such tricky terrain, but the thing is, the first two characters in his name, by chance, had the alluring property of being fairly close to left–right symmetric:

so it was almost irresistible for me to try to make a vertical ambigram where the final character was symmetrical as well. I swept aside all caution and plunged ahead, exactly symmetrizing the first two characters, and in the third one rashly tossing in the backwards "3"-shape on its right side, mirroring the *forwards* "3" on the left side, and making a couple of other adjustments as well, which you can easily see. Such brazen tampering departs wildly from the norm, and to be honest, I didn't (and still don't) know what an average resident of the Chinese Peoria would make of it. Maybe they would take my tweaks as innocuous decorations, or maybe they would guffaw at their clumsiness. How could I know?

In any case, there you have my off-the-wall reflections on the name of the writer Gāo Xíngjiàn, and I should point out the icing on the cake — namely, that the three tone-marks on Mr. Gāo's name as rendered in *pinyin* just happened, by pure luck, to make a symmetrical pattern, so I took advantage of that freebie, even highlighting it by rendering them in bright red.

Snail Mail

At a talk I gave at the University of Siena, I met a biology student who was doing research with snails, and on my return to Bologna I saluted her passion by wrapping her first name, "Viviana", around and around inside the spiral shell of a snail, or in Italian, a *chiocciola* (which, charmingly, is also the word for the "@" sign). I sent it to her expressly via snail mail.

Some Rotatory Names Done During the Sabbatical Year

At one point during our Bologna stay, an enthusiastic reader of my writings named Dorothy Mitchard contacted me, saying that she happened to be visiting northern Italy and was wondering if we could meet. Since her emails were very warm and lively, I said yes, and one afternoon she showed up at our apartment. I was delighted to be able to hand her this surprise present, totally out of the, and totally in, blue:

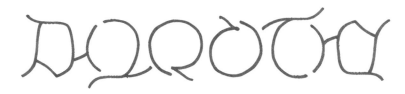

This was quite an audacious 180° rotation, with "DO" swiveling into "THY", and "R" into "O". When I started to sketch it out in pencil, I wasn't sure if I could carry it off, but I think I did pretty well in the end. The visual rhythm is striking, consisting in six approximate circles —those in D, O, R, O, T), and (Y. In this ambigram you will find no dots, no tapered lines, no fancy swirls, and no color-play —just minimalism.

On another occasion, some Italian friends invited us to their house for dinner, and I brought along a curiously stylized ambigram on their son's name:

DANIEL

Of course "DANIEL" was also my son's name, but I had only done "DANNY" for him, so this was a novelty. Note that the "A" and "I" are, deep down, identical to those in the region-name "LAZIO" (see page 104). This means that they share a conceptual skeleton.

Speaking of my own children, I took great pleasure in designing a bunch of ambigrams on their names, among which here are four — a brace for each of them:

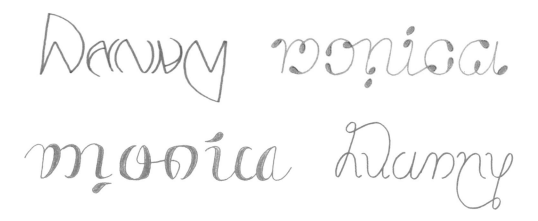

An interesting related exploration was the challenge I set myself of making an ambigram on Danny's name in which I never once lifted my pen from the paper. I eventually found a nice way of doing this, where his name was written vertically:

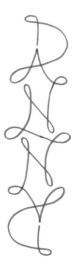

Ambigram Renaissance

I made another exploration of "Daniel" during one of my jaunts to Paris in 2002, when I met the philosopher Daniel Andler and made this design for him:

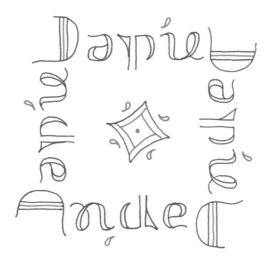

The odd thing about this square is that the "D" of "Daniel", when rotated 90° clockwise, becomes the extravagant "L" at its end, and likewise, the extravagant "r" of "Andler", when rotated 90° clockwise, becomes the "A" at its beginning. So this makes a kind of spinonym in which a single shape, in four successive orientations, takes on the successive identities of "D", "L", "r" and "A".

I realize that the "n" in "Daniel" is hard to read (when it's not in context, it's probably impossible), as are the "d" and "l" in "Andler", which makes the whole thing rather shaky. On the other hand, if your name is "Daniel Andler", you're going to read it instantly. If Daniel himself were the only person who would ever lay eyes on this creation, then no problem. But if he were to put it up on his office door, it would become more public — and if he decided to use it on the cover of his next book, then I would really be in hot water!

L'Ebbrezza della Bellezza

Many years earlier, my friend David Hertz, who is a professor of comparative literature and a talented pianist, had asked me if I would give a keynote talk at a small interdisciplinary conference he was organizing at IU, and he suggested to me the title "How Form Gives Pleasure". He wanted me to cross disciplines like mad, showing examples of elegant form in every arena I could. I greatly appreciated his idea, took him up on it, and in my talk I gave examples aplenty from poetry, music, math, painting, photography, and so on. I used a couple of classic photographs by Henri Cartier-Bresson, Chopin's whispering étude Opus 25 no. 2 in F minor, and

the great Cole Porter song "In the Still of the Night", as sung by Ella Fitzgerald, with its sublime melody, harmony, and lyrics. So much beauty to draw on! Also I used a few favorite ambigrams.

During my sabbatical year in Bologna, I made a friend named Patrizio Fròsini, who hailed from the Tuscan town of Pistoia; he invited me to give a talk for his fellow *pistoiesi*. I decided to reuse the basic themes from my "How Form Gives Pleasure" talk, but I came up with a new Italian title for it — one whose form gave me much pleasure: *L'Ebbrezza della Bellezza*, which could be translated as "Intoxication with Beauty". Of course the rhyme, alliteration, and double letters of the Italian title that I concocted for Patrizio are all lost in this anglicization. In this case, then, *traduttore traditore*, alas! But keep in mind that my title for Patrizio was itself a very liberal translation of David's suggested English title, so if you allow *that* much translational liberty, then perhaps an equally pleasing back-translation could be found in English, if one were to take the time to look under many stones. Perhaps "Inebriated by Beauty Created"?

My talk in Pistoia came late in the summer of 2002, thus toward the end of our Bologna year, which meant that in my quiver I had hundreds of brand-new ambigrams to draw on, and from them I chose a tiny subset as examples of an unusual form of visual beauty that would almost certainly be unfamiliar to my audience, since at the time ambigrammia was a very little-known type of art.

I have only the vaguest memory of which ones I chose, but I'm pretty sure they included my trusty "BACH/FUGA", my very recent single-chunk "BARBARA" (see page 66), and some of my Dante ambigrams (especially "*PARADISO purgatorio INFERNO*"). I probably also used my ambigrams on the names of four very famous Italian daily newspapers — namely, *Corriere della Sera*, *La Repubblica*, *La Stampa*, and *Il Sole 24 Ore*. I had designed one for the *Corriere* many years before, but now I was drawn to tackling larger challenges consisting of *sets* of ambigrams based on canonical groups of items, such as all the Italian regions, so I threw three more newspapers into the bargain. Below, I'll exhibit just the *Corriere* ambigram:

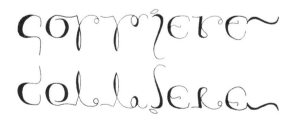

If you think this lake-reflection ambigram doesn't look very much in my style, I would have to agree with you. The reason is that I did it in the mid-1980s, before my ambigrammatical style had really coalesced. That tiny "a" in "della" is pitiful!

A Tightly Constrained Quartet

In my Pistoia talk I also displayed a quartet of names of Switzerland in the canonical order used in that country: German, French, Italian, English.

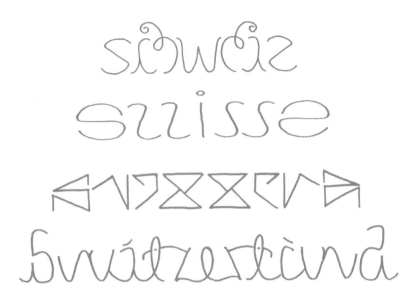

I tied my hands tightly by constraining them all to be lowercase wall reflections — but I managed to carry it off (to the extent that The People agree with me, that is).

How many cheats are there in this quartet? Just kidding! Although there are many, to think that one could separate them cleanly and give a definitive and precise whole-number count makes no sense, even though saying "There are over a dozen cheats here" makes perfect sense. Numerosity is a strangely subtle notion.

Although one cannot precisely *count* the cheats, I will point out a few of my favorites. In "Schweiz", the ball at the top of the stem of the "h" becomes the dot on the "i". In "Suisse", the two backwards "s"'s act as a "u". In "Svizzera", the two "z"'s manage to remain "z"'s even when mirror-reflected. (I'm quite proud of that.) In "Switzerland", the dots inside the loops of the "t" and the "l" somehow help one hallucinate both "tz" on the left side and "rl" on the right side.

Multi-level Locking-in

Another interesting feature of this quartet is that its four members all reinforce one another, in much the same way that the letters inside each individual word reinforce one another. On each of the four lines taken on its own, the initially shaky letters push upwards towards a tentative word, and the word in turn pushes back downwards toward the letters, semi-confirming them and thereby reducing

their shakiness, which fact then strengthens the word a bit more, and that in turn strengthens the letters, and quickly the word (and, perforce, its letters) gets locked in very tightly. It's a self-reinforcing virtuous circle.

But there is a virtuous circle on a *higher* level as well. In the mental lexicon of people who grow up in or near Switzerland, the three-word phrase "Schweiz Suisse Svizzera" is deeply ingrained, so if such a person starts to feel that the top line might say "Schweiz", with the lines below it also beginning with "S", then suddenly that highly familiar trio gets activated as a whole, which means that the person will look at line 2 expecting to find "Suisse" there (etc.), and when that guess seems to be supported by the letters on line 2, the confirmation starts to lock in the full phrase in the viewer's mind.

In short, in this ambigram (is it *one* or is it a set of *four?*), there are confirming reverberations sloshing simultaneously upwards and downwards among three hierarchical levels — letters, words, and the four-word phrase. (There is actually a fourth and even finer level — that of pen-strokes.) The perceptual locking-in takes place ultra-quickly and totally unconsciously. Any act of perception involves a subtle mixture of bottom-up and top-down processing, and ambigrammia is all about exploiting that mixture.

CHAPTER 13

A Surprise for Dr. J

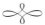

*Over generous servings of mango sherbet, **DRH** is chit-chatting with his friend **HRD**.*

DRH: Oh, by the way, a couple of months ago, I gave my mother's doctor an ambigram on his name. When you look at it in a mirror, it looks just the same.

HRD: That sounds like a delightful gift. So what's the doctor's name?

DRH: "Michael Jacobs". Got a pencil? Thanks! I'll write it down for you.

Michael Jacobs

HRD: You said that his name looks the same in a mirror. How could that be?

DRH: Well, it did eventually, but it took some work. Here it is, backwards:

Michael Jacobs

HRD: The two images don't look at all the same to me. What do you mean?

DRH: Just ignore the capital "M"; then you'll see that the name and its reverse are very similar. Look — I'll align them so that corresponding parts match up:

Michael Jacobs
Michael Jacobs

HRD: I'm sorry, but I still don't see any similarity between the two. I'm lost!

DRH: Hmm… I guess I need to spell this out a bit. If you distort the letters here and there, "Michael Jacobs" will come out mirror-symmetrical (except for the initial "M", which sadly sort of wrecks things). For example, look at the "l" at the end of "Michael" and the backwards "J" just below it. Just bend the "l" up at the bottom, and it'll look just like the "J". And, moving leftwards from there, you can do the same with the other letters. The "e" and the "a" below it can be twiddled to look alike, as can the "a" and the "c" below it. The "ch" becomes the backwards "ob" (that's the trickiest part), and the "i" becomes the "s". Look:

$$\text{Michael JacobsM}$$

As you see, just very minor alterations can bring this name tantalizingly close to being symmetrical. It's only the unmated "M" that spoils the fun. Wouldn't it have been nice if his name had been "ichael Jacobs"?

HRD: Dropping the "M" from "Michael"? What a fantasy! Mirror-symmetry would also fall in your lap if his name were "Michael JacobsM" — another fantasy. But "ichael" isn't anyone's first name and "JacobsM" isn't anyone's last name, so your burst of hopes went swirling down the drain, am I not right?

DRH: Not quite. My initial high hopes metamorphosed into other high hopes. It all came from pondering that frustrating backwards "M" at the far end.

HRD: Hmm… Why call it a *backwards* "M" when it's just an *ordinary* "M"?

DRH: Well, that's true if it's printed in Helvetica, say, or Avant Garde. In those sans-serif typefaces, "M" looks identical backwards and forwards, so to refer to a "backwards 'M'" sounds silly. But in a more classic typeface like Baskerville, the thick and thin strokes get exchanged when you reflect the "M", so there *is* a genuine distinction between forwards "M" and backwards "M".

$$\text{M} \quad \text{M}$$

Luckily, though, in designing an ambigram, I have the freedom not to use lines with thickness or serifs, so I can simply say (in agreement with you) that there's an unwanted "M" at the right end of the reflection of "Michael".

HRD: So whether we're talking about Baskerville, Helvetica, or hand-lettering, that darned "M", backwards or not, makes your goal look like a hopeless cause.

A Surprise for Dr. J

DRH: Well, let me just say that it was a very tantalizing situation. After all, my idea of making Dr. J's name and its reflection coincide was only inches away from being realized, yet at the same time it was clearly impossible!

HRD: So near, and yet so far... *Ah, doux mystère de la vie !*

DRH: This kind of tantalizing situation crops up all the time in Ambigrammia.

HRD: "Ambigrammia"? What's that?

DRH: Ambigram-making. You come close, but no cigar. You just barely miss the target. It's so frustrating, so you look for some kind of trick to make it work.

HRD: I take it you found a way out of the box canyon — a *deus ex machina...*

DRH: In the end, yes — a very pleasing way out; in fact, a "D" *ex machina...*

HRD: Was there some special insight, some sudden breakthrough, using a "D"?

DRH: Indeed! While gazing at that "M" sitting there just to the right of "Jacobs", I remembered that I was dealing with a medical doctor — an M.D. So then I thought, "Hmm... If I throw in 'MD' at the far end, I'll get the 'M' that I want!"

HRD: That's an ingenious move, you sly dog, you! But unfortunately, the mirror image then inherits a backwards "D" sitting out in front of "Michael"...

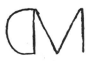

...and this time it really *is* backwards. So it seems that by tossing in his title of "MD", you wound up jumping from the frying pan into the fire!

DRH: True... For a while it really did feel like I was in the fire, but as I mulled it over, it occurred to me that I might try to somehow fold that backwards "D" into the "M", so it would look like part of it. I know that's kind of cheating, but I hoped I could make it look natural. In ambigrammia, wherever you cheat, you try to make it look like a charming aspect of your lettering style rather than a desperate forced move — that way, you can get away with it!

HRD: I suppose that if you're into ambigrammia, then you pretty much have to have that attitude — otherwise you'll never get off the ground.

DRH: Right! So I looked for a way to absorb that backwards "D" into the "M". At some point it hit me that I could pull them closer together until they touched:

That single vertical stroke could do double duty, fusing the two shapes into just one shape — a fancy "M" with a semicircular opening flourish. On the other hand, I hoped that at the righthand end, even when they were pulled together into one object, they would still look like separate letters. Here — take a look:

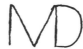

HRD: That's a clever idea, and I can easily see the shape as "MD", but how could you be sure that most people would see things in the way you intended?

DRH: That's the crux of the matter. In order to get other people to see the two ends "correctly", I made a few small tweaks to this hybrid object. First, I made the "v"-shape inside the "M" not go all the way down to the ground.

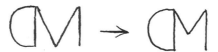

HRD: That's surprising! If I may ask, what was your purpose in doing this?

DRH: Well, look what would happen at the far end if I had left it as it was:

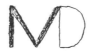

I can easily see this as a tired or lazy "N" leaning up against a "D". Can you?

HRD: Now that you point it out, I can see it that way, too. Since some viewers might see "ND" here, something should be done to prevent that misreading.

DRH: It seems that we see things eye-to-eye here. So after my "v"-raising tweak, the two hybrid shapes — one on the left, one on the right — looked this way:

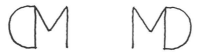

HRD: Nice move! Now the "lazy 'N'" risk is gone, I agree. Danger sidestepped! No one would hallucinate an "N" in the shape on the right. But… in the shape on the left, I just noticed something weird and kind of ugly. Your raising of the "v" made the "M" quite a bit narrower, and so now, next to it, that bulging-out backwards "D" looks bloated, unnatural. It sticks out like a sore thumb!

DRH: Good eye there! That's just how I felt, too, so I narrowed the "D" a bit:

HRD: That's far better. But what effect does that tweak have at the other end?

DRH: Again, that's crucial! Here's how it looks, after the thinning operation:

I thought — or at least I hoped — that people would still tend to see this shape as two letters. But despite all these improvements, I still wasn't happy with this, or with its flip-shape. They both seemed too squarish, not in keeping with the roundness of the other letters, so I took another leap into the unknown, trying to make a more curvy, scripty "M", like this:

HRD: Nice! This brand-new "M" is very legible and also eye-pleasing, but what about the "MD" on the other side? Does it survive this revolution?

DRH: I think you have to judge the whole thing in context, so let's just jump to the end product. Here's how the final ambigram looked:

HRD: So… you casually tossed your name and the year into the bargain — cute! It's pretty neat that you were able to "sign" that way. And what a coincidence that the year worked out so nicely, reflecting into "DOUG" so smoothly.

DRH: I wouldn't call it a "coincidence". I try to find a way of combining my name with *every* year. Sometimes it works better as a reflection, sometimes as a 180° rotation — but I've always been able to make it work out somehow.

HRD: That's kind of amazing… In any case, the whole ambigram is delightful, at least for me. Congratulations! The "M" in "Michael" reads easily, and the "MD" on the right also reads fine. I don't even notice any funny business in the "M" in "Michael". Its curved left side just strikes me as a kind of stylistic quirk. It doesn't set off any alarm bells. In fact, that opening curve gets echoed several times to the right — in the "c", the "h", the up-flips in the "l" and "J", and so on. All those curves just look like little stylistic touches — nothing to arouse suspicion. By golly, I think you're convincing me, bit by bit, that ambigrammia is not just an amusing game but a creative form of art!

DRH: I'm glad to hear it!

HRD: Also, the "MD" is a kind of *trompe-l'œil*. You read both letters and only later do you realize you've been tricked! All in all, your ambigram is very clever.

DRH: Thanks so much! But I wouldn't call this ambigram, or any of my ambigrams, "clever". I'd just say each one is the result of tons and tons of subtle judgment calls about which words and letters people are likely to see in a set of shapes. It's more a matter of concentration and experience than of cleverness.

HRD: Interesting. So… how many total judgment calls would you say you made before you reached the final ambigram?

DRH: It's hard to count decisions. For instance, whenever I talk of "making a tweak" in an ambigram, it sounds as if the operation was clean and clear-cut, but in fact, when I was working on my pencil sketch, I would often explore a whole range of closely related rival tweaks, adjusting line-lengths, reshaping curves very delicately, and so on. In the end, you can call the result of all those explorations "a single decision", if you like, but in fact I selected that particular route from a dozen or more rival routes that I tested, or at least briefly tasted. So counting decisions in Ambigrammia is very murky.

HRD: I agree. And your point isn't limited to just ambigram design. Below the surface of *any* human decision you can probably find dozens of little forays into possibility-space, all of them nudging the decider in one direction or another.

DRH: Decision-making is astonishingly rich and complex, and I've realized this fact more clearly in Ambigrammia than anywhere else. To illustrate this, I'll give you another example of a tweak I made but didn't mention earlier. Inside the name "Jacobs" there's a lowercase "b", and when you reflect that, you'll produce a "d" inside "Michael".

HRD: Oh, yes — I see the danger. But in the final ambigram, it seems that you sidestepped that danger very well. There's no lowercase "d" in sight.

DRH: Luckily! However, in my initial sketches, I didn't sidestep it at all. I made a sloppy mistake, and drew the "ob" in "Jacobs" this way:

instead of this way:

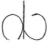

I put a gap in at the *bottom* of the "b" instead of the top. I'm ashamed that I made that choice at first, but after a while I saw the danger, and I switched.

HRD: Sorry if I'm obtuse, but both look just fine to me. In fact, I think I prefer the upper version, the one you ultimately rejected. So why did you switch?

DRH: Because you have to look at the *reflected* shape, which is supposed to be the "ch" inside "Michael". If I use the *upper* "ob", I get this shape, in reflection:

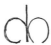

whereas with the *lower* "ob", the mirror-image "ch" will be this:

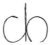

HRD: Wow — the lower "ch" is *much* clearer! The upper one runs the risk of being read as "do" or "dn", and that would yield "Midoael" or "Midnael".

DRH: Exactly! I was seriously risking treading on "d" territory, as I said before. That was careless on my part; I could easily have avoided that danger by drawing the "b" with the gap at the *top* of the loop, instead of at the *bottom*.

HRD: So why didn't you do that at the very outset?

DRH: The odd thing is that for a long time, I didn't even think of drawing the latter shape. As a result, the first version of the ambigram looked this way:

$$Michael\ JacobsM$$

HRD: Actually, it looks pretty good to me. It reads easily. No glitches.

DRH: Thank you, but that first "c" bothers me quite a lot. Admittedly, there's so much collective pressure pushing for "Michael" that I think it still works this

way — there's almost no risk that anyone would see "Midoael" or "Midnael", since those aren't names — but nonetheless, it could be considerably stronger.

HRD: But only at the risk of slightly weakening the "b" in "Jacobs". So if it's not one thing, it's another!

DRH: That's ambigrammia for you! It's always a balancing act: you strengthen *this* part, but you thereby weaken *that* part. Is it worth it? Does the *overall* strength, at the level of the entire ambigram, go up or down?

HRD: That's tricky. How do you know? How can you tell?

DRH: You can't ever be sure. The best you can do is use educated guesswork. Seat of the pants. Gut intuition. And by the way, the problems with lowercase "d" are still not over — not even in the final version I gave to Dr. Jacobs. There's a *second* spot where a "d" is threatening to wreck the party.

HRD: Hmm… Where is that?

DRH: Well, look at this area, near the end of "Jacobs":

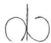

If you concentrate on just the "o" plus the vertical pole to its right, doesn't that look somewhat "d"-ish?

HRD: Now that you mention it, yes. But when you look at the combo as a whole, that worry goes away. My reasoning is simple. If the "o"-plus-pole were seen as "d", then how would you see the leftover curve on its right? It would be this:

But that shape isn't a letter at all. So this forces the "d"-ness to go away.

DRH: You speak of it so confidently, as if intellectual acts of reasoning were involved in perceptual matters. But perception is much faster than reasoning. Logical arguments hold no sway as far as perception is concerned. Anyway, why are you so sure that this shape couldn't be perceived as an "o"?

HRD: That's obvious — it doesn't *look* like an "o"!

DRH: Oh, really? Look at this:

What does *that* say?

HRD: All right, I concede your point. There's clearly *some* amount of "o"-ness in that gappy little curve. But in the full ambigram, that shape isn't standing alone — it's touching the pole, as you called it, which turns that unit into a "b".

DRH: So you say, but what's to prevent someone from reading "Jacdos"?

HRD: I'm not sure, although I've never heard of such a last name.

DRH: That's in fact the key to it. *World knowledge* comes in. Look at this logo:

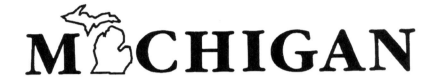

Can you read it? What does it say?

HRD: That's pretty funny! It screams "MICHIGAN!!!", despite the huge blight. Of course I realize that the blight consists of the shape of the state, so it's meant to *reinforce* the reading, not to interfere with it. But it's still funny, to me.

DRH: The state of Michigan used to use that logo on various documents.

HRD: I can see why. The word "MICHIGAN" jumps out immediately.

DRH: Sure… to anyone who knows the state's name. But if you *don't* know the name, you're in the dark. The logo might say "MACHIGAN", "MOCHIGAN", "MUCHIGAN", even "MWCHIGAN"… My point is, prior knowledge exerts a powerful top-down effect on how the mind unconsciously assigns a shape to a letter category. Long-time familiarity with the state name "MICHIGAN" makes you read the outline of the state as a capital "I".

HRD: I'm not so sure I really *read* the shape as an "I". I just see it as the state's shape, and it makes me smile. In any case, the logo evokes "MICHIGAN" in a vivid and humorous manner — at least to me, someone who knows the name.

DRH: Good. And now, back to my ambigram. In the world we live in, the last name "Jacdos" is nonexistent, whereas "Jacobs" is a common last name, so this knowledge pushes viewers, in a top-down way, to see the six letters as belonging to the expected categories, as in the droll Michigan logo. The microscopic chance of seeing "Jacdos" is overwhelmed by the very familiar name "Jacobs".

HRD: I take it that by "knowledge pushes viewers in a top-down way", you mean that the word as a whole evokes the letters, rather than the reverse?

DRH: Exactly. Or if it doesn't *evoke* them, at least it strongly *supports* them.

HRD: Aha! So that makes your work as an ambigrammist easy! I was beginning to think that ambigrammia was subtle as all get-out, but now you're telling me

that it's a piece of cake, a shoo-in, thanks to all the prior knowledge stored in readers' brains. All you need to do is vaguely *hint* at "Michael Jacobs", and the viewer's perceptual system will kick right in and swiftly take care of the rest, shoehorning every letter into the intended category.

DRH: Now you're being silly. How can a designer "hint" at the name "Michael" without having at least *some* of the letters be strong members of their intended categories? Think of the Michigan logo. There, every letter except #2 is as sharp and clear as a bell. That's not just a *hint* — it hands you the thing on a silver platter! *Hinting* isn't enough. And moreover, even when the hint is super-strong, it can still be overridden. Look at this:

Mzchael

What does it say?

HRD: "Mzchael". It's unpronounceable. So what's *that* all about?

DRH: I'm just spelling my point out. I've handed you six out of the seven letters in "Michael", but you didn't perceive the second letter as an "i". How come?

HRD: Because it *isn't* an "i". It's a "z".

DRH: Hmm… In that case, how come you read the Michigan logo so easily? Why didn't the second "letter" in that "word" throw you far off track?

HRD: Because it's not a letter at all. Since it's an *object*, you see it differently. You see it as if it were *hiding* the letter "I". It's covering it. I mean, the outline of the state is so obviously out of place that one mentally replaces it by a letter.

DRH: Suppose the designer had chosen to use the outline of the state to replace *both* "I"'s, instead of just the first one.

HRD: Then it would have been somewhat harder to read the state name, although not too much. But in my opinion, going that route would have been a bit over the top.

DRH: And what if the state's outline had been used to replace all *three* vowels in the state's name? "M*CH*G*N", so to speak.

HRD: I'd say that's where people would start to have trouble making it out. And just imagine if a map of the Lone Star State had been substituted for all three vowels in "MICHIGAN"! Or if the shapes of California, Oklahoma, and Florida were stuffed in, in place of the three vowels in "MICHIGAN". Good grief!

DRH: That's a hilarious idea. Of course no sensible logo-designer would ever have done such a thing. But what if the designer had chosen *this* route?

A Surprise for Dr. J

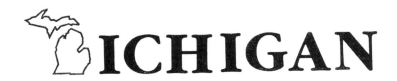

\mathcal{M}ICHIGAN

HRD: People would still probably read it, I guess, but it would sure seem lame! I'd say to myself, "Who designed *that*? What a ridiculous 'M'!"

DRH: Sticking the state outline into the word works just fine in the *interior*, but it doesn't work so well at the beginning. This shows that assigning shapes to letter categories is pretty subtle. And by the way, it's not just *letters* that constitute the relevant visual categories in ambigrammia, or in reading in general.

HRD: How so? What else is involved in reading?

DRH: Words!

HRD: Yes, of course, but words are composed of letters. Words as wholes are not independent visual categories!

DRH: *My eye* they're not!

HRD: What do you mean? How could words be independent of the letters that make them up?

DRH: Such independence can happen if all the letters inside a word are so weak that none of them can be recognized alone; in that case, it takes the *word*-level visual category to coax them out of the woodwork — or out of the *word*work.

HRD: I'm not following you. Can you give me an example?

DRH: Gladly. Scott Kim dreamt this idea up. Suppose each letter is just a solid-black rectangular block. When I write out a word, it merely looks like a series of blocks standing next to each other. So how are you going to be able to read it?

HRD: Clearly, I *won't* be able to read it.

DRH: Well, try it anyway:

▮▄ ▃▟▟ ▐▙▄▄ ▄▃ ▃ ▟▃▟▟▄▄ ▄▄▐▄▄▄▄▄▄.

HRD: "MICHIGAN", obviously! Just kidding. In fact, I can't make anything out.

DRH: All right, then. I'll give you a hint. "We all…"

HRD: "We all… We all live… in a yellow submarine." Hey! How did I see *that*?

DRH: The words *as wholes* just jumped out at you!

HRD: But how did *that* happen?

DRH: Because — as I was saying — words themselves are visual categories!

HRD: Are you telling me that if I show this set of nine blocks to random people:

they'll all recognize it as the word "submarine"? No way!

DRH: I agree. It's pretty unlikely, unless the blocks were embedded in a larger context. But in the earlier context, you *did* read "submarine", didn't you?

HRD: I wouldn't call what I did *reading*. You gave me a hint, and then I *guessed* at the word, or I *hallucinated* it, thanks to the context it was embedded in — namely, the rest of the famous Beatles lyric. Otherwise there's no way in the world I would ever have recognized it as saying "submarine".

DRH: But where *was* that "rest of the lyric"? It, too, was just a bunch of black blocks. Nothing but black blocks everywhere.

HRD: No, that's not true! There was more than just black blocks. There were also several *blank spaces*, and those are what gave the game away.

DRH: Oh, really? The blocks played no role at all?

HRD: Well, of course they did, but only a little bit. It was the *number* of blocks between the blank spaces that gave it away.

DRH: You mean the *proportions* of the various blocks played no role at all? Just the letter-counts of the words? Scott Kim could have put *any old* blocks there, of *any* shapes, as long as there were first 2 blocks, then 3, 4, 2, 1, 6, and finally 9 of them, and those *numbers* are what allowed you to read the song's lyric?

HRD: Okay, okay — I admit that the blocks' *shapes* were a major contributing factor as well. Some of the words jumped out thanks to the blocks' proportions.

DRH: Yes, but there's something else that also contributed but that we haven't mentioned. There's yet *another* visual category that was in play — a very salient one. So obvious that you don't even see it! The elephant in the room!

HRD: Really? What other visual category is involved in the act of reading? Letters, words… What else is there?

DRH: Well, there are familiar *phrases*. Phrases are to words as words are to letters. Some are very short, like "Thank you" and "Good luck" and "Merry Christmas"; some are frequent sentences, like "I don't know" and "I see your point"; some are famous expressions from literature, like "To be or not to be" and "Let there be light"; some are idioms and proverbs; some are book titles, movie titles, song titles… Each of these thousands of items that you know like the back of your hand is an abstract visual category in your mind.

HRD: They're *visual* categories? That strikes me as pretty far-fetched.

DRH: You think so? Let's compare your ability to read the familiar phrase I just showed you with another phrase, which is *not* a familiar one. Here it is, spelled out in black blocks for you:

Can you make it out?

HRD: Sure! Easy as pie! Something-something-something-something, then "a", then something-something. And maybe the third word is, uhh, "jump"?

DRH: That's right! You got two words out of seven! Pretty good!

HRD: So what does the whole thing say?

DRH: "You six jump from a purple aeroplane."

HRD: Oh, that's just what I was about to say. You took the words right out of my mouth. Speaking of mouths, can I offer you another bowl of sherbet? This time a scoop of raspberry and a scoop of lemon, perhaps? Purple and yellow!

DRH: Sounds awesome! Purple and yellow would hit the old spot!

HRD (after a trip to the fridge and back): Here you go.

DRH: Thanks very much! What I was about to say is that the phrase "We all live in a yellow submarine" exists in your mind and in the minds of millions of people around the globe. It's there *as a chunk*, and it can readily be triggered by a visual stimulus.

HRD: I guess we just proved that pretty clearly.

DRH: Actually, I have a remarkable story about this Beatles song — or rather, about that lyric from it. Many years ago, I was teaching a class on ambigrams, and I had the phrase, encoded in Scott Kim-style black boxes, in a manila envelope. I walked into the classroom, opened the envelope, slid out the piece of paper, and set it down on the table in front of me. One of the students — a very bright fellow — was sitting directly across the table from me…

HRD: Was his name by any chance "Mzchael"?

DRH: I somehow doubt it, but we can certainly call him that. So, for Mzchael it was upside-down, and yet the moment he laid eyes on those little rows of boxes, he blurted out, "We all live in a yellow submarine!" Just out of the blue. Can you imagine that? I was completely floored.

HRD: Mzchael read the thing *upside-down*!? I would have fallen off my chair in astonishment.

DRH: Well, I told you I was floored! Of course Mzchael wouldn't have been able to read the boxy message if it had said, either upside-down or right-side-up, "You six jump from a purple aeroplane." That's the difference between super-familiar visual categories and weird, aberrant ones. This brings us back to my handwritten "Mzchael". Why didn't you see "Michael" there, despite the "z"? After all, you had no trouble reading the Michigan logo despite its non-letter.

HRD: In the logo, the second "letter" looks like it's *blocking* a normal letter, but in your handwritten "Mzchael", the "z" is so clearly a "z" that I don't feel it's an alien object that's blocking some other letter. So instead of reading "Michael", I just see a *misspelling* of "Michael". But what if you were to throw in a dot on top? Maybe that would make me more likely to read the whole as "Michael".

DRH: Okay, let's throw in a dot on top:

Mżchael

Would you read that as "Michael" now?

HRD: Not really. It looks more like some weird Polish name, I'd say. In Polish, they put dots on some of their "z"'s.

DRH: They certainly do. By the way, if you look back at my final ambigram for Dr. Jacobs, you'll see that the dot over the "i" in "Michael" was missing, but that didn't seem to bother you at all.

HRD: Oh, interesting! I didn't notice that. It never occurred to me that the dot was missing. I easily read it as an "i". Or maybe I subliminally noticed that the dot was missing, but I just sort of let it slide, taking it as artistic license or something of the sort. A bit like the outline of Michigan in the logo.

DRH: Why didn't you read the dotless "i" in the ambigram as a "z"? After all, it zigzags just like a "z" should. It's just a thinner version of the zigzag above, which you *did* read as a "z". In short, why didn't you read my final ambigram as "Mzchael Jacobs, MD"?

HRD: Because, as you've just shown me, "Michael" is a *visual category* in my mind, whereas "Mzchael" isn't one, and also because that zigzag is too thin to be a "z".

DRH: So if it gets thin enough, it becomes an "i", despite being shaped like a "z"?

HRD: Right!

DRH: So tell me, how come you didn't read the last name as "Jacobi"? Its last letter is also very thin!

HRD: Because there's no dot on it! So it doesn't suggest an "i".

DRH: Oh, I see. So if I write it this way:

$$Jacobi$$

then you'll read it as "Jacobi"?

HRD: Well... No. The "s"-ness of the shape is too strong for the dot to turn it into an "i". Now it just looks like an "s" with a dot on top. It looks silly.

DRH: You know, you've just spelled out the reason that I didn't put a dot above the "i" in "Michael": its reflected counterpart — a dotted "s" ending "Jacobs" — would have looked silly. And also because I knew that the letter "i" often zigzags kind of like a narrow "z", especially in calligraphy:

$$with$$

See what I mean? There's very little "z"-ness in my undotted "i" in "Michael".

HRD: Agreed. The zigzag even *reinforces* its "i"-ness. It makes the shape a stronger member of the visual category "i"; it doesn't weaken its "i"-ness at all.

DRH: As long as the shape is thin enough not to encroach on "z" territory.

HRD: Hmm... By pointing out all the subtle judgments involved in this small creation of yours — and also, I suppose, in *any* high-quality ambigram — you're once again making me see ambigrammia more and more as sort of an art form.

DRH: Only *sort of*?

HRD: Well, ambigrammia is clearly pervaded by scads of subtle decisions — all sorts of considerations that escape the naïve eye (such as mine, before this conversation). I just didn't know that there was all this psychology lurking inside the act of ambigram-making. But I guess I would still hedge a bit about calling it an "art form", because art is supposed to be about *esthetics*.

DRH: Excuse me — are you implying that there's *no esthetics* here? Don't you think I was thinking about grace and elegant flow all the time when I shaped those letters in my ambigram? What mental forces lay behind the choices I made in all those curves and proportions? I could have drawn the shapes in a million *ugly* ways without harming their category membership. For instance:

$$Michael\ Jacobs$$

HRD: What a clumsy jumble! It looks childish and ridiculous!

DRH: Do you possibly mean that it's *ugly*? Not *esthetic*?

HRD: Okay, it's ugly. Gawky. Clunky. Klutzy. Esthetically unappealing.

DRH: Then we agree. Esthetics counts a great deal in this domain. And let me remind you that a few minutes ago, when I showed you this shape:

you strongly objected to it, saying that the semicircle was "bloated" and that it "stood out like a sore thumb". If I recall correctly, you even called it "ugly". So weren't you using unconscious esthetic criteria in that judgment?

HRD: Sure was. You caught me red-handed!

DRH: So it turns out that we're on the same wavelength. In the final ambigram I gave Dr. J, my choices of letter shapes and sizes and inter-letter distances, etc., were made largely for *esthetic* reasons. I instinctively ruled out a zillion gawky versions of "Michael Jacobs MD", such as the one I just drew for you.

HRD: You mean that you actually *considered* that clunky mess, as well as other equally ham-handed messes, and ruled them all out because of esthetics?

DRH: No, no — not at all. I never explicitly considered silly designs like that. While designing Dr. J's gift, I didn't entertain any grotesque, childish letters.

HRD: So… in what sense did you make tons of esthetics-based judgment calls, if you didn't explicitly rule out any ugly letters?

DRH: I just chose shapes that instinctively appealed to me — and that wisdom, if you'll permit me the self-praise, was a deep trait that I acquired over decades of letter-drawing experience. I fell under the spell of letterforms when I was very young. When I was 4, 5, 6, and even older, I spent hours drawing countless pathetic letters and words, like all kids do, but in doing so, I gradually refined my sense of letterforms and alphabetic styles until I homed in on a set of ingrained habits that included esthetics *automatically*. For instance, I loved gazing at the exotic capitals and smalls in cursive that were displayed above the blackboard in my second-grade classroom; their swirls enchanted my eye. For many years after that, I tried and tried to imitate them perfectly, hoping to incorporate them into my own personal handwriting. And even today, I try to make graceful shapes every time I sign my name, even in the most mundane of situations, such as on a check or a credit-card slip.

HRD: Can I infer that you enjoy paying your bills?

DRH: You can! I do! At least the signature-writing part of it. I enjoy writing *all* the words on the check! For instance, I love writing numbers, such as:

Eighteen

I get a kick out of making those elegant, swirly shapes with my hand's motions.

HRD: I don't think of *my* handwriting as having any artistic quality.

DRH: Well, different strokes for different folks. And by the way, you should see my mother's handwriting. Here's a sample — a poem she wrote as a teen-ager:

Silence and night,
A garden asleep,
What are the flowers dreaming?
The cool moonlight
Will quietly creep
Over a mad world's scheming.

I grew up with her handwriting as a model, and it had a huge influence on me.

HRD: Very graceful, I agree. I notice she uses a Greek-style "ε" for her "e"'s.

DRH: Yes, that's one of her hallmarks — and *her* mother did that, too. In fact, their handwriting styles are almost indistinguishable, to my eye.

HRD: So you're sort of channeling your dear old Mom as you write in cursive?

DRH: In a way, yes. In any case, all the decades of honing my handwriting are part and parcel of the unconscious esthetic pressures that guide my hand as I form the shapes of letters in an ambigram. Of course my strokes aren't perfect, and I see small esthetic flaws in them all over the place, but I do my best to make my ambigrams appeal to my own sense of calligraphic beauty.

HRD: Okay, but isn't that just icing on the cake? I mean, what does beauty have to do with ambigrammia? Isn't *legibility* the *sine qua non* of the thing? Isn't your main goal simply that people should be able to *read* your ambigrams?

DRH: Yes and no. If it looks forced, people will feel discomfort when they read it. It will hurt their eyeballs, so to speak. A good ambigram has to look unforced, natural, and graceful. In other words, the quirky little things that I do to letters to make them work two ways at once have to seem *deliberate*; they have to seem as if they were done only for reasons of *style* rather than for reasons of trickery or deception. If the viewer sniffs the intent to deceive, then the beauty

of the act is blown. It has to look as if the overriding reason for the unusual letter-shapes is *beauty* or *style*. It shouldn't look as if the various letters were all designed solely in order to make viewers read two different words from two different perspectives.

HRD: So you work at making each individual letter as graceful as possible.

DRH: Yes, but *local* beauty isn't the full story, because the types of beauty in the different letters making up the given name or word all have to be compatible or consistent with each other. They have to flow together to make a uniform, homogeneous style — otherwise, all you'll have is a jumbly hodgepodge of unrelated types of visual charm. I mean, suppose the first letter in an ambigram was swirly, like the "G" in my second-grade classroom's cursive alphabet; the next one was a blocky stencil-type letter "E'"; and the third one was a jagged triangle-based "B". The juxtaposition of these three strong category members, each one esthetically fine on its own, would grate on any sensitive viewer's eyes:

Is it legible? Certainly! But is it acceptable in an ambigram? Certainly not! The point is, you've got to make ambigrams whose flow pleases the eye all over, on every structural level. You want every part to resonate with every other part in some subconscious manner, just as the letters in "Michael Jacobs MD" do.

HRD: That's a fine goal to shoot for, but how can one hope to achieve such pleasing harmony? How can one consciously take into account all the myriads of unconscious pressures due to both category membership and esthetics?

DRH: I can only speak for myself, but I don't pay attention to all those pressures consciously. I do a *bit* of it consciously, but most of the work takes place behind the scenes. Or to put it more accurately, I did it in my youth, while I was training myself to write *this* way and not *that* way. It was done during my period of a million mistakes! When I was in elementary school, I made all sorts of elementary mistakes, and I made higher-level mistakes when I was in high school, and so forth. Now I'm much older and I still make plenty of mistakes — there's no doubt of that — but they're at a yet higher level.

HRD: What do you mean by "higher-level mistake"?

DRH: Well, for example, sometimes an ambigram that I've just made and think of as flawless will be read in a way that I never anticipated by my son Danny or my daughter Monica when I show it to them. That's a big shock, and it reveals a higher-level mistake on my part. I'd thought my ambigram was great, but their reading shows me I was wrong.

HRD: I suppose you get annoyed at Danny or Monica, or at other people who don't see what your creation "really" says. How could they be such dimwits?

DRH: To my shame, yes, I often do get a bit annoyed at them, but I shouldn't, because they're performing a great service for me. They're doing me the favor of debugging my ambigram, revealing flaws I was unaware of.

HRD: It's a bit like showing an architect that a bridge or stadium they've just designed and are very proud of will actually collapse in a certain type of high wind or when a large crowd is stomping in synch.

DRH: Exactly. You'd do an architect a great service by exposing such flaws. But although I'm thankful, I also feel annoyed, since I'm so disappointed that what I proudly produced has to be lugged back to the proverbial drawing board.

HRD: Literally speaking!

DRH: Yes. And whereas I should be annoyed at *myself*, I tend to be annoyed at my *critics* for revealing its weakness. Part of me is silently reproachful: "How on earth did you fail to read it in the way I intended it?" But another part of me is quietly thankful: "Your 'wrong' reading of my design is so helpful! It shows that someone else can easily perceive it in another way, even though I tried so hard to make it unambiguous." So part of me is grateful and part of me is ticked off. But in the end, despite my little pique, I always go back to the drawing board and try to fix things up. And sometimes I have to go back to the drawing board many times in a row. You have no idea how often I've gone back and redrawn some teeny tiny curve over and over again, always trying to improve it.

HRD: So Danny and Monica and sundry other critics help keep you honest, eh?

DRH: Exactly. And I myself am one of those sundry other critics. For example, suppose I've just designed an ambigram and then you and I go off to lunch. After lunch I return to my study, but my mind is still focused on our conversation, not on what I was doing before lunch. As I approach my drawing board, the ambigram catches my eye, and before I know it, I realize that some "wrong" reading has jumped out at me, and I can't deny the experience. My very own ambigram has hit me in a fresh new way, simply because I've been away from it for an hour or two. I read it as Y when I'd intended it to say X. That unwelcome vision lets me know for sure that some revision is called for.

HRD: So you, the designer, sometimes wind up playing the role of an uninvolved naïve reader? I would guess that putting on naïve glasses is not so easy.

DRH: I do my best at it. That's perhaps the subtlest skill in all of ambigrammia — the ability to imagine how others will see your design. To internalize other people's eyes is extremely tricky and takes years of practice. But no matter how much practice you have at judging legibility, you can never be sure of your

judgment. It's always a bit of a gamble. And so my rule is that I have to run any new ambigram by someone else's eyes — preferably two or three other people's eyes — to get a fair sampling of the public "out there".

HRD: To me, that means that the final version of your ambigram isn't really your own handiwork but is a *joint* work, due to you and your critics together.

DRH: In a sense, you're right — but that idea could apply to many creative acts. How many people are acknowledged by the author at the beginning of a book? But although they contributed, we don't put all their names on the cover.

HRD: Point well taken. I have just one last question for you.

DRH: Shoot!

HRD: You began with the intention of doing an ambigram on "Michael Jacobs", but you wound up with one on "Michael Jacobs MD" instead. So does your final design count as a success or as a failure?

DRH: Well, Michael Jacobs didn't *ask* me for an ambigram — I just decided to do one for him because he was my mother's physician during a period when I was designing ambigrams left and right on the names of people I was dealing with — and one day while I was talking with him, it occurred to me that he would probably enjoy an ambigram. So the idea came from me alone. So from *his* point of view, my original intention wasn't visible. For all he knew, my very first thought was to tackle "Michael Jacobs MD".

HRD: Sure, but *we* know that that wasn't your very first thought. Your first goal was just his *name*, without the "MD". From your point of view, even if not from his, you failed in what you set out to do. Doesn't that mean that for the past hour or so, we've been discussing a failure story, not a success story?

DRH: Hmm… Narrowly construed, that *could* be the case. But a more accurate viewpoint is that there was no precise goal that I was trying to reach, other than making a pleasing ambigram for Michael Jacobs. Like most people, Dr. Jacobs didn't have any prior awareness at all of the existence of ambigrams, and didn't expect any gift of any sort from me. All I wanted to do was to surprise him with an unexpected gift based on his name!

HRD: In that case, you could have hired a professional calligrapher to write it in some fancy way, or a sculptor to sculpt it in marble, or a wood carver to carve it in ebony. Sorry for teasing you, but I'm just thinking out loud…

DRH: You're right, I could have hired someone else, but then it wouldn't have been created by *me*. I enjoy presenting people with ambigrams that I myself have made, not handing them commissioned artworks based on their names — and so I wasn't about to go out and hire somebody to make a wood carving.

HRD: I know; I was just giving you a hard time.

DRH: Originally I was shooting for an ambigram on the name "Michael Jacobs", of course, but there was quite a bit of flexibility in my self-imposed challenge — so when I had a near miss on my first try, I was able to parlay my failure into a success in a closely related challenge. I replaced one goal by another goal, and thereby finessed a failure into a success. All of this was of course invisible to the recipient, who saw only the polished final product. He didn't know that I had originally set out on one track, failed, backtracked, and switched goals. He could easily believe that I set out to do "Michael Jacobs MD" from the get-go.

HRD: So when you handed him the gift, you were in a sense pulling the wool over his eyes?

DRH: No, in no sense at all was I pulling the wool over his eyes! It's just that I didn't tell him the full story of how it came about — the story I've just told you. It's like seeing a movie without seeing any of the thousands of out-takes. Is that fooling the moviegoers?

HRD: No, because moviegoers are very aware that so much went on in the preparation of the movie. But a typical ambigram recipient, I would assume, doesn't have the slightest idea of how much work it took to come up with the artwork. It just seems to have come out of nowhere.

DRH: Right. That's part of the pleasure of giving an ambigram as a gift. The recipient enjoys being mystified and baffled and surprised! It's like a magic trick — people *like* to be baffled. If they knew what went on behind the scenes, their sense of delight might be diminished.

HRD: So what about Dr. Jacobs — was he baffled and delighted by his present?

DRH: He was indeed, thanks for asking, and many years later I even wound up writing a dialogue about its genesis, including lots of pictures and a few jokes.

HRD: No kidding! That sounds like a barrel of fun. Who were the characters in the dialogue? Achilles and the Tortoise, naturally, right? And maybe the Crab?

DRH: Hmm… Not quite, but you can go look it up in my book *Ambigrammia: Between Creation and Discovery*. I seem to recall that it's Chapter 13, but maybe I'm off by a bit. In any case, I think you'd get a kick out of reading it.

HRD: Wouldn't miss it for the world. How did it end?

DRH: Well, a little abruptly.

CHAPTER 14

From the Early 2000s

Back in Fioripoli

In August of 2002, enriched by our Italian year, we returned to Bloomington, but I personally was exhausted, and oh-so relieved to be home. A few months later, our next-door neighbor, Barbara Wolf, of whom we were very fond but who was quite lonely, told us the exciting news that she was soon getting married to a fellow named Robert, and she invited us all to the wedding, to be held on the campus. Accordingly, I made an ambigram to celebrate the big occasion.

I used my then-favored "confetti" style, and I made the ampersand (or the "&") turn into the "B" of "Barbara". What's most interesting here, though, is the date. "15 March" is pretty legible (despite the feeble "h"), but in the *year* there's a kind of magic, since the diagonal stroke that you hallucinate in the "2" vanishes in the "3", and the unconscious joining of the upper and lower halves on the "3"'s right edge doesn't occur on the "2"'s left edge. Also, to excuse the gaps inside the "2" and the "3", I inserted little gaps into both zeroes, thereby making the year's visual style uniform. I was so happy with that year's ambigram!

Signatures and Such

A minor part of my gift to ROBERT & BARBARA was a penciled-in "signature" in two diagonally opposite corners. Below is a version in ink:

This simple signature has appeared in hundreds of my ambigrams over the years, always newly done, and thus slightly different each time.

Sometimes, though, I've wanted my name to turn into the current year instead. (It's convenient that "Doug" has four letters and that all the years in which I've so far lived have only four digits.) Some years were pieces of cake, but others were challenges. Here are three examples of tricky years to flip into "DOUG":

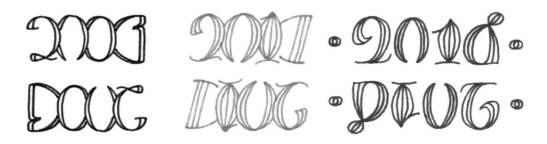

In "2003 / DOUG", I cheated by pretending that the "D" was slightly obscured by an "O" lying on top of it, which hopefully would lead viewers to hallucinate a complete "D" (while not hurting the "3" too much) — and for stylistic uniformity's sake, I played that "overlap" game with all four letters/numerals.

Chapter 14

In "2017/DOUG", I did a similar thing, this time with the "7" instead of the "3"; however, coaxing the numeral "1" (basically a stick with two serifs) to turn into the letter "O" (a circle) was tougher. I finally figured out a way to do it by adding three internal lines. That ploy, in the context of the *year* (where the shape was sitting just to the right of a very clear "0"), yielded a chubby "1", but in the context of my *name* (where the same shape was sitting just to the left of a very clear "U"), it yielded a slender "O". (Or so I hoped. Only Peoria knows if the ploy worked.)

In "2018/DOUG", I used the same "1"/"O" trick (which by now was old hat), and found a way of making "8" rotate into "D". Of course it was a somewhat dubious "D", but that's par for the course in ambigrammia. And seen the other way, it was also a somewhat dubious "8". In fact, the levels of dubiousness of both the "8" and the "D" were very similar. If one of them had been very strong and the other one had been very weak, then some adjustments would have been called for, because you can't have a weak "D" at the start of my name, nor can you have a weak "8" at the end of "2018". Using techniques like this, I've managed, though just barely by the skin of my teeth, to make "DOUG" turn into every single year since I started signing the ambigrams that I gave away as gifts.

Gradually, after I'd started signing and dating my ambigram-gifts, I grew tired of repeatedly trotting out the same old riffs for that purpose, so I explored novel ideas. One was to use my initials — "DRH". Here are three superficially different but conceptually identical ways in which I did that:

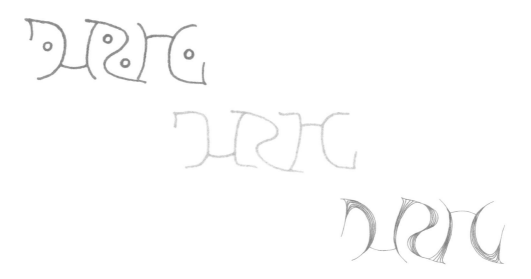

In all of them, the "H"'s high crossbar, when flipped, serves to join the "D" to the "R"; the hope is that the joining-stroke is so low that it won't muddy up the waters too much.

Once in a blue moon, I would sign a 180°-rotation ambigram with my first and last names together, using the "confetti" style, with a nice round "O" at the center:

I also figured out how to realize a decent lake reflection on my name, but I don't recall ever signing an ambigram with it.

One time I even channeled my old friend Greg Anti-Huber by concocting a clockwise spinonym spelling out my first name in capitals:

When I showed it to Dr. Anti-Huber, he exclaimed, "By Guth, I didn't know your name had that property!" "Neither did I," said I.

Another Ambigrammia Course

In 2006, I proposed an ambigrams class to IU's School of Fine Arts, and they gave me a green light. Ten students signed up, which was a fine number, but I soon discovered that while a couple of them took to the art form like ducks to water, others struggled with it for the entire semester, to my chagrin (and theirs as well). Even for people who are artistically gifted, skill in ambigrammia is not a given.

The first assignment I gave was the name of the town in which we all resided. As is my usual practice, I myself did all the assignments I gave my students, and to this first assignment I came up with a solution that I think is worth sharing.

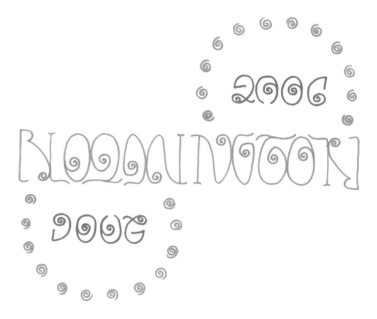

As usual, consistency of case was an important goal for me. And although this ambigram wasn't a gift, I chose to sign it with my name and the year, so it provides one more example of "DOUG" flipping into a twenty-first century year.

Probably the most eye-grabbing aspect of this ambigram is the pair of circles made of curlicues — and as you surely guessed, the spark to make them came from the five curlicues that were already present inside both "BLOOM" and "NGTON". Actually, that's not quite accurate. In fact, it's utterly false. The truth is that at the outset I'd drawn only *two* curlicues in each of those two areas, not five. Nonetheless, it was their presence that sparked, in my mind, the idea "Make two big circles of curlicues" — so I revised my pencil-sketch by adding a few more curlicues inside certain letters, carefully placing them so they would describe a *convex* circular arc inside "BLOOM" and a *concave* circular arc inside "NGTON". Once those two arcs looked graceful enough to me, I extended them with twelve more curlicues apiece, above and below the town name, thus producing two full circles.

This kind of jumping back and forth is typical of my *modus operandi* (and maybe of everyone's) in artistic creation — one idea triggers another, which then feeds back into and modifies the idea that gave rise to it — and around and around in a virtuous circle this process can go, eventually converging on a stable final creation.

My next assignment to the class was to make ambigrams on the seven classic colors of the rainbow (*red orange yellow green blue indigo violet*), often abbreviated as "ROY G BIV". Once again acting as a student in my own class, I enthusiastically tackled the assignment, and what resulted is, I think, one of my most memorable ambigrams.

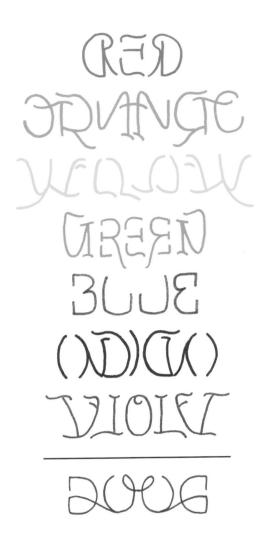

Musings on the Rainbow Ambigram

Although I just now described the above artwork as *one* ambigram, on second thought I would say it is *two*. The seven colors make up one ambigram, while the bottom line comprises another one — a cherry atop the sundae (or rather, abottom it). Some people might object and say this is a set of *eight* ambigrams, and they, too, would be quite right, since there's no exact answer to most counting questions ("How many towns are in Italy? How many friends do you have?"); it all comes down to how you assign things to categories. Nonetheless, I prefer to think of the top seven lines as forming a single unit, because they are the rainbow's colors.

It would be one thing if these seven words had no semantic connection to one another and were simply a haphazard mix of 180° rotations, 90° rotations, wall reflections, lake reflections, q-turns, and rotoflips. Then the tower would just be a

random jumble made of seven unrelated ambigrams. But that's far from the case. Each line is a common color name, and they are given in the standard order. All are wall reflections, all have been realized in capital letters, and all share a similar lettering style. These facts (plus the colors the seven lines were drawn in!), endow the rainbow 'gram with a strong feeling of unity; they tightly weld its seven parts into a single artistic entity.

I must confess that in my first attempt, I used capitals in only six of the seven lines, while for "yellow" I used lower case. However, when I stepped back and considered this inconsistency, it struck me as a glaring defect, so I struggled for a long time to make a wall reflection on "YELLOW", and I hope that you feel I did a decent job of it. But... if you happen to think that my solution for line #3 is weak, please keep in mind that this seven-story building is meant to be looked at *as a whole*, rather than each story being scrutinized in isolation. So line #3's legibility should be evaluated in context.

Let me be a bit more explicit. There are several distinct pressures pushing for line #3 to be read as "YELLOW". One is the fact that the English word "YELLOW" exists (and is very common); another is the color of the ink it has been drawn in; another is that it is flanked by six other color names that all reinforce each other; and another, of course, is simply the several parts — the roman letters — of which it is made. Even if some of its letters are hard to make out on their own, that's a red herring; its letters are *not* on their own, but are together. That's the nature of ambigrams; letters are grouped inside *structures*, so there's a resonance between the whole and its parts — the parts suggest a whole, and the whole confirms the parts.

In this case, there are *two* such resonances, as there are wholes at two distinct levels — first, that of the full rainbow (whose parts are the seven color names), and second, that of each color name (whose parts are letters). Actually, there is a third level of wholes — namely, that of letters (whose parts are strokes). So in fact there are *three* resonances here, each of which contributes to the mutual reinforcement of parts and wholes. Collectively, then, these three resonances serve to strongly lock in a single interpretation at the highest structural level — that of the full rainbow. What is this, if not perceptual synergy?

Of course, if you don't know what a rainbow is (an unlikely scenario), then the resonance between the seven stories and the edifice they comprise will be missing. Then again, you may never have encountered any English color names (because you grew up speaking only Basque — but then how can you be reading this book and understanding this question?). If you don't know those words, the resonance at the middle level will be missing. Or if you don't know the roman alphabet, then obviously the lowest-level resonance will have no effect on you. But... this ambigram is aimed at a literate, rainbow-knowing, English-speaking Peoria whose citizens are not colorblind and who probably know the "ROY G BIV" mnemonic.

From the Early 2000s

I'd like to comment on line #5, which of course says "BLJE". Just kidding! Why *doesn't* it say "BLJE"? Because "BLJE" isn't an English word! And because all the *other* lines are color names! And because it's printed in *blue*! So why is line #5's third letter not "J"? For all the just-given reasons. Of course, if it's taken entirely in isolation, it's a stronger "J" than a "U". That's clear. But in perception, we are influenced by stimuli coming at us on many levels, and this is a model case of that.

Let's move to line #6: "INDIGO". Here, as in the "Sunkist" logo on page 63 and "DANTE ALIGHIERI" on page 126, one stroke of the letter "N" (or "n") has been swallowed by a neighbor-letter (namely, the "D"). You might complain that that's *cheating*! Well, well, well… Welcome to Ambigrammia, dear reader.

And now, an observation about line #7: "VIOLET". It's not symmetrical! The "O", when reflected, has a curl that twirls in the wrong direction. Fearful asymmetry! Why didn't I fix this flagrant flaw? Well, firstly, the reflected "O", despite its naughty little curl, loses nothing of its "O"-ness, and for me that's all that really counts. And secondly, I have to let the cat out of the bag here — *none* of the words in my rainbow is symmetrical! Look, for example, at line #5. If you reflect the "B", it won't coincide exactly with the "E". Or take the "E" in line #1 — that shape certainly does not reflect into itself (although it retains its "E"-ness).

So there's an amusing extra pattern in this rainbow ambigram: even though it reads just as clearly when it's reflected in a mirror, it's asymmetrical from top to toe. That quirky subtlety pleased me a lot when I came up with it, and you might enjoy pinpointing all the asymmetries in these words.

Before we leave the rainbow ambigram, one last comment. In designing it, I was deliberately austere in my lettering style. In other words, I reached my destination using the simplest means possible. No retinal pizzazz here — not even any thickening of lines (let alone tapering). As ambigrams go, this one is pretty minimal. Less is more!

And finally I turn to line #8, which, unlike its cohorts in the rainbow, *is* in fact mirror-symmetric (if you overlook the inevitable small imperfections of my hand-lettering). But before I discuss this line any further, I have to ask you, my readers: What does it actually *say*? I suspect some of you will read it one way, and others differently. To be more concrete, I suspect that to some viewers, a certain four-letter *first name* will jump out, while to others, it will read as a certain four-digit *numeral*. What I'm trying to say, but without spelling it out explicitly, is that the bottom line not only is mirror-symmetric but also is an oscillation ambigram. Now you see one thing; a moment later, another; then back to the first thing; and so on. And if you look at line #8 in a mirror, the identical oscillation will take place. Now in *my* book (this book here, that is), that's really jumping through a heap of hoops at one time! Never before had I created an ambigram that had four readings, nor have I ever created one again.

Chapter 14

A highlight of my 2006 ambigrams class was Scott Kim flying from out west to the Midwest to give us a guest lecture (Zoom didn't exist back then!), and he and I even put up a small exhibit of our recent ambigrams in my research center. For the occasion, I designed a brand-new lake reflection on my friend's name:

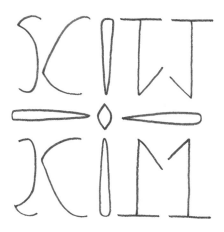

Perhaps there is a dot on the capital "I" in "KIM", or perhaps there is not. But dot or not, it's fun to see (once again) a slender "O" turn into a wide "I", and vice versa.

The hardest challenge I gave my class was to make an ambigram on the city name "Kalamazoo", in capitals or smalls (or even a mixture), using any symmetry they wished. Scott and I also tackled the challenge. I don't have Scott's solution (which of course was superb), but I have a couple of my own, one in lowercase cursive, and the other in uppercase block letters (in a stretched sense of that term):

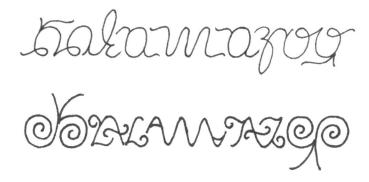

I must say, this city's unusual name is among the roughest ambigrammatical challenges I've ever taken on. These solutions (or attempts) were so hard to come up with! And a related challenge I gave my students was the word "zoo" (upper or lower case, any symmetry). I'll let you, dear reader, tilt at that windmill yourself.

In the aftermath of teaching this class, feeling quite giddy with inspiration, I went on to design new ambigrams galore, of which I'll give but a smattering below.

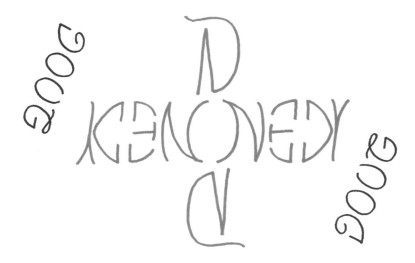

The multi-talented and gracious Donald Kennedy was president of Stanford University from 1980 till 1992, but I knew him first as an early mentor to my sister Laura when she majored in biology there, then as an avid backer of my work-in-progress *Gödel, Escher, Bach*, then as my parents' next-door neighbor on Mirada Avenue, then as a co-foe of sexism, then as a co-lover of running in the Stanford hills, then as a wild Stanford basketball fan, and ultimately as a warm friend. You can probably guess what I most like about this ambigram: the way the two "N"'s in the middle of his last name evoke a ghostly "O" in the middle of his first name.

You are already familiar with the following dedicatee from earlier pages in this book. Below I offer a wall reflection in his honor.

Chapter 14

It's not too hard to figure out why I broke the "D" in the top line into three pieces, and why I made the first letter in the middle line curve the wrong way, and why I cleaved the "o" in the bottom line, making it look like two parentheses…

Next, two 180° turns on the name of another close friend who joined my research group in its first incarnation, at the University of Michigan, back in 1984. The upper MM ambigram, in upper case, was part of my Geneva exhibit that year, and the lower one, in lower case, was done 22 years later. What a difference in style! And yet, on a deeper level, the same style!

Not too surprisingly, I prefer the slimmer, sparer, later version, even if I find the abrupt up-stroke at the end of "Melanie" (or rather, "melanie") a bit iffy. As for the earlier version, well, that "E"-to-"M" trick looks kind of laughable to my eyes today. But maybe, rather than laughing *at* it, I should just laugh *with* it.

Mr. Mongold's Calculus Class

In 2006, my son Danny was taking calculus at Bloomington High School South with a legendary teacher named Mr. Mongold. Somehow I got invited to give a guest lecture in Mr. Mongold's class, and I took deep pleasure in presenting a derivation of the mysteriously beautiful identity that runs this way:

$$\pi/4 = 1 - 1/3 + 1/5 - 1/7 + 1/9 - 1/11 + 1/13 - 1/15 + 1/17……$$

Chills still run up and down my spine whenever I contemplate this eerie equation.

I got invited back by Mr. Mongold for a second presentation, and this time I decided to talk about ambigrams. This was obviously a digression from the topic of calculus, but Mr. Mongold was very open-minded, thinking that anything that had to do with symmetry was math-related and would be enlightening to his students. His attitude reminded me of the time when I was in seventh grade and my beloved math teacher Mr. Truscott let our class listen, on the radio, for the whole hour, to Don Larsen's perfect game in the Yankees–Dodgers 1956 World Series, with Mickey Mantle's perfection-saving catch — unforgettable!

To prepare for my return performance in Mr. Mongold's class, I designed an ambigram on every single student's first name (always in capital letters, just for fun); then I printed up and handed out to all 19 students (and Mr. Mongold, of course) a thin volume, in color, featuring all of my final designs plus all the pencil sketches that preceded them. Here is a small sampler from that booklet.

Those three tiny dots in "ADAM" are so crucial to making it legible! Ditto for the four hyphens inside "ANDREW", the ten polka dots inside "BARBIE", the four squiggles inside "CHRIS", and the four yellow circles inside "ROXANNE". By the way, in that 'gram, I am very pleased with the way that the "O" and the "X", so salient in the first half of the name, both poof out of existence in the second half.

Roman Holiday

In the fall of 2006, I received an invitation from Walter Veltroni, then mayor of Rome, to participate in the *Festival della Matematica* that he was sponsoring for the coming spring. As it happened, my 15-year-old daughter Monica was a huge admirer of Veltroni, and when I told her of this out-of-the-blue invitation, she was beside herself with excitement. I eagerly accepted, but made a special request to the festival's organizers, asking if our family might have the honor of shaking hands personally with the mayor. The very next day a reply came back, saying we were all warmly welcomed to be the mayor's personal guests for tea and coffee in his office on the morning of March 16th (which by chance was Danny's 19th birthday). That was Above and Beyond the Call of Duty!

In March of 2007, we flew to Rome and had a marvelous week there, having delicious daily dinners side by side with some of the greatest living mathematicians, including Andrew Wiles, John Nash, Benoît Mandelbrot, and Michael Atiyah, plus — icing on the cake — former world chess champion Boris Spassky. One evening I confessed to Spassky that back in 1972, I had been riveted by the famous world-championship chess match in Reykjavík between himself and Bobby Fischer, avidly rooting for Fischer (who later turned out to be a Very Bad Boy). Spassky just smiled and said, "*Of course* you were for him! You're an American! It makes perfect sense!" He also added that the years when he'd been world champion were the worst of his life, because the pressure from the Soviet government was almost unbearable. It was a huge relief to him when he lost his crown to Fischer.

On the festival's last day, in front of a huge audience of 3,000 people, Spassky played a simultaneous exhibition against fifteen of us "math people". He would wander from table to table and see if we were ready to move, and if not, he'd just wander to someone else. After I'd made 19 moves, he offered me a draw (I knew he was just doing it to be nice, as he'd already offered draws to several other opponents, who'd all accepted with delight), but I refused the kind offer. A few moves later I was checkmated. (Natch.) I still have a record of our game.

Before we flew to Italy, Monica had knitted for Mayor Veltroni a woolen cap with a cute little pom-pom, using the colors of Veltroni's favorite soccer team (Roma, of course). I, too, had carefully prepared some gifts for the Mayor and his family — namely, a few ambigrams. Two of them are shown on the next page.

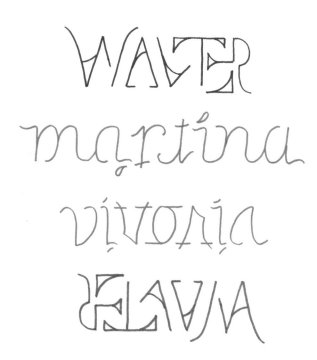

The top line says "Sindaco di Roma", meaning "Mayor of Rome". The space between "di" and "Roma" might strike you as being a little too narrow, but I had to adjust it very carefully so that "Sindaco" didn't come out looking like "Sinda co" — thus it involved seeking just the right balance-point between opposing forces (which, needless to say, is the name of the game in all of ambigrammia.)

The other ambigram that I made for Mayor Veltroni included his first name plus those of his wife and their two daughters.

The visit to Mayor Veltroni's office, overlooking the ancient *Foro romano*, was unforgettable. He treated us with warmth and grace, offering us a tray of pastries, along with tea and coffee in elegant china cups (plus cream and sugar for me). He was surprised and delighted that we all spoke Italian fluently. It turned out that he'd just written a novel, and he gave us copies, and when he learned it was Danny's birthday, he walked over to a cabinet, opened it, and pulled out a hefty tome called *Enciclopedia di Roma*, chock-full of lovely pictures, handing it to Danny as a special present. That hour-long visit lives forever in our memories.

On the flight back to the U.S., I read *La Scoperta dell'alba* and enjoyed it greatly, and in an email I offered to translate it into English. Mayor Veltroni (who soon became "Walter" to me) was thrilled by my offer, and so that's what happened. Early in 2008, *The Discovery of Dawn* was published, with a short preface by me.

To return to *Ambigrammia: Between Creation and Discovery*, let me ask you if you can read the name of Walter's wife. (I hope that their two daughters' names are pieces of cake.) If you can't make it out, let me give you a hint: its first letter is "F". Need another hint? I wish you didn't, but okay, the second letter is "L". That "TER"/"FL" gamble was pretty risky, I admit. But now that you know the answer to my question, could you imagine a more quintessentially Roman name?

Trees and Fruits

One day in the summer of 2007, white-hot with ambigram fever, I gave myself a vast open-ended challenge: to do ambigrams on the names of all the trees and fruits that I could think of. This included all the commonest ones, like "oak", "magnolia", "apple", and "plum", and rather exotic ones, like "baobab", "catalpa", "pawpaw", and "lingonberry". I spent several intense days making pencil-sketches, and by the end I'd done about 160. I never bothered to refine them, let alone trace them all in ink; I was mostly doing it just to prove to myself that *whatever* word you threw at me, I could handle it — and I'd satisfied myself on that score.

Here's a tiny subset — a mere three out of those 160 pencil-sketches — first a wall reflection, then two 180° rotations:

Clearly, in choosing from among so many, I had to do heaps of cherry-picking.

One of the most joyous days of my life was Tuesday, November 4th, 2008. That was the historic date on which Barack Hussein Obama was elected president of the United States. I was astonished. I could not believe my eyes or ears. It felt like a miracle had been wrought. I so much wished that my late mother, my late father, my late wife Carol, the Reverend Martin Luther King, Jr., and so many others, had lived to see this stunning day. Although those people didn't make it, at least Carol's and my children and I got to see what felt like a glorious new dawn, and I was deeply grateful for having been granted that opportunity.

Not long after the new administration took over the reins from the previous one, it hit me that I might try to design an ambigram to celebrate this monumental turn of events in our country's highly checkered history — that is to say, in our country's tragically black-and-white history. After all, it suddenly seemed that we Americans had collectively turned a corner towards a far more hopeful future. In an exhilarated mood, I made my ambigram, and I like to think that it wears my joy on its metaphorical sleeve:

To be his Energy Secretary, President Obama brilliantly nominated an old friend of the Hofstadter family — the outstanding Stanford physicist Steven Chu. That was providential! I figured that if I were to send my ambigram to the White House, it would never reach the eyes of its honorees, but if I sent it via Steve Chu, it would have a much better chance. So that's what I did, and a couple of weeks later I received an email from Steve saying that he'd handed my present to the First Couple when he and they were flying aboard Air Force One, and that both Barack and Michelle had gotten quite a kick out of it. I was overjoyed to think that my red, white, and blue ambigram had tickled its destinatees pink!

The Capstone, Keystone, and Cornerstone of All Russian Literature

Quite bizarrely, outside of Russia, it's virtually unknown that Russians nearly universally consider the apex of their literary canon to be the novel-in-verse *Eugene Onegin*, by Alexander Sergeevich Pushkin (1799–1837). Outside of Russia, if you ask "What is *Eugene Onegin*?" and someone replies, chances are a hundred to one that they'll say, "Oh, it's a splendid opera by Tchaikovsky!", with no awareness that it came from a far greater work by Pushkin. Inside Russia, however, people will say, "It's the peak of our literature!" or "I memorized the entire book in high school."

I discovered *Eugene Onegin* by chance in 1986, after reading the sparkling novel-in-verse *The Golden Gate* by Vikram Seth. So enthralled was I with his book's effervescence and humanity that I wrote Seth, who was then a graduate student in the economic demography of China at Stanford — and a few months later I was having coffee with him at Printer's Inc. bookstore in Palo Alto. I innocently asked, "What on earth gave you the idea of writing a novel-in-verse?" He replied, "Oh — I was inspired by Sir Charles Johnston's lithe, lilting, luminous translation of Pushkin's novel-in-verse *Eugene Onegin* into English!" I was really caught off guard. Moments later, Vikram marched me over to the bookstore's poetry section, found a copy of that very book, and bought it for me as a gift. That gift changed my life.

And yet I was not suddenly smitten with Charles Johnston's anglicized *Onegin*. Quite the contrary: I didn't even glance at it for years. What *did* happen was that several years after I became friends with Vikram Seth, I was once again in Printer's Inc., and I happened upon a different verse translation of *Eugene Onegin*, this one by James Falen, a professor of Russian at the University of Tennessee in Knoxville. I thought to myself, "What?! How can some hillbilly upstart from deep in the American boonies have the chutzpah to try to translate this work into English when the *definitive* translation was made in 1977 by a knighted British diplomat?" Yet, out of curiosity, I bought it anyway. When I got home, I set it alongside Johnston's version on my bookshelf. There they both gathered dust for another couple of years, until one day in 1993, when Carol and I decided to read the two and compare them, stanza by stanza.

It didn't take us long to reach a verdict, and it was the exact opposite of what I had expected. Falen's anglicization left Johnston's in the dust, hands down. Soon I was head over heels in love with Falen's version, and that launched me on a binge of reading different translations of *EO*, memorizing nearly 1,000 lines of the book myself in the original Russian, trying my hand at translating a few stanzas, getting hooked on that addictive activity, and finally, in 1998–99, producing my very own verse translation, which I dedicated to Jim Falen and his wife Eve, for they, in the intervening years, had become my very dear friends. My obsession with *EO* had no bounds, and it continues to this day.

In 2009 I taught a seminar on *EO* here at IU; it was cross-listed in Slavic Languages as well as in Comparative Literature, and about ten students signed up for it. We had a ball reading the whole novel-in-verse aloud (it consists of 380 so-called "Onegin stanzas" of fourteen lines apiece). Perhaps 100 of the stanzas we read came from Jim Falen's translation, another 100 from Babette Deutsch's marvelous 1937 translation, and maybe another 100 from my own. The remaining stanzas came from other translations (including Charles Johnston's, Walter Arndt's, and Oliver Elton's) — and I also read aloud many stanzas in the original Russian to the students, even requiring them to memorize any ten stanzas they wished, in either English or Russian.

One evening toward the semester's end, I invited all the students over to my house, and after tasty pizza, salad, and sherbet, each of us recited our ten newly-memorized Onegin stanzas aloud (remember, I always play the role of a student whenever I teach, so I, too, recited ten freshly-memorized stanzas). On that same evening I handed out copies of a booklet that I'd made with ambigrams on all their names (for each person, I'd done two: one in capitals, one in smalls). Here is the cover of that booklet, featuring the title of Pushkin's verse novel first in upper case and then in lower case:

And here is a sampler of the students' names from the booklet:

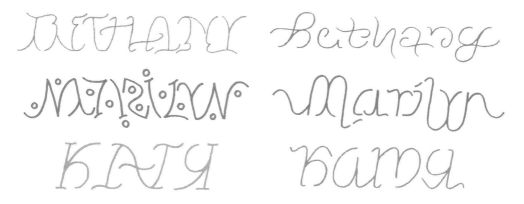

I hope the upper two lines are reasonably readable by speakers of English; the third line, however, is not in English. Katya (who was a graduate student in organ performance) was born in Russia and spent her first twelve or so years there; then her family moved to the U.S., and by the time she took my *EO* seminar, she had spent perhaps fifteen years here. She still had a trace of a Russian accent, and her way of reading aloud was also somehow redolent of Russia; whether consciously or not, her reading style was laced with irony and wry humor, so that it was an immense treat whenever her turn to read rolled around. Her name in uppercase Cyrillic is "*КАТЯ*", and in lowercase cursive Cyrillic is "*Катя*".

As I stated earlier, I normally shy away from ambigrammatical challenges in other writing systems, since I am not a native-level writer or reader of any script other than the roman alphabet — but in Katya's case I made an exception, and I think it was an easy enough challenge that it worked out well.

My final challenge was to salute, albeit posthumously, an honorary member of our seminar, whose initials are "ASP". Here is how I rotationally rendered his full name, first in upper case and then in lower case:

I am only too aware of various shortcomings in each of these attempts, but even so, I am overall pleased with them. At the time, I was elated to have jumped through these challenging hoops.

Audacity

That fall I met a bright young museum curator named Jillian and also her romantic partner Seth (no connection to the author Vikram Seth). Jillian and I soon discovered we had many common interests, as did Seth and I, and we had a merry time talking until the wee hours a few nights in a row. Late in 2009, I decided to make an ambigram for the couple, but with their names having such different lengths, it was a sticky wicket to get them to mesh. After lots of struggle, I came up with a pretty zany maneuver, yet maybe you won't find it too outlandish:

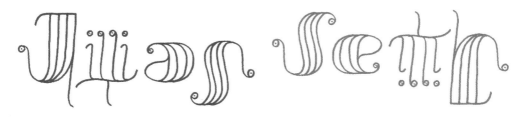

How can *four* letters ("illi") possibly rotate into just *one* ("t")? Well, here you see my attempt. To make it happen, I borrowed the quadruple strokes that I had used in the three other letters, and I also engaged in some playful games with dots.

Do you believe that explanation, dear reader? You shouldn't. It may sound plausible at first blush, but actually it's pure nonsense, because in it I reversed the causality. In truth, the quadruple strokes in "J", "a", "n", and in "S", "e", "h", as well as the light-hearted dot-play, all *flowed from* the zany "illi"/"t" solution, rather than giving rise to it. In other words, the tail sort of wagged the dog.

I'm proud of this act of ambigrammatical bravado, even if to some viewers it may seem way over the top. In fact, I freely admit that it is over the top, but that's exactly why I've included it here. In any case, a small serendipitous side effect was that the "n" in Jillian's name looked like a casually dashed-off portrait of her. You never know what'll come up, in this strange land of Ambigrammia.

CHAPTER 15

Zologrammes à Paris

Salsagrammes

Starting on New Year's Day of A.D. 2010 (a year that, for obvious reasons, I nicknamed "Zolo"), I took a one-semester sabbatical in Paris, which I extended over the summer, thus bringing it to eight months altogether. For the previous five years, I'd been working like the devil with my French friend and cog-sci colleague Emmanuel Sander on two books — one in English, one in French — about the centrality of analogy in thought. From 2005 on, I had spent a month each summer in the City of Light, and Emmanuel had spent a month each fall in the Burg of Blooms; it had been a wonderfully stimulating collaboration, but even after five years of intense labor, we were still far from the finish line, and needed a big chunk of time together. As it was a lifelong dream of mine to live in Paris for an extended period, this was Fate handing me just what I wanted, and on a *plateau d'argent*.

Months in advance, I found a lovely apartment in the fifth *arrondissement*, on the rue Buffon, right next to the magnificent Jardin des Plantes (founded in 1635 as the Royal Garden of Medicinal Plants). As a lonely singleton, I felt that it would be crucial for me to have some "extracurricular" activity that would bring me into contact with, as they say, "people" (nudge-nudge wink-wink). As my departure approached, my kids suggested that I, as a vegetarian, might look into vegetarian cooking lessons, which was an inspired idea, but somehow it didn't grab me.

One fateful morning in November 2009, as I was pulling out of my garage at home, I noticed something on the car's floor. I leaned over, picked it up, and saw it was an ancient cassette of salsa songs. It must've been hiding under the driver's seat for many a moon. Remembering I'd once liked its music very much, I stuck it into the cassette player, and *bang*! — in a flash, I knew what I would do in Paris.

I looked up *leçons de salsa* in Paris on the Web and found plenty of sites, but one really charmed me. It was called "Paris Mambo" and it had a certain *je ne sais quoi* that tugged at my heartstrings. Within days of arriving in Paris, I was attending not just one but two weekly classes with its founders, Hubert and Karine Ceram, in widely separated districts of Paris — Alésia and Belleville. Hubert and Karine were both excellent teachers, and although I was scared out of my wits that I wouldn't be good enough to "hang in there", I somehow managed to do so for the entire eight months, and in the end, my plunge into salsa turned out to be just as revolutionary in my life as my discovery of *Eugene Onegin* had been.

Those unforgettable months in what the Romans once called "Lutetia" were also one of the most fertile ambigrammatical periods in my life. During that time, I created (er... *discovered!*) two or three hundred ambigrams of many sorts, of which I'll give you a small sample here. First off, the name of my beloved salsa studio:

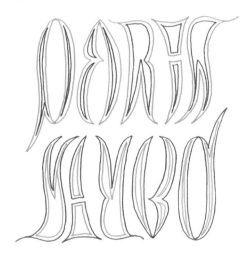

I admit that to someone who has never heard of Paris Mambo, this 'gram will probably be rather elusive, but I was trying to capture the amazing swirling spirit of Hubert and Karine in my letterforms.

You've already seen (in Chapter 8) the T-shirt homage that I made to Paris Mambo and to Hubert and Karine, as well as two wall reflections of "salsa", but even so, I can't resist sticking in yet one more variation on that delicious theme:

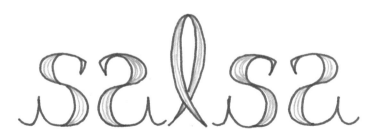

There were ten students in each of my weekly classes, and after a few months had gone by and we all knew each other to some extent, I made an ambigram for each of them, as well as for each of Karine and Hubert's excellent assistants. Among the students were two young women who I often ran into on the platform of the Alésia *métro* station as we arrived for our lesson with Hubert. They were clearly very close friends, and as a tribute to their *amitié*, I designed ambigrams for the two of them, making them look as similar as I possibly could. Here they are:

I urge you to take a moment to try to decipher them. Each of them features an extremely French first name and an extremely French last name, the latter of course being drawn at right angles to the former.

The one on the left says (or was meant to say) "Emmanuelle Choisy", and the one on the right says (or was meant to say) "Estelle Lebigre". As you surely can anticipate, my favorite spots in these ambigrams are where the first and last names crisscross. On the left, the space between the "n" and the "u" forms an "o", and on the right, the crossbar of the second "E" in "ESTELLE" becomes a lowercase "i" (topped off by a red dot). Of course, some of the letters in these 'grams are a bit far-fetched, but then again, we're in the land of Ambigrammia, aren't we?

Métrogrammes

I always took the *métro* from "my" station (Gare d'Austerlitz) to my salsa lessons, passing through about ten stations each time. Ever since my teen-age years, I'd always loved the names of the Paris *métro* stations, so profoundly redolent of European history, and the station names along my route started sinking into my brain. After a month or two, I realized I had nearly memorized all the stations on a few lines without even trying, which pleased me no end, so then I set myself the eccentric goal of explicitly memorizing all 300 station names along all fourteen lines. It took a lot of practice, but after a few months, I had them all down pat, and could mentally chart a route from any station to any other. To me, this was a way

of becoming a "true Parisian". One day, as Emmanuel and I were riding the *métro* together, I took nervous delight in reciting the entire *réseau* to him, and he (a genuine Parisian, born and bred) was very impressed!

My natural next step was to see if I could do ambigrams on all 300 station names, so one day I screwed up my courage and embarked on that monumental campaign. I decided to tackle the longest station names first, and over the course of a week or two, I did the following 28 (listed in alphabetical order):

Barbès–Rochechouart, Breguet–Sabin, Champs-Élysées–Clemenceau, Charles de Gaulle–Étoile, Châtelet–Les Halles, Cluny–La Sorbonne, Denfert–Rochereau, Faidherbe–Chaligny, Gare de l'Est, Gare du Nord, Havre–Caumartin, Lamarck–Caulaincourt, La Motte-Picquet–Grenelle, Ledru–Rollin, Louvre–Rivoli, Marcadet–Poissonniers, Marx–Dormoy, Maubert–Mutualité, Michel-Ange–Auteuil, Michel-Ange–Molitor, Montparnasse–Bienvenüe, Mouton–Duvernet, Réaumur–Sébastopol, Reuilly–Diderot, Richelieu–Drouot, Sèvres–Babylone, Sèvres–Lecourbe, Strasbourg–Saint-Denis.

Each one of these 28 names exuded an indescribable poetic aroma for me, and they kept on reverberating in my head. I won't exhibit my solutions for all 28, but just to give you a little taste, here are three samples (those whose names are given in red above):

Chapter 15

I had a wild little hope that maybe somehow, when I finished doing all 300 station names, I could get them officially adopted by the R.A.T.P. (*Régie autonome des transports parisiens*) and perhaps posted in all the stations. But how could such a dream ever come about? Well, at some point I was invited to give a lecture at the world-famous École des Beaux Arts (France's most prestigious art school), and in an eyeblink I said yes. I chose to talk on ambigrams, including many from the list above. A professor who attended it told me that she would be glad, on my behalf, to contact a friend of hers who was high up in the ranks of the R.A.T.P., to see if they would be interested in my ambigrams. I was thrilled at the idea, but alas, I never heard back from anyone at the R.A.T.P. Oh, well — *qui ne risque rien n'a rien.* (And I never even tried to do the other 270 or so…)

Pianogramme

By chance, 1 March Zolo was the 200th anniversary of the birth of Frédéric François Chopin — my life's greatest hero — who, although he was born in Warsaw and grew up there, spent the latter half of his life in Paris. That morning, I hied myself to the Place Chopin in the 16th *arrondissement* where, in a small café, I consumed a *café crème* along with a warmed-up *pain au chocolat* (thus a "*chaud pain*"), and when I returned to my apartment, I listened to all sorts of Chopin pieces. While doing so, I felt inspired to make an ambigram celebrating the special day:

It was only while designing it that I noticed a fabulous coincidence: exactly at the midpoint of his name occurred the consecutive letters "CC" — the roman numeral for "200". What luck! And I savored it to the hilt by highlighting those letters in blue. When it was done, I sent it by email to a musicologist friend — a

Chopin specialist — who was visiting the Chopin Foundation in Warsaw, and she soon replied, telling me that my artwork had been greatly appreciated by "Chopin nerds" from all over the world who were gathered there for Chopin's bicentennial.

Amstramgrammes…

Two months later (May 14th), my sister Laura was having her "big six-oh", so I designed an ambigram to celebrate the day and sent it to her via email.

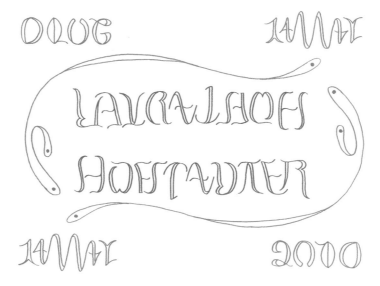

I had an acquaintance who worked in the offices of a high-class publishing house called *autrement* (meaning "otherwise"), so when I dropped in on her there, I brought along a suitable ambigram, which I presented to the firm's director:

The visual rhythm of this 'gram, meaning the periodic placement of its vertical strokes, is perhaps the most pleasing I've ever produced, and it occurred to me that they might wish to use it in some fashion, which would have thrilled me (recall my old Chemway dream), but I guess the folks at *autrement* thought otherwise, since they never got back to me. *Dommage…*

It happened that *autrement* had just published a beautiful book of letterplay called *Les mots ont des visages* ("Words Have Faces") by a remarkably imaginative

artist named Joël Guenoun (see pages 29–30), and his book revealed that he was an ambigrammist of great skill, which inspired me to design a dot-speckled ambigram on his name:

As I was winding up my stay in *la ville lumière* (still a lonely singleton, alas, but at least a bit of a *salsero*), I did a couple of ambigrams in honor of some of the great city's famous spots. One was a quarter-turn that rotated Paris's most celebrated symbol into the name of the grassy park at whose western end it is found:

(To be more explicit, "Tour Eiffel" rotates into "Champ de Mars".) I'll be the first to admit that this one is fetched pretty far, but somehow I still find it fetching.

My final Paris/Zolo offering in this chapter links one of the city's most famous artistic squares (think of van Gogh, Renoir, Toulouse-Lautrec, Degas, and Utrillo, among others) with the picturesque hill at whose summit it is located:

CHAPTER 16

Couplings

From Salsa to Chacha to Kismet

Despite the many joys of my eight-month sojourn in Lutetia, I was glad to return to Villefleury and to find myself back among my old friends, my books, my papers, my piano, and the art on my walls. On the other hand, I didn't want to lose the precious momentum that I'd gained from Hubert and Karine. Although I was still just a low intermediate, salsa had become a vital new facet of who I was.

I found, to my great relief, that there was a dance studio called "Panache" in town, and I called them up. Yes, they did indeed offer salsa classes, and Sandy, the studio's owner, even coaxed me into joining a "silver" (intermediate-level) chacha class as well, telling me that they needed men. She added, "If you know some salsa, you can easily handle a silver chacha class." I wasn't so sure of that, but I joined the class anyway, partly out of curiosity, partly out of hopes to meet "people".

And sure enough, the first time I went to my chacha class, there was a quiet, demure, and graceful woman named Baofen Lin, with whom I got to dance a few times during the hour. At first I was intrigued; by the hour's end, I was entranced! Yet aside from the fact that she had a clear gift for dancing and had grown up in China, I knew nothing about her. After a few more chacha sessions, I asked her if she'd like to have tea with me after class, and she accepted. 太好了！

That evening I learned that Baofen had been born in Hangzhou, had lived in the U.S. for fifteen years, worked as a software developer, was avidly learning French, and had recently taken up the study of the piano. When I asked what kind of piano music she liked, she mentioned Gabriel Fauré's *Dolly* suite. Such surprises! I was impressed by these promising facts about Baofen, and on top of it all, she was single! Oddly enough, something seemed to be happening on the "people" front!

It took only a couple of months before Baofen and I were a romantic item, and I naturally felt that this called for a celebratory ambigram. In fact, I made a few, of which my favorite was this blue-and-red oscillation. Under it, I tossed in a green/pink oscillation between the year ("2010") and my pet name for it ("ZOLO"):

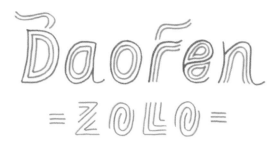

This requires a bit of explanation. Way back in 1976, when I started studying Chinese, my teacher, Professor Richard Kao, wanted to give me a Chinese name. Using my initials "DRH", he chose "侯道仁", pronounced "Hóu Dàorén", and meaning "Marquis Pathway-Benevolent". You couldn't ask for a more classical Chinese name, and I grew very fond of it, both visually and aurally.

Over the decades, I kept on studying Mandarin (or more precisely, flailing wildly against it), and when Baofen and I started going out together, I told her my Chinese name, whose classical flavor she appreciated. But it was pure coincidence that all it took to make her first name out of mine was the addition of two little curved strokes on top — one above the "D", yielding a "B", and the other above the "r", yielding an "f". When I stumbled across that providential property of our first names, I felt it was kismet.

From a prior marriage, Baofen had a son named David Liu, who was studying microbiology at Purdue University. David completed his undergraduate studies at the end of 2010, and I gave him a graduation present of an ambigram on his name:

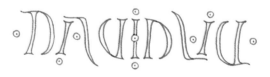

In the summers of 2011 and 2012, I took Baofen to Europe, a continent she had never visited before. She was thrilled to visit Paris, Versailles, Venice, Bologna, Florence, Siena, and many other places. And on September 1st, 2012 — roughly two years after we'd met — Baofen and I got married in Bloomington, in a bilingual ceremony (English and Mandarin) featuring the two of us doing a short chacha routine, which segued directly into a circle of ten of us dancing a much longer and flashier salsa number for all the assembled guests.

Couplings

Below is the ambigram that I made to commemorate that special day.

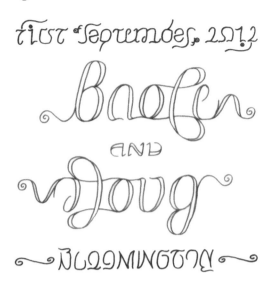

Looking at it critically at a remove of ten years, I see both strong and weak points. On the weak side, the "f" in "Baofen" is a stretch, the "n" is far too small, and the swirl before the "D" in "Doug" is extravagant. Probably today I could do a bit better. On the strong side, I think our names are legible and more or less graceful, and "BLOOMINGTON" (reinvented afresh for the occasion) is a success. Also, making "first" flip into "2012" was a surprising move, but it worked — and turning an elevated "of" in *front* of the month name into a comma *after* it was brazen, but it worked, too! Also in the month name, isn't it curious how the "p", which normally would rotate into a "d", becomes a "b" (and vice versa)? Thanks to the context in which those two letters are embedded, the trick was doable. All these risks I took show why I consider ambigrammia an ideal arena in which to study creativity.

Shortly after we met, Baofen and I started getting together with a group of friends every Sunday evening in my house's *stanza giochi* (playroom) to do salsa dancing. Some of us were young, some were old, some were advanced, some were novices, but we all were salsa *aficionados*, and our little circle, which we named *Los Aficionados*, continued meeting for five years, during which we all became pretty seasoned salsa dancers (*rueda* style — meaning a circle with a caller), able to do dozens of different memorized moves at the drop of a *sombrero*.

Celebrating Others' Wedding Bells

Over the many years that I've done ambigrams, a surprisingly large fraction of them (probably several hundred) have been made to honor couples. The previous

chapters have featured occasional examples, but this chapter is devoted in full to that genre. The four pieces in this section were all created as hat-tips to friends who were just setting sail on the ancient and venerated ship of matrimony; the ones in the following section were made to honor long-term happy partnerships.

Lori and Tom were good friends of Carol's and mine, and they were married in the early 1990s in a tiny stone chapel on the IU campus. This simple lake reflection is a gossamer 'gram whose sparseness pleases my eye.

This wedding gift to my friends Karen and Michael, which I discovered in 2011, features letters with a jagged and somewhat flamelike or organic quality. As you may have noticed, "KAREN" is in capitals, while "Michael" is in lower case.

AUG. 8TH 2015
Rachel
AND
Winston
Bloomington

I hope that it jumped out at you that this gift to Rachel and Winston was presented to them on the 8th of August, 2015, in Bloomington. If it didn't, well, it's back to the drawing board for me…

In order to coax the bride's and groom's names into flipping gracefully into each other, I needed a couple of novel tricks, especially the rotation of "el" into "W". In the end, luckily, the names were happily wedded, as were the flames.

The swirly version of "Bloomington" was created (*i.e.*, discovered) just for this gift, and I haven't reused it since then. A few of its letters, if ripped out of context and taken on their own, would be far from recognizable — yet when they're all used together, I think they work quite well! Perception is mysterious… And finally, my circly sideways "signature" was unique to this gift.

Victoria and Christer got married in Stockholm at the height of Covid days, so I couldn't attend their wedding, but I was there in both spirit and letters.

VICTORIA
+
CHRISTER

Next I turn to ambigrams that celebrate the long and steady trust and caring of couplehood rather than the joyous but transient ceremony of a wedding. First up are my old French friends the Fauconniers, who, for some five decades, were profoundly devoted to each other:

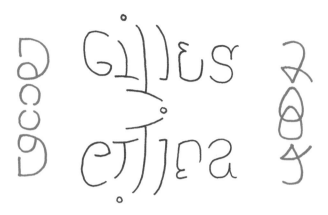

Lake reflections are, as by now you know, rare birds in the ambigram world (at least in mine), but this is a nice example of one, and it celebrates two rare birds in the human world. Gilles Fauconnier was a remarkably discoverative linguist and pioneering cognitive scientist, as well as an incredibly warm-hearted soul, and his wife Tina was a gentle and generous woman who fell deeply in love with China and its culture. I have seldom seen such a well-paired couple. I held Gilles and Tina in very high esteem, and I miss them dearly.

I flanked my blue lake reflection with two red ones — on the left, my name (playfully rendered), and on the right, the year of discovery (equally playfully rendered). Note that the two overlapping "eggs", hovering in mid-air between the "2" and the "4", become top-heavy instead of bottom-heavy when lake-reflected (but that makes no difference to their legibility).

While we're on the topic of discoverers and discoverativity, I'd like to quote from an obituary for Gilles written by his long-time colleagues Eve Sweetser, Seana Coulson, and Mark Turner:

> He was perhaps best known to the International Cognitive Linguistics Association community at large as the discoverer of mental spaces (as he always said, "*Not* the inventor — they were there all along!").

Indeed, mental spaces "were there all along", just as ambigrams have always "been there", as have all so-called "creations" — even *Eugene Onegin!*

Another sentence that surprised me in their essay was this: "He was known to undergraduate cognitive science majors as the faculty member who required them to read *Gödel, Escher, Bach*." Although I knew Gilles for more than 35 years, I'd had no idea of this until I read it in the obituary, and I found it very touching.

Here is another couple with whom I corresponded for quite a while and finally met when they drove all the way from East Lansing, Michigan to a concert and banquet that I organized here in Bloomington:

When seen this way, it's just the feminine moiety of the twosome; to obtain the masculine moiety, you have to rotate it by 180°. I'll do it for you. Here you go:

I hope that you've made out the two names. If you're still stumped, I apologize for my klutzy 2011 performance. The names are "Karen" and "Bob". I find this ambigram fun because in the act of flippage, five letters become just three. It also makes me smile because it looks a bit like a couple of fish swimming in a small aquarium — first leftwards, then rightwards. Swim on, fishies!

In 2015, out of the blue, I received an invitation from the former mayor of the ancient Italian hilltown of Orvieto to visit him and his wife in their home. I was touched by this warmth, and since Baofen and I were going to be in Italy that summer, I accepted. I brought them three ambigrams, one of which is shown above. Although my signature was standard technology, I was gratified to discover that the year could be written in highly legible roman numerals.

As hosts, Susanna and Antonio Còncina (or "Toni", as he is usually called) were more than gracious. They put us up overnight, cooked us delicious meals, introduced us to some of their friends, and Toni, a gifted musician, even gave us a jazz recital on his grand piano. So tell me: What is it about the mayors of Italian cities, whether of just one hill or of seven, that makes them so special?

A couple of years later, while on sabbatical in Hangzhou, China, I received another bolt from the blue: an email from billionaire philanthropist George Soros, telling me of the influence my writings had had on him over the years, and inviting me for dinner at his apartment if at some point I found myself in New York City. I had long admired Soros' humanitarian concerns and his dedication to the cause of building open societies around the world, but never would I have predicted this in a million (or even a billion) years.

Two months after my sabbatical year was over, I flew to New York to visit my daughter Monica, and that weekend, a dinner *chez Soros* was set up. I asked if I could bring Monica along, and was told that *any* guests I might care to invite were most welcome, so joining me were Monica, her friend Alexis, and two other friends of mine — philosopher Achille Varzi and mathematician Karl Sigmund. I made ambigrams for everybody, including this one for George and his wife Tamiko:

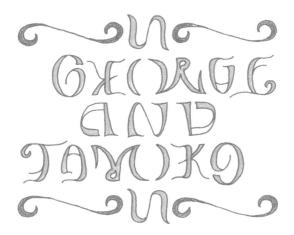

Hidden inside it is their last name. To see it, all you need to do is rotate yourself or the ambigram by 90°, and there it will appear, running right across the midline.

The evening was very unusual. Since George is nearly deaf, in front of each guest there was a microphone with a red button, and if you wanted to speak, you pressed your button and then George could hear you. He peppered us all with questions about artificial intelligence, surveillance, and other serious topics. Karl talked about the Vienna Circle and its high ideals, and Achille spoke with passion about his teaching of philosophy to inmates in prisons. Our lively and intense discussion lasted three hours. I retain a special memory of that evening, as it's not every night that I dine in the home of a visionary billionaire.

Chapter 16

CHAPTER 17

Michaeliana

The Underestimated Lability of Letters

You may already have been aware of the remarkable flexibility of the letters of our alphabet long before you started reading *ABCD*, but if so, you're pretty unusual; to most people it's not an obvious fact. Even Peter Jones, when he first concocted his humorous reverse-readable words in the early 1960s, didn't have any idea of how much additional freedom there was still left to exploit.

In this chapter I'll demonstrate the striking fluidity of letters by showing how diversely the name "Michael" can adapt itself to mate with other names. It's not that this name is an outlier in terms of fluidity; it just happens that over the decades I've had occasion to do lots of ambigrams for people named "Michael" (somewhere between 30 and 40), so I have a rich collection of doubly-readable calligraphic renderings of "Michael" on which to draw.

You've already seen my wall reflection for Michael and Barbara (page 96), my little surprise for Michael Jacobs (page 140), and my rotary wedding gift to Karen and Michael (page 187). Now I will present a present that I designed for yet another Michael and his wife, featuring an eye-catching diagonal that swirls its way southeast from Seattle to Miami, passing through Omaha, as well as an unlikely indivisible chunk converting "HARL" into "HAE".

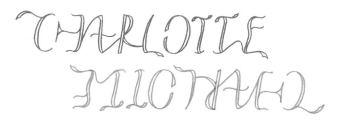

Next up are Sir Michael Atiyah (a mathematician at Mayor Veltroni's *Festival della Matematica*), and the neurologist Michael Shadlen. (Check out the chunks!)

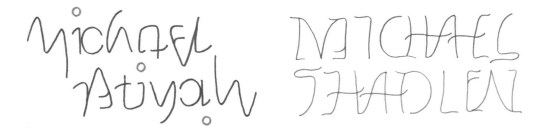

At some point long ago — I retain no memory of when, where, or why — I executed several more ambigrams on this common first name. Here are two:

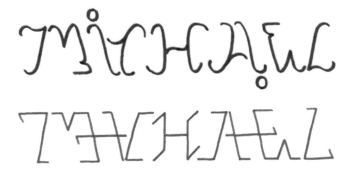

They look about as different as two "Michael"'s could ever look. Just think — one of them's brown and the other one's purple! How dissimilar can you get? On top of that cosmically huge gulf, the upper one is mighty curvy, while the lower one comes from Zigzag City. Wow. Could ever any two entities on the surface of this planet look less alike than these two 'grams?

And yet, I invite you to peer more deeply — to focus on the *ideas* lying behind them rather than on their precise shapes. If you examine these two "Michael"'s at that more abstract level, you will see that they are essentially *isomorphic*, meaning that they have the same conceptual skeleton. It's just that each of them has been translated into the visual language of the other.

Let me explain why I use the metaphor of translation here. Well-educated but monolingual speakers of English who have no knowledge of other tongues have no qualms about declaring that they've read and appreciated great masterpieces of, say, Russian, French, or German literature, because they take for granted that the act of literary translation did not distort anything that really matters. High-quality translation is assumed to be an essence-preserving act, even though it's obvious that

at the surface level — the level of the actual printed words — the original text and the re-created text are galaxies apart.

In a similar fashion, the purple and brown ambigrams are galaxies apart, not just in terms of color, of course, but in terms of basic line elements — *swashes* on the one hand, *slashes* on the other. If, however, you look beyond those eye-grabbing traits, what you'll find is a small set of *abstract ideas* that are fully shared by the two ambigrams. I could pass those ideas to Scott Kim over the telephone in a handful of words, and from my words he could construct his own ambigram using this same skeleton in no time flat. I would tell him that both "Michael"'s are 180° rotations, that both are rendered in all-caps, and that in both of them, the initial "M" rotates into the final "EL", the "IC" rotates into the "A", and the "H" rotates into itself. That's what isomorphism is — two structures sharing a single conceptual skeleton.

Yet another "Michael" is the wall reflection below:

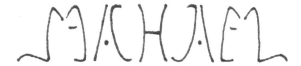

I just noticed a curious fact: this 'gram shares most of the conceptual skeleton of the two that I just discussed: it's wholly in capitals, and more surprisingly, its initial "M" reflects into its final "EL", its "IC" reflects into its "A", and its "H" reflects into itself. I'll never know if this was deliberate on my part, or just a coincidence.

In 1987, toward the end of our several-year stay in Ann Arbor, Carol and I became friends with Michael and Debby Conrad, and I made a couple of ambigrams for them, including this lake reflection on Michael's name.

The doubling of all the lines was done using my photocopy machine. It's perhaps a bit of gratuitous shallow style, but it wasn't done to hide defects; it was done simply for the visual fun of it.

To wrap up my showcase of the fluidity of our everyday letters as exemplified by many renditions of "Michael", I present a quirky q-turn in which the first name of a gifted literary translator rotates clockwise into his last name.

Can you make out the last name? The overlap of the "I" and the "C" in the first name, done in order to yield an "A" in the last name, may be this q-turn's sassiest ploy (after all, it risks being read as "K"), but the rotation of the "M" into a "K" (as well as of the "H" into an "N") also involves a subtle trick, in which what is first seen as one line becomes, post-rotation, two serifs, and vice versa.

Michael Kandel is best known for his virtuosic English translations of the wordplay-drenched works of the late Polish philosopher and science-fiction writer Stanisław Lem. And it's a distinct feather in the cap of Indiana University that some decades ago Kandel earned his doctorate in Slavic Letters here in Flowerville (that is, here in Kwiatowa Wola — or here in Цветоград, in Slavic letters).

CHAPTER 18

Cognitive Science and Music

Speaking of Indiana University...

In 1988, after four years at the University of Michigan, I returned to Indiana University, where I would be joining a brand-new cognitive-science program. I wanted to make an ambigram to help inaugurate it, and I found a simple but easily legible wall reflection, hoping that the program's directors might adopt it as a logo:

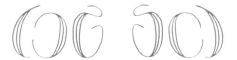

They said they liked it very much, but in the end they went for a different logo. I was disappointed, but, oh, well — you win some, you lose some.

Some 22 years passed, and one day during my Parisian sabbatical, I got an email from the cog-sci program's directors and — what do you know! — they wanted me to design an ambigram to put on a postcard to advertise the program to prospective majors and graduate students. I think they'd forgotten I'd already done that once, but this time I decided to give them something more ambitious:

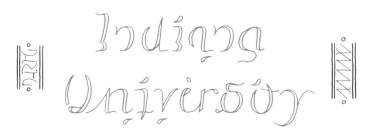

You will recognize my initials in green on the left side, and on the right side the year in roman numerals. As for the Big Red part, I'll let you rotate it by 180° and see what it turns into. No huge surprise if you've been forewarned, of course, but probably quite a stunner if you've never heard of ambigrams in your life!

The Indiana University Cognitive Science powers-that-be once again said they liked this ambigram, and this time they put their money where their mouth was. They printed up a few thousand postcards with this image, and over the next few years they sent them all out (except for the handful that I still have at home), so in the end I felt happy.

Ambigrams, Beauty, Computers, Depth

Having just mentioned cognitive science, I feel that this might be the right moment for me to step back and offer some personal reflections, coming from a long-term cognitive-science perspective, on whether computers might one day be able to originate high-quality ambigrams. Back in 1987, soon four decades ago, in my book *Ambigrammi*, I devoted a long section to that question. At that time, my musings were triggered by my sense of indignation when various people had innocently asked me, after I'd given them ambigrams I'd made on their names, "Oh, did your computer do this for you?" I was thrown for a loop by the naïveté of that question, which fell so wide of the mark.

Probably such naïve off-the-cuff remarks were motivated by such facts as that (1) many ambigrams are symmetrical; (2) many people naturally connect symmetry with mathematics; and (3) mathematics is but a stone's throw from computers. So "of course" a computer *had* to be responsible for a charming pattern that exhibited an unexpected symmetry.

To me, however, that was a galling mental leap, since I knew so well that any ambigram drawn by me had emerged only after a long and thoughtful process of scrutiny, guessing, hoping, sketching, disappointment, erasing, re-sketching, careful weighing of many alternatives, checking with my trusty panel of ambigram-judges, making trips back to the drawing board, rethinking, revising, polishing, and so on, round and round and round. In short, ambigrammia, in my view, lay at the antipodes of what computers were able to do. So I felt incensed by the dismissive implication that all my intense mental work could just as easily have been carried out by a mindless brute-force mechanical process, and that the little gift that had sparked delight might have emerged from some set of ready-made, fixed formulas. I was offended at the thought that all I would need to do is feed any old word or name into "my computer" and presto! — out would come a perfectly rendered, perfectly graceful, perfectly symmetrical ambigram. The very idea seemed to spit on my belief in the mystique of artistic creativity.

In *Ambigrammi*, I laid out all sorts of reasons that computers were infinitely far from being able to do ambigrams. I talked about the hopelessness of relying on precompiled "ambi-alphabets"; about how ambigrams involve not just the *letters* inside words but perceptual *chunks*; about the intimate intermingling of bottom-up forces and top-down pressures in the act of reading; about ambigrammia's reliance on our human susceptibility to illusion and our tendency to "see" things that aren't really there; about the immense subtlety of trying to assess legibility (how do you mechanize Peoria?); about how certain parts of words are far more important for legibility than other parts are; about the unconscious expectations generated by a lifetime of exposure to zillions of letters, words, names, phrases, typefaces, ads, and styles of handwriting; about the ineffable holy trinity of Grace, Elegance, Beauty… All of my arguments were certainly valid when I made them, in the mid-1980s.

And yet today, several decades later, in this era of so-called "deep learning" and "deep neural nets", in this era of ChatGPT and DALL-E and so many other unanticipated AI systems trained on unimaginably huge reservoirs of "big data" and driven by unimaginable amounts of computational power (easily a billion times greater than back in 1987), I have to wonder whether my arguments from so many years ago still hold water. Today's "deep" AI systems can perform feats that would have been inconceivable for the very best of yesterday's AI programs. In so many once-formidable domains (*e.g.*, chess, Go, translation, text generation, video games, and so on), today's systems have not just humbled but *humiliated* human experts — and of course such systems far surpass the dreams of even the most gung-ho of AI researchers of times gone by.

By the way, I keep putting the word "deep" in quote marks because I have a hard time accepting the unspoken implication that today's giant networks, despite their oodles of layers of artificial neurons and their untold billions or even trillions of parameters, are actually deep in the sense of *profound*. Yes, today's "deep" neural networks are surely deep architecturally (meaning they have lots of layers), but do they really *understand* anything, let alone understand it *deeply*? Is the creation (that is, the discovery) of high-quality ambigrams a goal that lies easily within reach today? Or is ambigrammia still untouchable by computers? I honestly do not know.

I haven't yet heard of anyone at Google or Open AI or Meta (or wherever) trying to get a "deep" neural network to come up with beautiful new ambigrams, but I can imagine that it could be a tempting challenge for someone at such a place to take up, even if they'd never made a single ambigram on their own, or thought for a moment about the mental process of coming up with ambigrams. All they would need is to have taken a course or two in neural networks and to have access to *big big big big* data, and of course to boatloads of computational power.

I used to be absolutely sure that coming up with a delightful new ambigram was an intrinsically *human* experience drawing invisibly on all sorts of aspects of

life stored in one's memory. I once thought ambigrammia was inseparable from such human intangibles as the glowing feeling of a fresh insight, the joy of seeing a never-imagined new shape, the spontaneous laughter evoked by a wild and daring leap, the sense of mystery and awe unleashed by a totally unexpected surprise, and on and on. Now, though, sad to say, I'm not so sure that *any* of these oh-so-human intangibles is essential to the creation (or discovery) of an excellent new ambigram.

Part of me still thinks (and all of me still hopes) that high-quality ambigrammia is still way out of range of giant computational systems, but over this past decade (roughly from 2013 to 2023), so many of my long-cherished and certain-seeming beliefs about what computers can and cannot do have been so radically shaken — even shattered — that I no longer have unquestioned faith in my once-trusty intuitions. Instead, I just have to say, with a sense of great malaise, "I don't know."

Myth Becomes Mensch

After such worried musings about computers and AI, I'll return to ambigrams, which, for me, are a source of serenity and joy as opposed to angst and dread.

In early 2014, 62 years after falling in love with the music of Frédéric Chopin thanks to a record my parents bought in 1952, I had the inspiration of trying to contact the pianist, Alexander Jenner, who had performed the twelve études from Opus 25 on that LP. He'd always had a shadowy but mythical presence in my soul, as his youthful recording (he was just 20 when he made it) had enriched my life in such a deep and lasting way (no quote marks around "deep" this time). I was thrilled to discover, after some internettic sleuthing, that Alexander Jenner was not just still alive (he was 84 and living in Vienna), but fit as a fiddle and sharp as a tack.

Our correspondence started off with a four-page handwritten letter I wrote to him, but it quickly metamorphosed into cheery and chatty emails covering every topic under the sun, and accordingly, our opening salutations soon changed from "Dear Prof. Jenner" and "Dear Prof. Hofstadter" to "Dear Sasha" (his father was Russian and that's a Russian nickname for "Alexander") and "Dear Doug". What had started as a crazy dream was actually being realized.

The idea of actually *meeting* Alexander Jenner, that lifelong idol of mine, who had now become simply "Sasha", soon loomed large in my imagination, and Sasha himself was very enthusiastic about the prospect, as was Baofen. He suggested that we spend a Viennese weekend together with his daughter Patricia (aka "Paca") and her husband Mike Jenner. So in May of 2014 Baofen and I flew from Venice to Vienna, where we were met at the airport by Sasha, who treated us like long-lost cousins (although for him, such kindness was just par for the course).

I had prepared ambigrams in advance for all three Jenners, and at a dinner after a concert to which Sasha had taken us, I presented them. Here is Sasha's:

There are a couple of *trompe-l'œil* effects here — notably, the way that the "AND" on the top line turns into the "NN" on the bottom line, and the way that the "X", quite prominent on the top line, goes unnoticed on the bottom line.

And here's the ambigram that I gave to Paca and Mike (or rather, here's a pencil sketch of it):

For some reason, I didn't photocopy the final felt-tip-pen version I made for them, but I am very fond of this sketch; in fact, it is among my top favorites of all the ambigrams I've ever done, probably because (a) it is so legible; (b) its letterforms have a pleasingly uniform style; (c) it uses some multi-letter chunks I'd never used before; and (d) the couple to whom I gave it were such sweet people, and were so tightly linked to my lifelong hero Sasha. (The only sin I need to atone for here is that of having ended "Patricia" with an "A" instead of an "a", and I confess that that's a capital sin.)

Eta Canon

I'll now briefly rewind the tape of my life and go back to the year 1976, the year I met Scott Kim. As you know, Scott was passionate about symmetry and letterforms, but I haven't mentioned his equal passion for music. Scott and I often played piano pieces for each other, and we both revered J. S. Bach's intricate polyphonic constructions, especially fugues and canons. (If you're not familiar with canons, a canon is a multi-voice piece of music where at least two of the voices play exactly the same melody, but offset in pitch, time, or in some other manner. The

simplest type of canon is a *round*, such as "Frère Jacques", where several voices come in, one after another, singing exactly the same melody. There are many other varieties of canon, but in all of them, a melody accompanies itself in some way.)

One day Scott showed me a canon for two violins, allegedly composed by Wolfgang Amadeus Mozart. The special thing about this canon was that if it were placed on a flat table between two violinists who stood facing each other, and if they both were to sight-read the notes on the table from start to finish, the resulting two-voiced piece would sound like a lovely melody with accompaniment. Such a canon is sometimes called a "canon by retrograde inversion", since the tune that the first violinist is playing right-side-up and forwards is being played by the other violinist both upside-down (inverted) and backwards (retrograde).

I was fascinated by this idea, so I decided to see if I could compose such a piece myself. I decided to use a lot of polyrhythms — specifically, two notes played against three. I also decided to make my melody swing back and forth *irregularly* between two's and three's. To do this, I used a number-theoretical sequence that I had discovered when I was a teen-ager, which was based on $\sqrt{2}$. The sequence started out "1, 2, 1, 2, 1, 1, 2, 1, 2, 1, 1, 2, 1, 2, 1, 2, 1, 1, 2..." If you count the 1's between successive 2's, you get the following sequence: "1, 2, 1, 2, 1, 1, 2..." In other words, the sequence "equals its own derivative", in an obvious sense of that phrase. And the average value of this infinite aperiodic sequence turns out to be $\sqrt{2}$.

As a teen-ager, I had explored this sequence and dozens of its cousins for years, and I called them "eta-sequences". So for my own canon by retrograde inversion, I decided to use the first few dozen terms of the eta-sequence of $\sqrt{2}$, merely adding 1 to each term; this gave "2323223232232323223..." My melody-to-be would feature that irregular eta-heartbeat. As for the pitches, I had to find a sequence of notes that, if two musicians stood facing each other and sight-read the melodic line at the same time, what came out would sound harmonious and ear-pleasing.

I actually didn't write a piece for two violins, but for two voices on the piano, one in the treble clef and the other in the bass clef. It took me a couple of days of hard work, sitting at the keyboard, to come up with a natural-sounding melody that had the above rhythmic pattern and that harmonized well with its own retrograde inversion. When I'd finished my canon, I learned to play it fluently and showed it to Scott and a few other friends. It amused me to reach the halfway point in the piece, then to rotate the sheet of paper by 180° and casually continue playing.

Many years later I decided to get all my small piano compositions performed for my 70th birthday. Until then, my pieces were all just handwritten manuscripts, but I felt it would be much better to have them elegantly typeset, and I found someone who was skilled at such work, and he did a great job with them. Most of my pieces had titles, but this one had never been given a proper title, so I decided on "Eta Canon", or, using the lowercase Greek letter eta, "η Canon".

As my Eta Canon's score was rotationally symmetrical, it was inevitable that I would come up with some rotationally symmetrical ambigrams to decorate it. One would give the composer's name; another would give the piece's title; the third would give the location and date of composition (Stanford, August 1976).

What you see below is my canon by retrograde inversion, embellished with three ambigrams designed almost forty years after the music itself was composed. The purple 180° rotation on "DOUGLAS R. HOFSTADTER" was brand-new, and both it and the red-and-blue 180° rotation giving the location and date were chock-full of swirly curlicues — purely the results of tight constraints. Needless to say, if I'd been left to my own devices, I would never have thought of such designs…

CHAPTER 19

Unigrams and Multigrams

NYC Trix

A few years ago, I yearned to draw a map of my natal town. I don't recall the spark that lit the fire, but it launched me on an epic trek, riding five horses at the same time! Actually, the horses were merely burros, and to be honest, the burros were just boroughs. But no matter! Off I set on an epic trek upon five boroughs at once. And good grief — before I could even finish saying "The Bronx is up and the Battery's down!", my map was already complete! And it had all been drawn in capital letters, to boot! And all using 180° rotations! Will wonders never cease?

Ambigrammia Seen as Magical

Occasionally, when I show people amusing ambigrammatical stunts like the five boroughs above, they will ask me, with eyes full of wonder, "Can you do this for *any* name?" I usually reply, "Well, it all depends on what you mean by '*do this*'. What does '*do this*' mean to you?"

I think what people generally mean by the question is: "Can you take any old word or name and make it turn into itself via 180° rotation?" They don't take into account such crucial questions as *how legible* the end result might be and who the *intended audience* is, nor the possibility of my resorting to *other symmetries*, such as wall reflections, lake reflections, q-turns (clockwise or counterclockwise), let alone rotoflips — nor does it occur to them that I even have the option of *reframing the challenge* itself (meaning that, instead of doing "Elizabeth", I might try to do "ELIZABETH" or "Betty" or "BETTY" or "Liz" or "LIZ" or "Lizzie" or "LIZZIE", depending on Elizabeth's range of nicknames). Like legibility and audience, such dodgings or tweakings of the challenge are out of sight, out of mind for them.

If, however, what the questioner means is: "Can you always take a name precisely as given to you, and execute a perfectly legible 180° rotation on it?", then the answer is: "No, I certainly cannot always do that — not by any stretch of the imagination!" It's true that I often can do *something like* what they are imagining, but often I'm just stymied, and have to move on to explore alternate strategies.

Mostly, when people ask this question, they don't have legibility, intended audience, different symmetries, or challenge-reframing in mind. They simply believe that, whatever curve ball they might throw at me, I can hit it smack out of the park. And maybe that's just as well for me and other ambigrammists; it makes what we do seem more like a set of magically inexplicable tricks than hard work.

Variety Is the Spice of Life

The first year I taught a class on ambigrammia was 1985; since then I've done it several times more, including one time at the height of the Covid pandemic. For that reason, I taught the class via Zoom. I had ten students — some undergrads, some grads — and their initial levels of skill in ambigram design ranged from pretty high to not so hot. Of course I was able to help each of them improve to some extent, but I think the ones I helped the most were the few who, from the get-go, seemed to have a natural bent for the art form.

The first assignment I gave involved just single words, such as their own first names, but after that, I wanted them to tackle *sets* of words, so I asked them for suggestions, one of which was the twelve canonical birthstones (one for each month of the year). I liked the idea, but doing twelve ambigrams felt too daunting to most

of the students, so together we sought a less difficult set of closely related words. Somebody suggested four classic spice names: "parsley", "sage", "rosemary", and "thyme". Everyone liked this theme, so over the next couple of weeks, we all made attempts at those four words ("we" of course included me, as I'm always a student in my own classes).

Given that I had so much more experience than my students, I threw in some extra constraints when I myself tackled these words. I decided I would try to do all four in lowercase letters, and with 180° rotations. (One page ago, I said that I can't always meet such rigid constraints; however, I can always *try*!) It turned out I was able to do what I considered to be an "A" assignment under those constraints, so I then decided to raise the bar. My next self-challenge, for variety's sake, was to try to do all four spices as wall reflections containing only uppercase letters. That was a tougher challenge, but even so, I managed to jump through all the hoops as well. Here are the eight spice-name designs that I concocted:

First off, a bit of self-critiquing. What is *Rarsley* (top left)? For that matter, what is *YARSLEY* (top right)? And what on earth is *KOSEMARY*? Also, the "H" and "M" in "THYME" are identical! (Okay, not *exactly* identical, but that's just because I goofed up a little in the tracing.) Surely all these flaws add up to a verdict of "Back to the drawing board, Doug!"?

Well, let me rise to my own defense. I'll begin with the "H" and "M". Yes, they're identical, but all five letters in that word are meant to be read *in context*, not in isolation. Think back to "current events" (page 60), where the initial letters of the two words were exactly the same shape. Yet a speaker of English can't help but perceive them as "c" and "e" respectively, thanks to top-down pressures due to the context they're found in. I submit that the same principle applies here. Not only are "THYHE", "TMYHE", and "TMYME" not English words, they aren't even *pronounceable* in English. And so an English speaker's eye–brain system won't even hallucinate those theoretically possible readings; it will just see "THYME".

And by the way, the context for the "H" and "M" doesn't consist of just the three other *letters* in the word; it includes the names of three other *spices*. And not just any old spices; in fact, the phrase *"parsley, sage, rosemary, and thyme"* is a familiar element of our anglophonic culture. It occurs in the lyrics of the centuries-old English folk song "Scarborough Fair", which, thanks to Paul Simon and Art Garfunkel, became very famous in the 1960s, and is still famous today. So the full context in which any of the above letters is to be read is much wider than just a handful of its neighbor-letters; it implicitly includes the old song-phrase, which gives rise to strong top-down perceptual pressures. No native English speaker will see non-words like "YARSLEY", "KOSEMARY", or "TMYME", since the four spice-names, in the song's order, all help to prime each other and to lock each other in.

Thinking of the four spices as a single unit leads to the same question as I asked about the rainbow: "How many ambigrams have we here?" Of course you could say *eight* (and how could I disagree?), but I go for just *two*. I don't feel the whole display amounts to just one ambigram, though, since each column has its own *case* (lower or upper), its own *symmetry* (rotation or reflection), and its own *style*. I see each column as a single, coherent, strongly self-reinforcing ambigram. I will henceforth call a collection of ambigrams that share theme, symmetry, and style a *unigram*. A less tightly integrated set of related ambigrams I'll call a *multigram*.

A Birthstone Unigram

Only a handful of the students dared to tackle the twelve-birthstone challenge, but I myself couldn't resist it. When we looked the birthstones up, it turned out that there was some ambiguity as to what they were. All the lists included the most obvious gemstones, such as ruby, emerald, and diamond, but there was some blur concerning certain months, so that in the end we just had to arbitrarily decide which stones to include and which ones to omit.

Once again I decided to tie my hands a bit, by imposing uniformity on all my designs, so as to make a unigram. After a bit of exploring, I opted for using 180° rotations and all capitals. Here is what I came up with (in alphabetical order):

AMETHYST

DIAMOND

EMERALD

GARNET

JASPER

ONYX

PERIDOT

RUBY

SAPPHIRE

TOPAZ

TOURMALINE

TURQUOISE

Chapter 19

A Pot-pourri of Classical Composers

Very early in my ambigrammatical "career", I tackled the vast and ill-defined galaxy of Italian city and town names, and in the course of that grand adventure I learned all sorts of new tricks, many of which I've re-used ever since. The choice of places was hardly random; I did all of Italy's biggest and most legendary cities and many of its smaller historic ones, but after a while my drive and excitement began to flag; the list seemed endless and the task felt all-consuming.

Ironically, though, not long thereafter, in the late 1980s, I fell into a similar sinkhole — this time the set of composers of classical music. This list, too, was endless and had no sharp boundaries, but even so, the challenge sucked me in once again — and as with Italian cities, I did dozens and dozens of them, until finally one day I started feeling that I was just "pedaling in sauerkraut" (a favorite French phrase), so I quit pedaling, dismounted from my ambicycle, and took a shower.

I recently reviewed that old set of composer ambigrams and saw I'd left out a few salient names and done a poor job on others, so I plunged back into that blurry galaxy, polishing many old names and adding lots of new ones. From the set, I've chosen 25 and shown them below, grouped by nationality: German/Austrian, French, Russian, American, and then a few others from miscellaneous lands.

By no means am I claiming that what follows is The Canonical List of The 25 Greatest Composers; it's merely a personal gesture in that direction. If you're surprised that Chopin is not included, it's because in earlier chapters I've already shown three ambigrams on his name. Also I left out nearly all opera composers, but in compensation, I threw in a couple of my favorite composers of popular songs.

I won't decipher any of them for you; I presume they're familiar, and I hope they're legible. Most are 180° rotations, but there are some wall reflections as well. (How many?) Since I made no attempt at uniformity, it's a 25-element multigram, rather than a unigram. At the end, I'll offer a few comments.

ALEXANDERSCRIABIN

RACHMANINOFF

wprokofiev

igorstravinsky

aaron
copland

samuelbarber

coleporter

georgegershwin

MANUEL DE FALLA

DVOŘÁK

GRIEG

Vaughan williams

VIVALDI

The hardest one to read, I would guess, is the name of the composer of the orchestral suite *Love for Three Oranges*. Does that little hint help? I hope so! (Despite its bold teetering at the very edge of legibility, it's my favorite of the whole set.) There is also one name in the exhibit that consists of just one indivisible chunk. Can you find it? And of the twelve capital "S"'s, which one, in your opinion, is the most outrageous? And of course I like the playful thing that happens to the hyphen in the one hyphenated name.

Since music is my very lifeblood, I'm glad that I worked so hard to honor the people who have given me such a profound source of meaning over many decades.

CHAPTER 20

Six (or so) Impossible Things

My Deep Childhood Roots in Physics

My father was an accomplished experimental physicist and a professor on the physics faculty at Stanford, and so, from a very early age, I was surrounded by talk about atoms and nuclei, protons and neutrons, linear accelerators, electron beams, radioactivity, alpha particles, gamma rays, deuterons, klystron tubes, scintillation counters, and on and on. Now little Douggie didn't have the foggiest idea what any of these amazing-sounding things were, but he was fascinated by them all, and understood that they had to do with some of the deepest mysteries of the universe. What was an atom? And a nucleus? What were protons and neutrons? What were electrons and positrons? And photons, neutrinos, and antineutrinos? What was quantum mechanics? For that matter, what was mass? What was energy? What was momentum? And what was angular momentum, so mysterious-sounding?

I was mesmerized by these kinds of questions about the hidden laws of nature and the ultimate constituents of light and matter, and many years later I wound up getting a Ph.D. in physics, although I then switched gears and went into cognitive science, for that discipline turned out, in the end, to be more up my alley. Despite my long and troubled love–hate relationship with physics in grad school, I retained a fascination with it after bailing out, and enormous respect for the experimentalists and theoreticians who explored physics with passion and flair.

Shedding Light on the Luminiferous Ether

It was thus that I felt deeply honored to be invited, in 1987, to participate in a symposium in the department of physics at Case Western Reserve University in

Cleveland, celebrating the 100th anniversary of the pathbreaking, ether-shattering Michelson–Morley experiment, which was conducted there. In 1887, Albert Michelson and Edward Morley showed that the measured speed of light is always the same whether you are stationary relative to the source, moving towards it, or moving away from it. It doesn't matter how you are moving relative to the source, or how it is moving relative to you — the light always approaches you (or recedes from you) at exactly the same speed. This discovery was so counterintuitive, even paradoxical, that it sent physicists reeling in absolute perplexity.

The ultimate explanation for the Michelson–Morley results was found only in 1905 by Albert Einstein, who took as a *postulate* the invariability of c (that is, the speed of light waves), and showed that this postulate led directly to revolutionary consequences about the nature of space and time, which dovetailed beautifully with James Clerk Maxwell's equations of electricity and magnetism. In particular, the M–M experiment, along with AE's special theory of relativity, disproved the long-standing belief that light was a vibration in some kind of jello-like space-pervading *medium*, to which had been given the name "luminiferous ether". The ether was imagined to be to light waves what air (or water) was to sound waves — it was a ghostly yet material medium that "jiggled" when light passed through it. This notion was pulverized by the M–M experiment and Einstein's explanation of it.

I must have given some kind of short presentation on that splendid centennial occasion at Case Western, although I have no memory of what I said. All that I remember is that at some point, I projected on the screen the handwritten names of three key scientists who had been lauded to the skies by prior speakers:

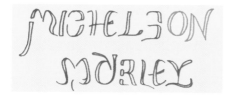

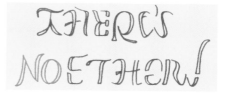

At first, the audience must have been baffled by the peculiar lettering styles, but when I manually rotated my transparencies with these calligraphed names, not only were the resultant upside-down pieces of calligraphy easily readable, but they put their metaphorical fingers on the key themes of the symposium:

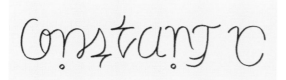

This simple little stunt evoked gasps and spontaneous applause from the attendees, which taught me a memorable lesson: When you have nothing substantial to say, say it with panache! And by the way, soon we will encounter another "No ether".

Niels Bohr and H-orb Lines

Among the most crucial steps in the early twentieth century's revolution in physics was the so-called "Bohr atom", dreamt up by Danish physicist Niels Bohr in 1913. Building on the recent discovery by New Zealander Ernest Rutherford that atoms had tiny hard cores, which Rutherford called "nuclei", Bohr was led to the radical hypothesis that an atom was like a microscopic solar system. He saw electrons as analogous to planets in circular orbits, with the nucleus playing the role of the sun. The most bizarre and daring aspect of Bohr's atom, though, was that electron orbits, unlike those of big astronomical planets, had predictable sizes; his mini-planets were constrained to go in circles whose radii could be calculated by sticking various whole numbers (1, 2, 3…) into a simple formula. There was thus a smallest possible orbit (called the "ground state"), and then a somewhat larger one, and then a larger one, and so on. But orbits of sizes between these were *verboten*.

To many of Bohr's contemporaries, this seemed as outlandish as saying that people could only have heights of exactly 1 foot, 2 feet, 3 feet, 4 feet, and so on — but never 5 feet 2 inches or 6 feet 1 inch! As you grew, you would always have to instantly shoot up by exactly one foot (or two, or three…), with no intermediate stages allowed! Of course this is absurd. How, then, could an analogous theory for atoms be correct? But despite the seeming absurdity of his ideas, Bohr pressed on.

By absorbing some incoming energy, he posited, an electron could be bumped up from its ground state to "higher" orbits, and likewise it could "decay" from a higher orbit to a lower orbit. As it jumped "down", it would emit a tiny burst of light, whose energy precisely equaled the difference in energies belonging to the two orbits involved, thus respecting the sacrosanct law of conservation of energy.

Using his model, Bohr found a simple algebraic formula that gave all the wavelengths of light that hydrogen atoms could emit when electrons made inter-orbit leaps. To his immense joy, his formula was identical to the experimentally confirmed formula published in 1885 by a Swiss high-school teacher named Johann Balmer, who had divined it from just a few of hydrogen's observed spectral lines (wavelengths of emitted light). The derivation of Balmer's mysterious formula from Bohr's otherwise dubious model suddenly lent the model great credibility.

The Bohr atom ran profoundly against the grain of nineteenth-century physics, but since it predicted very accurately all observed H-orb lines, this crazy-seeming set of ideas eventually wound up becoming incorporated into the enigmatic world of microphysics that, in those pioneering days, was being revealed bit by bit.

Anagrammia and Ambigrammia

Some people, such as myself, savor *ars magna* ("the great art"), which is one of the names given to anagrammia (the pursuit of anagrams — that is, rearranging the letters in a given word or phrase to spell out a different word or phrase). A classic example of *ars magna* is the rearrangement of "ars magna" into "anagrams". As a sometime practitioner of *ars magna*, I regret that I never had the chance to show Niels Bohr that the letters in "Bohr" and "Niels" can be rearranged to spell "H-orb lines". *Nomen est omen!* Surely he would have exclaimed, "Oh — I didn't know the spectral lines of hydrogen-atom orbits had that property!" But he died in 1962 and I found my anagram only in 1998, far too late a date. That's fate.

Another regret is that I never got to show Dr. Bohr my counterclockwise quarter-turn ambigram that converts his horizontal last name into the vertical word "ATOM", with decorations reflecting some of the ideas in his 1913 paper.

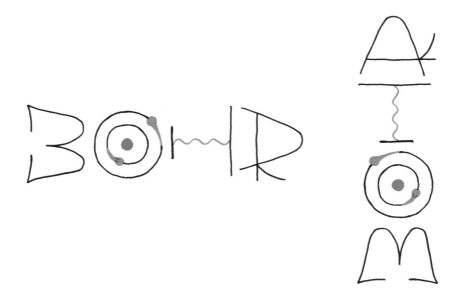

How I Just Barely Missed Out on Discovering General Relativity

In 1915, Albert Einstein published what many consider to be the apex of his soaring scientific trajectory — namely, his theory of general relativity, which extended the ideas of special relativity into a full-fledged theory of gravitation. One of general relativity's more mind-bending predictions was that the presence of *mass–energy* (two seemingly unrelated notions that special relativity had united) caused the invisible fabric of "four-space" (the merger of space and time, another amazing unification due to special relativity) to be *warped*, and that this distortion

of four-space gave rise to gravitation. This abstruse and eerie idea clashed with Isaac Newton's beautiful and time-tested theory of gravitation, but the two rival theories offered nearly indistinguishable predictions of observable phenomena — so close that it took extraordinarily delicate astronomical measurements during a solar eclipse in 1919 to tip the balance in favor of Einstein's new theory.

In Chapter 7, I already displayed two ambigrams on general relativity, but I'd like to include one more here — actually, a very ungraceful one (it mixes cases without a qualm, and features letters possessing no stylistic unity at all), but it's so legible and to-the-point in this context that it would be silly of me to leave it out. Besides, I feel it's good to reveal a bit of my discard pile (even if the act of showing it makes it, by definition, *not* part of my discard pile…). So check it out:

Swivel it around through 180 degrees, and here's what you get:

It's provocative to think that, had I dreamt up this ambigram and the pair in Chapter 7 before 1915, then I, rather than Albert Einstein, would have been universally hailed and celebrated as the creator/inventor/discoverer of general relativity! But dagnabbit, I missed my chance.

Quantum Mechanics and the Uncertainty Principle

In the mid-1920s, Erwin Schrödinger and Werner Heisenberg independently discovered vastly different mathematical approaches to quantum phenomena. At the outset it seemed, paradoxically, that the two theories were correct but were also irreconcilable. Heisenberg merely scoffed at his rival; Schrödinger, by contrast, proved that despite their huge apparent difference, the two were equivalent.

A couple of years later, Heisenberg realized that a consequence of the brand-new quantum mechanics was that certain physical quantities could not be measured simultaneously. In particular, a particle's precise *position* could not be determined at the same at the same time as its *momentum*. The same held for a particle's *energy* and the *time* at which the energy was measured. You could measure either of the two quantities as precisely as you wished, but the more precisely you measured one of them, the less precisely you could determine the other. This disorienting

discovery was called the *uncertainty principle*, and at some uncertain point in space-time I celebrated it, somewhat impressionistically, in a lake reflection:

You don't need me to tell you that there is a lot of sleight of hand going on here. Basically, the simple perceptual principle I relied on in this ambigram is that in reading, you get most of your information from the *upper* halves of letters, so that you can almost ignore their *lower* halves. To bring this out more clearly, I'll here exhibit just the upper halves of both words:

Each of them is readable, or at least guessable, without its lower half.

Going Forwards and Backwards in Time

In the late 1940s and early 1950s, Richard Feynman came up with a stunningly visual approach to quantum phenomena, using pictures that became known as "Feynman diagrams". It was one of the most influential advances ever made in theoretical physics. One of the strangest features of Feynman diagrams was that an *antiparticle* was represented as *a (normal) particle going backwards in time*. Thus an electron going backwards in time was a positron (its antiparticle) moving forwards in time.

Of course, an electron going backwards in time is hardly an easily digested idea for your average non-physicist; in fact, it may well sound downright impossible. At this juncture, however, I feel it is worth quoting a few lines from Lewis Carroll's *Through the Looking-Glass*:

> Alice laughed. "There's no use trying," she said. "One can't believe impossible things."
>
> "I daresay you haven't had much practice," said the Queen. "When I was your age, I always did it for half-an-hour a day. Why, sometimes I've believed as many as six impossible things before breakfast."

The White Queen would surely approve of Feynman diagrams, since they incorporate a number of "impossible things to believe", and yet they have yielded by far the most accurate theoretical predictions of any scientific phenomena ever investigated (for example, agreement to eleven decimal places with extraordinarily precise experimental measurements of the muon's so-called "anomalous magnetic moment"). Feynman diagrams are so central to physics that many years ago, I felt compelled to pay my ambigrammatical respects to them, using a wall reflection that symbolized time reversal:

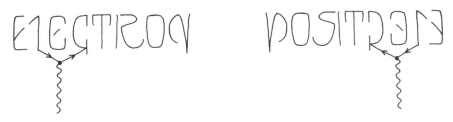

The two tilted lines with rightward arrows (joining the "L" and "C" in "ELECTRON") represent an electron moving forwards in time, while their mirror images with leftward arrows (joining the "R" and "N" in "POSITRON") represent an electron moving backwards in time (in other words, a positron).

The vertical wiggly line in each of these diagrams represents a *photon*, or "light quantum" (an idea proposed by an unknown Swiss patent clerk in 1905 and roundly dismissed by all physicists for the next 18 years). A photon behaves as a particle (and also as its own antiparticle!), which means that when it collides with something, it deposits its energy and momentum in a localized space-time spot. However, photons behave not only as *particles* of light but also as *waves* of light (which is why Feynman chose to symbolize them with a wiggle). The Janus-like character of light is yet another impossible thing to believe before breakfast, I'm afraid.

Every Rascal Thinks He Knows the Answer…

It's *so* impossible to believe, in fact, that three decades ago, I couldn't resist celebrating it with an oscillation ambigram:

I attribute the relatively easy double-readability of this oscillation largely to the fact that "Particle" is written in narrow lowercase letters (aside from its initial "P"), while "WAVE" is written in wide uppercase letters. (You may have to move back a bit in order for the latter reading to jump out at you.) This idea of making an oscillation with narrow letters for one reading and wide letters for the other reading was anticipated in my "SCOTT KIM" oscillation (see page 91).

Here, side by side, are the two intended readings, "decoded":

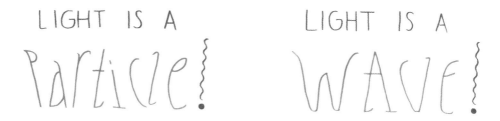

It's not an accident that the exclamation points suggest both wave-nature and particle-nature.

Even today, light's behavior remains one of the greatest unsolved mysteries of physics. As that Swiss patent clerk nostalgically observed toward the end of his life, "All these fifty years of conscious brooding have brought me no closer to the answer to the question '*What are light quanta?*'. Of course today every rascal thinks he knows the answer, but he is deluding himself." Despite the quaint, dated, and sexist wording of this lament by a genius, it is still somehow charming.

Butterflies in My Brain

As I said a few pages back, I thrashed my way down an agonizingly rocky road for eight years in physics grad school, but in the last of those bitter years, thanks to an amazing series of strokes of luck, I wound up going out in a small blaze of glory: thanks to my knowledge of computer programming (at that time a relative rarity in physics), I was the first human being to espy a strange and beautiful shell that was lying unseen, slightly covered by sand, on the vast beach of solid-state physics.

This eerie two-dimensional structure eventually became well-known under the name "Hofstadter butterfly", which is okay by me, as it does indeed look somewhat like a butterfly, but I usually call it "Gplot", which was the name I gave the graph when I discovered it (or created it?) in the fall of 1974. At the time, I was "on sabbatical" in Regensburg, Germany with my Swiss-born *Doktorvater* Gregory Wannier. (Note the old German word meaning "thesis advisor", again lamentably dripping with sexism.) My Regensburg sojourn was actually Wannier's sabbatical, not mine — I, wearing a student's cap, had merely come along for the ride.

The graph I discovered had to do with how electrons in a crystal behave if you immerse the crystal in a constant and uniform magnetic field. Here is Gplot:

How high up you are corresponds to the strength of the magnetic field, and the colored lines at that height correspond to the quantum-mechanically allowed electron energies — but the esoteric physics of the situation is beside the point here; all I want to say is that Gplot is made out of *infinitely many smaller copies of itself,* each one somewhat distorted — but the smaller the copy, the less distorted it is. This kind of "self-similarity" (also called "nesting" or "recursiveness", and, some years later, "fractality") was, at the time, unheard-of in physics, and for that reason, some years after I published an article about it (in 1976), Gplot made quite a splash.

Why am I going on about this? So that I can get to the ambigram, of course. In 2016, at the request of physicist Indu Satija, who had just written a book called *Butterfly in the Quantum World,* I drew an ambigram flipping my last name into the word "butterfly" (and vice versa), and it was included in her book as a bookmark:

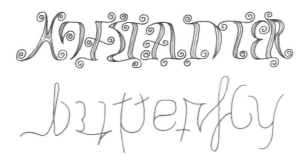

I'll let you rotate yourself or the ambigram to see the second reading. One half of this 'gram is as spare as they come, and the other half is as ornate as they come.

A Thermodynamical Unigram

Speaking of ornateness, I have one final physics ambigram — in fact, a unigram — a colorful curly flight of fancy — to share with you in this chapter. Without further ado, here it is:

If by now, dear reader, you haven't figured out that these are the four laws of thermodynamics, then alas and alack, I've failed royally here!

For anyone who can't decipher the rotated laws, I'll write them all out:

(1) Conservation of Energy
(2) No Perpetual Motion Machines
(3) Absolute 0° is Not Attainable
(4) Something Will Always Go Wrong

The first three laws are taught in any thermodynamics course. The imaginary "Fourth Law" was often cited by my dad when something went unexpectedly awry. It was his way of joking that the world's seeming perversity is actually a law of nature. I believe that physicists of his generation often humorously cited the Fourth Law to express this thought, although today it's usually called "Murphy's Law".

I designed this unigram on a whim one morning a couple of years ago (it took me several hours of hard work, some of which involved figuring out how to word each of the four laws in a pithy way). Of course this 'gram is far-fetched and in many spots pushes letters to their limits (or beyond), but somehow I like it anyway.

I wonder what Peter Jones would have thought of my odd ways of writing the laws of thermodynamics. I'm pretty sure that the two of us together would have laughed our heads off, looking at them. And thus I gratefully tip my hat to Peter *in memoriam*, for having inspired me to do this piece of tomfoolery.

CHAPTER 21

A Phalanx of Fine Physicists

My Youthful Image of Physicists

From childhood onward, I was fascinated not only by the ideas of physics but by physicists themselves. The ones I knew most closely (through my parents, of course) struck me as not just intelligent, but inquisitive, cultured, literate, artistic, musical, witty, nature-loving, generous, and deeply committed to making the world a better place. They seemed to embody all the best sides of humanity. I eventually learned that this idealized impression did not accurately reflect the nature of most professional physicists; in fact, my biased impression was probably due more to my parents' excellent taste in choosing friends than to anything else, but even so, I retained a very positive image of physicists.

When I began studying physics seriously, in graduate school, I couldn't help but develop an interest in the individuals who had made the amazing discoveries I was learning about, especially those towering geniuses — heroes to me — who had unearthed "impossible things to believe before breakfast". And after I had at last earned a Ph.D., even though I felt personally defeated by physics, I still enjoyed reading books about its history, as well as biographies of famous physicists, since I so deeply admired their personalities and the brilliant thought patterns that had invisibly occurred behind their brows.

And so, inevitably, just as with classical composers, I fell into another sinkhole (or obsession or binge) consisting of making ambigrams on the names of top-notch physicists from ancient times to the present, and given that my dad knew so many physicists around the world, I had actually met several dozen of the people whose names I was tackling. Of those, I knew ten or more quite well, and a handful were even intimate family friends. Paying tribute to all these familiar names was almost like coming home after a long odyssey.

I wound up doing just over 200 doubly-readable names of important physicists spanning two millennia, yet paradoxically, the more I did, the more I felt I *ought* to do. Instead of getting shorter, my list of names still to do grew ever longer. It made me laugh to think that, in looking up and writing down names of Nobel Prize winners from decades ago, I felt I was scraping the bottom of the barrel! Finally, at some point, I just drew the line. Two hundred physicists was enough! From my binge, I've culled about forty historic names, but what follows is not offered as an objective list of the forty greatest physicists; it's just my personal set of hat-tips.

Founders of the Science of Physics

First off, two outstanding figures from the Hellenic era: the philosopher who first speculated that atoms must exist, and the fabled bather who cried "Eureka!"

That I opted not to add thickness to the strokes in the bather's name is no sign of disrespect. Rather, it just means that in creating ambigrams, I care more about ideas and simplicity than about imbuing my designs with surface flash.

Next, two astronomers whose revolutionary ideas about the motion of celestial orbs (planets orbited the sun, following ellipses) changed science forever.

You may have noticed that the 'gram on the left features two planets circling stars (and maybe two comets also), and the wall reflection on the right features an ellipse.

I now salute the Italian genius who, by training a telescope on the heavens, discovered four moons of Jupiter; who stated the first principle of relativity of motion; who showed via experimentation that Aristotle had egregiously erred in his armchair theorizing about falling objects; and who profoundly declared that "The Book of Nature is written in the language of mathematics."

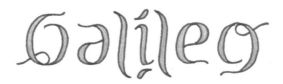

My first try on this name was in capitals, but it had a weakness that gave me pause, so I went back and sought other ideas. I found a slightly better version, still in caps, but felt it wasn't good enough. Then I came across the above lowercase version (or at least its conceptual skeleton), and felt it had been handed to me on a silver platter; I wondered why I hadn't espied it from the very start. Once I'd made the final version, it seemed to me to read almost as easily as if it were printed in Baskerville or Helvetica. That's really rare in ambigrammia. To me, this one feels much more like a discovery than a creation. Alan Guth would surely agree.

The Flowering of Classical Physics

We come next to two English seventeenth-century scientists who were bitter rivals. The one on the left discovered the diffraction of light and from it proposed that light is a wave; he also proposed the law of force governing elasticity. The one on the right argued that light consists of particles and proposed the law of force for gravitation (and, on the side, he developed differential and integral calculus).

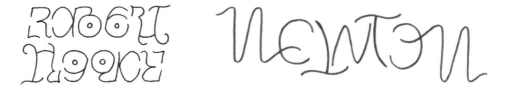

Robert Hooke and Isaac Newton were giants who stood on each other's shoulders.

Many figures in the nineteenth century contributed to the understanding of electricity and magnetism, but none so profoundly as the two saluted below:

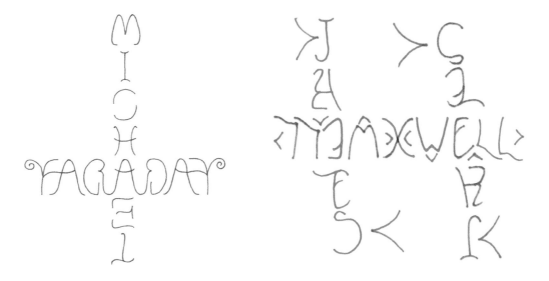

Michael Faraday, whose mind was far more visual than it was mathematical, introduced the subtle concept of *fields*, both magnetic and electric, and drew vivid pictures of them. Today, Faraday's insight pervades every branch of physics.

A couple of decades later, James Clerk Maxwell, using deep mathematical analogies, developed the theory of fields to abstract heights that Faraday couldn't have imagined. Around 1864, manipulating his equations, Maxwell experienced an awe-inspiring epiphany when he discovered that invisible electric and magnetic fields, oscillating perpendicularly to each other, could propel each other through empty space at a unique fixed velocity, which he proceeded to calculate. The result, when he found it, must have made shivers race up and down his spine, for the theoretical number he'd calculated was virtually identical to the fantastic speed at which light had been experimentally measured to travel through vacuum. No one on earth (except perhaps Faraday) had ever imagined that *light*, that mysterious yet everyday phenomenon, had the slightest thing to do with such rare and peculiar phenomena as static electricity, which gives a shock when you touch a doorknob, or the twisty magnetic tugs between certain pieces of metal. Maxwell's epiphany must have been one of the deepest thrills anyone has ever experienced.

The nineteenth century also gave rise to the new discipline of thermodynamics, which grew out of an intense quest for ever more efficient steam engines. Arguably the most important pioneer in this quest was this French engineer and physicist:

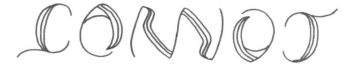

Tragically, Sadi Carnot (who was named after the medieval Persian poet Saadi of Shiraz) died in 1832, at the very young age of 36, long before he could witness the endless reverberations of his ideas in physics, chemistry, biology, and engineering.

During the nineteenth century, a furious debate raged among physicists and chemists over whether or not atoms existed. One of the most ardent advocates of atomism was Maxwell, who envisioned gas atoms colliding with each other inside a vessel held at a given temperature. Despite having only the vaguest image of atoms, he was able to estimate, in 1867, how many of them (if they existed!) would have various velocities; his brilliant analysis gave birth to the field of statistical mechanics.

A few years later, the next great statistical-mechanics pioneer came along. He was an Austrian physicist who was intrigued by the mystery and symmetry of time:

Chapter 21

Ludwig Boltzmann wondered why, given that Newton's equations of motion are time-symmetric, one can easily distinguish between an event running *forwards* in time and the same event imagined as running *backwards* in time. For example, a block of ice will spontaneously melt in a tub of hot water, yielding a uniformly lukewarm tub of water, but a lukewarm tub of water will never spontaneously turn into a tub of hot water with a block of ice floating in it.

Or think of a break shot in pool: when fifteen billiard balls arranged in a tight and motionless triangle are struck by the cue ball, they will scatter and bounce all around the table, but you'll never see the reverse, whereby fifteen balls careening about on a pool table suddenly converge into a tight and motionless triangle, with the cue ball speedily sailing away from it. Break shots on pool tables are a dime a dozen, while a *time-reversed* break shot strikes us as nonsensical and impossible. But how can this intuition be reconciled with the fact that no one can tell whether a random film clip of colliding billiard balls is being shown forwards or backwards?

Boltzmann spent most of his life trying to explain how events on a *macroscopic* level can clearly reveal time's arrow (for example, the block of ice melting in hot water, or the chaos-wreaking break shot on a pool table), while the *microscopic* laws of physics have no arrow. His insights into time's symmetry and asymmetry still lie at the core of statistical mechanics; I wish that he could have seen his manifestly asymmetrical last name written in a manifestly symmetrical fashion.

A Dramatic Break at the Turn of the Century

We come now to the turn of the twentieth century, that pivotal moment when everything in physics swiveled about, almost on a dime. In the year 1900, the word "quantum" was given to physics by a conservative middle-aged German physicist:

Before 1900, Max Planck had been struggling for many years to explain the so-called "black-body spectrum" (roughly speaking, the colors taken on by a hot burner on an electric stove as it heats up). He finally concocted a formula that matched the experimental data to a tee, but he was unable to *derive* it from known physical laws; it was just an inspired guess. Luckily, after months of groping in the dark, he hit upon an artificial mathematical trick from which he could derive his formula. However, he hated this trick because it blatantly contradicted what he

considered to be nature's deepest fabric — continuity. It presumed that the atoms jiggling in a black body's walls could take on only certain *discrete* energy levels, not a *continuous* range of energies. And yet, despite all his qualms about these "quanta" of vibrational energy, he published his formula plus its derivation since it matched the experimental data so precisely. His fervent hope was that, in the future, the ugly assumption from which he had been able to derive the black-body spectrum would be superseded by a deeper and more beautiful insight… but that never happened.

The next major figure in the story of the quantum was someone we have already met: the Technical Expert (Third Class) working in a Swiss patent office in Bern in 1905. That was the year in which, on April Fool's Day, this expert was promoted to the rank of Technical Expert (Second Class). Callooh callay! No wonder they called it his *annus mirabilis*! In that same year, the second-class patent examiner published four revolutionary papers that turned physics on its head.

The first of those four papers is usually called "the photoelectric-effect paper", which, alas, is a most misleading label, since the photoelectric effect is discussed only at the end, and only as a kind of footnote to a far more profound idea. It *should* be called "the light-quantum paper", since its key idea is the particulate nature of light. This immortal paper starts out by stating an *anomaly*, then proposes an *analogy*, then supplies an anti-intuitive *answer* to the anomaly, and ends with an *annex* suggesting three experimental tests of the proposed answer.

The *anomaly* is the odd fact that some physical energy-carriers are spread-out and undulatory (wave-like), while others are localized and corpuscular (particle-like). "Does this dichotomy of the world make sense?", asks the author rhetorically.

The *analogy* compares a black body (a cavity containing only light, and held at a fixed temperature) with an ideal gas. When considered as *physical* systems, the two seem to have little in common, but the author reveals a hidden *mathematical* similarity between the formulas expressing their thermodynamic properties.

Then, after a page of careful algebraic shifts, he arrives at an idea that implies a fantastic, maybe crazy, *answer* to the anomaly: the hypothesis that light, in contradiction to a century of seemingly watertight proofs that it is undulatory, is instead *corpuscular*. Nothing could have made physicists of the day more scornful than this brazen and patently blockheaded claim from a mere patent clerk.

And then the *annex* gives the clerk's humble predictions of three consequences, one of which was a simple formula for the photoelectric effect. Who, then, was this uppity unknown upstart of a light-quantizer? I suspect you already know…

Chapter 21

The sad thing is that it took eighteen years before the world of physics took the upstart's light-quantum hypothesis seriously. Max Planck of course abhorred it, since it not only was consistent with his ugly 1900 paper, but further *extended* its ugliness. To Planck, all this quantum stuff that he'd reluctantly launched was becoming a frightful incubus ravaging the pristine beauty of classical physics.

By far the most careful and respected investigator of the photoelectric effect, Robert Millikan, published his definitive treatise on the subject in 1916, in it saying that Einstein's 1905-predicted graph of the effect had, most puzzlingly, turned out to be spot-on, but adding that the *basis* for that graph (namely, the alleged quanta of light) was clearly nonsensical. Millikan even had the gall to claim that Einstein himself had, in the intervening years, renounced his light-quantum hypothesis. This claim, however, was pure, empty fluff; there was nary an ounce of truth to it.

It was only in 1923, when Arthur Holly Compton observed light (or more precisely, X-rays) scattering off atoms and changing in "color" (that is, frequency) — a phenomenon that flew in the face of the then-accepted undulatory picture of light, but which matched AE's corpuscular theory to a tee — that the physics world started to accept the "impossible to believe" idea that light was always produced and absorbed in indivisible "packets" or "chunks", rather than in smooth waves. So in the end, the Einstein of 1905 was vindicated, but how long it had taken!

In 1896, the French physicist Henri Becquerel observed a new kind of ray emanating from uranium samples. These rays behaved differently from X-rays, which had recently been discovered in Germany, and Becquerel was joined by a young Polish colleague and her French husband in investigating the nature of the new rays. The brilliant Pole named the general phenomenon "radioactivity", and with her husband she went on to discover several new radioactive elements.

MARIECURIE

Not only did Marie Skłodowska Curie win a pair of Nobel Prizes for her pioneering research (the first one in physics, the second one in chemistry), but her family — herself, her husband, their daughter, and their son-in-law — collectively garnered a *quintet* of them!

I already mentioned the intrepid New Zealander who, using both experiment and theory, came up with the image of an atom as having an infinitesimal nucleus. The path to this idea began with what he called "alpha particles" — a type of ray spewed out by uranium. Despite knowing next to nothing about these invisible particles — just their mass and charge — our creative experimenter was able to

make a beam of them and to aim it at a very thin sheet of gold foil suspended in a pitch-dark room. He then had his diligent and owl-eyed assistants observe tiny pinpricks of light sparking from a fluorescent screen in the room, each pinprick revealing where a scattered alpha particle had landed. Over a period of weeks, the assistants moved the screen all around the room and thus were they able to observe the relative frequencies of alpha-bounces in different directions.

Once in a great while, an alpha particle would go sailing straight back in the direction of its source, an event about which the experimenter famously exclaimed, "It was almost as incredible as if you fired a 15-inch shell at a piece of tissue paper and it came back and hit you." I have always liked this caricature analogy, but it's not obvious *why* it was incredible. To explain that, I will offer a different image.

Imagine being in outer space and shooting a series of comets at the far-off solar system. Most of them would simply pass through it and emerge on the far side almost undeflected, but an occasional comet would pass close enough to the sun that the sun's powerful pull would fling the intruder off in some other direction. And once in a blue moon, one of the inbound comets would, by pure chance, come so close to the sun that it would wind up getting shot straight back toward whence it had come — reverse scattering, so to speak. Although the solar system is inconceivably vaster than a gold atom and a comet is inconceivably vaster than an alpha particle, the idea is in essence the same. So that's my way of explaining what was so astonishing about alpha particles ricocheting off of the gold foil.

In any case, our experimenter, through very careful mathematical reasoning, concluded that occasional back-scattering necessarily implied the existence of a tiny positively-charged core of each gold atom, far smaller than the dimensions of the atom itself (just as old Sol is tiny compared to the planetary system at whose center it sits). And that is how atomic nuclei were discovered, circa 1911, by Ernest…

RUTHERFORD

Building on that epoch-making experiment by Rutherford and colleagues, as well as on Max Planck's reluctant proposal of quantized vibrations, and ignoring (or disdaining) AE's light-quantum idea, a 28-year-old Danish physicist named…

niels Bohr

dreamt up his discrete-energy-levels model of the hydrogen atom, which was in amazingly close agreement with the carefully measured electromagnetic spectrum of hydrogen (meaning the colors that its atoms naturally emitted and absorbed).

As I mentioned in Chapter 20, Bohr, in devising his atomic model, pulled several impossible-to-believe postulates out of a hat, blithely charging ahead even though they violated well-confirmed laws of nature. I would characterize the philosophy behind his model as follows: "Things in the realm of Microscopia are necessarily alien to creatures who grew up in Macroscopia. These new principles that I've proposed, strange though they may seem, are just how things must be, way down there on the tiny scale of atoms."

Bohr's circular orbits went a long way towards explaining the spectrum of the hydrogen atom, but when the spectrum was scrutinized ever more finely, what had once seemed like *single* spectral lines turned out to be *clusters* of very closely-spaced lines. At that point (circa 1915), a great German physicist jumped into the fray and, much as Johannes Kepler had replaced the Copernican/Galilean *circular* planetary orbits by *elliptical* planetary orbits, he replaced Bohr's circular orbits by elliptical orbits, and was thereby able to account for the newly-seen clusters of spectral lines. Sadly, he was overlooked by the Nobel committee, yet he served as teacher and mentor to seven Nobel Prize winners in physics! I speak of Arnold…

To me, this was a most familiar name from my teen-age years onwards, since on my dad's bookshelves there were two physics texts in German — *Wellenmechanik* ("Wave Mechanics") and *Atombau und Spektrallinien* ("Atomic Structure and Spectral Lines") — out of which he had studied when he was in his twenties (this made a big impression on me), and both were written by Arnold Sommerfeld.

Shortly after Bohr's atom hit the scene, a very young British physicist and a considerably older one — the latter in fact the former's Papa — bounced X-rays off of crystals and figured out how to use the angles and intensities of the diffracted X-rays to deduce the geometrical arrangement of the atoms in the crystals. The internal structure of crystals was revealed for the first time ever, and thus did X-ray diffraction become one of that era's most important scientific tools.

I think of this William Bragg/Lawrence Bragg 'gram as denoting Bragg *père* when peered at upside-up, and Bragg *fils* when peered at upside-down. Thanks to its unadorned simplicity and graceful lines, it is one of my favorites of this set. (I hope you will pardon my braggadocio and not think me a braggart.)

The Emerging Centrality of Symmetry in Physics

Symmetry operations play a key role not just in this book but also in modern physics, a fact that was realized only in the early twentieth century. Several great mathematicians spearheaded this breakthrough, but by far the most important result was discovered in 1915 by E.N. Her theorem states that to every continuous symmetry of the laws of physics there is a related quantity that is *conserved*, an idea that stunned the world when she discovered it. Thus, that the laws of physics are *time*-invariant (they don't change as time passes) implies that *energy* is conserved. That they are *translation*-invariant (they don't vary as you move from place to place) implies *momentum* is conserved. That they are *rotation*-invariant (they don't depend on one's orientation in space) implies that *angular momentum* is conserved. When I learned these surprising relationships in graduate school, I almost fell off my chair.

Emmy Noether studied under David Hilbert in Germany and became a good friend of Albert Einstein. It was in fact Einstein who helped her emigrate to the United States when the Nazis took power. She became a professor at Bryn Mawr, where she taught until her early death in 1935. At that university there is a humble stone memorial with nothing but her two initials and her dates. Recently I found a simple anagram on her name — namely, "MY THEOREM — E.N." — that honors her great achievement. I wonder if she knew her name had that property.

Noether's brilliant friend Hermann Weyl — another refugee from Nazism — was inspired in 1918 by Noether's ideas to study the symmetries of Einstein's equations for general relativity. He miraculously found that Maxwell's equations could be derived from Einstein's equations if the latter had a property he called

"gauge symmetry". Einstein was thrilled, but then he found a subtle flaw in Weyl's reasoning, and the promising idea was dead in the water. It was, however, revived in 1929 when an analogous gauge symmetry, this time of the equations of quantum mechanics, allowed Maxwell's equations once again to be deduced. There was no hidden flaw this time, but it didn't lead to any new physics. It was only in 1954 that yet another Weylian gauge symmetry was found, opening up new worlds in physics.

Quantum Mechanics Arrives

It was in the 1920s that the greatest revolution ever in physics took place. The spark that kindled the fire was when a young French prince —

— in the wake of Compton's 1923 discovery that light is both particle and wave, asked, in his 1924 doctoral thesis, if the same might not also be true of an electron.

In retrospect, it is surprising that Einstein himself didn't come up with this symmetrical hypothesis long before Prince Louis de Broglie did, but it's just one of those curious quirks of history. In any case, de Broglie's suggestion was quickly taken up by several theorists of the day, and in 1926 a quantum wave equation for electrons was proposed. When it was applied to the single electron in orbit in a hydrogen atom, it agreed perfectly with the experimental data.

You may recall (Chapter 20) that two rival theories of quantum phenomena were proposed in the mid-twenties, and although they competed for a while on the quantum stage, they were soon proven equivalent. *Matrix mechanics* was dreamt up by a young German (upper line) and *wave mechanics* by an elder Austrian (lower):

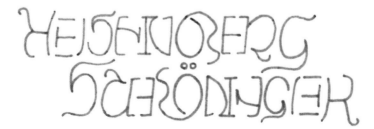

"HEISENBERG/SCHRÖDINGER", devised some 35 years ago, still pleases me (although I think I'd do it a bit better today), and I vividly recall thinking, back then, how miraculous it was that the rivals' names fit together so neatly. In other words, "How stunning it is that these seemingly unrelated names have this intimate

link, hidden but inherent in them!" Today, however, I just yawn and think, "It was bound to be doable, given that the two names are about the same length."

A few months ago, I interwove the roughly equally-long names of the two discoverers of another subtle quantum phenomenon:

Eight letters and nine letters, respectively — a piece of cake, not a miracle at all!

Samuel Goudsmit and George Uhlenbeck were graduate students at the University of Leiden in the Netherlands when they jointly dreamt up an exotic new quantum concept that came to be known as *spin*. I feel that that term gives me the license to call the above 180°-rotation ambigram a "spinonym" — although unlike Greg Huber's "GUTH" glyph (or my subsequent "DOUG" glyph), this spinonym can be read only when it is facing up or facing down.

Goudsmit and Uhlenbeck learned, in 1926, that every hydrogen spectral line splits into *two* lines whenever a magnetic field is present, and the size of the split is proportional to the magnetic field's strength. To explain this, they imagined that electrons could spin like gyroscopes, except that unlike a gyroscope, an electron's axis could point in only two directions relative to the applied magnetic field: either parallel or antiparallel to it (called *up* and *down*). An orbiting electron with spin up accounted for one of the two lines; one with spin down accounted for the other.

Spin was a close cousin to angular momentum, since it was reminiscent of a ball's rotation about an axis, and yet it was as different from everyday macroscopic rotation as electron orbits were different from planetary orbits. Just as you cannot force an electron to occupy a position between two quantum orbits, so you cannot force an electron's axis of spin to point in an intermediate direction between *up* and *down*. Such bizarreness might make your head spin, but by 1926, any type of bizarre behavior in Microscopia was coming to be just one more impossible thing to believe before (or during, or after) breakfast.

A crucial quantum breakthrough took place in that same year, when a totally unexpected interpretation of Schrödinger's "wave function" was suggested by…

Born proposed that what was "waving" in, say, the 3-D space surrounding a hydrogen nucleus was the *probability* of finding the electron at any given spot. That is, if you moved around inside the atom, the chance of finding the electron where

you were would vary according to Schrödinger's equation, and even if you just sat still, the probability of finding the electron in your lap would vary over time.

If this radical idea of Max Born's was correct, it implied that probability, as opposed to certainty, played an uneliminable role in quantum mechanics, which in turn meant that events in Microscopia could happen just at random, spontaneously, without the existence of any *cause*. In short, if Born's randomness was intrinsically built into the fabric of nature, then determinism was dead. This, for some people (especially Einstein), was the most impossible of all impossible things to believe.

The Birth of Particle Physics

On the north side of the English Channel, quantum ideas were slowly trickling in. In September 1925, a paper by Werner Heisenberg on his brand-new matrix mechanics found its way to Cambridge. A few weeks later, a Cambridge physics student who'd read the paper was taking a Sunday walk in the countryside when it struck him that there was a similarity between a notion in Heisenberg's paper and an arcane topic he'd once studied in a classical-mechanics course. The student —

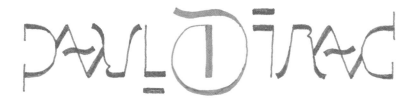

— was anxious to investigate this potential link between classical and quantum phenomena, but as he didn't remember any of the classical-mechanics details, he had to wait until Monday morning, when the physics library would open and he could consult a textbook. Bright and early that morning he sped to the library, where he discovered that his Sunday walk's hunch was much deeper than he had suspected. It led him to propose a systematic one-to-one correspondence between *Poisson brackets* in classical mechanics and *commutators* in quantum mechanics. This unexpected analogical mapping of old onto new was the subject of the first of several monumental papers written by Paul Adrien Maurice Dirac.

Perhaps Dirac's greatest stroke of genius, though, was the 1928 paper in which he masterfully combined special relativity with the idea of a wave function and came up with what today is known as "the Dirac equation" (and those words are often uttered with a tone of reverence). Here it is, reverently written out:

$$(i\gamma^{\mu}\partial_{\mu} - m)\psi = 0$$

A Phalanx of Fine Physicists

I won't try to explain this equation; I just wanted to display it, since it is so simple and elegant, and since it led to so many profound consequences, including a far deeper view of what spin is, plus the prediction of the existence of antiparticles. In fact, the Dirac equation eventually gave rise to the heart of particle physics — quantum electrodynamics ("QED" for short). If any equation in physics embodies the notion of symmetry, it's this one; and so, to my mind, its discoverer deserves a lovely ambigram (and — icing on the cake — a lovely Nobel Prize). When I was a lonely struggling particle-physics graduate student in the early 1970s, even in my periods of greatest despair I could always return to this equation and feel its magic.

Dirac also invented a tricky mathematical notion called a "delta function", which is, in essence, a *very very* narrow bell-shaped curve. It's the limit of what you get if you make the bell thinner and thinner and simultaneously taller and taller, always keeping its area constant. When it becomes *infinitely* tall and *infinitely* narrow, then you have a Dirac delta function.

My dad used to call colleagues who were extremely sharp in an extremely narrow specialty but who were nil in all other areas of life "delta functions" — a humorous label I still use now and then. Ironically, Dirac himself merited this label, since all his talent was concentrated in physics, and in human company he barely fit in at all. My parents came to know Dirac in the late 1930s, and my mother recalled a soirée in Princeton where a physicist had just played the sublime gigue ending Bach's first partita for piano. When asked what he thought of it, Dirac said, "Oh — I loved the crossing hands." My mother also recalled a time when Dirac was telling a story about his wife Margit, whose brother was the renowned Hungarian physicist Eugene Wigner (pronounced "Vigner"). Dirac spoke of her neither as "Margit" nor as "my wife", but as "Wigner's sister". Technically speaking, what he said was correct, but humanly speaking, he was revealing just how much of a delta function he was.

I'll add just a few words on my ambigram on Dirac's name. I instantly saw that "PAUL" and "IRAC" would rotate easily into each other, but that meant that if I went that route, the "D" in the middle would have to turn into itself. I decided to try it out, but it took a bit of fancy footwork. What I wound up with is a shape that is not the same after a 180° rotation, yet I think it possesses sufficient "D"-ness in either orientation. Perhaps my unorthodox way of thickening of its strokes (at top and bottom instead of along the sides) contributes to that; and in order to maintain that style, I extended the unorthodox thickening to all the other letters.

Chutzpah and Neutrinos

One time when a 40-year-old Albert Einstein had just finished giving a lecture in a jam-packed auditorium in Vienna, a youngster in the audience stood up and loudly announced to the crowd, "*Was Herr Einstein gerade gesagt hat war nicht so blöd.*"

("What Mr. Einstein just said was not so foolish.") The 19-year-old *Knabe*, destined to be one of the great physicists of the twentieth century but at that point totally unknown, had no idea of the chutzpah of what he had just blurted out. Similar uninhibited audacity cropped up repeatedly over his entire career. His name was:

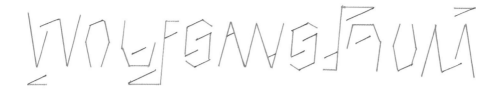

I confess that I drew all 67 of those straight-line segments with the help of a ruler, rather than freehand — but at least I didn't use a computer!

In the 1920s, when Pauli was just beginning to gain renown, he was puzzled by an obscure atomic phenomenon called "the anomalous Zeeman effect". One day a friend ran into him as he was distractedly strolling down a Copenhagen street. The friend said, "You look most unhappy, Pauli. What's troubling you?" Without a moment's hesitation, Pauli replied, "How could anyone not be despondent when thinking about the anomalous Zeeman effect?" Surely you feel the same way.

Perhaps the most famous remark Wolfgang Pauli ever made was a withering criticism of a lecture he had just attended. He said, "That wasn't *right*; it wasn't even *wrong*!" And one day, when Pauli himself was uncharacteristically floundering a bit in a lecture, a Hungarian colleague named Eugene Guth (unrelated to Alan Guth) gently tried to help him out with a suggestion. Pauli just glared at him and crushingly intoned, "Guth, what *you* know, *I* know." How harshly he could bark!

It was Pauli who, in 1925, realized that identical particles in Microscopia, being perfectly interchangeable, had to behave in a very special and non-classical manner. For electrons, his insight was that no two of them could ever be in the same quantum state, and this law was called the *Pauli exclusion principle*. This turned out to be the key to understanding the nature of all multi-electron atoms, and thus it explained all the patterns in Dimitri Mendeleev's periodic table of the elements.

By 1930, physicists were aware of a serious enigma in the phenomenon of beta decay, which took place when certain atomic nuclei unpredictably spat out both a proton and an electron. Careful measurements had revealed that in such decays, neither energy nor momentum nor angular momentum was conserved. The conservation of each of these quantities constituted the three most hallowed laws in all of physics, and nuclear beta decay violated all of them at once! Pauli pondered this confusing situation at length, and finally it occurred to him that there might be a stealthy and massless (or near-massless) third particle invisibly sneaking off with exactly the right amounts of energy, momentum, and angular momentum

— a *deus ex machina* that would save all three conservation laws in one fell swoop. And yet he felt deeply ashamed of having conjured up a particle out of thin air. Such things simply weren't done! At that time, the only known particles were the electron, the proton, and the photon. Even the neutron wasn't known. There was no such thing as the densely teeming "particle zoo", which plagued physics later.

Pauli didn't dare write a paper describing his half-cocked speculation, but he at least wrote a letter to a friend in which he sketched it out. He suggested that the friend, who was heading off to a conference on radioactivity, might run the idea up the flagpole and see if anyone saluted. To Pauli's shock, it caught on like wildfire, and soon the existence of his hypothetical highly elusive speck was widely accepted. But despite this advance, no one yet knew how beta decay really worked.

By the mid-1930s, Pauli was one of the quantum world's brightest stars, and myths grew up about him. One such myth, jocularly called "the Pauli effect", had it that any time he walked into a laboratory, a piece of equipment would fail. (It was even claimed that if Pauli was in a train passing through a town that had a physics laboratory, some lab apparatus would break during his transit.) One day Pauli visited a physics lab and no equipment broke at all. Everyone wondered what had gone wrong until some wit observed, "It's the Pauli effect once again!" When I first heard this story as a kid, I thought it was hilarious; it may well have been the first joke based on meta-level self-reference that I ever encountered. For the rest of my life I would continue making jokes of this sort.

During Christmas vacation of my dad's Swiss sabbatical year (1958–59), we rented a chalet in the Alps near Geneva and skied every day. One day, however, my dad heard the news that Wolfgang Pauli had just died in Zurich. Even though he had never met Pauli, he was very saddened, and he decided to take the train to Zurich the next day in order to attend Pauli's funeral. He asked me if I wanted to come along, and since, at age 13, I'd never been in a German-speaking city, I was intrigued, so I said yes. I will never forget being in Zurich during Pauli's funeral.

There is a stipulation that nominations for the Nobel Prize must be kept secret for fifty years before they can become public. Well, my father won the Nobel Prize in physics in 1961, and in 2011, fifty years had passed. It was right around then that I learned of the fifty-year-secrecy rule, and of course curiosity drove me to find out who had nominated my dad. To my surprise and delight, among the names in the list I found on the web was that of Wolfgang Pauli! He wasn't *always* so harsh…

In 1932, it came as a big surprise that inside nuclei there were not just positively charged protons but also electrically neutral particles that had almost exactly the same mass as the proton; these newcomers were given the name *neutron*. (The word had been coined earlier by Pauli for his massless, or nearly massless, speck, but no one else had adopted that name, so it was used for the new heavy particle.) It was soon found that *free* neutrons (neutrons in empty space) decayed after a while.

I use the vague term "after a while" because there was no *precise* lifetime for a neutron; this was, after all, the weird world of Microscopia, where events happened acausally, unpredictably. But at least there was a precise *average* lifetime for a free neutron — close to 15 minutes. So at some random point in its brief life, usually between five minutes and an hour after being "born", a free neutron would poof out of existence, leaving behind a proton and an electron, and meanwhile a much lighter speck would presumably flit away, unseen. Neutron decay was the purest form of beta decay, much simpler than the beta decay of an atom's nucleus.

At first people thought that neutron decay revealed hidden machinations inside the neutron itself. That is, they imagined that any neutron, before decaying, must contain a proton, an electron, and a tiny "Pauli speck", all swarming around together, a bit like three insects trapped inside a jar; if you remove its lid, then the three bugs will soon buzz off. But a young Italian physicist in Rome —

Enrico Fermi

— had doubts about such a picture. Enrico Fermi believed there were no particles at all buzzing about inside a neutron, whether it was floating in space or bound inside a nucleus; rather, he believed that a neutron just abruptly poofed out of existence, and at the same instant, three brand-new particles were suddenly *created*.

Fermi's colleague Edoardo Amaldi gave the name *neutrino* ("little neutral one") to Pauli's neutral and massless (or nearly so) speck, and Fermi turned his personal vision of a neutron's beta decay into a precise mathematical theory wherein one "destruction operator" and three "creation operators" all acted simultaneously. He wrote it up and sent it off to the elite British journal *Nature* — but he was rebuffed by its editors, who dismissively wrote: "Your article's speculations are too remote from physical reality to be of interest to the practising scientists who make up the audience of the journal." Disheartened but resilient, Fermi sent his article to less prestigious journals in other lands, and soon it was published. Thus did Fermi's theory of the "weak interaction" gain a crucial toehold in the physics world.

Fermi's wife was an Italian Jew, and as storm clouds gathered over Europe in the late 1930's, they decided to move to the New World. Once they had settled in America, Fermi, who was aware of the theoretical possibility of a *chain reaction* (a newly-minted phrase) in certain radioactive substances, especially uranium, started trying to produce such a thing. In late 1942, he and his colleagues created the first "atomic pile" in an abandoned underground squash court in Chicago; then he realized it might be usable in a bomb, and from that grew the Manhattan Project.

He soon went to Los Alamos to help develop the atom bomb, although he recommended against using it on a civilian target. After the war was over, Fermi, like a number of other Manhattan Project physicists who'd been exposed to highly radioactive substances in Los Alamos before anyone realized their great danger, contracted cancer, and he died from it at the early age of 53.

I have a curious personal connection with Fermi, albeit a rather oblique one. My dad, in a 1956 paper called "Electron Scattering and Nuclear Structure", coined the term "fermi" to denote a distance equal to 10^{-15} meter (a convenient unit when one is dealing with subatomic phenomena), and his coinage, meant of course as a tribute to Enrico Fermi, was subsequently adopted far and wide.

The Birth of Solid-state Physics

I earlier mentioned that Wolfgang Pauli was one of my dad's Nobel Prize nominators. Another name that I found in that list was this one:

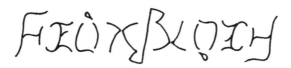

I wasn't in the least surprised to see that Felix Bloch had nominated my dad, since for decades they were the closest of friends and colleagues at Stanford. I grew up knowing Felix and his whole family extremely well, and from that long friendship I gained a great deal, including a love for skiing.

In the late 1920s, when Felix Bloch was Werner Heisenberg's first doctoral student (they were only five years apart in age), he discovered *Bloch waves*, which are the basis of solid-state physics, and a few years later he discovered *Bloch domains*, which are indispensable in describing the internal structure of magnetic substances like iron. Bloch's 1952 Nobel Prize in physics, shared with Edward Purcell, was for pioneering research into nuclear magnetic resonance, which later gave rise to the all-important medical tool of magnetic resonance imaging.

In 1934, Felix, who was Jewish, fled from Europe because of the rise of Hitler, and, taking a career risk, he accepted an offer to join the physics faculty of a then-unknown small university way out in the Far West of the United States. To get to Stanford from the east coast, he bought a car and drove all the way out, stopping in the Grand Teton Range in Wyoming to do a few days of mountain-climbing, an activity that, as a child growing up near the Swiss Alps, he had always loved. During that short stay, he and a local guide found a new route up a difficult peak in the Tetons, and it was officially named the "Wilson–Bloch ascent". In his later years, Felix was as proud of that achievement as he was of his Nobel Prize.

During the war, Felix wanted to contribute to the war effort against Germany, so for a year or so he joined the top-secret Manhattan Project in Los Alamos, but designing a weapon that could kill many thousands of people was too troubling, so he left New Mexico and moved to Boston to work on developing radar. After the war was over, Felix could never bring himself to forgive his former close friend Werner Heisenberg for having remained in Germany to help the Nazis.

I could tell plenty of other stories about Felix, but that's enough for now. The ambigram I made in his honor (unfortunately I did it long after his death) is one of my favorites of this set, mostly because of the novel "XBL" trick in the middle, but also because of its minimalistic style.

Nuclear Physics and Cosmology

When I was just a kid in fifth or sixth grade at Stanford Elementary School, I would sometimes arise before school started, walk down the hill to the tile-roofed campus, head for the Student Union, go downstairs to the diner-like counter where a few students were eating breakfast, and then, feeling oh-so grown-up in such elite company, I would order myself eggs and potatoes (but not coffee!).

The main reason I went down there is that only a few feet from the counter there were several shelves of science paperbacks published by Mentor Books, such as *The Sea Around Us*, by Rachel Carson. Avid for knowledge, I would browse through them with high curiosity, especially those that dealt with physics or math. One morning I was riveted when I read the title "ONE TWO THREE… INFINITY". The cover featured planets and galaxies, test tubes and pipettes, a rocket taking off, and best of all, the square root of $1 - v^2/c^2$ (whatever that exotic formula meant). The book, replete with droll illustrations by the author himself, felt heaven-sent. I purchased it and dove right in, and although I never reached the very end, what I read of it had a lasting impact on my young and absorptive mind.

Its author was a Ukrainian-Russian émigré physicist named George Gamow (pronounced "*Gamm*-off") who had come up with major insights in nuclear physics, astrophysics, and cosmology, and even in molecular biology, where, guessing that different triplets of bases in a DNA strand would map onto different amino acids,

he astutely anticipated the nature of the genetic code. Gamow was not afraid to jump across disciplinary boundaries and to make hypotheses of all sorts.

Besides being a superb physicist and writer, Gamow was an irrepressible prankster and punster. His most memorable shenanigan was when, without asking permission, he freely tossed in the name of a famous physicist as the third author of a paper that he and a doctoral student had just finishing writing, solely in order to make an amusing piece of wordplay. (I will recount the story below.)

One of Gamow's greatest contributions to our understanding of the universe was his explanation of how, after the hypothetical Big Bang, the chemical elements were formed inside stars; he called this process "stellar nucleosynthesis". In the late 1940s, he had two younger colleagues who realized that if the Big Bang had in fact taken place, it must have given rise to an immense burst of very high-temperature electromagnetic radiation that filled every cubic centimeter of the growing universe. The rapid expansion of the universe would have greatly stretched the wavelengths of all the component waves in that primordial burst, effectively reducing the radiation's temperature to a tiny fraction of its original value. Gamow's two protégés realized that this ancient radiation (originally intense gamma rays but now extremely feeble microwaves), must *still*, many billions of years later, be coursing through every cubic centimeter of the universe, and this meant it would, at least in principle, be detectable. Calling this ethereal by-product of the Big Bang the "residual cosmic microwave background radiation", they published several papers describing its nature and calculating its current temperature.

These researchers — Robert Herman and Ralph Alpher — went on to have distinguished careers in physics, but unfortunately their prediction of the existence of the cosmic background radiation gradually faded out of sight… and out of mind.

In 1964, two radio astronomers at Bell Laboratories in New Jersey — Arno Penzias and Robert Wilson — were using a radio antenna to probe the skies, but to their consternation there was a constant annoying low-frequency signal that seemed to be polluting their observations. They tried many ways to get rid of this noise, but nothing worked. At one point, they speculated that it might be due to pigeon droppings in the antenna's horn, so they thoroughly cleaned their antenna and started up again, but the radio noise was still there. Little did Penzias and Wilson know, but what they had mistaken for bird droppings was the slowly fading signature of the universe's ancient and tumultuous origin.

Chapter 21

Eventually they realized that these signals were coming from the sky, not from nearby terrestrial sources or defects in the antenna, but they still had no clue as to what they were. They mentioned this puzzle to some theoretician colleagues, who, without realizing it, rediscovered what Alpher and Herman had figured out and had published roughly fifteen years earlier. The next year, two back-to-back letters were published in *The Astrophysical Journal*, one describing the mysterious signals and the other speculating as to their nature, but never mentioning Alpher and Herman. These letters provoked great excitement among cosmologists and astrophysicists, and some years later, Penzias and Wilson were awarded the Nobel Prize for having accidentally bumped into the Big Bang's residual radiation. Unfortunately, Ralph Alpher and Robert Herman were left out in the cold, receiving no recognition for their remarkably prescient prediction of the ancient cooled-down radiation.

I witnessed their sadness up close, since Bob Herman was one of my dad's closest friends, and I watched as his initial dismay at their lack of recognition by colleagues turned slowly to bitterness. My dad nominated Alpher and Herman for all sorts of awards, including the Nobel Prize, and eventually — thanks in large part to Steven Weinberg's excellent expository book *The First Three Minutes* — they did receive a couple of minor awards, but it always struck me as most ironic that two scientists who were clueless about a signal that they'd found were given a Nobel Prize for stumbling upon it, while two scientists who, many years earlier, had precisely predicted its existence and its nature received far less recognition.

Here's a riddle for you. The year is 1948. Your name is "G. Gamow", and you have a doctoral student whose name is "R. Alpher". The two of you have just finished writing a physics paper of which you're very proud. At the top of the paper, you're planning to list your names *in alphabetical order*. What other highly visible physicist of the day would you choose to toss in as a co-author, just out of whimsy, in order to coax quick smiles to readers' lips?

Hint #1: I just gave you a big hint in italics. Hint #2: Think of a famous German-born nuclear physicist whose last name sounds just like "beta". Hint #3:

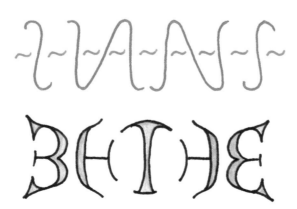

In 1948, Hans Bethe was one of the most visible physicists in the world, thanks to his many contributions to nuclear theory, especially his explanation of how energy is produced in the interior of stars. It was *his* name that George Gamow threw into the pot, thus listing the paper's authors as (ostensibly) *Alpher, Bethe, Gamow*. That was a witticism well worth the making! (In case you don't know the Greek alphabet, then please go look up its first three letters!) The paper itself, on stellar nucleosynthesis, was of such high quality that Bethe was delighted to have his name alpherbethecally sandwiched between those of Alpher and Gamow, and it became famous not just as a joke, but also for its physics.

During World War II, Bethe was a major contributor to the development of the atomic bomb at Los Alamos, and after the war he worked on the hydrogen bomb as well, even though he hoped that the effort would not succeed. Eventually, he came to feel that all further development of nuclear weapons should be stopped, and he became a strong advocate for the abolition of nuclear weapons.

Particle Physics Comes into Its Own

I will never forget a statement that my dad casually made to me in the fall of 1958, when I was 13 years old and we had just arrived in Geneva for his sabbatical year at CERN. There was an "Atoms for Peace" conference going on in the sprawling United Nations building near the lake, and one afternoon he took me to it. At some point the two of us were wandering down a long, vast hallway that was empty except for a lone figure in the distance, approaching us. To my surprise, my dad said to me, "That may be the world's smartest man." (I was too young and the times were too early for me to notice the unintended sexism in the remark.)

The distant figure approached, and when he was within earshot, my dad said, "Hi, Dick — this is my son Doug." (They had known each other at Princeton, back around 1940.) A bit of light chit-chat ensued, and then we parted. That was my first encounter with a legendary figure of twentieth-century physics:

Our next encounter took place when I was 15 and had just started studying calculus a month or two earlier. Feynman was visiting Stanford and came to our house for dinner. "Calculus, eh?", he barked at me, in his strong Brooklyn accent. "So... what's the derivative of $1/\sqrt{x}$?" I was thrown off guard by this impromptu quiz and awkwardly stumbled around a bit, finally coming up with the answer, but I felt ashamed of my mediocre performance (and puzzled by his aggressiveness).

The next time we met I did much better. It was in his office at Caltech in June of 1975, shortly after I'd discovered Gplot but while I was still musing about the endless mysteries of particle physics. A few months earlier I'd come up with a kind of crazy idea about Feynman diagrams, and I wanted to run it by maybe the world's smartest man, or at least maybe the world's greatest expert on that topic.

He politely listened to me express my idea, and then, without an ounce of malice but simply with acute insight, he shot my idea down almost instantaneously. I was feeling a bit crushed, but then he nonchalantly asked me, "So… what is your Ph.D. work about?" With a sense of relief, I said, "Oh, I can show you. It's out in my car." I walked out to the parking lot, fetched my graph of Gplot, and brought it back in. I explained to Feynman that it represented the quantum-mechanically allowed energies of electrons in a highly idealized crystal in a magnetic field (and he offhandedly commented that the equation that gave rise to it seemed to be its own Fourier transform, a fact that I had only noticed after a *year* of working with it), and I added that my graph was made out of infinitely many smaller copies of itself. At this, his eyes bugged out with wonderment, and he exclaimed, "This is fantastic! I have to show it to my son Carl! Would you mind if I made a photocopy of it?" I was deeply flattered that Richard Feynman, of all people, was so impressed with my recent discovery, and an hour or two later I left his office in an elated mood.

Our next encounter took place six years later, when I was giving a physics colloquium at Caltech. My lecture was not on physics but on the subtle nature of analogy-making, and the huge auditorium was filled to the rafters with students, post-docs, and professors. Maybe the world's smartest man was sitting in the front row, and for some reason he kept interrupting my talk, which drove me to distraction but highly amused the other 499 audience members.

Just one example will suffice. I opened my talk by asking (this was in 1981, when Margaret Thatcher was Prime Minister of the United Kingdom and Nancy Reagan was First Lady of the United States), "Who is the First Lady of England?" I was hoping to elicit a cute, mildly creative answer such as, say, "Denis Thatcher" or "Prince Philip" (or perhaps "Margaret Thatcher" or "Queen Elizabeth") — but before anyone in the audience could say anything, Feynman brashly blurted out, "*My wife!*" Bewildered, I said, "Oh! Okay… Dick Feynman's wife. But *why*?" (I was somewhat cowed by his supreme self-confidence.) "Because she's *English*, and because she's *great*!" snapped back maybe the world's smartest man. Hmm…

Since the proposer of this dizzy answer was not a crackpot but Richard P. Feynman, I duly wrote it down on the board, and then asked the audience if there might possibly be any other answers. I quickly received many good ideas from them (this was Caltech, after all), and my lecture got back on track, but Feynman kept on heckling me for the whole hour, giving quirky smart-ass answers that only a village idiot could concoct, and evoking frequent chuckling in the crowd. It was

quite an epic battle, with RPF constantly yelling out off-the-wall pseudo-analogies and DRH trying each time to politely humor His Rowdiness. Never had I dreamt I'd have a public jousting match with such a brilliant thinker acting so perversely.

When the skirmish was all over and I'd had a few days to collect my thoughts, I concluded that Richard Feynman, analogy-maker *par excellence*, simply didn't want to entertain any theorizing whatsoever about the mechanisms of analogy-making, because he felt that how his own mind worked was something deeply mysterious and was (and *should* be) untouchable by science — and so, from the get-go, he just wanted to mock my approach to analogy-making without even giving it the time of day. That, at least, is my *ex post facto* theory of the weird show that Richard Feynman put on, on that afternoon back in 1981.

Feynman was, and still is, adored by many for his humorous storytelling (as in *Surely You're Joking, Mr. Feynman*, a book of anecdotes that, in my view, is chock-full of self-promotion and surprisingly transparent false modesty), and he was, and still is, admired by the entire physics world for his profusion of discoveries (Feynman diagrams, endless insights into QED, the path-integral formulation of quantum mechanics, the V–A theory of the weak interaction, the idea of partons inside nucleons, an explanation of the vortices in superfluid helium, early contributions to quantum computing, etc.). He was also one of the most lucid teachers of physics ever, producing such masterpieces as the three-volume series *The Feynman Lectures on Physics*, and his seven lay-level Messenger Lectures at Cornell University in 1964, which became an excellent little book called *The Character of Physical Law*, and, toward the end of his life, a popular explanation of quantum electrodynamics called simply *QED*. On top of all that, he was an incorrigible skirt-chaser, an avid bongo-drummer, and a talented artist — and his favorite place to draw (and to muse about physics and physiques) was a topless bar in Pasadena, run by his friend Angelo Gianone. (I wonder what the First Lady of England thought of that.)

Richard Feynman was a unique phenomenon — scintillating, brilliant, wacky, egotistical, and annoying. I have to concede that my dad's first words to me about him contained more than a grain of truth, though far from the whole truth.

Next up is Mr. Quark. To be fair, there are two claimants to that honorific, since quarks were dreamt up simultaneously by both Mr. Quark and Mr. Ace (who called them "aces", not "quarks"). Mr. Ace is better known under his other name, however, which is "George Zweig". As for Mr. Quark, he is better known as:

GELLMANN

Murray Gell-Mann was, in a way, the Vladimir Nabokov of physics. Aside from being idiosyncratically creative in his chosen *métier*, he was extremely proud and fiercely competitive (which means he was also extremely insecure); he loved words and loved to display his fluent intimacy with zillions of obscure facts about countless languages, and he always made sure to pronounce the names of foreign people and places with predictably pedantic precision; and where Nabokov was a fanatic butterfly-spotter, Gell-Mann was a fanatic bird-spotter.

But warts and all, MGM was indisputably one of the twentieth century's greatest physicists. From childhood on, he was a keen observer and indexer of all that he encountered, and this led to his noting subtle patterns among elementary particles. In the late 1950s, his "Eightfold Way" (an allusion to Buddhism) placed particles belonging to the rapidly expanding particle zoo into groups of eight (or sometimes ten), but a few years later, that idea was superseded by what I might call the "Threefold Way", which was a new vision of strongly-interacting particles (*e.g.*, neutrons and protons, but many others as well) as compounds made of hypothetical quarks with fractional charges (either $\pm 1/3$ or $\pm 2/3$ the charge of the electron).

For some people (such as myself, and also my dad), fractional charge was a viscerally repellent idea — but even though esthetics drives much of physics, one can't always be sure that one's personal esthetic preferences will be in synch with *Nature's* esthetic preferences — and in the case of quarks, it turned out, after quite a few years of uncertainty and debate, that quarks actually do exist (albeit in an eerie and shadowy sense of that word, since no quark will ever show itself in isolation), and that we skeptics were just plain wrong. *Errare humanum est.*

Although hundreds if not thousands of very bright people were involved in the revelation of the nature of the "strong force" (the force that binds the constituents of a nucleus together), Murray Gell-Mann was doubtless the most central figure of that epic achievement of the human mind — and wherever he went, he made sure that everyone around was aware of the incomparably strong force of his intellect.

I'll give just one example. In 2005, I attended a conference at the fabled Bibliotheca Alexandrina in Alexandria, Egypt, commemorating the centennial of Albert Einstein's *annus mirabilis*, and quite a few famous physicists were there, including Gell-Mann. I, being much more of a cognitive scientist than a physicist, gave a talk about Einstein's pervasive use of analogies, which had impressed me a great deal; I also attended all the other talks, of which the one I most appreciated was given by Serge Haroche on the 1935 paper in which Einstein, with co-authors Boris Podolsky and Nathan Rosen, introduced the "EPR paradox", which later became known as "quantum entanglement". (As a result of his extreme doubts about the nondeterminism that plagued quantum mechanics, Einstein came up with the idea of pairs of particles that were "entangled" with one another no matter how far apart they were, even over cosmic distances. Entanglement struck

him as a *reductio ad absurdum* of quantum mechanics; he was convinced he had blown it out of the water.) The morning after Serge Haroche's talk, I was chit-chatting in a quiet courtyard with MGM and a couple of other people, and I casually mentioned how pleased I was that Haroche had focused on the EPR paradox, since it was so important to Einstein's worldview and yet no other speaker had even alluded to it. On hearing this innocent remark, Gell-Mann suddenly went near-apoplectic and burst out, "The ideas in that paper were no contribution at all! Entanglement was merely a trivial consequence of indeterminacy! Einstein never understood quantum mechanics in the least! He didn't even understand it as well as any random undergraduate physics major understands it today! He was just tremendously stubborn and could be extremely stupid!"

And then, as if these dazzling lightning-bolts of clarity weren't enough, MGM kept shouting for a whole minute more about Einstein's foolishness, while growing ever redder in the face. Without a trace of subtlety or self-awareness, Murray Gell-Mann was informing us that *he* effortlessly understood ideas in physics that had been impenetrable mysteries to the person who many physicists looked up to as the greatest physicist of all time — in fact, as possibly the greatest human mind of all time. I couldn't help shuddering internally at MGM's unfathomable outburst, and bowed out of the conversation. Many people tell similar Gell-Mann stories.

To conclude my comments on Murray Gell-Mann on a more positive note, I'll turn to my ambigram. I hope you like the six red dashes diagonally slicing through the eight blue letters, rather like a neutrino coolly sailing through a pile of lead bricks. I put the first four of them there in order to strengthen category memberships (to be more precise, dash #3 is acting as a hyphen); the final two dashes, by contrast, are mere decorations. Actually, no — I shouldn't just dismiss them as "mere decorations", since decorations in ambigrammia aren't "mere"; they are often enormously important. Decorations are crucial in defining *visual style*, and style is precisely what imbues an ambigram with its unique strangeness, charm, and beauty (a truth that Mr. Quark would have jumped up and down to hear).

When I was 16 and in love with math, another famous physicist came to our house for dinner. Unlike Richard Feynman, who'd embarrassed me with his pop quiz in calculus, this gentler soul presented me with a copy, inscribed by him to me, of G. H. Hardy's classic text *A Course of Pure Mathematics*. It was a thrill to have one of the two discoverers of the violation of parity — meaning the violation of perfect left/right symmetry in the laws of nature — wishing to contribute to my mathematics education. I was touched by this gesture on the part of…

Chapter 21

Only a few years earlier, Chen Ning Yang and Tsung-Dao Lee had proposed that the weak interaction was not left–right symmetric, a proposal that clashed with the entrenched belief that any physical event's mirror image was just as compatible with the laws of nature as the event itself. It seemed obvious to almost all thinking people that our hearts could have been on our right sides, that our DNA double helices could have twisted in the other direction, that writing systems could work as easily one way as the other way, that a clock's hands could rotate counterclockwise instead of clockwise, and so forth. And yet, said Lee and Yang in 1956, maybe the mirror image of a beta-decay event is physically impossible, or else maybe it doesn't have the same probability of occurring as the beta decay itself.

A handful of physicists warmed up to this idea, but most thought it very unlikely. It rubbed them the wrong way. How could nature favor left over right, or right over left? How could anyone sane think that the very fabric of the universe was asymmetrical? To many the idea seemed laughable, but to Chien-Shiung Wu at Columbia University it was at least plausible, so she rapidly threw together an experiment to test the idea, and lo and behold, it came out showing that nature *is* asymmetric. Her unexpected finding still echoes strongly today in particle physics.

Parity violation was not the first revolutionary idea that C. N. Yang had had. A few years earlier, in 1950, he had been inspired by the "gauge symmetry" idea that was originally thought up by Hermann Weyl in 1918, but which was soon shot down by Einstein. Weyl's idea, despite the severe setback, did not die; it only went dormant for a while, and roughly one decade later, first Fritz London and then Weyl himself resuscitated the idea in a new form and in a new context.

I remind the reader that Weyl's 1918 idea had derived electromagnetism from a symmetry hiding in the equations of Einstein's general relativity. This pulling of a rabbit out of a hat was a stunning *tour de force*, even though it contained a fatal error. It seemed too promising to be merely relegated to the dustbin of interesting-but-wrong ideas in physics. In the late 1920s, both London and Weyl explored a different but analogous way of trying to derive electromagnetism — this time not from the equations that explained gravitation, but from the brand-new equations of quantum mechanics. Their idea was a close cousin to Weyl's 1918 idea, and this time it succeeded completely, but as I said earlier in this chapter, it didn't lead to any new physics. Electromagnetism, no matter how it was derived, was old hat.

In the early 1950s, however, there were new equations in particle physics to play around with — equations that had been unknown to London and Weyl in the late 1920s. Yang wondered if these new equations, in analogy to those explored earlier by Weyl, might have hidden symmetries that would give rise to new physics. Yang went way out on a limb and speculated about a generalization of London's and Weyl's gauge symmetry. It was a beautiful and daring idea, but Yang ran into serious mathematical difficulties, so he abandoned it for a few years. In 1954,

though, when he visited Brookhaven Laboratory, he found an ideal collaborator in his accidental officemate Robert Mills. Working together, they overcame all the previous mathematical obstacles, and that year they published an article on their findings. It pointed to a radically new kind of force in nature, but unfortunately, that hypothetical force didn't seem to match any force that was known at the time, so the article garnered little attention and seemed doomed to oblivion.

A decade later, however, particle physicists had come up with new ways of looking at the strong and weak forces, and some believed there was at least a slim chance for a modified Yang-Mills approach to work. And so, during the 1960s, Yang-Mills gauge theories gradually emerged from obscurity and started to have a revival; by the early 1970s, they were all the rage. Eventually, the weak and strong interactions were both recast as Yang-Mills gauge theories that were analogous to quantum electrodynamics ("QED"), and the analogy was extended to their names: "quantum flavordynamics" ("QFD") for the weak interaction, and for the strong, "quantum chromodynamics" ("QCD"). In sum, Chen Ning Yang's early-1950s brainstorm, although it remained formidably abstruse, joined the mainstream, and particle physics was never the same again.

Among the eventual lucky beneficiaries of the Yang-Mills approach were two bright lads who had entered the Bronx High School of Science together in 1946, and who soon became fast friends. After spending their college years side by side at Cornell University, they followed quite separate trajectories, but both devoted their lives to particle physics. In certain ways they had very similar styles; in others they were diametric opposites. The same might be said of their names…

GLASHOW WEINBERG

In the late 1950s, Sheldon Glashow, at the behest of his doctoral advisor, the QED pioneer Julian Schwinger, was already struggling to unify the weak force with the electromagnetic force, and eventually his attempt, when put together with the esoteric notion of "spontaneous symmetry-breaking", gave his old friend Steven Weinberg the inspiration to create a "unified electroweak theory", and the 1967 paper Weinberg wrote on this became the most cited paper ever in particle physics.

Nonbeauty and Nonbelievability

You might expect me at this point to praise both Glashow and Weinberg to the skies, but I regret that I am unable to muster the enthusiasm to do so. I freely acknowledge their brilliance as physicists, but I don't understand or admire the theories that they created. To be honest, their so-called "electroweak unification"

(due not just to Glashow and Weinberg, of course, but to countless other physicists as well, but I will spare you the list) makes me think of someone who clumsily grafts a watermelon onto a raspberry bush and then crows that the watermelon and the raspberry now constitute just one beautifully unified fruit — the "wasperbelly".

This harsh caricature analogy is not made lightly. Any unification in physics takes as its model Maxwell's 1864 unification of electricity and magnetism, whose equations fit together like Astaire and Rogers. The merger between the two forces feels natural and seamless, and through it they clearly become a single entity. The electroweak "unification", however, feels like a shotgun wedding. It is no more natural or inevitable than the comical graft yielding the supposed "wasperbelly".

I earlier hinted at my extremely dolorous days in particle physics in the late 1960s and early 1970s; well, it was just these kinds of ideas — in fact, it was *these very ideas* — that disillusioned me and even turned my stomach. Actually, it wasn't these ideas alone that had this effect on me as a grad student; I recall going to a couple of physics colloquia on the then newly hot idea of string theory, in which the notions of 10-dimensional, 11-dimensional, and 26-dimensional universes were casually bandied about. I couldn't believe what I was hearing, and wanted to vomit. This, sadly, is the kind of thing that happened all the time during the last couple of years of my flailing-away at particle physics.

I felt truly nauseated by certain ideas in particle physics out of a profound, unshakable, and inexplicable personal sense of esthetics — and the proclaimed unification of the weak force with the electromagnetic force was, for me, the straw that broke the camel's back. Although it eventually led to a spate of Nobel Prizes, I found many of the ideas in it both hideously ugly and totally impenetrable. That may sound like an unlikely combination, but it accurately describes my feelings, first as a physics graduate student and then, in subsequent decades, as an ex-would-be physicist striving mightily to understand and make peace with the very ideas that had driven him to bail out of physics in hair-tearing despair.

I will go further and admit that there were many occasions, in those distant days, when I felt that somehow, something in particle physics had taken such a terribly wrong turn that the field was verging ever more dangerously on becoming a pseudoscience. And worse yet, as time passes, I feel this fear even more. All I need to do is read the abstracts of a few recent articles with titles such as "BPS States in the Duality Web of the Omega Deformation" or "Supersymmetric Localization in AdS5 and the Protected Chiral Algebras", and in an eyeblink I find myself once again fighting an overwhelming gag reflex. Alas, particle physics is not getting any better today; it's only growing worse (if that were possible).

If you feel you cannot relate to my reactions to particle physics, then let me run an analogy by you. Imagine that an elite international committee of top-flight ambigrammists were to give its highest award — the world-coveted *Premio Nonbello*

per l'Ambigrammia — to an ambigram that you personally find stylistically hideous and absolutely illegible. That would be a confusing feeling, wouldn't it? On hearing this news, would you say to yourself, "Hmm… I guess that that ambigram *does* have its merits after all, even though at first blush I was sure it was just a deliberately absurd joke"? Under intense peer pressure, would you be willing and able to change your own sense of esthetics? Would you have an epiphany about what *is* and what *is not* beautiful? Would you knuckle under and repentantly say, "Those grotesque chicken scratches that at first I couldn't make head or tail of are — oh, wow, now I see it all so clearly! — quintessential members of their intended categories, and the word that they make up is sublimely beautiful, to boot!"?

More generally, how should one react when something that one instinctively finds grotesque and incomprehensible is honored at the highest levels of world culture, and by judges whom one greatly respects? Should one defer to others' opinions, especially when those others are recognized as world experts, or should one believe in oneself, and stick to one's own guns?

With particle physics, I stuck to my guns. I don't mean to say that I decided my mind was superior to the minds of particle physicists; I didn't have that kind of arrogance. But finding myself unable to mentally flex and adapt myself to the collective judgment of particle physicists, I eventually just bowed out, with a lingering sense of bewilderment and sadness. I had many friends who were particle physicists, and I certainly didn't go around telling them they were all crazy, but I felt no reticence about telling them that I found almost all the recent ideas in their field to be repellently ugly. To my dismay but not to my surprise, such comments met mostly with blank stares, and we simply had to agree to disagree.

Let me return to Glashow and Weinberg. After the "great wasperbelly unification" — oops, I meant the great *electroweak* unification — they came to have very different views of particle physics. Weinberg in particular devoted many years to crafting a triptych called *The Quantum Theory of Fields*, which he saw as a set of pillars supporting his lasting legacy to posterity. The first two volumes, entitled "Foundations" and "Modern Applications", were thorough and scholarly, but not revolutionary; by contrast, the third volume, entitled "Supersymmetry", was (if you will permit the expression) a house of cards. It was all about a huge family of hypothetical particles for which not an iota of evidence existed. It was just hundreds of pages of opaque jargon and dense equations mathematically probing the number of nonexistent angels that could dance on the head of a nonexistent pin. Talk about going out on a limb! By the way, you need not take *my* word for this; Weinberg himself candidly stated the same thing in his foreword to Volume III:

> There is so far not a shred of direct experimental evidence and only a few bits of indirect evidence that supersymmetry has anything to do with the real world.

Why, then, was this outstanding thinker spending so much of his precious time writing such a volume? I haven't the foggiest, and this brings me back to Glashow.

In December of 2017, during my three-month stay as a visitor in the Physics Department in Uppsala, Sweden, I attended a lecture by Glashow on the history and current state of particle physics. I was quite blown away when, in the Q-&-A session, someone asked him his opinion about supersymmetry, and he launched into a virulent diatribe against it, along the way raking his erstwhile friend Steve Weinberg over the coals for being "the last holdout in America who still believes in supersymmetry". He did so in an amusing fashion, carefully avoiding Weinberg's name by saying "a very eminent colleague somewhere in Texas", but it was crystal-clear who he meant. Also during his talk, Glashow referred to the famous Higgs boson (an essential ingredient of electroweak unification) as "the toilet in the house of particle physics". That was pretty astonishing as well.

Martinus Veltman, one of several Nobelists intimately linked with electroweak unification, wrote a very informative (although marred by totally unedited Dutch-style English) lay-level book called *Facts and Mysteries in Elementary Particle Physics*, and toward the end he wrote this remarkable paragraph (italics mine):

> The reader may ask why, in this book, string theory and supersymmetry have not been discussed.... The fact is that this book is about *physics*, and this implies that the theoretical ideas discussed must be supported by experimental facts. Neither supersymmetry nor string theory satisfy this criterion. They are figments of the theoretical mind. To quote Pauli: they are not even wrong. They have no place here.

All this goes to show that visceral esthetic reactions are not out of place in physics. It's not as if physicists were purely rational creatures, immune to the allure of beauty or the abhorrence of ugliness. On the contrary, all serious researchers in physics are *always* driven by their unconscious esthetic tastes; taste is in fact the principal determinant of what they find promising, interesting, or believable. I've just shown you two fine examples of world-class particle physicists declaring they had to hold their noses to block the stench of the ideas of some of their colleagues. Well, I'm not all that different from those skeptical *éminences grises*; it's just that I hopped off the train a few stations earlier than they did.

Post Scriptum

I likened electroweak unification to grafting a watermelon onto a raspberry bush and declaring the two fruits to have been unified into just one. But strictly speaking, the violation of parity by the weak interaction means that only *left-handed* weakly-interacting particles are welcome in the mathematical expression "uniting" the two forces in a shotgun wedding. In my analogy, this means that only the *left*

halves of watermelons should be grafted onto raspberry bushes. (If you object that there is no such thing as a watermelon's intrinsic left half, that just shows how naïvely you cling to botanic symmetry!) Grafting watermelons' left halves onto raspberry bushes is a surefire way of growing luscious wasperbellies. But with their *right* halves, no way! QFD!

Bells and No-Bells

Well, that's enough of my physics confessions. I will now at last bring this longest chapter of *ABCD* to a conclusion by celebrating two great discoverers who are less known than the physicists already discussed, yet whose discoveries are of enormous importance. I chose to salute them here in part because neither was recognized with a Nobel Prize; that, in my opinion, is a great loss.

No Nobel went to the dedicated and perspicacious Cambridge postgraduate student from Northern Ireland who, in 1967, using a huge array of radio antennas that she had helped to build over a two-year period, noticed a strange periodicity in the signals emanating from a certain portion of the sky. She excitedly reported this oddity to her doctoral advisor, who reacted by telling her it was "just interference" from some human-made source. She went back and made her chart-paper slide more rapidly under the mechanical pen, so that the signals would emerge more clearly, and in this new regime the regular pulsation became clear as a bell. And yet her advisor once again flat-out told her she was mistaken — it was interference. She, however, had a deep, quiet faith in herself, and so she persevered. The same periodicity turned up repeatedly, even when she tried out another radio telescope. Then she found another periodic signal emanating from another part of the sky; at that point, she knew for sure that she had made a very significant discovery.

What Jocelyn Bell (later Jocelyn Bell Burnell) had detected was decidedly not human-made radio interference but a *pulsar* — a rapidly rotating neutron star that, like a lighthouse beacon, shone a very narrow beam into space each time it spun around on its axis. The news caused a worldwide sensation, and pulsars were soon

recognized as one of the greatest discoveries ever made in astrophysics. But it was her older male advisor, not Jocelyn Bell, who, seven years later, was given a Nobel Prize for his female student's discovery, a discovery on which he had repeatedly cast cold water. As Bell herself bemusedly put it, her advisor won the No-Bell Prize.

No Nobel went as well to the dedicated and perspicacious theoretical physicist (also hailing from Northern Ireland), who, in 1964, proved a subtle theorem about quantum phenomena that showed how to put Albert Einstein's intuitions about quantum entanglement of particles to an experimental test. Was entanglement an inconceivable sort of "spooky action at a distance", ergo nonsensical and fictitious, as Einstein had claimed in 1935? Or was it the way things really are? The theorem unambiguously pointed the way to resolving this deep issue.

On October 4th, 2022, just over 32 years after John Stewart Bell died of a sudden stroke, the Nobel Prize in Physics was announced; it went to three excellent experimentalists for their highly creative discoveries, conducted over many decades, showing that Nature violates Bell's inequality. Their experiments had revealed that Albert Einstein's usually flawless physical intuition was, in this case, out of step with reality. What would Einstein have made of the fact that quantum entanglement, which he once dreamt up to serve as a blatant example of surreal absurdity, is not surreal but real? Hard to say. In any case, the 2022 Physics Nobel was once again a No-Bell Prize.

E Pluribus Unum

❖

Oklahoma State Collage

In the spring of 1989, I flew out to Oklahoma State University in Stillwater to teach an invited one-week seminar called "Constraints and Creativity" to a small and select group of honors students. I greatly enjoyed those students, and one of my many assignments for them that week was to design an ambigram on "Oklahoma". Some 34 years later, while sifting through my files of old ambigrams, I found a collage that I had made of their solutions. I had totally forgotten about it, and it charmed me. It's fun and fascinating to see their imaginations and their pens at work. Take a look:

My Own States of the Union

In 2006, I generalized that challenge to all fifty state names and did them all, after a fashion, but there were many that I wasn't satisfied with. I figured I would wrestle with those unruly states at some later time — and indeed, as years passed, I made new versions of the weakest ones, but unfortunately, as my solutions grew stronger, my standards also rose, so it turned into a kind of arms race. Only in this past year did I at last buckle down and finalize my fifty states, which are displayed in the next ten pages. About twenty are brand-new, while lots survive from 2006 — and one of them (the q-turn on "OHIO") even goes back to 1984, when it was part of my exhibit in Adelina von Fürstenberg's Centre d'art contemporain in Geneva.

As I've remarked before, there is a powerful top-down contextual effect in any collection of tightly related ambigrams, such as the rainbow's seven colors, the four herbs mentioned in "Scarborough Fair", New York's five boroughs, and so on. In this case, anyone who grew up in the Western hemisphere, Europe, or Australia (etc.) comes strongly primed in advance, in that they know many American state names like the back of their hand, even if they've never visited any of them. What denizen of Berlin, Brisbane, or Bogotá has never heard of California, Florida, or Texas — or, for that matter, of Mississippi, Michigan, or Minnesota? Almost any well-educated adult from such places will know those names, although they may be less familiar with Rhode Island, Arkansas, and Nebraska.

In sum, for a typical reader of *ABCD*, all of my fifty state names will strongly reinforce one another, so that even those that cheat like the devil will jump out at the eye, thanks to the larger context (or at least so I hope). That's why I called this chapter "E Pluribus Unum", meaning that strength emerges from the unity of many independent parts. And so this collection — this multigram — constitutes one work of art, in the same sense that, say, Chopin's twenty-four preludes Opus 28 constitute one work of music. I wouldn't claim that the fifty-state show given below is *one ambigram*, but I would have no hesitation in calling it *one work of art*, despite the great diversity of styles. Or perhaps *because of* the great diversity of styles. What could be more diverse than Chopin's preludes Opus 28? Yet what could be more unified a work of art than Chopin's preludes Opus 28?

Actually, I would claim that all the ambigrams below (even the wildest outliers among them) are in *exactly the same style* — namely, my personal style. They are all outcomes of my lifelong love for letterforms and graceful lines, my feel for visual harmony, my joy in novelty, my sense of humor, my internalized Peoria, and so on. Anyone who has read this book up to here will recognize DRH style in each of the fifty 'grams below. And of course there was no cherry-picking; I had no choice as to *which states* to ambigrammize. I had to do them *all*; that was a fixed constraint. My only choice was *which versions* to show, and which to hide. So here we go…

ALABAMA

ALASKA

Arizona

arkansas

california

Chapter 22

COLORADO

CONNECTICUT

DELAWARE

FLORIDA

GEORGIA

Hawaii

Idaho

Illinois

INDIANA

Iowa

kansas

Kentucky

Louisiana

maine

MARYLAND

E Pluribus Unum

massachussetts

michigan

minnesota

mississippi

missouri

MONTANA

NEBRASKA

NEVADA

NEWHAMPSHIRE

NEW JERSEY

NEW MEXICO

NEW YORK

North Carolina

NORTH DAKOTA

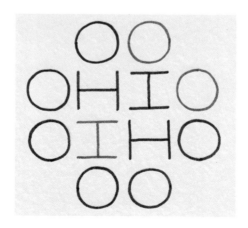

Oklahoma

Oregon

Pennsylvania

Rhode Island

South Carolina

South Dakota

Tennessee

Texas

Utah

Vermont

VIRGINIA

washington

WESTVIRGINIA

WISCONSIN

WYOMING

And Two to Grow on…

My wife Baofen, after seeing and enjoying the above set of fifty, pointed out to me that I was unintentionally discriminating against two regions of the United States whose inhabitants — all of them full American citizens — have never had voting representation in Congress. And so, at her urging and as a gesture toward the righting of wrongs, I designed two more, which here are:

Some Silver and Bronze Medal Winners

Before quitting the arena of state names, I'd like to show some alternatives. The fact is, I have more alternative versions of each state name than you could shake a stick at. I was very fond of some that I had omitted in this multigram, and friends and relatives even told me they preferred various versions that I had left out, so I decided to draw up an appendix consisting of a few favorite omitted ones.

For example, several friends liked this wall reflection on "ARIZONA":

I like it, too, because of the ambiguous games that it plays with double vertical lines, but I don't think it's as charming as the 180° rotation that I chose in its stead.

And here is a "ropy" rotation on "IDAHO" that one friend admired but that I didn't use because I always saw an "N" jumping out at me in the middle:

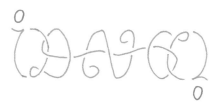

Speaking of "IDAHO", another nice try that didn't make the cut was this droll rotoflip. Turn the horizontal football counterclockwise 90° so that it's standing up, then wall-reflect it, and you'll get the vertical football:

Since it's sitting here on this page, I guess you could think of it as a reasonably decent second-stringer. And its four evenly-spaced green circles make me smile.

Next up, here are two alternative versions of "Michigan":

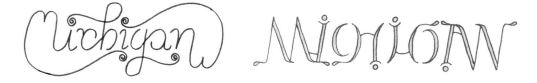

The one on the left dates back to 2006, while the one on the right is very recent.

It was hard for me to leave out the following version of "Mississippi":

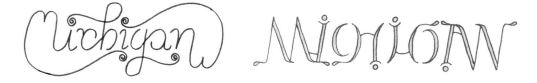

The reason I did so was that the members of my personal Peoria opted nearly unanimously for the curlier blue/green version, stressing its simplicity and greater legibility. I went along, although a bit reluctantly, with The People.

Another tough choice was to exclude this sober lowercase version of "Missouri" in favor of the jolly polka-dotted uppercase version:

That was my own choice, though; no one else even saw the two competing versions, let alone opined on them, since both of them were brand-new.

Some of The People felt strongly that the following was a superior "NEVADA" to the one that I selected…

…and maybe they were right. Peoria only knows!

It was self-evident that the fourfold 1984 "OHIO" q-turn had to be displayed, but it saddened me to leave out this minimal and elegant 180° rotation:

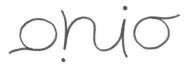

Next, here is an alternative version of "Utah" that didn't make the A-team, but that I nonetheless felt deserved to see the light of day in this appendix:

A couple of my Peorians were fans of this very jagged version of "VIRGINIA":

and they even told me that it's in heavy-metal style. I wouldn't know, but I'll take their word for it. In any case, it's got retinal pizzazz to burn, but I personally don't think it holds a candle to the "VIRGINIA" that I chose for the multigram.

To conclude this tour of the United States, I wanted to share with you a logo that I often drive by when I go grocery shopping. It adorns a Kroger gas station. That may sound boring, but do you see why I am showing it here?

For a long time, all I saw in it was four colored shapes surrounding a white central area defined by four graceful curves, but one day it suddenly hit me that the central white area is "the lower 48" — meaning the continental United States. On the left is the Pacific Ocean, on the right the Atlantic (both appropriately blue). At the top is Canada, in bright red (inspired by the maple leaf that stands for our northern neighbor). And on the bottom, in yellow, is a mixture of Mexico and the Gulf of Mexico. I'm not sure why that area is yellow, but I admit that I've always associated that color with Mexico — *un color de alegría*. In any case, at the four corners of this stylized USA, you see Seattle, San Diego, Miami, and Presque Isle.

When I mentioned this remarkably economical logo to various friends, they all said they'd seen it, but none of them had ever noticed that it was based on the outline of the 48 states, captured in an admirably minimal fashion — just four arcs. Although this logo has little to do with ambigrammia, I wanted to end this chapter with it, because it concisely symbolizes the tour we just made of the USA, and because I find it elegant, simple, and congenial in spirit with the art in this book.

CHAPTER 23

The August Lulu

From Sea to Shining Sea

When I first tackled the fifty states as a set, back in 2006, I also challenged myself to do a couple of other sets of related names, such as the capital cities of all the countries in Europe. Although that was a very ambitious project, somehow I managed to slog my way through them all, using a mixture of capitals and smalls, cursive letters and block letters, and rotations and reflections. But then, glutton for punishment that I was, I got it into my head to take on the names of the capitals of all fifty U.S. states.

I can't recall exactly why, but at that time in my life I was obsessed with wall reflections in capital letters. Maybe it was because of the rainbow ambigram that I'd recently done under that double constraint, but in any case, I challenged myself to do all fifty capitals exclusively in capital letters, and using only wall reflections. That was a challenge and a half — something like running a marathon with both hands tied behind your back. I worked on the project off and on for months, and came up with a set of pencil sketches that made me feel proud. I even hoped to polish them all and publish them as a booklet, to be called...

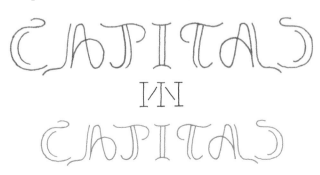

Unfortunately, though, other projects got in the way, and that never happened. In the end, though, maybe it's best that *Capitals in Capitals* is part of this volume instead. *CiC* is an opus aimed at people who know U.S. geography very well — perhaps because they grew up in America, perhaps because they love traveling and maps, perhaps because they're fans of American novels or films, or who knows why. A random Kenyan or Croatian, however, despite having grown up with the roman alphabet, will have a far harder time with this set than a random American will. Even a random Australian or Briton might encounter roadblocks — and it goes without saying that people from such lands as China, Nepal, and Egypt, where the primary writing system is not the roman alphabet and where U.S. state capitals are seldom mentioned, will most likely encounter roadblocks all over the place.

Compared to my fifty state names, most of the names in this ambigrammatical fireworks show are less flamboyant. It's not that they're stylistically less daring, but they tend to lie more toward the minimality end of the spectrum. For instance, the strokes used in all but four of these capitals — "MADISON", "SPRINGFIELD", "PHOENIX", and "HONOLULU" — are just one pen-nib in width. But despite this simplicity, some of them go pretty far out on a limb — so far out that your typical state-capital connoisseur, rather than genuinely reading the words, will *hallucinate* some parts of them without being aware of so doing.

Actually, hallucination is a standard ingredient of the normal act of reading, and it takes place surprisingly frequently in reading-aloud. I'll never forget how perplexed I was, way back in second grade, when kids in my class who were asked to read a very easy sentence aloud would unwittingly replace a word right in front of their noses with another word. Back then I was baffled and shocked, but now I understand and sympathize; they were simply hallucinating a semantically related word. That kind of unconscious substitution error, which we all commit sometimes, comes from having a rich associative network, including an immense amount of world knowledge. And in the following set of fifty state-capital names, such acts of perceptual hallucination not only are *allowed*; they are constantly *needed*.

A handful of the capitals, of course, don't require any hallucination; in fact, they're almost as readable as if they were printed in Helvetica or Baskerville — namely, "ATLANTA", "TALLAHASSEE", "DENVER", and maybe a couple of others. In particular, I felt that "ATLANTA" had been handed to me on a gold platter; it was just a question of how, in terms of style, I should take advantage of this fortuitous gift. Another ambigrammist — Scott Kim, John Langdon, Greg Huber, Roy Leban, or Joël Guenoun, say — might have done something quite different with this gift, but this is what I did.

I now present *Capitals in Capitals* — the capstone, so to speak, of this book. The path we will take meanders all the way across the fifty states, starting near the North Atlantic and finishing near the South Pacific. I wish you a capital trek!

The August Lulu

AUGUSTA CONCORD

MONTPELIER BOSTON

PROVIDENCE HARTFORD

ALBANY HARRISBURG

~TRENTON~ DOVER

ANNAPOLIS (CHARLESTON)

RICHMOND RALEIGH

(COLUMBIA) ATLANTA

TALLAHASSEE MONTGOMERY

JACKSON

BATON ROUGE

LITTLE ROCK

JEFFERSON CITY

NASHVILLE

FRANKFORT

COLUMBUS

INDIANAPOLIS

LANSING

MADISON

SPRINGFIELD

DES MOINES

ST PAUL

BISMARCK

PIERRE

LINCOLN

TOPEKA OKLAHOMA
CITY

AUSTIN SANTA FE

DENVER CHEYENNE

HELENA BOISE

·SALT LAKE CITY· PHOENIX

CARSON
CITY SACRAMENTO

SALEM OLYMPIA

JUNEAU HONOLULU

Please pardon me for boasting that this westward-ho voyage, swinging up and down as it traverses the country, features an august opening and comes in for a lulu of a landing. For that reason, I've nicknamed it "the August Lulu".

I hope that you were able, despite the rampant ambiguity at the level of *letters*, to make out all the *names* (most likely with a few or even many hesitations) — but if you didn't grow up in the U.S.A., that's pretty unlikely. As I said above, the readability of these ambigrams relies deeply on prior familiarity with the city names involved. In that sense, these capitals in capitals are a bit like Scott Kim's proverbs made out of rectangular blocks of various sizes. If your mind isn't equipped with the proverbs that Scott encoded, there's no chance that you'll be able to decipher them — but if you do know them, at least some of them will jump right out at you. Much the same holds for these mirror-reversible capitals.

For an example of a tricky one, consider "ANNAPOLIS". It doesn't take too great a stretch of the imagination to see the first four letters as "ANNA", but it takes quite a stretch to see their mirror images as "POLIS". Yet somehow all the shapes together suggest a few key letters that reinforce each other just enough to get you off the ground; and once you've seen "ANNA", deciphering the rest is a piece of cake — *provided* you already know the town name "ANNAPOLIS" like the back of your hand. In that case, it'll be but a split second before you "read" that word — or more precisely, before you hallucinate it.

A much easier one to read is "LINCOLN", although a dozen early sketches exploring a different avenue of approach (with "C" as midpoint) reveal that it took me quite a while to spot the "obvious" solution (with "C" reflecting to "O"). Even once I'd dreamt up that key idea, I was still pretty far from the goal line. Unlike in "ATLANTA", where the "L" and "N" reflect fairly easily into each other, here I had *two* "L"'s and *two* "N"'s to deal with. The inner "L" and "N" were much as in "ATLANTA", but the outer ones were different, because it was "LI", not "L", that had to reflect into "N". That forced a gap inside the final "N", which I then felt a need to echo inside the inner "L" and "N". It took much rumination and many decisions before I had my final pencil sketch — and then, of course, I had to do the felt-tip tracing. It was certainly not a free lunch served on a silver platter.

I once asked myself how many decisions I made in all, in coming up with *Capitals in Capitals*. I knew perfectly well that this was a fabulously meaningless question, yet I couldn't resist thinking about it, so I made some crude estimations and calculations and came up with a figure of about one million decisions — based on maybe 300 hours of work, with roughly one decision taking place per second. You need not take this figure in the least seriously; it's just an amusing factoid (or falsitoid) — but despite its utter silliness, it's somehow thought-provoking.

Check out the backwards "P" dangling off the final "E" in "PROVIDENCE", and the backwards "C" at the end of "CHEYENNE". I hope you didn't cringe at either of them when you first read those words — but if you did, I'd understand, as they're very brazen cheats. And yet how different, in the end, are those extraneous shapes from the extraneous squiggles I made fun of in the "MERCURY/HOT" ambigram on page 116? Not all that different, at least in spirit. We're looking at brazen cheats in both cases. And if cheats were taboo, then ambigrammia would be a hopeless cause. The cheats in "MERCURY/HOT" are cruder and clumsier, to be sure, than the flowing river of dashes in "TALLAHASSEE", the unexplained gaps in "LINCOLN", and the gala of swirls in "CARSON CITY" — but all cheats are cousins, in a way.

One of the standard devices I use now and then in wall reflections is to make a capital "A" reflect into a capital "O", exploiting a fact about cursive letters that I learned in second grade: a cursive "O" has a concave swirl in its upper right corner, allowing it to link to another letter. I rely crucially on this swirl in "CHARLESTON", "COLUMBIA", "FRANKFORT", "OLYMPIA", and "OKLAHOMA CITY" (twice in that name!). However, it saddens me that today's children are no longer learning cursive letters at all, so my device wouldn't work for them.

Of course this isn't the only way I exploit cursive writing in my ambigrams — I do it all the time and in countless different ways — so that means that many of my ambigrams will soon look old-fashioned, and perhaps will even be unreadable by young people. And if the disappearance of cursive writing from school curricula saddens me, how much more must it sadden Scott Kim, who uses cursive writing left and right in his ambigrams! Neither of us could have anticipated, several decades ago, this small way in which technology would change our world.

I wonder if Alan Guth, if he saw this display, would exclaim, "Gee, I didn't know the state capitals had that property!" Well, yes, the state capitals *do* have "that property" — the August Lulu's existence proves it! — but they have that property only when they're written using letters super-carefully distorted in all sorts of weird ways solely to make people who grew up in the United States hallucinate them all. In short, "that property" is not really a property of the city names, but a big collection of subtle discoveries that mostly have to do with the receiving minds.

Specifically, those minds have to be (1) used to wildly fringy letterforms; (2) very familiar with U.S. geography, and (3) ready to jump on a dime to seeing whole words when triggered by fragmentary clues. And the *generating* mind, in trying to make "that property" come magically out of the woodwork, has to have vast prior experience with the extreme fringes of roman-letter categories, plus a keen intuition about how certain sequences of fringe-letters are most likely to strike random Peorians. Only in that very twisted, unnatural sense could someone argue that the fifty state-capital names "have that property".

It is a curious irony that the severe constraint of having to do every single member of this family made my task a bit easier. For any Peorian plebeian who is familiar with all the capitals, if one of them turns out hard to read, its being in the company of so many others means that state-capital names will quickly pop to mind, so it *will* get read despite its pushing at the edges of letter-categories.

This is a general lesson: although it's hugely ambitious to tackle every member of a large set of related challenges, the flip side is that for viewers of the final result, all the separate members will reinforce each other, which will make them cohere as a whole. In short, much as I wrote about the state names, *E pluribus unum*.

I think of the August Lulu as a unigram — one single big ambigram. Each of its components is conceptually bound with the other 49 through their shared traits: capitalism, wall-reflectionism, minimalism — and also, of course, state-capitalism.

And lastly, just as there are two would-be states, there are two would-be state capitals, and so now — many years after my initial sketches of capitals in capitals — I designed wall reflections for them and hereby append them to the collection:

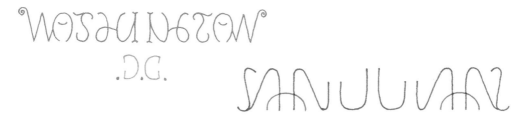

Behind the Scenes

Just as I followed the fifty states by showing some alternate versions, I'll follow the fifty state capitals with some alternate versions, once again in a geographically westward sweep. I thus begin near the Atlantic Ocean, with "HARTFORD":

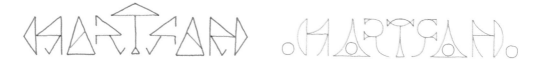

Each of these renditions of the capital city of Connecticut has its own playful Art Deco style, and they also share a conceptual skeleton. I could describe either of them over the phone to an experienced ambigrammist like Greg Huber or Roy Leban in a few minutes, and they could come close to reproducing it themselves.

Here are two alternate versions of the capital of Alabama:

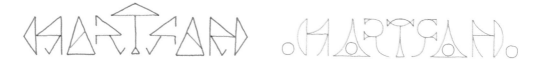

They're fairly similar, but they play with different geometries: on the left, the "O"'s are rendered as rounded diamonds, and on the right, they're roughly hexagons. For me, both versions flicker back and forth between legibility and illegibility.

Now let's make a northwards jump, to two midwestern capitals:

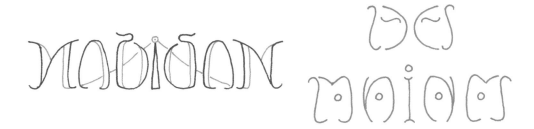

The "M"/"N" flip in "MADISON" is pretty daring, and the two "cords" tying the "light on the lighthouse" to the lower serifs on the "M" and "N" were put there solely to get you to see an "A" on the left and an "O" on the right. I hope that that ploy worked for you (in other words, that it pulled the wool right over your eyes).

As for "DES MOINES", it's very sparse in comparison with the swirly version that I used in the official set of fifty. Perhaps that makes it a little more readable.

Above, I mentioned that I initially made lots of explorations of "LINCOLN" using the "C" as the midpoint. Here are two of them:

It's hard to make a "C" that reflects into itself, and it's also hard to get an "N" to reflect into an "O". That's why I was so relieved when I found another path to the goal, with the "C" and "O" being each other's reflections. I feel it worked out much better than these early attempts (but only Peoria knows for sure).

When I glance at these, the intended readings are strongly interfered with by hallucinations like "SHAWNEE", "SAATTA FE", "CHEROKEE", "CHEEKBONE", and even "CHEXEKANE", so that's why I didn't use these in the collection.

A particularly tough challenge was the capital of Montana. I made many attempts at it, and two versions that I tried but ultimately rejected are shown below:

The "H"-to-"A" reflection challenge poses serious problems (how open do you leave the top? how tilted do you make the two edges? what kinds of ornaments might help push the viewer unconsciously toward "H" or "A"?), and I tried out all sorts of avenues to coax the viewer into seeing what I wanted, finally settling on the version that I incorporated into the August Lulu. It, too, of course resorts to trickery, but I think it might work a little better than the two versions shown above.

The last two alternates I'll share are of capitals near or in the Pacific Ocean.

In "SALEM", the main stumbling block was how to get the "SA" to reflect convincingly into an "M". How big a gap did I dare to leave between the "S" and the "A" without dashing to pieces the desired "M"-ness at the far end? Also, in order to avoid threatening the "M", the crossbar of the "A" could only be hinted at, so what kind of subtle hint would work best? These, of course, are the kinds of dilemmas — mental battles, if you will — that come up all the time in ambigrammia, and all sorts of factors have to be taken into account.

Lastly, good old "HONOLULU". I originally used this circle-spangled version in the August Lulu, but Danny and Monica — my most relied-upon commentators — preferred the more austere circle-less version, so I bowed to their judgment. Still, I wanted to display this alternate, because I think the red circles do a good job at whispering "O"-ness in the first half without too much threatening "L"-ness in the second half. Obviously, though, to people who have never heard of Honolulu, this concoction (as well as the one Danny and Monica preferred) would just look like a weird jumble of pseudo-letters, but such a naïve audience is not the one I was aiming at. I had to presume that my audience was very familiar with all fifty state capital names, for otherwise the challenge would have been way out of range.

Well, dear reader, now you've seen my most ambitious ambigrammatical feat to date. Long ago and far away, I never would have guessed that such a thing could be accomplished, but somehow I managed to jump through all the hoops — at least to the extent that you *agree* that I did so. In any case, I hope that you savored your romp through this last ambigrammatical meadow!

Why This Book? Why Now?

Ambigrammia as a Beauty-Creation Drive

Why, one might wonder (and "one" includes me), have I devoted such a large portion of my life to the obscure and esoteric art form of ambigrammia? It's certainly not because I'm a professional ambigrammist, since in all these years I've sold only one ambigram (and without intending to!). Given that I'm not a pro, is ambigrammia then merely a hobby or pastime for me? No, it's far more than that. It's what I would call a passionate binge — one among dozens scattered down the decades of my life, ever in pursuit of some elusive form of beauty. Indeed, when I look back, I see my life as a relentless search for beauty — a quest that I recently took to calling "my wild grace chase", and for a couple of years I devoted far too much time to writing far too long a tome bearing that title.

What is it that makes creating ambigrams so compelling for me? It's not just their double-readability or their sometime symmetry. The hope of coming up with a design with those alluring traits is merely a launching pad that sets me off on a quest. What fires me up during the quest are those exciting moments of discovery, those sudden jolts of insight — and later, when it's done and polished, the repeated savoring of unanticipated small pieces of visual magic that I found along the way. I often gaze and wonder, "How did I ever think *that* up?" Yes, strangely enough, my peak achievements in ambigrammia continue to gratify me, their one-time maker, with their surprising internal harmonies.

My joy at creating a new ambigram and then savoring it many times over reminds me a bit of my reactions, as a teen-ager, to hearing the fugues in Bach's *Well-Tempered Clavier* the very first time, and then over and over again. It wasn't the intellectual side of these highly complex pieces that thrilled me; it was the powerful emotions that they evoked. But the fact that these pieces were *fugues*, compositions

having subtle and intricate contrapuntal structures, compositions having voices interweaving in a way that I had never imagined, was inseparable from the feelings of awe and reverence that coursed up and down my spine as I listened to them.

I think that something comparable, though diluted, could be said about the pleasure that ambigrams give me, both when I make them and when I look at them. Take my very recent wall reflection on "SAN JUAN", for example. To me, it's a tiny visual poem. I derive pleasure from its graceful rhythm, especially the vertical lines and the hairpin bends in the "A"'s and "N"'s — but most of all I savor the two red semicircles on the baseline. Where did *they* come from? From my mind, of course — but in the white heat of creation, it felt as if the idea of semicircles came *to* me, not *from* me, and out of nowhere. It was a strange and subtle move, and it still remains a surprise to me, its finder/inventor. Of course this 'gram doesn't have anything of the profundity or sublimity of a Bach fugue, but nonetheless, every time I look at it, something about it catches me off guard and enchants me.

That's just one small random example, but it's typical. Similar things could be said about most of the ambigrams I've included in this book. Each one started out as a mystery shrouded in total fog — but I persevered, had some bad luck and some good luck, eventually found a hidden pathway, and finally, with hard work, wound up with a polished gem that retains charm for me long after the fact.

When facing a fresh new ambigram challenge, I can never anticipate what I'll wind up doing with it. Will the end product be a 180° rotation, a wall reflection, a lake reflection, a quarter-turn, a rotoflip, or even (once in a blue blue moon) an oscillation? Will it be in capitals, smalls, cursive, or some mixture thereof? I don't know in advance. Will it be curvy or angular, jagged or jaunty, ornate or minimal, swashbuckling or spare? No idea! And sometimes it takes me hours — or even days — to discover the secret that, all the time, was lurking hidden inside it.

I repeat: the fact that the final artwork has two readings is not the main source of joy for me, though of course it plays a role. What gives me the greatest pleasure is the fact that here is a brand-new miniature piece of art, born from the yoking-together of a challenge and a constraint. The final polished piece is the outcome of thousands of microscopic decisions, most of which I was unaware of even as I made them; and once it's done and is aging, it continues to reward me with surprises for years after its birth, even though I was both its mother and its father!

Again, here's an analogy to a different form of art. Do I delight in a stanza from *Eugene Onegin* because it features a subtle mixture of feminine and masculine rhymes and is in iambic tetrameter? Well, sure, in part, but there's a lot more to it than that. Those structural facts define only the *vessel*, and a very elegant vessel it is indeed, but the stanza would mean nothing to me if the sentiments conveyed by that vessel were not strong and affecting. The intimate marriage of form and content is what it's all about, and the same is true for ambigrams.

What a joyful experience it is to be able to convert a novel challenge into a tiny visual gem! In the end, it's not the fact that I've produced a doubly-readable piece of writing that transports me. In the end, it's the beauty — the fact that I've somehow come up with a totally unforeseen embodiment of beauty — that matters.

Art and Humanity

A few months ago, in talking with my friend Joshua Cynamon, I explained that I've recently felt plagued by waves of troubled confusion over putting so much energy and care into an album of doubly-readable pieces of calligraphy — just frilly little colorful baubles. What a crazy thing to spend one's later years on, especially in the frightening times that we're living through.

I said to Josh, "I'm working on this book during a period when many of my dearest friends are growing older and confronting great sadness, when democracy seems teetering on the brink of destruction, when the very concept of truth seems to be going down the drain, when artificial intelligence may soon overtake human intelligence, when global warming is threatening the survival of all sentient life on earth… At this scary moment in history, doesn't it seem weird and self-indulgent of me to be working on something so frivolous and flighty as a collection of ambigrams? And yet, writing this book *does* mean a great deal to me. After all, in it, I'm celebrating beauty and creativity, and I'm tipping my hat to all sorts of people I admire and care about (friends, relatives, musicians, physicists, salsa dancers, fellow ambigrammists, and on and on) — and doing all this is, in a way, what's keeping me sane. It's a kind of stabilizing rudder for me, in stormy weather."

Josh replied, "I can well imagine your doubts, Doug, but actually I feel that it's very sensible for you to be working so hard on your ambigrams book — in fact, it's a *crucial* thing for you to be doing — because bringing beauty into the world is so important to you, and to us all, most especially in dark times."

Josh's thoughtful reaction helped me to feel once again that my artistic project was worthwhile, and it brought back a memory of an amazing remark that my daughter Monica, then 25, came out with during a phone call at 2 AM on that nightmarish night in November 2016 when we saw the unbearable handwriting on the wall: that an unspeakably evil person was going to win the presidential election. Monica was sobbing in Brooklyn and I was trembling in Bloomington; we were both beside ourselves in horror and bewilderment. Monica asked me, "How can this be happening?" I said, "I don't know. I don't know." She asked, "What is humanity coming to?" All I could think of to say was, "The world is unpredictable. Nobody can know where things will go." And then, out of the blue, Monica said, "In the end, only art can save the world." It was such a powerful and idealistic statement of faith that I've never forgotten it, and I dearly hope that she is right.

WORDS OF THANKS

My passion for letterforms runs all the way back to my childhood, when my grandmother Mary Givan shared a book on the roman alphabet with me. The shapes entranced me. Throughout my teen-age years and my early adulthood, my parents, Robert and Nancy Hofstadter, encouraged my love for artistic exploration, and my sister Laura was always supportive and filled with a lively curiosity and an excellent sense of humor, which became integral to how I see the world.

By far the two most central figures in my now six-decade ambigrammatical adventure are those to whom I have dedicated this book: Peter Jones (who left us in May of 2021) and Scott Kim.

Peter, during our childhood and adolescence on Stanford University's campus, had an indescribable impact on my way of perceiving the world. His artistic gifts were enormous, but his playful creative spirit was equally rich. He was (at least in my view) the world's first pioneer of ambigrammia, way back in 1964, and his creation/discovery sparked my own first baby steps in ambigrammia at that time.

Scott, who independently came up with the idea of ambigrammia about ten years after Peter did, but who carried it much further than Peter and I had ever dreamt, is world-renowned for his astonishing creativity/discoverativity, but it's not just that that I admire. I admire just as much Scott's infallible sense of the beautiful flowing line — a sense of grace that permeates everything that he does.

Once I had overcome my shock at the beauty of Scott's "inversions" (doing so took me a few years!) and started trying to design artistic ambigrams myself, several enthusiastic and talented friends jumped in, especially Greg Huber, Roy Leban, and David Moser, all three of whom have remained key members of my "local Peoria" — indispensable sources of feedback. And my late wife Carol Hofstadter, who herself was artistically gifted, inspired me to new heights in ambigrammia.

In September of 1979, Scot Morris introduced what he called Scott Kim's "designatures" in his monthly "Games" column in *Omni* magazine, and nine years

later, after the word "ambigram" had been coined, Scot invited me (as well as Scott Kim and David Moser) to help judge an ambigrams competition at *Omni*. Those columns of Scot M's made ambigrams known all over the world.

In the 1980s and 1990s, three people invited me to give talks on and to have shows of my artistic work: Adelina von Fürstenberg in Geneva, Hu Hohn in Banff, and Tim Buell in Calgary. Their sincere excitement for my art changed my life.

My 1987 book *Ambigrammi: Un microcosmo ideale per lo studio della creatività* came out of the intense interest and hard work of Maria Gloria Bicocchi, Ilaria Guidi, and Fulvio Salvadori at Hopeful Monster Editore in Florence. I will always be deeply grateful to them for having published that book.

At some point in the late 1980s, I learned of John Langdon's independent arrival, in the early 1970s, at the concept of ambigrammia, and from then on John was a comrade-in-arms in the arena of ambigrammia, and he has always set and maintained the highest standards of artistry.

In 1997, my late friend and administrative assistant for 22 years, Helga Keller, promoted the idea of an exhibit of my art with Betsy Stirratt, director of the SoFA Gallery at Indiana University, and that marvelous 1998 show was a turning point in my life. I was deeply touched that Prudence Gill and Lawrence Mirsky liked my exhibit so much that the next year they organized similar though smaller exhibits at Ohio State University and at Cooper Union, respectively. The publisher John Donatich, at that time Vice President at Basic Books, came to my presentation at Cooper Union and warmly encouraged me to do a book on my art — and at long last, here we are, but with Yale rather than Basic, since John became director of Yale U. P. shortly thereafter.

In 2002, the typographically playful Italian artist Aldo Spinelli spontaneously organized two exhibits of my ambigrams in northern Italy, which helped spur my ambigrammatical *rinascimento*. Grazie tante, Aldo!

Ever since the turn of the millennium and century, my devoted friend Glen Layne-Worthey has been keenly interested in my ideas and my art, and as far as ambigrams are concerned, he has been a reliable member of my local Peoria for the last ten years or so, and has provided invaluable feedback and insights galore.

Bill Frucht at Yale University Press read an early version of this book from top to toe and gave me 5,742 enormously helpful suggestions, for which I can't thank him enough. (In the end, I took 3,444 of them.) Also of great help at Yale have been Amanda Gerstenfeld, Joyce Ippolito, and Jenya Weinreb. My typesetting Zoom sessions with Julie Allred at BW&A Books have been delightful. The tricky matter of obtaining permissions from all sorts of sources, including ones stretching way back into the seemingly untraceable past, was promptly and efficiently taken care of by Melissa Flamson and Deborah Nicholls at With Permissions. Had I not had all this excellent professional help, this book simply wouldn't exist.

Lastly, I come to my family. Carol's and my children Danny and Monica, now all grown up, have been commentators on my art since I can't say when. Monica in particular pushed me to work on this book, which for a long time I had hoped to write, but I was spinning my wheels. Finally Monica lit my fire and sparked me to do it. She and Danny are the most frequently consulted members of my "local Peoria", and through their eyes I see things I would otherwise never have seen. My wife Baofen also plays a key role in my local Peoria, her judgments being informed by her innate sense of grace (always manifested in her dancing, which was in fact how we met in 2010). I greatly appreciate Baofen's enjoyment of my designs and, more importantly, her unwavering love and moral support.

December 2024
Bloomington, Indiana

BIBLIOGRAPHY

Cooper, Gloria (compiler). *Squad Helps Dog Bite Victim (and Other Flubs from the Nation's Press)*. Garden City, New York: Dolphin Books (Doubleday), 1980.

Cooper, Gloria (editor). *Red Tape Holds Up New Bridge (and More Flubs from the Nation's Press)*. New York: Perigee Books (Putnam Publishing Group), 1987.

Dehaene, Stanislas. *Reading in the Brain: The Science and Evolution of a Human Invention*. New York: Viking, 2009.

Gebstadter, Egbert B. *Writoblendia: Xylographs Yummy and Zany*. Perth: Elihu Multiversity Press, 2025.

Guenoun, Joël. *Les mots ont des visages*. Paris: Éditions Autrement, 1998.

Hamel, Patrice. *Répliques*. Roanne, France: Théâtre municipal de Roanne, 1999.

Hofstadter, Douglas. *Ambigrammi: Un microcosmo ideale per lo studio della creatività*. Florence: Hopeful Monster Editore, 1987.

Kim, Scott. *Inversions: A Catalog of Calligraphic Cartwheels*. Peterborough, New Hampshire: BYTE Books, 1981.

Langdon, John. *Wordplay: Ambigrams and Reflections on the Art of Ambigrams*. New York: Harcourt Brace Jovanovich, 1992.

Polster, Burkard. *Eye Twisters: Ambigrams and Other Visual Puzzles to Amaze and Entertain*. London: Constable, 2007.

Prokhorov, Nikita. *Ambigrams Revealed: A Graphic Designer's Guide to Creating Typographic Art Using Optical Illusions, Symmetry, and Visual Perception*. San Francisco: New Riders, 2013.

Needless to say, one can find scads of ambigrams on the Web. I recommend the website of Gilles Esposito-Farèse, which contains many of Gilles' own ambigrams, and points to the websites of many other ambigrammists, generally of high quality.

ILLUSTRATION CREDITS

pp. 12–14: Drawings by Peter Jones, courtesy of Katherine Jones.

pp. 18, 21: © Scott Kim, scottkim.com.

pp. 24–25: © John Langdon.

p. 26: Font by Peter Schnorr (ca. 1900), from Ludwig Petzendorfer, ed., *Treasury of Authentic Art Nouveau Alphabets* (Dover Publications, 1984).

p. 27: (1) Anonymous Odessa font (ca. 1900) and (2) "Mig" font by M. J. Gradl, both from Ludwig Petzendorfer, ed., *Treasury of Authentic Art Nouveau Alphabets* (Dover Publications, 1984); (3) "Fat Cat" font (ca. 1974), from Dan X. Solo, *Art Deco Display Alphabets* (New York: Dover, 1982); (4) "Bobo Bold" font, from Paul E. Kennedy, *Modern Display Alphabets* (New York: Dover Publications, 1974); (5) "Zany" font, from Dan X. Solo, *Art Deco Display Alphabets* (New York: Dover, 1982).

p. 28: (1) "Calypso" font by Roger Excoffon (1958), (2) "Stop" font by Aldo Novarese, (3) "Sinaloa" font by Rosmarie Tissi (1972), (4) "Piccadilly" font by Christopher Mathews (1973), and (5) "Magnificat" font, by Friedrich Peter (1975), all from Letraset, Inc., *Graphic Art Materials Reference Manual* (Paramus, New Jersey: Letraset, Inc., 1981).

p. 30: (1) Courtesy of Roy Leban; (2) © Greg Huber; (3) © Robert Petrick Art; (4) Courtesy of Joël Guenoun; (5) Courtesy of Basile Morin.

p. 31: (1) "Figure(Ground)" by Tom Tanaka (with suggestions from Scott Kim, il miglior fabbro) and (2) "Ambi(Gram)" by Tom Tanaka (first appeared in *Word Ways*), both courtesy of Tom Tanaka.

p. 32: © Greg Huber.

p. 36: Photograph by Matt Kahn.

p. 38: © Fondation Henri Cartier-Bresson / Magnum Photos.

p. 40: (1) © Scott Kim, scottkim.com; (2) photo © RMN-Grand Palais / Art Resource, New York. © 2023 Estate of Pablo Picasso / Artists Rights Society (ARS), New York.

p. 51: © Scott Kim, scottkim.com.

p. 55: From a symposium at Indiana University.

pp. 56–57: Courtesy of David Moser.

p. 58: Restaurant sign using David Moser's sinosign.

p. 59: (1) JEEP® Paw Prints Tire Cover, manufactured by Mopar. Jeep is a trademark of FCA US LLC; (2) Baby Club header from Marsh.net, Nov. 11, 2016; (3) Logo for *Yosemite, A Journal for Members of The Yosemite Association*, El Portal, California; (4) Logo for Yards Unlimited, Inc.; (5) Logo (historical) for Monroe County Public Library, Indiana; (6) Welcome sign; (7) Beauty ad; (8) "Dog love" logo, evoking the style of the sculpture by Robert Indiana, *Love* (1964); (9) "Thlete" logo is a trademark of Thlete Outdoors LLC; (10) "Luxembourg" logo; (11) Logo (historical) for THE MAIDS, a trademark of The Maids International, Inc.

p. 60: (1) and (2) "Google Doodle" is a trademark of Google LLC. This book is not endorsed by or affiliated with Google in any way. (2) © 2023 The Pollock-Krasner Foundation / Artists Rights Society (ARS), New York.

pp. 61–62: © Scott Kim, scottkim.com.

p. 63: "Sunkist" is a registered trademark of Sunkist Growers, Inc.

p. 80: (2) From *Hair: A Book of Braiding and Styles*, by Anne Akers Johnson. Copyright © 1995 by Klutz Press. Reprinted by permission of Scholastic Inc.

pp. 107–108: Photos © Giancarlo Costa / Bridgeman Images.

p. 109: O. O. Bowers, "Gettysburg Address" (1926). Lincoln Broadsides. Brown Digital Repository at the Library of Brown University, Providence, Rhode Island: https://repository.library.brown.edu/studio/item/bdr:76402/.

p. 112: State Historical Museum, Moscow, Russia. Photo © Fine Art Images / Bridgeman Images.

p. 116: (1) and (2) Courtesy of Michael B. McCormick.

p. 117: (1) and (2) Courtesy of Tiff Crutchfield; (3) and (4) © Charles Krausie.

p. 118: © Scott Kim, scottkim.com.

p. 119: Courtesy of Elwin Gill.

p. 146: (2) © Scott Kim, scottkim.com.

p. 258: Collage of 15 "Oklahoma" student ambigrams from the author's seminar in Stillwater, Oklahoma, spring 1989. Courtesy of Douglas Brehm, Tanya B. Ward, Stephanie Jung, the family of Karen Kealy, Shannon K. Knight, Robert Lafon, Mark Lansdown, the family of Betty McMahan, Grant Moak, Kathryn Tate Ringer, and Michael Silberstein. Every effort was made to locate the other students for permission, including Vickie Bouffleur, Kevin James Conley, A. Wayne "Tay Sha" Earles, Susan Heil, Suzanne Landtroop, Asa Lawton, Belinda L. Neumann, Michelle Robertson, Lucy Simpson, Gail Sullivan, and David Thiessen.

p. 273: This logo is a registered trademark of Kwik Shop, Inc.

INDEX

This index, drawn up by the author in a grueling two-week slog, is far from perfect, as is any index. After all, each entry is itself a mental category, and precise category membership in the world of ambigrams, as in the world at large, is merely a convenient myth. And of course the names of abstract categories are anything but inevitable and objective, to put it mildly. Plus, what merits indexing and what does not is highly subjective. In short, an index like this one is just a personal work of art, which may amuse readers more than it helps them find sought items.

In my moments of self-doubt, I fear that it may be no more useful to my readers than a dime-store magnet would be to someone desperately hunting for a needle in a haystack. However, I hope that I'm wrong and that this index is sufficiently accurate, complete, and in synch with readers' minds for it to be useful, now and then, to them.

"ABCD" acrostics: "Above and Beyond the Call of Duty", 34, 169; "Ambigrammia as a Beauty-Creation Drive", 284; "Ambigrammia: Between Creation and Discovery", cover; "Ambigrams, Beauty, Computers, Depth", 198; "Ambigrams Bring Cash, Dude!", 121; "Artistry, Beauty, Creation, Discovery", 86

abrupt ending to dialogue, 156

absorbing one letter into another, 21, 63, 138–140

absurd stretchings of the concept "ambigram", 111, 116

AI systems, astonishing recent achievements of, 199

Alighieri, Dante, author of *La Divina Commedia*, 123, 126–127

aligning a word: with its mirror reflection or its rotation, 96, 136; with the reflection or rotation of a different target phrase, 6–8

Allred, Julie, book designer and producer, 288

Alpher–Bethe–Gamow paper on chemical elements' origin, 245–246

Alpher, Ralph, American physicist, 244–245

Amaldi, Edoardo, Italian physicist and neutrino namer, 241

ambi-alphabets, resulting only in inspiration-free ambigrams, 199

ambiface from the late 1940s in Italy, 107–108

"ambigram" (the word): coining of, 4, 23, 44; definition of, xi, 1–2, 67; having different meanings for different ambigrammists, 26

ambigram albums for students: in calculus class, 168; in *Eugene Onegin* class, 174–175; in salsa class, 179

Ambigrammia: as an art form, activity, and territory, 2; beauty as core of, 286; becoming a genuine art form, 16, 18; boundaries of, 90; defined, 2, 138; DRH doubting its value, 286; HRD wondering if it is an art form, 141, 150; independently discovered by Peter Jones, Scott Kim, and John Langdon, 18; little known at one time, ix, 133; as merely a frivolous game, 15, 141, 286; out of reach of computers in the 1980s, 198–200; question of possible mechanizability of, at this time, 198–200; receding into the fog for eight years, 106; risk-taking as a crucial aspect of, 186; as source of serenity and joy, 200, 286; why it arose in the latter half of the twentieth century, 26–29

Ambigrammi: Un microcosmo ideale per lo studio della creatività (1987 DRH book), 115, 288: ambigrams borrowed from, 87–105; as dialogue between DRH and E. B. Gebstadter, 87; DRH/EBG discussing if AI could devise ambigrams, 198–199

ambigrammists: needing to have a reliable internal model of The People, 82; not being authoritative about what categories their letters and words belong to, 82, 280; ones I know personally, 29

ambigrams: "correct" versus "wrong" readings of, 82, 85, 153–155; cousins of, 107–114; as creations or discoveries, 2; easily findable on the Web, 29; found

versus made, 71; as intimate marriages of form and content, 285; as joint works of art, 155; large set of, as a single collective challenge, 86, 133; as lying at various points on the creation/discovery spectrum, 35; as magic tricks, 156; monetary value of, 121; not in one's native script, perils of tackling, 129, 175; as pocket-sized creativity puzzles, ix, 4; as pretty shells lying on the beach, 33, 35; as related to math and symmetry, 198; as requiring overall eye-pleasing flow, 153; as small pieces of visual magic, 284; unpredictability of, to their own creator/discoverer, 285; as veins of receptivity in the collective human mind, 4, 280; visual rhythm of, 182

Ambigrams: A Panoply of Palindromic Pinwheels (unrealized book by DRH), 45, 87

ambigrams by DRH: *Aaron Copland*, 211; *ABCD*, front cover, i, xiii; *a Carol*, 87; *Adam*, 168; *A. Einstein/Constant c*, 215; *Alabama*, 260; *Alaska*, 260; *Albany*, 276; *Alejandra/Magdalena*, 95; *Alexander Jenner*, 201; *Alexander Scriabin*, 211; *Alexander Sergeevich Pushkin*, 175; *Alice/Roy*, 98; *Allen Wheelis*, 99; *Amalfi*, 100; *ambigram*, 3; *ambigrams*, 3; *amethyst*, 208; *Andrew*, 168; *Anna Karenina/Happy families…*, 110; *Annapolis*, 276; *Antonio e Susanna*, 190; *Aquileia*, 100; *Archimedes*, 226; *Arizona*, 260, 270; *Arkansas*, 260; *Assisi*, 100; *Atlanta*, 276; *Augusta*, 276; *Austin*, 278; *autrement*, 182; *Bach*, 209; *Bach/fuga*, 3, 51; *Banff*, 49; *Baofen/Daoren*, 185; *Baofen and Doug*, 186; *Barbara*, 66; *Barbie*, 168; *Bari*, 100; *Baton Rouge*, 277; *Beethoven*, 210; *Bethany*, 175; *Bismarck*, 277; *blackberry*, 171; *Bloomington*, 161, 186, 188; *Bloomington/Palo Alto*, 76; *Bob Wolf*, 46; *Bohr/atom*, 217; *Boise*, 278; *Bologna*, 100; *Boltzmann*, 228; *Boston*, 276; *Bragg*, 233; *Brahms*, 210; *Brindisi*, 100; *Bronx*, 204; *Brooklyn*, 204; *Bruno Gaume*, 128; *Cagliari*, 100; *calculus/Mongold*, 168; *California*, 260; *Camille Saint-Saëns*, 210; *Camillo Neri*, 125; *Capitals in Capitals*, 274; *Carnot*, 228; *Carol/Doug*, 89; *Carson City*, 278; *Charleston*, 276; *Charlotte/Michael*, 193; *Chemway*, 16; *Chen Ning Yang*, 250; *cherry*, 171; *Cheyenne*, 278, 282; *Chopin*, 15, 94; *Chris*, 168; *Claude Debussy*, 210; *cog sci*, 197; *Cole Porter*, 211; *Colorado*, 261; *Columbia*, 276; *Columbus*, 277; *Como*, 100; *Concord*, 276; *Connecticut*, 261; *Copernicus*, 226; *Corriere della Sera*, 133; *creation vs discovery*, 2; *Cyril Erb*, 45; *dab*, 72; *Daniel*, 130; *Daniel Andler*, 132; *Danny*, 130, 168; *Dante Alighieri*, 126; *Dante et Beatrice*, 127; *Dave*, 20; *David James Moser*, 166; *David Liu*, 185; *David/Moser*, 48; *Debbie Hickox*, 69; *de Broglie*, 235; *Delaware*, 261; *Democritus*, 226; *Denfert–Rochereau*, 180; *Denver*, 278; *Derek*, 66; *Des Moines*, 277, 282; *diamond*, 208; *District of Columbia*, 270; *dollop*, 72; *Don Kennedy*, 166; *Dorothy*, 130; *Doug*, 15, 158, 162, 188, 189, 190; *Doug/Carol*, 88; *Doug/2003*, 158; *Doug/2004*, 140; *Doug/2006*, 161, 162, 166; *Doug/2007*, 158, 170; *Doug/2010*, 179, 182; *Doug/2011*, 190; *Doug/2014*, 201; *Doug/2018*, 158; *Doug/2020*, 188; *Douglas Hofstadter*, front cover, 160; *Douglas R. Hofstadter*, 203; *Dover*, 276; *DRH*, i, iii, 159, 197; *Dvořák*, 212; *Egypt*, 73; *Einstein*, 230; *electron/positron*, 220; *Elizabeth II Regina*, 65; *emerald*, 208; *Emmanuelle Choisy*, 179; *Emmy Noether*, 234; *Enrico Fermi*, 241; *Estelle Lebigre*, 179; *η canon*, 203; *Eugene Onegin*, 174; *Felix Bloch*, 242; *few/numerous*, 90; *Fiesole*, 101; *15 March*, 157; *Firenze*, 101; *first of September, 2012*, 186; *Florida*, 261; *14 May*, 182;

Francisco/Claro, 89; *Frankfort*, 277; *Franz Josef Haydn*, 209; *Frédéric Chopin*, 181; *Gabriel Fauré*, 210; *Galileo*, 226; *Gamow*, 243; *Gāo Xíngjiàn*, 128; *garnet*, 208; *Gell-Mann*, 248; *George and Tamiko Soros*, 191; *George Gershwin*, 211; *Georgia*, 261; *Gilles et Tina*, 189; *Glashow/Weinberg*, 252; *Goudsmit/Uhlenbeck*, 236; *gravitation=acceleration*, 71; *Great Britain*, 74; *Grieg*, 212; *Hans Bethe*, 245; *Harrisburg*, 276; *Hartford*, 276, 281; *Hastorf*, 15; *Hawaii*, 262; *Heisenberg/Schrödinger*, 235; *Helena*, 278, 283; *Herman and Alpher*, 244; *Hermann Weyl*, 234; *Hofstadter/butterfly*, 222; *Honolulu*, 278, 283; *Hubert/Karine*, 78; *Hu Hohn*, 50; *Idaho*, 262, 271; *Igor Stravinsky*, 211; *Illinois*, 262; *Indiana*, 262; *Indianapolis*, 277; *Indiana University/cognitive science*, 197; *inertia=gravity*, 70; *Iowa*, 262; *Ivano Dionigi*, 125; *Jackson*, 277; *James Clerk Maxwell*, 227; *jasper*, 208; *Jefferson City*, 277; *Jillian/Seth*, 176; *Jocelyn Bell Burnell*, 256; *Joël Guenoun*, 183; *John Bell*, 257; *John Langdon*, 24; *John/Liz*, 93; *Josh Bell*, 97; *Juneau*, 278; *Kalamazoo*, 165; *Kansas*, 263; *Karen/Bob*, 190; *Karen/Michael*, 187; *Катя*, 175; *Kees/Ursula*, 46; *Kentucky*, 263; *Kepler*, 226; *Khrushchev*, 15; *Lansing*, 277; *Laura James Hofstadter*, 182; *laws of thermodynamics (first, second, third, fourth)*, 223; *Lazio*, 104; *Leo/Tolstoy*, 110; *light is a wave/particle*, 220; *Liguria*, 104; *Lincoln*, 277, 282; *Little Rock*, 277; *Louisiana*, 263; *Louvre–Rivoli*, 180; *Lucie*, 106; *Madison*, 277, 282; *Maine*, 263; *Manhattan*, 204; *Manuel de Falla*, 212; *Maria Chiara Prodi*, 124; *Mariangela*, 124; *Marie Curie*, 231; *Marilyn*, 175; *Martina*, 170; *Mary & Rudi*, 97; *Maryland*, 263; *Massachusetts*, 264; *mass-energy/curved space*, 218; *Maubert Mutualité*, 180; *Maurice Ravel*, 212; *Max Born*, 236; *Max Planck*, 229; *Melanie Mitchell*, 167; *Michael*, 194, 195; *Michael Atiyah*, 194; *Michael/Barbara*, 96; *Michael Conrad*, 195; *Michael Faraday*, 227; *Michael Jacobs, M.D.*, 140, 142, 150; *Michael Kandel*, 196; *Michael Shadlen*, 194; *Michelson-Morley/there's no ether*, 215; *Michigan*, 264, 271; *Minnesota*, 264; *Mississippi*, 264, 271; *Missouri*, 264, 272; *MMX*, 197; *MMXV*, 190; *Monica*, 130; *Montana*, 265; *Montgomery*, 276, 281; *Montpelier*, 276; *Mozart*, 210; *myself*, 15; *Nashville*, 277; *Nebraska*, 265; *Nevada*, 265, 272; *New Hampshire*, 265; *New Jersey*, 265; *New Mexico*, 266; *Newton*, 227; *New York*, 266; *Niels Bohr*, 232; *North Carolina*, 266; *North Dakota*, 266; *Ohio*, 266, 272; *Oklahoma*, 267; *Oklahoma City*, 278; *Oliviero/05|five|50*, 9; *Olympia*, 278; *onyx*, 208; *Oregon*, 267; *Orgosolo*, 101; *oro loro*, 72; *Paradiso Purgatorio Inferno*, 126; *Paris Mambo*, 78, 178; *Paris 1 mars*, 181; *Parma*, 101; *parsley*, 206; *Patricia Jenner/Mike Jenner*, 201; *Paul Dirac*, 237; *Pennsylvania*, 267; *persimmon*, 171; *Peter Jones*, 47; *peridot*, 208; *Phoenix*, 278; *Pierre*, 277; *Pino Longo*, 98; *Place du Tertre/Butte Montmartre*, 183; *position/momentum*, 219; *Potenza*, 101; *President Barack Obama/Michelle Obama, First Lady*, 172; *Prokofiev*, 211; *Providence*, 276; *psychology*, 15; *Puerto Rico*, 270; *Queens*, 204; *Rachel and Winston*, 188; *Rachmaninoff*, 211; *Raleigh*, 276; *Ravenna*, 101; *red orange yellow green blue indigo violet*, 162; *Rhode Island*, 267; *Richard Feynman*, 246; *Richmond*, 276; *Robert*, 114; *Robert et Barbara*, 157; *Robert Hooke*, 227; *Roma*, 101; *rosemary*, 206; *Roxanne*, 168; *ruby*, 208; *Rutherford*, 232; *Sacramento*, 278; *sage*, 206; *Salem*, 278, 283; *salsa*, 78, 79, 178; *Salt Lake City*, 278; *Samuel Barber*, 211; *San*

Index

Diego, 84; *San Juan*, 281; *Santa Fe*, 278, 282; *sapphire*, 208; *Schubert*, 210; *Schumann*, 210; *Schweiz Suisse Svizzera Switzerland*, 134; *Scott Kim*, 91, 95, 165; *Sicilia*, 104; *Sindaco di Roma*, 170; *Sommerfeld*, 233; *Sondra*, 22; *South Carolina*, 267; *South Dakota*, 268; *Springfield*, 277; *Stanford/August 1976*, 203; *Staten Island*, 204; *St. Paul*, 277; *Sweden*, 73; *Tallahassee*, 276; *Tennessee*, 268; *Texas*, 268; *thyme*, 206; *tidbit*, 72; *Todi*, 101; *Tom + Lori*, 187; *topaz*, 208; *Topeka*, 278; *Torino*, 101; *Toscana*, 104; *Tour Eiffel/Champ de Mars*, 183; *tourmaline*, 208; *traduttore traditore*, 123; *Trento*, 101; *Trenton*, 276; *turquoise*, 208; *2003*, 157; *2004*, 189; *2006*, 73; *2009*, 174; *Umberto Eco*, 122; *USA/CCCP*, 94; *Utah*, 268; *Vaughan Williams*, 212; *Venezia*, 101; *Vermont*, 268; *Verona*, 101; *Victoria + Christer*, 188; *Virginia*, 269, 272; *Vittoria*, 170; *Vivaldi*, 212; *Viviana*, 130; *Walter/Flavia*, 170; *Walter Veltroni*, 170; *Washington*, 269; *Washington, D.C.*, 281; *West Virginia*, 269; *William Shakespeare*, 63; *Wisconsin*, 269; *Wolfgang Pauli*, 239; *Wyoming*, 269; *youth*, 68; *Ziva/Paul*, 92; *ZOLO/2010*, 185

ambigrams by Peter Jones: *antidisestablishmentarianism*, 13; *banana*, 13; *people*, 14; *Peter/Jones*, 14; *sphynx*, 13; *Stanford*, 12; *Wurlitzer*, 13

ambigrams by Scott Kim: *Dave*, 18; *Elaine/Denny*, 118; *Fanya*, 40; *harmony*, 51; *Inversions/Scott Kim*, 21; *Kim*, 18; *Peter/Rachel*, 118; *Philip*, 18; *Rembrandt*, 18; *Richard Guy/01234…*, xii; *Schönberg/123456…*, xi

ambigrams by John Langdon: *John Langdon*, 24; *minimum*, 25; *optical/illusion*, 25; *philosophy*, 25; *syzygy*, 25; *wordplay*, 24

ambigrams by David Moser: *China/中国*, 56; *China/中國*, 57

ambigrams by various others: anonymous (*auto tua*), 72; by Tiff Crutchfield (*Basic/Pascal*), 117; by Elwin Gill (*San Diego*), 119; by Joël Guenoun (*jour/nuit*), 30; by Greg Huber (*Penn & Teller*), 30; by Charles Krausie (*life/death*), 117; by Mitchell T. Lavin (*chump*), 67; by Roy Leban (*Emily + Roy*), 30; by Michael McCormick (*Mercury/hot*), 116, (*Pluto*), 116; by Basile Morin (*cette rose ici semée…*), 30; by Oklahoma honors students (*Oklahoma*), 258; by Robert Petrick (*photograph*), 30; by Tom Tanaka (*ambigram*; *figure/ground*), 31

ambiguity: in Greg Huber's utterance, 42; in newspaper headlines, 42–43

"AMBULANCE" doubled, as *reductio ad absurdum* of the notion of "ambigram", 111

anagrammia, 217

anagrams, 33, 217, 234; better seen as discoveries or as creations?, 33–34

"Analogy, Essence, and Elegance" course, 115–117

Andler, Daniel, French philosopher, 132

angels dancing on the head of a pin, 254

Anna Karenina: first two sentences of, 110; full text of, forming a portrait of Leo Tolstoy, 109

"ANNAPOLIS", as quintessential hallucination example, 279

Arbuthnot, Lucie, long-ago friend of DRH, 106

arc with gap, as member of category "o", 143–144

Archimedes, Hellenic physicist, mathematician, and utterer of "*Eureka!*", 123, 226

architect, drastic errors made by, 154

Arndt, Walter, German-American literary translator, 174

Arnheim, Rudi and Mary, 97–98; 112

ars magna, *see* anagrammia

Art Deco style, 281

art exhibits by DRH, 44–45, 121–122, 167

Artic continent, as home to Ambigrammia, 86

artistic taste, one's own versus humanity's collective, 85

Art Nouveau alphabets, 26–27

Astaire, Fred, dancing partner of Ginger Rogers, 253

asymmetry: as an amusing twist in a mostly symmetrical ambigram, 73, 125, 164; of the laws of nature, 251

Atiyah, Michael, British mathematician, 194

audience of an ambigram, crucial to take into account, 83, 132, 205, 275, 280–283

audiography, as an art form, 36

Auer, Rachel, violinist and professor, 188

August Lulu (nickname for "Capitals in Capitals"), 274–283

austerity, *see* minimalism

automorphisms and auto dealers, 72

"auto tua" as both palindrome and wall reflection, 72

autrement, Paris-based publishing house, 182

Bach, Johann Sebastian, German baroque composer of more than just "Minuet in G major", 209: gigue by, 238; as master of fugues, 3, 50; *Well-Tempered Clavier*, giving thrills to teen-aged DRH, 284–285

"Bach/fuga" q-turn, 3, 50–51, 53, 54, 133

back-and-forth jumping between ideas, as DRH creativity *modus operandi*, 161

"Bǎi huā qí fàng" (百花齐放), Chinese saying meaning "Let a hundred flowers bloom", 52, 119

balance point between opposing forces in Ambigrammia, 170

Balmer, Johann, Swiss teacher whose guessed formula led to the Bohr atom, 216

Banff Centre for Arts and Creativity, 48

"Bān mén nòng fǔ" (班门弄斧), Chinese saying about a novice's naïveté, 52

Barozzi, Giulio Cesare, Italian mathematician, 124

Baskerville typeface's high legibility, 19, 46, 82, 114, 275

Basque language, unlikely to be the reader's only language, 163

Beatles song "Yellow Submarine", lyrics to, 146–148

Beatrice (Dante's lifelong love), 127

beauty: as crucially valuable in times of crisis, 286; indispensable role of, in physics, 249, 252–256; as relevant, or irrelevant, to ambigrammia, 152–153; *see also* grace; esthetics

Becquerel, Henri, French physicist who discovered radioactivity, 231

Beethoven, Ludwig van, German composer of more than just *da-da-da-dum*, 210

belief in impossible things before breakfast, forced by physics, 219, 220, 236, 237

Bell Burnell, Jocelyn, Northern Irish astrophysicist who found pulsars, 256–257

Bell, John, Northern Irish physicist who found "spooky action at a distance", 257

Bell, Joshua, American violinist and ambigrammist of renown, 96

Benton, Morris Fuller, American typeface designer, 113

beta decay: as not mirror-symmetric, 251; Fermi's theory of, 239–240, 241

Bethe, Hans, German-American physicist who renounced arms he built, 245–246

Index

Bicocchi, Maria Gloria, co-founder of Hopeful Monster publisher, 288

Big Bang, 244–245

big data plus deep neural networks, as possible route to mechanizing ambigrammia, 199–200

bilboquet (ball-in-cup game), 125

bilingual ambigrams, 92, 94

birthstones as an ambigrammatical challenge, 205, 207–208

biscriptual ambigrams and non-ambigrams, 92, 94, 113

Blackman, Bob and Karen, friends of DRH, 190

"blje" versus "blue", as potential readings of a word, 164

Bloch, Felix, Swiss-American physicist and friend of Hofstadter family, 242–243

Bloomington, alternate names for: "Burg of Blooms", 177; "Fioripoli", 157; "Flowerville", 196; "Kwiatowa Wola", 196; "Villefleury", 184; "Цветоград", 196

"Bloomington/Palo Alto" challenge, 75–76

Bobo (Art Deco typeface), 27

Boeninger, Robert, lifelong friend of DRH, 114

Bohr, Niels, Danish pioneer in quantum physics, 216–217, 232–233

Bologna, DRH sabbatical year in, 122–135

Boltzmann, Ludwig, Austrian statistical-mechanics pioneer, 228–229

Bongard, Mikhail, Russian computer scientist, x; visual analogy problems by, x

book-cover ambigrams, requiring top-notch quality, 83, 132

Born, Max, German quantum pioneer who showed that acausality reigns, 236

boroughs of New York City, unigram of, 204

bottom-up versus top-down perception, 58–64, 128, 135, 144–150, 186, 199

Bowers, O. O., American artist who turned Gettysburg Address into Lincoln, 109

boxed proverbs (Scott Kim), 61–62, 279

Bragg, Lawrence, British physicist who collaborated with his father, 233–234

Bragg, William, British physicist who collaborated with his son, 233–234

Brahms, Johannes, German romantic composer, 210, 213

Brassaï, Hungarian-French artist who learned French by reading Proust, 40

brazen moves made by DRH in ambigrams: 22 (*Sondra*), 50 (*Hu Hohn*), 100 (*Assisi* and *Bari*), 104 (*Toscana*), 176 (*Jillian/Seth*), 183 (*Tour Eiffel/Champ de Mars*), 211 (*Prokofiev*), 223 (the four laws of thermodynamics), 276–278 (The August Lulu as a whole)

break shot on pool table, normal versus time-reversed, 229

Broglie, Prince Louis de, French physicist who proposed wavelike electrons, 235

Brown, Dan, American novelist and fan of John Langdon's ambigrams, 26

Brush, Carol, 86; *see also* Carol Hofstadter

Buell, Timothy, organizer of DRH art exhibit in Calgary, 121, 288

bull's head assembled from rusty bicycle parts by Pablo Picasso, 40

"c" versus "e" in "current events", 60–61

Caesar, Julius, "*Veni, vidi, vici*" and "*Et tu*" utterer, 123

calculus-class students' names, multigram of, 168–169

calligraphic swirls as a device for hiding letters in, 19, 22, 122

Calypso (twentieth-century typeface), 28

canon: defined, 202; written by DRH, 203; written by Mozart, 202

"Can you do this for *any* name?", 205

capital block letters, as standard for Peter Jones and DRH, 13–15, 18–19

capital cities of Europe, brief mention of multigram by DRH on, 274

capital "I" with dot on top, *see* "I"

Capitalism in Ambigrammia, 281

capital sin, 201

Capitals in Capitals, 274–275

caricature analogies in the text, 4, 84, 113, 118, 253–254, 274, 293

Carnot, Sadi, French thermodynamics pioneer, 228

Carroll, Lewis, English author whose White Queen believed impossible things, 219

Cartier-Bresson, Henri, French photographer who captured *moments décisifs*, 38, 132

case (upper versus lower), desirability of maintaining consistency of, 88, 201

category boundaries, stretching of, 54

category membership: key role of, in counting anything, 162; of letterlike shapes, 19–20, 79–82, 97; as not sharp but blurry, 79–82, 85, 207; of phrases as wholes, 147–149; sensitivity to, as crucial for an ambigrammist, 54; slippery edge cases in, x; statistical determination of, by collective judgments, 80–82, 85, 104; versus esthetics, 153; of words as wholes, 21, 79–80, 91

caving in obsequiously to other peoples' judgments about esthetics, 254

"CC", in ambigram celebrating Chopin's 200th birthday, 181

Ceram, Hubert and Karine, DRH's Parisian salsa teachers, 78–79, 178

challenges by Scott Kim to the readers of *ABCD*, xii

Chartres cathedral photo (Matt Kahn), 36–37

ChatGPT, as possible ambigrammist, 199

cheating: as crucial in ambigrammia, 16, 54–55, 75; desired invisibility of, 75, 138; by faking three-dimensionality of letters, 158; by hyphenating a monosyllabic word, 49–50; of industrial strength, 74; of many sorts, pointed out explicitly, 102–103; the more the merrier!, 74; non-countability of instances of, 134; seen as playfulness rather than dishonesty, 75, 138; selected examples of, 134; in The August Lulu, 280; too much of it (for shame!), 90, 110–111, 116–117, 119; by using letters of different sizes, 89–91, 110

cheativity versus creativity, 115–117

"Chemway", DRH's first artistic ambigram, 16, 182

cherry atop (or abottom) the sundae, 162

cherry-picking among fruits, 171

chicken-scratches masquerading as letters or words, 18, 54, 254

"China" with norm-violating "i" on poster, 55

"China/中国" q-turn, 56

"China/中國" oscillation, 57, 58

Chinese characters, DRH's uncertainty about tweakability of, 129

Chinese phrase about art being made in heaven, 43

Chinese proverbs, 52, 119

Chinese term for "ambigram" (双观语, *shuānngguān yǔ*, "double-view phrase"), 56

Chinese term for "pun" (双关语, *shuāngguān yǔ*, "double entendre"), 56

Chinese wall-reflection ambigram by DRH, 128–129

chiocciola (Italian word for "@"), 129

Choisy, Emmanuelle, Parisian salsa student, 179

Chopin, Frédéric, Polish composer: ambigram for bicentennial birthday, 181–182; composing not for Peoria but for self, 85; as dedicatee of DRH ambigrams, 15, 94, 181–182; études Opus 25, 132, 200; preludes Opus 28, 259

Chu, Steven, American physicist and Hofstadter family friend, 172

"chump" in cursive as intrinsically symmetric, hence a non-ambigram, 67, 75

chunks versus letters, 199

circles made of curlicues, 161

city names, ambigrams on, *see* Italian city names; Capitals in Capitals

Claro, Francisco, lifelong friend of DRH, also of Chopin and Bach, 89, 95

cleverness, as opposed to experience and concentration, in ambigrammia, 141

clockwise q-turn, defined, 46; *see also* q-turn

clumsy childish lettering becoming graceful over a period of years, 153

Codogno, Maurizio, long-ago Italian student who showed DRH an ambiface, 107

Cognitive Science program at Indiana University, logos for, 197–198

colored dots sprinkled on ambigrams: as new DRH style element in twenty-first century, 123–128, 157–158; exemplified elsewhere, 159, 160, 168, 174, 175, 179, 183, 185, 208, 210, 212, 226, 257, 261, 264, 265, 269, 271, 276–278

composers, multigram on names of, 209–213

Compton, Arthur Holly, American physicist who found the light quantum, 231

computer drawing-tools, usage of in ambigrammia, 51

computers in Ambigrammia: designing ambigrams on their own, 198–200; not used by DRH, 51; used by Scott Kim and John Langdon, 51

computers, what they can and cannot do, 200

conceptual skeleton of an ambigram, 9–10, 74; concocted in shower, 84; fleshed out after shower, 84; realized in different ways, 159, 194–195, 281

Concina, Antonio, former mayor of Orvieto, Italy, 190–191

Concina, Susanna, generous host, 190–191

confetti, 36–37, 160; *see also* colored dots

Conrad, Michael and Debby, DRH's and Carol's friends in Detroit, 195

conservation laws for energy, momentum, angular momentum, 223, 234, 239–240

"Constraints and Creativity" seminar by DRH in Oklahoma, 258

Copernicus, Nicolaus, Polish astronomer/physicist who toppled geocentrism, 226

cosmic microwave background radiation, 244–245

Coulson, Seana, American cognitive linguist, 189

counterclockwise q-turn, 3, 46; *see also* q-turn

counting-questions, unanswerability of most, 134, 162

couple's mutual suitability, "proven" by a high-quality ambigram, 96, 185

couples, long-term, ambigrammatical celebration of, 189–192

courses in ambigrammia taught by DRH, 53, 115–117, 160–162, 165

cousins of various types to ambigrams, 107–114

"COWS", uppercase/lowercase ambiguity of, 113

creation versus discovery, 2, 4, 32–43, 189, 218, 221

creative perception, induced by an ambigrammatical challenge, 99

creative process: as nothing but selection, 36; hidden behind the scenes, 10

creativity: as insightful perception, 35; nature of, x–xii, 35; symposium on, in Geneva, 44

credit, claimed for mere perception of something already there, 69–70

crowd-pleasing (as opposed to self-pleasing) art, 85

Curie, Marie Skłodowska, Polish–French physicist/chemist, 231

curlicues inside letters of an ambigram, 161, 280

"current events" with identical "c" and "e", 60–61

cursive writing: in "chump", 67, 75; enjoyed by DRH while paying down the drain in the modern world, 280; grace of, mesmerizing DRH as a child, 151, 153; as key element of Scott Kim's ambigrams, 18, 24; of Nancy Hofstadter and Mary Givan, 152; used by DRH (just flip through the book); used by John Langdon, 24–25; used by Michael McCormick, 116

Cynamon, Joshua, friend of DRH and of beauty in times of crisis, 286

"D" *ex machina*, 138

Dali, Salvador, Catalonian artist who napped while a spoon fell from his hand, 28

DALL-E, as possible ambigrammist, 199

"Dave" as an easy ambigrammatical challenge, 20

debugging of flawed ambigrams, thanks to help of one's local Peoria, 154

Debussy, Claude, French composer of more than just "Clair de lune", 210, 213

decipherment versus reading of ambigrams, 46, 79, 114, 223

decisions, non-countability of, in Ambigrammia and in life, 141, 279, 285

"deep": 199; with quote marks, 199; without quote marks, 200

Dell'Eva, Lucia, *maestra* who helped DRH and children after loss of Carol, 124

delta function (infinitely narrow and infinitely tall spike), 238

Democritus, Hellenic philosopher who imagined that atoms exist, 226

De Paulis, Silvia, *maestra* who helped DRH and children after loss of Carol, 124

Descartes, René, French philosopher who said "*Cogito ergo sum*", 123

"designature" as an early name for ambigrams, 21, 117

determinism, as incompatible with quantum mechanics, 237

Deutsch, Babette, American author and literary translator, 174

dialogue between DRH and EBG, 86

dialogue between DRH and HRD, 136–156, 198–199

"Did your computer do this for you?", often-asked naïve question, 198

difficult-to-read ambigrams, made easier by adjacency with other difficult ones, 281; *see also* resonance

difficulty of an ambigrammatical challenge, subtlety of judging, 76–77

Index

Dionigi, Ivano, classics professor in Bologna, 125

Dirac equation, beauty of, 237–238

Dirac, Paul, British physicist who admired crossed hands in Bach gigue, 237, 238

discoverativity, as a necessary skill in ambigrammia, 2

discovery/creation spectrum, various points along, 72, 76; *see also* creation versus discovery

distance from one's own artistic creations, importance of, 154

District of Columbia and Puerto Rico, as disenfranchised U.S. states, 270, 281

Divina Commedia (tripartite poem in *terza rima* by Dante), 126–127

Donatich, John, V.P. at Basic Books, then director of Yale University Press, 288

"Don't be bashful; be bold!" (DRH maxim), 22, 129, 186

dot on top: as strong sign of lowercase "i"-ness, 54; as violating uppercase "I"-ness, 93; as missing in a lowercase "i", 149

dots, colored, *see* colored dots

doubly constrained unigrams: 180° rotation plus capital letters, 204, 208; wall reflection plus capital letters, 24, 162–164, 274; wall reflection plus lowercase letters, 134

drawing board, back to the, 154, 188, 206

Dr. J, *see* Jacobs, Michael, M.D.

dubious category memberships, careful adjustment of, 159

duck/rabbit illusion, 88, 91; *see also* oscillations

Eco, Umberto, Italian semiologist and author, 122

"Eiffel Tower/Champ de Mars" q-turn, 183

Einstein, Albert: *annus mirabilis* of, 230, 249–250; disbelief in nondeterminism, 237; erroneous intuition about entanglement, 250, 257; hypothesizing that light is corpuscular, 230–231; led by simple thought experiments to formulating general relativity, 70–71; as "not so foolish", 239; postulate of constant *c* (the speed of light), 215; profound perceptivity of, 70–71, 230–231; promoted from Technical Expert Third Class to Second Class, 230; quaint sexist language used by, 221; shooting down Weyl's gauge theory, 235; still baffled, in his final days, by the light quantum, 221; "stubbornness" and "stupidity" of, 250

electromagnetism, 228, 234–235, 251

electrons and positrons, 219–220

elision of letters, 21, 63

Elizabeth II Regina (HRH), 65, 90

elliptical orbits, instead of circular, 226, 233

Elton, Oliver, British literary translator, 174

English–Hebrew oscillogram, 92

entanglement of particles (Einstein's "spooky action at a distance"), 249–250, 257

"E Pluribus Unum" (multigram of the fifty states of the Union), 259–272; mentioned by Scott Kim, ix; as having just one single uniform style, 259

ix, 258–273

EPR paradox, *see* entanglement

epsilon-shaped cursive "e" used by Nancy Hofstadter and Mary Givan, 152

equivalence principle (Albert Einstein's "happiest thought of my life"), 70–71

Erb, Cyril, lifelong Swiss friend of DRH, 45, 90

Escher, Maurits Cornelis, Dutch graphic artist inspired by the Alhambra, 17, 29

Esposito-Farèse, Gilles, French physicist and ambigrammist, 29

esthetics: as crucial in ambigrammia, 35, 150–153; as crucial in physics, 249, 252–256

Eta Canon (canon by retrograde inversion by DRH), 201–203

eta-sequences, 202

ether, no experimental evidence for, *see* no ether

Eugene Onegin (novel-in-verse by A. S. Pushkin), 173–175; class on, taught by DRH, 174–175; as discovery, 189; as marriage of form and content, 285; memorization of, 173–174; Russians' reverence for, 173

Eugene Onegin (opera by P. I. Tchaikovsky), 173

exclusion principle (W. Pauli), 239

Excoffon, Roger, French typeface designer, 28

exhibitions of DRH art: Banff, 48–51; Calgary, 120; Cooper Union, 120; Geneva, 44–48; Genova, 121; Milano, 121; Ohio State, 120; SoFA Gallery (IU), 120

expectations in reading, rooted in one's native language, 19

explorativity, as a necessary skill in ambigrammia, 2, 73

"eye", as shorthand for "inner Peoria", 84

Falen, James E., American literary translator, highly inspirational for DRH, 173

Falen, Eve, spouse of James and co-dedicatee of DRH's *Onegin* translation, 173

"FANYA" ambigram, sketched by Scott Kim on a napkin, 40

Faraday, Michael, English inventor/discoverer of electromagnetic fields, 227–228

Fat Cat (Art Deco typeface), 27

Fauconnier, Gilles, French-American cognitive linguist, 189–190

Fauconnier, Tina, ardent student of Chinese language and culture, 189

Fauré, Gabriel, *Dolly* suite by, keystone to Baofen/Daoren romance, 184

"fermi", name of tiny unit of length, coined by Robert Hofstadter, 242

Fermi, Enrico, Italian physicist who made the first atomic pile, 241–242

Fermi, Laura, spouse of Enrico and author of *Atoms in the Family*, 241

Festival della Matematica, organized by Rome's Mayor Veltroni, 169–171

Feynman diagrams, featuring antiparticles moving backward in time, 219–220

Feynman, Richard, American physicist and self-styled "curious character", 246–248; as "maybe world's smartest man", 246–247; as village idiot, 247–248

fifty states, multigram of, by DRH, 259–272

figure/ground lexifusions: as members of the category "ambigram", 26, 31; as not members of the category "ambigram", 25–26; exemplified, 25, 31

Fiore, Winston, real-estate developer and bartender, 188

Fiorentino, Viviana, Sicilian/Sienese snail-lover, 129–130

"First Lady of England" analogy question, 247

Fischer, Bobby, one-time world chess champion, 169

Fitzgerald, Ella, American jazz singer, known as "First Lady of Song", 133

five-letters-to-three ambigram challenges, 45–46, 190

flames and flamelike letters, 187–188

Flamson, Melissa, seeker and finder of permissions, 288

Fontenrose, Lefty, American ambigrammist, 29

"Fortune/chance favors the prepared mind" (Louis Pasteur), 40, 123

four letters into one, *see* "illi"

four readings of a single ambigram, 164

four-space, 217–218

fractionally charged particles, 249

frame, cheatingly incorporated in an ambigram, 48, 101–103

Frey, Seth, one-time cog-sci graduate student at Indiana University, 176

fringe members of categories, 27–29, 100, 104, 213, 280–282

Fròsini, Patrizio, *matematico pistoiese*, 133

Frucht, William, editor at Yale University Press, 288

fugues, 3, 50, 284–285

Fürstenberg, Adelina von, gallery director in Geneva, 44–45, 87, 119, 259, 288

Galilei, Galileo, world's first relativist, and discoverer of Jupiter's moons, 70, 226

Gamow, George, 243–244; *see also* Alpher; Herman; Alpher–Bethe–Gamow

Gao Xingjian, Chinese author inspired by Mozart, 128–129

gappy-go-lucky lettering style, 44–47, 97, 157–158, 196, 264, 267, 277, 280

Garibaldi, Giuseppe, Italian hero, in ambiface with J. Stalin, 107–108

gauge symmetry, 234–235

Gaume, Bruno, psychology professor in Toulouse, 128

Gebstadter, Egbert B., Aussie author of *Writoblendia: Xylographs Yummy and Zany*, 87

Gell-Mann, Murray, American particle-physics pioneer and bird fancier, 249–250

geode, hiding a magical-seeming crystal, 39

Gerstenfeld, Amanda, editorial assistant at Yale University Press, 288

Gettysburg address, written as a portrait of Abraham Lincoln, 109

Gianone, Angelo, topless-bar owner, 248

Gill, Elwin, flourish-loving ambigrammist, 119

Gill, Prudence, director of Hopkins Hall Gallery at Ohio State University, 288

Givan, Mary, DRH's grandmother and alphabetic mentor, 152, 287

Glashow, Sheldon, American physicist, 252; mocking supersymmetry, 255

global flow of letters in an ambigram, 153, 182

Golden Gate, The (novel-in-verse by Vikram Seth), 93, 173

Goldhaber, Michael, lifelong friend of DRH, and called "RRZ" by DRH, 187

gold platter, items served on, 275

Google doodles with hidden "Google", 60

Goudsmit, Samuel, Dutch physicist and co-discoverer of spin, with Uhlenbeck, 236

Gplot (graph of electron energies in crystal in magnetic field), 221–222, 247

grace, as crucial in ambigrammia, 12, 53, 118, 150–153

Gradl, M. J., alphabetic artist, 26

Gramma Sutra, extracts from, 88–89

gravitation, nature of, as revealed by Einstein, 70–71, 217–218

great art, contrasted with crowd-pleasing art, 85

gridfonts, x–xi, 120

Guenoun, Joël, French ambigrammist and letterplay artist, 29, 182–183, 275

Gugelot, Ursula and Kees, old friends of Hofstadter family, 46

Guidi, Ilaria, co-founder of Hopeful Monster, 288

"guó" (國) serving as stem of roman letter "i", 55

Guth, Alan, blurting out "I didn't know my name had that property", 32–35, 43, 85; hypothetically amazed by "that property" of state capitals, 280; hypothetically called on as expert witness in plagiarism trial, 58; hypothetically delighted by DRH "salsa" ambigram, 79; quoted by Debbie Hickox, 69

Guth, Eugene, Hungarian physicist needlessly and nastily needled by Pauli, 239

Guy, Richard, British number theorist, xii

hallucination: as natural part of reading, 63, 126, 134, 147, 158, 196, 199, 207, 275, 279, 280, 282, 292; of lines and serifs, 196

"Halt — a gun!" (anagram of "Alan Guth"), 33

Hamel, Patrice, French ambigrammist, 29

hand-drawn style of DRH ambigrams, 51–53

"Happy families are all alike…" (Tolstoy), 110, 123

hard-to-read ambigrams as "better", 79

Hardy, G. H., British mathematician who thought 1729 was a dull integer, 250

Haroche, Serge, French physicist and speaker re Einstein's quantal doubt, 249–250

Hastorf, Albert, Stanford psychology professor of Peter Jones and DRH, 15, 17

head and tail, exchanged by counterclockwise q-turns, 46

Hebrew–English oscillogram, 92

Heisenberg, Werner, German matrix-mechanics pioneer, 218–219, 235, 242–243

Helvetica typeface's high legibility, 19, 46, 275

herbs, two different unigrams on names of, 206

Herman, Robert, American physicist and Hofstadter family friend, 244–245

Hertz, David, pianist, professor, and friend of DRH, 132

heterograms versus homograms, 14

Hewish, Anthony, British astrophysicist whose student discovered pulsars, 256–257

Hickox, Debbie, hypothetical friend of reader, 68–70

Higgs boson, 255

Hinchliffe, Jillian: portrait of, inside ambigram, 176; puzzle-museum curator, 176

Hobo (typeface), 90

"HOBO" as cyrillic/roman ambigram, 112–113

Hofstadter butterfly, *see* Gplot

Hofstadter, Carol: amused by "Gramma Sutra", 89; on cloud nine, reading *Eugene Onegin* with husband Doug, 173; as dedicatee of DRH ambigrams, 87–89; ever-supportive of DRH exploring Ambigrammia, 287; missing out on election of Obama, 172; mother of Danny and Monica, 289; sudden death of, 103; zigzagging around Italy with DRH, 86

Hofstadter, Danny: as member of DRH's local Peoria, 83, 153–154, 283, 289; receiving *Enciclopedia di Roma* from Rome's mayor, 171; suggesting vegetarian cooking lessons, 177; taking calculus class, 167; three ambigrams for, 131

Index

Hofstadter, Douglas: ambigrammatical discard pile of, 218; ambigrammatical style of, coalescing, 133; as ambiparent, 105; amused by "OIHOS", 1; art exhibits by, 44–45, 119–121; as author, 17, 22, 45, 87, 115, 126, 190; bashing head against Chinese language, 185: as basic Chinese tutor, 55; beaten out as general-relativity discoverer, 218; belief in artistic creativity's mystique, 198; blown away and intimidated by Scott Kim's ambigrams, 18–21; braggadocio of, 234, 279; canon by, 202; cheating left and right, 54; childhood fascination with physics, 214; as cognitive scientist, xi, 197, 214; combining own name with year, 140; creative life of, curtailed by wife's death, 105–106; as curmudgeon, 118; discovering beautiful shell on beach, 221–222; dislike of quarks, 249; doubting ambigrammia's importance, 284, 286; early admiration for physicists, 225; enchanted by cursive alphabet in classroom, 151; encounter with Gell-Mann, 249–250; encounters with Feynman, 246–248; exhilarated by 2008 election, 172; exploring avenues of approach for Oliviero Stock's birthday, 5–9; exploring letterforms when young, 153; favorite microworlds of, x–xi; first artistic ambigram by, 16; frequent use of wall reflections by, 24; gagging on electroweak "unification", 252–253; giving ambigrams as gifts, 153; gradual shift in public identity of, 115, 119–121; grateful for Peorian critiques, 154; imagining ambigram while in shower, 84; influenced by mother's handwriting, 152; inspired by Peter Jones, 14, 26; inspired by Scott Kim and John Langdon, 26; internalizing other people's eyes, 154–155; judging ambigrams contest, 118; jumping into cha-cha class, 184; kept sane by working on *ABCD*, 286; knowing no Hebrew, 92; lecturing in Italian, 86; local Peoria of, 83, 153–154, 283, 287–289; as lonely singleton, 177, 183; love–hate relationship with physics, 214, 221, 252–254; mantra used by, in teaching, 117; meeting childhood hero after 62 years, 200–201; memorizing *métro* stations, 179–180; misjudging own ambigrams' quality, 153–154; *modus operandi* of, in creativity, 161; moving from Indiana to Michigan, 115; multiple binges of, 284; musing about ambigrammia's mechanizability, 199–200; not always able to realize a 180° rotation, 205; not considering ugly letters, 151; as own critic, 154; as own fan, 283–285; panicked by global threats, 286; parlaying failure into success, 156; personal religion of, in ambigrammia, 53; reading *One Two Three… Infinity* as a kid, 243; revival of ambigrammia in, 123–135; sabbatical years of, 103, 122–135, 177, 197, 221; as sadistic letter-abuser, 3; sale of ambigram by, 121, 284; salsa-dancing's importance for, 178, 184–186; savoring an ambigram long after its creation/discovery, 284–285; savoring the creation/ discovery of an ambigram, 284; saying little, but with flair, 216; in seventh heaven, reading *Eugene Onegin* with wife Carol, 173; in shock in Bloomington in November 2016, 286; signing *Inversions* with own ambigrams, 22; spotting "if" in arrows, 42; standard way of tackling ambigram challenges, 6; sticking to own guns re particle physics' ugliness, 254; as student in own classes, 206; tackling state capitals with hands tied behind back, 274; teaching ambigrammia, 53, 115–117, 205–208, 258–259; tending toward block capitals, 24, 69; thrilled by Bach fugues, 284; translating novels, 171, 173; unsure how to tweak Chinese characters, 129; *Wild Grace Chase* of, 284; as would-be photographer, 37

Hofstadter, Laura: supportive of brother, 287; ambigram for 60th birthday of, 182

Hofstadter, Monica: as admirer of Walter Veltroni, 169; faith in art as saving the world, 286; as guest at Soros dinner, 191; as member of DRH's local Peoria, 83, 153–154, 283, 289; pushing DRH to get this book done, 289; suggesting vegetarian cooking lessons, 177; in tears in Brooklyn in November 2016, 286; two ambigrams for, 131

Hofstadter, Nancy: elegant handwriting of, 152; encouraging DRH, 287; missing out on election of Obama, 172

Hofstadter, Robert: citing Fourth Law of Thermodynamics, 224; coining "fermi" as unit of nuclear distance, 242; describing Dirac as delta function, 238; encouraging DRH, 287; introducing DRH to "maybe the world's smartest man", 246; missing out on election of Obama, 172; Nobel Prize connections, 240, 245; pointing out double-readability of "SOHIO", 1; studying physics in German, 233

Hohn, Hu: invitation from, 48, 288; challenge of making an ambigram for, 49–50

homogram, *see* heterogram

Hooke, Robert, seventeenth-century English physicist and rival of Newton, 227

hoops, jumping through many at once, 164, 175, 206, 283

Hopeful Monster publisher, 87

"H-orb lines", anagram of "Niels Bohr", 217

"Hóu Dàorén" (侯道仁), DRH's Chinese name, 185

"How did I ever think *that* up?", 284–285

"How Form Gives Pleasure" (DRH lecture suggested by David Hertz), 132–133

"How many ambigrams in this unigram?", 135, 162, 207

"How many shapes in this written sample?", 111–112

HRD (Humorous Reversal of DRH), 136–156

Hubbard Welsh, Lori, longtime Hofstadter family friend, 187

Huber, Greg, as ambigrammist, 29, 287; as ambispeaker, 42; baffled by Guth's remark, 32–35, 85; calling own works "iffyglyphs", 23; as creator/discoverer of "Guth" spinonym, 32–35, 43; as member of DRH's local Peoria, 83, 287; tackling an ambigram challenge differently from DRH, 275, 281; working on "Bach/fugue" ambigram, 50

human touch in ambigrammia, desirability of, 52

humor, as desirable quality in ambigrammia, 53, 106

hyphen, jaunty, 50

I and Eye dancing together, 84

"i" becoming "g" after 180° rotation, 98–99

"i"-ness, role of dot in, 54

"I" with dot on top: as typographical outrage, 93; as device for shoring up shaky category membership, 76, 93, 98, 100, 101, 104, 124, 125, 126, 165, 168, 175, 185, 188, 194, 208, 210, 212, 219, 223, 226, 235, 236, 239, 242, 250, 262, 264, 269, 270, 271, 282

ice melting in warm bathtub, but not the reverse, 229

"ichael" as an unlikely first name, 137

icing, fortuitous, on the cake of an ambigram, 74, 128–129, 176, 181, 238

"if" street sign, 41

ignoring superfluous shapes in an ambigram, 20

"I have to speak with some authority before the class" (G. Huber), ambiguity of, 42

ill-definedness of ambigrammatical challenges, 5, 209, 224

illegibility, often not noticed by beginning ambigrammists, 52

"illi" becoming "t" after 180° rotation, 176

independent discovery of "the same ambigram" by different people, 34, 74

indivisible chunks, *see* minimal chunks

"innocent" embellishment giving rise to fringe members of ambigrammia, 111, 116

intellectual reasoning (slow) versus perception (quick), 143

intrinsic ambigrams, 67–70, 72, 75, 79

"inversion", as original name for ambigrams, 21

Inversions: A Catalog of Calligraphic Cartwheels (Scott Kim), ix, 21–22, 45

Ippolito, Joyce, book production manager, 288

isomorphic ambigrams, 194–195

Italian cities' names, multigram of, 100–103, 208

Italian newspaper titles, multigram of, 133

Italian regions' names, multigram of, 103–104

"Jacdos" as an unlikely last name, 144

"JacobsM" as an unlikely last name, 137

Jacobs, Michael, M.D., story behind DRH's ambigrammatical gift to, 136–156

jauntiness, as desirable in ambigrammia, 106

jazz scribbles, 120

Jenner, Alexander ("Sasha"), pianist who inspired youthful DRH, 200–201

Jenner, Paca and Mike, daughter and son-in-law of Sasha Jenner, 200–201

Johnston, Charles, British diplomat and translator, 173

Jones, Peter: as dedicatee of *ABCD*, v, 287; as dedicatee of DRH ambigram, 47; as the first-ever ambigrammist, 12–16, 26, 29; hat posthumously tipped to by DRH, 47, 95, 224; as lifelong friend of and inspiration to DRH, 287; realizing only in part the fluidity of letters, 193

Kahn, Matt, as creative photographer, 36–37; as design teacher, 39

"Kalamazoo" as extreme ambigrammatical challenge, 165

Kandel, Michael, American literary translator, 196

Kao, Richard, DRH's first Chinese teacher at Stanford, 185

Keller, Helga, DRH's administrative assistant who promoted art exhibit, 120, 288

Kennedy, Donald, Stanford biology professor and Hofstadter family friend, 17

Kepler, Johannes, German astronomer, 226

Khosrovi, Margie, longtime friend of DRH, 75

Kim, Scott: ability to do ambigrams in head, 77; ambigrams by, xi, xii, 18, 21, 40, 51, 118; appreciating "misfortunes" in ambigrammia, 75; author of *Inversions*, ix, 21; boxed phrases designed by, 61–62, 146, 148, 279; cheating left and right by, 54; creativity of, 20; crestfallen at cursive writing's fading, 280; dedicatee of DRH ambigrams, 91, 95, 165; dedicatee of this book, v, 287; first meeting with DRH, 17–18; grace of ambigrams by, 18, 287; grotesque "o" by, 54; improvising ambigrams in ink, 22, 118–119; independent discoverer/inventor of ambigrammia, 18, 24, 26, 287; judging ambigrams contest, 118; member of DRH's local Peoria, 83; musician, 201–202; norm-violating "m" by, 54; as puzzle designer, xi; signing copies of *Inversions*, 118; spotting gleaming shell on beach, 39–40; stretching the definition of "ambigram", xi–xii; student of Matt Kahn, 39; super-legibility of ambigrams by, 118–119; tackling an ambigram challenge differently

from DRH, 275; tricks in early ambigrams of, 18–19; user of drawing software, 51–52

King, Martin Luther, Jr., American civil-rights advocate, 172

Klee, Paul, Swiss artist who painted a red fugue, ix

Krausie, Charles, winner of *Omni* "designatures" contest, 117, 119

Kroger gas-station logo, 273

Kvant magazine, ambigrams contest in, 71

lake reflection: defined, 7; exemplified, 9, 50, 69, 133, 165, 187, 189, 195, 219; reasons for generally avoiding, 68

Langdon, John: ambigrams by, 24–26; artistry of, 25, 288; author of *Wordplay*, 24; on constraints, xii; independent discoverer/inventor of ambigrammia, 23–24, 26, 288; love of beautiful classic letterforms, xi; tackling an ambigram challenge differently from DRH, 275; user of drawing software, 51–52

Larm, Victoria, Swedish historical novelist, 188

Larsen, Don, New York Yankees pitcher of perfect game in World Series, 168

Lavin, Mitchell T., who gained fifteen minutes of fame from a cursive word, 67

Layne-Worthey, Glen, long-time DRH friend and member of DRH's local Peoria (despite living in Urbana), 288

Leake, Alice and Roy, Bloomington friends of DRH, 98

Leban, Roy: as ambigrammist, 29, 287; as member of DRH's local Peoria, 83, 287; tackling an ambigram challenge differently from DRH, 275, 281

L'Ebbrezza della Bellezza (DRH lecture), 132–135

Lebigre, Estelle, Parisian salsa student, 179

Lee, Tsung-Dao, Chinese-American physicist, 251

legibility: as crucial in ambigrammia, 4, 53, 117–119, 152, 205; slightly sacrificed at the altar of visual beauty, 79, 213

Les mots ont des visages (book by Joël Guenoun), 182

"Let a hundred flowers bloom!" (Chinese saying), 119

letters: broken apart and recombined, 18–19, 35; far-fetched, 12–15, 19–20, 22, 65, 97, 99, 102, 104–105, 118, 119, 176, 178, 179, 183, 186, 213, 223–224, 279, 281; gawkiness of, 12–15, 133, 150–151; mutual reinforcement of, 134–135, 188; reasons for quirkiness of, xii, 238; reinforced by words they are in, 134–135; replaced by non-letters, inside words, 59; underestimated liability of, 193; upper halves versus lower halves of, 219

Letter Spirit project, x–xi

letter-to-letter mappings in early ambigrams, 14–15, 66

light, corpuscular or undulatory, 220–221, 227, 228

light quantum, third-class Swiss patent-office clerk's third-class idea, 220

Lin, Baofen: dancing cha-cha with grace, 184; dancing salsa with even more grace, 185, 186; as dedicatee of DRH ambigrams, 185–186; meeting Sasha Jenner, 200; meshing of "Baofen" with "Daoren" seen as kismet, 185; as sometime member of DRH's local Peoria, 83, 289; standing up for D.C. and Puerto Rico, 270; studying piano, 184; transitioning from being DRH's cha-cha/salsa partner to being DRH's life partner, 184–186; traveling in Europe, 185, 191

Lincoln, Abraham, portrait of, realized as Gettysburg address, 109

Liu, David, son of Baofen, husband of Mattie, and dad of Ian and Fiona (and now answering to the last name of "Mackenzie-Liu"), 185

Lucretius, Roman author of the poem *De Rerum Natura*, 125

local versus global beauty, 153

locking-in, in acts of perception, 134–135, 163–164, 207

logical arguments, uselessness of, in reading ambigrams, 143

London, Fritz, German-American physicist, 251

Love for Three Oranges, suite by Sergei Prokofiev, 211, 213

lowercase cursive letters, frequent use by Scott Kim, 18; *see also* cursive writing

low-hanging versus high-hanging fruit, 68–70, 72–74

luck, role of, in Ambigrammia, 185

"lucky coincidence" that "DOUG : 2004" could be wall-reflected, 140

"M", backward, 137

magnetic field: first observed by Michael Faraday, 228; crystal immersed in, 222

magnetic resonance imaging, 242

Magnificat (twentieth-century typeface), 28

makeup, caked on, to hide problematic substrate, 52, 104, 118; *see also* retinal razzle-dazzle

Mandelbrot, Benoît, French-American mathematician, 169

manipulativity, as a necessary skill in ambigrammia, 2

Mansell, Judy and Ron, expert art framers for DRH exhibits, 120

Mantle, Mickey, New York Yankee who saved Don Larsen's perfect game, 168

Mao Zedong, Chinese leader who wanted 100 flowers to bloom, 55, 119, 123

mass, inertial versus gravitational, 70

Mathews, Christopher, typeface designer, 28

Maxwell, James Clerk, Scottish physicist who linked light to electromagnetism, 228

Maxwell's equations of electromagnetism, 215, 228, 234–235, 253

"maybe world's smartest man", 246–247

"May" versus "maggio" versus "5" versus "five" versus "V", 8

McCormick, Michael, student in DRH class, 115–116

"MD" as key discovery for "Michael Jacobs" ambigram, 138–140, 155

melodies with crystalline inevitability, 39

memorization: of a DRH ambigram, by this book's reader, xii; of Paris *métro* system, 179–180; of stanzas of *Eugene Onegin*, 173–174

Mendeleev, Dimitri, Russian chemist who organized the periodic table, 239

Mercurese, scribbles written in, 116

"Mercury/hot" ambigram (Michael McCormick), 116, 280

Messner, Sandy, DRH's dance teacher at Panache, 184

métrogrammes, multigram of, 179–181

"Michael" in DRH ambigrams, 96, 140, 142, 150, 187, 193–196

"Michael/Barbara" wall reflection, story behind, 96

"Michael Jacobs MD" ambigram, story behind, 136–156

Michelson–Morley experiment, 215

Michigan, outline of, masquerading as letter, 144–145

microscopic physical laws as alien to macroscopic beings, 233, 237, 239, 241

"Midoel" or "Midnael" as possible misreadings of "Michael", 142–143

Mig (alphabet by M. J. Gradl), 26–27

Millikan, Robert, American physicist and light-quantum skeptic, 231

Mills, Robert, American physicist, 253

Minati, Mariangela, *maestra* who helped DRH and children after loss of Carol, 124

minimal chunks inside an ambigram, 66, 102, 194, 213

minimalism: desirability of, in ambigrammia, 9, 25, 50, 53, 97, 118–119, 130, 164, 167, 243; exemplified: 9, 20, 40, 50, 73, 74, 84, 97, 130, 131, 134, 140, 162–164, 167, 175, 187, 196, 204, 220, 222, 264, 268, 273, 281, 282; of logo, 273

mirror-symmetric oscillation ambigram having four readings, 162, 164

mirror symmetry, 3; *see also* lake reflection; wall reflection

Mirsky, Lawrence, director of Cooper Union art gallery, 288

"Misfortunes are good" (Scott Kim), 75

Mishra, Punya, ambigrammist, 29

misreadings, by self or others, as helpful clues to an ambigrammist, 154, 282–283

Mitchard, Dorothy, avid reader of DRH books, 130

Mitchell, Melanie, longtime friend and one-time doctoral student of DRH, 167

mixing lower case and upper case with no shame, 88, 102, 125, 201, 218

moment décisif, as always sought and often found by Henri Cartier-Bresson, 38

Mongold, Greg, excellent high-school calculus teacher, 167–168

monosyllabic word, hyphenated, 49–50

Montalvo, Fanya, friend of DRH and of Scott Kim, 39

Morin, Basile, ambigrammist, 29

Morris, Scot: publisher of Scott Kim's "designatures" in *Omni* magazine, 21, 287; organizer of ambigram contests, 117–118, 288

Moser, David: as ambigrammist, 29, 287; becoming fluent in Chinese, 56; as dedicatee of DRH ambigram, 48, 166; hat tipped to by DRH, 47–48, 287; as judge of *Omni* ambigrams contest, 118; as member of Chinese *GEB* translation team, 56; as member of DRH's local Peoria, 83, 287; sinosigns by, 56–58; taking first baby steps in Chinese thanks to DRH, 55

motifs, *see* repeated small motifs

moviegoers, aware of complexity behind the scenes, 156

Mozart, Wolfgang Amadeus: canon by, 202; music by, as *verboten* stimulant, 128

Mr. Ace (George Zweig), 248

Mr. Quark, two claimants to the title of, 248

multigrams: defined, 207; exemplified: calculus students, 168; composers, 209–212; *Eugene Onegin* students, 175; Gramma Sutra, 88–89; Italian cities, 100–101; Italian newspaper titles, 133; Italian regions, 104; Paris *métro* stations, 180; physicists, 226–257; salsa students, 179; states, 260–269; trees and fruits, 171

Murphy's law, *see* thermodynamics

mutual propping-up of shaky letters inside a word, 21; *see also* locking-in

Mzchael, reader of upside-down black-boxed Beatles lyric, 145, 148, 149

Nabokov, Vladimir, Russian-American poetaster, paraphrast, lepidopterist, 249

names suggested early on for ambigrams, list of, 23

narrow "O" seen as a wide "I" (and vice versa), 30, 91, 165; *see also* "1 (numeral)"

Nash, John, American mathematician, 169

Necker cube, 88; *see also* oscillations

Neri, Camillo, classics professor in Bologna, 125

neutrino, 239–241

neutron, decay of, 240–241

newspaper headlines, ambiguities in, 42–43

Newton, Isaac, English physicist who thought light was made of corpuscles, 227

Nicholls, Deborah, seeker and finder of permissions, 288

nine-dots puzzle and "thinking outside the box", 4

9/11 tragedy, 120

90°-rotation ambigram, *see* q-turn, rotoflip

Nobel Prize in literature, 128

Nobel Prize in physics, 226, 233, 240, 242, 244–245, 257

No-Bell Prizes in physics, 257

no ether, experimental evidence for, 215

Noether, Emmy, mathematical physicist: theorem of, 234; anagram for, 234

nomen est omen, 217

Nonbello Prize for Ambigrammia, 253–254

non-Euclidean geometry, simultaneous discovery of by several people, 29

non-uniformity of style as charming, 124

norm violations as par for the course in Ambigrammia, 49–51, 54, 73

"not even wrong" (insult by W. Pauli), 239, 255

Novarese, Aldo, Italian typeface designer, 28

nullogram, 53

"O", ghostly, 166, 168, 179, 191

Obama, Barack, President, 172

Obama, Michelle, First Lady, 172

objective category membership as a myth, 82

Odessa (Art Nouveau typeface), 26–27

"OIHOS", as upside-down reading of "SOHIO" logo, 1–2

"Oklahoma" ambigrams by Oklahoman honors students, 258

Olivieromaggio: as discovery rather than creation, 34–35; story of, 5–11

Omni magazine: ambigram contests, 52, 117–118; Scot Morris column, 21, 117

"1" (numeral) turned into an "O" (letter) under 180° rotation, 158–159

180°-rotation ambigram: defined, 3; exemplified (all throughout this book); *see also* q-turn; rotoflip

oscillations: defined, 57, 88; dubious members of the category, 111, 113; exemplified, 25, 31, 41, 57–58, 89, 90, 91, 92, 109, 110, 111, 162, 185, 220–221; shaky readability of, 89

outrageous letters, *see* fringe members of categories

outtakes from "E Pluribus Unum", 270–272

outtakes from "The August Lulu", 281–283

palindromes, relationship to ambigrams, 3, 72, 107

paradox: of art prices, 121; of cheating in ambigrammia, 74–75

Paris, DRH sabbatical in, 78, 177–183, 197

parity, violation of, 250–251, 255–256

particle physics, viscerally repelling DRH, 253–256

parts versus wholes, 111–112

Pasteur, Louis, French chemist and biologist, 123

Pauli, Wolfgang, Austrian physicist known not only for his "effect", 238–240, 255

paying through the nose, art purchasers' preference for, 121

Penzias, Arno, American radio astronomer, 244–245

People, The: as abbreviation for "The **Peo**rian **Ple**bs", 82; assumptions about typical members of, 163, 280; as crucial for an ambigrammist to have a good internal model of, 82; as ultimate judges of ambigram readings, 82, 280

Peoria: Chinese, 129; inner and local, 83, 154–155, 259, 271, 272; mechanizability of, 199; Polish, 85; *see also* playing in Peoria

perception as involving creative insights, 33–43

perceptivity, 69–70

percepts versus concepts, 112

perceptual synergy, 164; *see also* resonance; locking-in

perfection in Ambigrammia, as equivalent to triviality, 74–75

Peter, Friedrich, German typeface designer, 28, 81

Petrick, Robert, ambigrammist, 29

photoelectric effect, 230

photography as an art form, 36–39

photon, 220–221

phrases as visual categories, 147–149

physicists, multigram of, by DRH, 225–257

physics and its history, 4, 214–257

pi, spine-tingling formula for, 167

piano, potentially having fugues as an intrinsic property, 34

Picasso, Pablo, Spanish artist who saw a bull's head in a junked bike, 40

Piccadilly (twentieth-century typeface), 28

"pies" as a super-quasi-ambigram, 113

pizzazz, retinal, *see* retinal razzle-dazzle

plagiarism in Ambigrammia, 58

Planck, Max, German discoverer of energy quantization, 229–230, 231

planet names, as an ambigrammatical challenge, 115–116

playfulness, as desirable quality in ambigrammia, 53

playing in Peoria: 35, 82–85, 91, 94, 129, 159, 163, 199, 259, 271, 272, 280–282, 287–289; *see also* The People

Pluto: wobbling planetary status of, 115; wobbly ambigrams on name of, 116

Podolsky, Boris, Russian-American physicist, 249

Polish "z" with dot on top, 149

Pollock, Jackson, American artist known for his "drip" paintings, 60

Polombian poffee, pool jazz, plus porn, parrots, papers, and pauliflower, 81

Polster, Burkard, Australian ambigrammist and author of ambigram book, 29

Porter, Cole, American composer of "You're the Top", 133, 211

portrait hidden inside a piece of writing, 109, 176

position and momentum, not simultaneously measurable, 218

Poznań, as Polish Peoria, 85

price of an ambigram, 121

"prime numbers" of ambigrammia, 66; *see also* minimal chunks

priming, role of, in the reading of ambigrams, 259

Prodi, Maria Chiara, one-time student in Bologna, 124

Prodi, Romano, one-time head of European Union, 124

projectivity, as a necessary skill in ambigrammia, 2

Prokhorov, Nikita, ambigrammist and author of ambigram book, 29, 119

Index

Prokofiev, Sergei, Russian composer of *Love for Three Oranges*, 211, 213

proverbs, boxed (Scott Kim), 61–62, 279

pulsars, discovery of, by a mere graduate student, and female, to boot, 256–257

Purcell, Edward, American physicist, 242

Pushkin, Alexander Sergeevich, Russian author of *Eugene Onegin*, 93, 173

QED, QCD, and QFD, 252

q-turn: defined, 46; exemplified, 3, 46, 47, 48, 51, 56, 88, 93, 94, 95, 114, 183, 191, 196, 217, 266; DRH predilection for, 48

quarter-turn ambigram, *see* q-turn

"quince pies" as bilingual ambigram, 112

Rachmaninoff, Sergei, Russian composer of more than just C# minor prelude, 211

rainbow unigram, ix, 162–164, 274

rascal who doesn't understand light quanta, 221

reading, *see* bottom-up versus top-down perception; hallucination; legibility; letters; resonance

receiving minds, requirements on, to read far-fetched ambigrams, 280

recipient of ambigram, unaware of cogitation behind the scenes, 10, 155–156

rectangles acting as letters in famous phrases, 61–62, 146–148

rediscovery of Greg Huber's spinonym by students forty years later, 34

reflection versus rotation, 6–7, 24, 69

reframing of an ambigrammatical challenge, 10, 35, 137, 138, 155, 205

regrouping as crucial in ambigrammia, 18; *see also* minimal chunks

relativity, special, 215, 217

relativity, general: ambigrams on, 70–71, 218; clashing with Newton's theory of gravity, 218; coming from musing about an ancient fact, 70–71; creation or discovery?, 218

renaissance, in DRH, of ambigrammia, 120–121, 122–135

repeated small motifs, enhancing uniformity of style, 105, 168–169, 250

resonance between parts and wholes, 20–21, 134–135, 163–164, 206

retinal razzle-dazzle: as distraction from weak conceptual skeleton, 52, 117–119; eschewed by DRH, 9, 20, 50, 73, 74, 84, 97, 130, 131, 134, 140, 162–164, 175, 187, 196, 204, 220, 222, 264, 268; eschewed by Scott Kim, 118–119; exploited by DRH, 76, 94, 101–102, 122, 175, 178, 222

Reutersvärd, Oscar, Swedish artist of paradox and ambiguity, 28–29

rhythm: in an ambigram, 182; in a piece of music, 202

riffs in ambigrammia, 23, 74, 99

river through Tallahassee, nonexistent, 276, 280

Rogers, Ginger, dancing partner of Fred Astaire, 253

Rosen, Nathan, American physicist, 249

rotation ambigram, *see* 180°-rotation ambigram; q-turn; rotoflip

rotoflips: defined, 45–46, 48–49; exemplified, 45, 49, 73, 99, 106, 266, 271

rotoportrait, *see* ambiface

"ROY G BIV" mnemonic, assumed known by Peorians, 164

ruler, usage of, by DRH, 104, 239

Russian words that are intrinsically symmetrical, 71

Rutherford, Ernest, New Zealand physicist who discovered nuclei, 216, 231–232

Saint-Saëns, Camille, 210, 213; inevitable melody discovered by, 39, 40

"salsa" (word), questionable intrinsic mirror-symmetry of, 79

salsagrammes, 177–179; multigram of, 179

salsa lessons, 78, 177

salsa students' names, multigram of, 179

Salvadori, Fulvio, translator of *Ambigrammi*, 288

Sander, Emmanuel, DRH friend and co-author of *Surfaces and Essences*, 177

"San Diego" ambigrams, 84, 119

"SAN JUAN" ambigram, as visual poem, 281, 285

Satija, Indu, author of *Butterfly in the Quantum World* and avid marathon-runner, 222

"Scarborough Fair", English folk song, 207, 259

Schnorr, Peter, alphabet drawn by, 26

Schönberg, Arnold, Austrian-American atonal composer, xi

School of Fine Arts ("SoFA") at Indiana University, 120, 160, 288

Schrödinger, Erwin, Austrian wave-mechanics pioneer, 218, 235

Schumann, Robert, German composer who said about Chopin, "Hats off, folks — a genius!", 123, 210

Schwinger, Julian, American physicist, 252

selection as deep art, 36–43

sequence-extrapolation challenges, x

Seth, Vikram, Indian author of *The Golden Gate*, 93, 173

seven-letters-to-four ambigram challenge, 176

seven-letters-to-three ambigram challenge, 116

sewer-cover photograph (Matt Kahn), 36–37

sexist language, unintentional, 221, 246

Shadlen, Michael, American neurologist, 194

shallow style: overused by novices, 52, 117–119; used by DRH, 94, 98, 195; *see also* retinal razzle-dazzle

shotgun wedding, as metaphor for electroweak unification, 253, 255

Sigmund, Karl, Austrian game theorist and Vienna Circle historian, 191–192

signatures for ambigrams, developed by DRH, 158–160

"Silence and night, a garden asleep…" (poem by Nancy Hofstadter), 152

single-stroke vertical cursive ambigram, 131

silver platter, items on, 69, 96, 102, 127–128, 129, 177, 279; *see also* gold platter

Simon, Paul, and Art Garfunkel, American pop duo, 207

simplicity, as desirable in ambigrammia, 53

simplified Chinese characters, 55–57

Sinaloa (twentieth-century typeface), 28

sinosigns by David Moser, 56–58

sinosign sign, pirated by restaurant in Memphis, Tennessee, 58

six-circle ambigram, 130

Slavic Letters and Slavic letters, 196

"SOHIO" logo as having a rotated second reading, 1–2

solid-state physics, 221, 242

Sommerfeld, Arnold, German quantum-physics pioneer, 233

Soros, George, Hungarian-American financier and philanthropist, 191–192

Soros, Tamiko, gracious host, 191–192

Index

Spassky, Boris, one-time world chess champion, 169

spices, *see* herbs

spin of elementary particles, 236, 238

Spinelli, Aldo, Italian artist, author, and arranger of DRH exhibits, 121, 288

spinonyms: defined, 32; exemplified, 32, 132, 160, 236

sprinkling of dots by DRH on ambigrams, *see* colored dots

"squintygrams" (T. Tanaka), 31

Stalin, Joseph, Soviet antihero, in ambiface with G. Garibaldi, 107–108

standard technology in ambigrammia, 23, 74, 99

state-capitalism, 281

states-of-the-Union multigram, *see* "E Pluribus Unum"

Stirratt, Betsy, organizer of DRH art show in SoFA Gallery, 120, 288

Stock, Oliviero, Italian AI-and-humor researcher, 5, 34–35; DRH birthday present for, 5–11

Stop (twentieth-century typeface), 28

stories behind various ambigrams: "Jillian/Seth", 176; "LINCOLN", 279; "Michael Jacobs MD", 136–156; "Michael/Barbara", 96; *Olivieromaggio*, 5–11; rainbow unigram, 162–164; The August Lulu, 274, 279

strokes and letters, mutual reinforcement of, 135; *see also* resonance; locking-in

strong force inside the nucleus, 249

strongest and weakest parts in an ambigram, 51, 186

Sturmark, Christer, Swedish author, publisher, and secular humanist, 188

style versus trickery in ambigrammia, 152–153

sufficiently subtle discoveries count as full-fledged creations, 32–43, 70–71

Sunkist logo, 63

supersymmetry, as superstition in particle physics, 254

swashes, swirls, and flourishes, 22, 26, 27, 28, 54, 76, 103–105, 116, 117, 119, 122, 165, 176, 178, 183, 187, 188, 203, 222, 223, 265, 271, 278, 280

Sweetser, Eve, American cognitive scientist, 189

Swiss ambigrams, quartet of, 134–135

symmetry: choice of, up to the ambigrammist, 6, 7, 10, 205; of DRH's and Scott Kim's forewords, ix; violation of, as a cute touch, provided legibility is not sacrificed, 73, 125, 164; *see also* 180° rotation; lake reflection; wall reflection; oscillation; q-turn; rotoflip

synergy of individually shaky letters in a word, 21, 134–135; *see also* resonance; locking-in

Syrochkina, Katya, peerless reader-aloud of Onegin stanzas, 175

Tabachnikov, Sergei, editor of *Kvant* magazine, 71

tail wagging its dog, 176

Tanaka, Tom, translator, wordplay explorer, and ambigrammist, 31

tapering lines versus fixed-width lines, 51

Tchaikovsky, Pyotr Ilyich, Russian composer of more than just *The Nutcracker*, 173

terza rima, to hell with, 127

"that property", 32–35, 49, 58, 69, 79, 85, 160, 217, 234, 280

"The most creative ambigrams are the least creative ones" paradox, 74–75

thermodynamics, four laws of, unigram of, 223–224

thin fixed-width lines, often used by DRH, 51, 52, 275

"thinking outside the box", 4, 73, 89

time's arrow, mystery of, 228–229

tintinnabulum, inverted, used in an ambigram, 97

Tissi, Rosmarie, Swiss typeface designer, 28

Tolstoy, Leo, Russian author of more than just *War and Peace*, 109, 123

tone marks in "Gāo Xíngjiàn" ambigram as tasty icing on the cake, 128–129

top-down processing in reading, 61–64, 104, 128, 144–150, 186

"Traduttore traditore", cute sound bite but merely an unsound bark, 123, 133

translation: as essence-preserving act, 194–195; traitorous or faithful, 123, 133, 173

trees and fruits, multigram of, 171

Trento, DRH sabbatical year in, 103, 124

trompe-l'œil, 36–37, 141, 201

Truscott, George, DRH's excellent junior high-school algebra teacher, 168

Turner, Mark, American cognitive scientist, 189

tweaking shapes to strengthen category membership, 7–9, 137–140, 142–144

two extra states, 270

two extra state capitals, 281

typefaces, as breaking new ground in the twentieth century, 27–28

typos, unseen in proofreading, 63

ugliness: in Ambigrammia, importance of avoiding, 150–151; in physics, making DRH bow out, 254

Uhlenbeck, George, Dutch physicist and co-discoverer of spin, with Goudsmit, 236

uncertainty principle, 218–219

unconscious processing in reading, 61

unification, in physics: electromagnetic, 228, 253; electroweak, 252–256

uniformity of style: becoming more reliable over time as DRH's ambigrammatical fluency grows, 105; of the fifty-state "E Pluribus Unum" multigram as a whole, 259; as greatly desirable inside an individual ambigram, 53, 64, 153, 158; particularly clear in rainbow unigram, 162–164

uniformly-sized letters, as desirable in ambigrams, 90, 110

unigrams: defined, 207; exemplified, 134 (four names of Switzerland); 162 (seven rainbow colors); 204 (five New York City boroughs); 206 (four herbs); 208 (twelve birthstones); 223 (four laws of thermodynamics); 276–278 (fifty state capitals)

unity, tight, of a unigram, 163

unspeakable evil, 286

"up", "down", "strange", "charm", "truth", "beauty" (the six quark flavors), 250

uppercase and lowercase ambigrams done together, 174–175, 220–221

upper halves versus lower halves of letters, in reading, 219

upside-down reading feat by Mzchael, 148–149

US/SU friendship, ambigram to promote, 94

Varzi, Achille, Italian philosophy professor who also teaches prisoners, 191–192

veins of receptivity in the collective human mind, 4, 85, 280

Veltman, Martinus, Dutch physicist who spurned strings and supersymmetry, 255

Veltroni, Walter, mayor of Rome and organizer of math festival, 169–171

Index

virtuous circle of ideas sparking other ideas and in turn being modified, as *modus operandi* in creativity in general, 161

"visience" or "visuence", 82–83; *see also* audience

visual themes, echoed in an ambigram, 105; *see also* repeated small motifs

Vivaldi, Antonio, Italian baroque composer who wrote a good concerto

Vivaldi (typeface), category membership of certain capital letters of, 81–82

wall reflection: defined, 7; used as default by Peter Jones and DRH, 13–15; used with capital or lowercase letters as a double constraint, 134, 162–164, 274

Wannier, Gregory, Swiss-American physicist and DRH *Doktorvater*, 221

wasperbelly (watermelon grafted onto raspberry bush), 253, 254, 255–256

watermelons, left halves of, indispensable for electroweak unification, 255–256

water molecule pictured inside an ambigram, 50

weak interaction in particle physics, 240–241, 253–256

"We all live in a yellow submarine": drawn as series of opaque boxes, 146; instantly deciphered upside-down by Mzchael, 148–149

wedding-gift ambigrams, 83, 92, 186–188

Weinberg, Steven, electroweak unifier and supersymmetry gull, 245, 252, 254–255

Weinstein, Karen, feminist activist and spouse of DRH's old friend RRZ, 187

Welsh, Tom, education researcher and professor, 187

Weyl, Hermann, German mathematician who founded gauge theory, 234–235

Wheelis, Allen, American psychiatrist and writer, 99

Whirly Art (line drawings by DRH), 121

Wigner, Eugene, Hungarian physicist, 238

Wiles, Andrew, British mathematician who proved Fermat's last theorem, 169

Wilson, Robert, American radio astronomer, 244–245

Wolf, Barbara, next-door neighbor and friend of DRH, 157

Wolf, Robert, ping-pong player and old friend of DRH, 46–47

word familiarity as key top-down force in ambigrammia, 97, 104, 128, 144–145, 149, 163–164, 206, 259, 275, 279

Wordplay (book by John Langdon), 24

words and letters, mutual reinforcement of, 134–135; *see also* resonance; locking-in

words and phrases, mutual reinforcement of, 135; *see also* resonance; locking-in

words as visual categories, 146–147

world knowledge, importance of, in Ambigrammia, 144, 275, 279

Writoblendia, art form invented/discovered by Petra Jones, Kim Scott, and Jane Langdon, and practiced by Egbert B. Gebstadter and many others, 290

Wu, Chien-Shiung, Chinese-American physicist who showed parity is violated, 251

Yang, Chen Ning, Chinese-American physicist, 250–252

Yang-Mills gauge theories, 252

years, combined with DRH's name, in ambigram signatures, 158

"Yellow Submarine" (Beatles), lyrics to, 146–148

"You six jump from a purple aeroplane", drawn as a series of opaque boxes, 148

"z" wall-reflected into itself, 134

Zany (Art Deco typeface), 27

Zelchenko, Peter, typeface expert, 113

"zhōng" (中) serving as dot on roman letter "i", 55

"Zolo", as nickname for the year 2010, 177, 185

Zweig, George, ace Russian-American physicist, 248